Simon Schama
The Power of Art

Art is a lie which makes you realize the truth.
PABLO PICASSO

Art is dangerous; yes, it can never be chaste,
if it's chaste, it's not art.
PABLO PICASSO

Simon Schama
The Power of Art

THE BODLEY HEAD
LONDON

For Clare Beavan, without whom this would have been impossible, and without whom television – and life – would be a lot duller.

Published by The Bodley Head 2009

6 8 10 9 7 5

This edition published in Great Britain in 2009 by
The Bodley Head
Random House, 20 Vauxhall Bridge Road,
London SW1V 2SA
First published in Great Britain in 2006 by BBC Books

www.bodleyhead.co.uk
www.rbooks.co.uk

Addresses for companies within The Random House Group Limited can be found at:
www.randomhouse.co.uk/offices.htm

The Random House Group Limited Reg. No. 954009

A CIP catalogue record for this book
is available from the British Library

ISBN 9781847921185 (TPB)

MIX
Paper from
responsible sources
FSC® C018179

Penguin Random House is committed to a sustainable future for our business, our readers and our planet. This book is made from Forest Stewardship Council® certified paper.

Printed and bound in China by C&C Offset Printing Co.,Ltd

Introduction

GREAT ART HAS DREADFUL MANNERS. The hushed reverence of the gallery can fool you into believing masterpieces are polite things, visions that soothe, charm and beguile, but actually they are thugs. Merciless and wily, the greatest paintings grab you in a headlock, rough up your composure and then proceed in short order to rearrange your sense of reality.

This wasn't why you'd come in out of the rain, was it? There you were, standing in a museum on a Sunday afternoon, ready for a nicely measured dose of beauty – time innocently spent with the wizardry of two-dimensional illusions. Can't you just taste those strawberries on their silver platter? Can't you just smell those pines on a tawny Provençal hillside? Can't you just hear the belching of the Dutch drunks? Can't you just feel that watered silk, the glossy flank of that stallion? No you can't, but still, nothing wrong with imagining, bingeing on the eye-candy, surrendering to the fancy? You settle into the routine, let the colour come to you, walk your eye around the design. Perhaps you do the headset shuffle: sidle, stare, listen, walk; sidle, stare, listen, walk, your attention commanded by the soothingly authoritative voice, a male voice in an expensive suit, the wisdoms toffishly enunciated and thoughtfully rationed so that you don't get too tired for the visit to the gift shop.

But then for some reason you go off-piste; round a corner, beyond the headset zone, and it happens: the peculiar bit. Isn't there something unsettlingly off-kilter about Cézanne's bowl of apples, the way they're sitting askew on the table? For that matter, the tabletop itself seems up-tilted from the horizontal, inviting a giddy slide – a movement that never quite starts, but never quite stops either. What's going on? Or those eyes of Rembrandt's staring from the collapsed pudding of a face? Such a cliché, such a tired joke, such a sentimental projection: the looker looked at. All the same, you can't help but go on staring, feeling accosted, implicated, as though it's somehow all your fault. Sorry, Rembrandt. The people in the gallery disappear. The gallery wall disappears. You're in the hands of some cheap stage hypnotist. You snap out of it, move on and glance – well, why not – at that peachy Titian nude laid out before the swelling hills and, oh-oh, something starts to happen, and not just in your eyeballs. Or you stand dutifully before a Cubist collage, the kind of thing you've never quite got, and still can't see the point of, at least not from the pleasure point

of view – but what the hell? You give it a go, and before you know it some piece of your brain starts to do a little dance to the strumming of that guitar, and fragments of newspaper and half-obscured pipes and edges and flats and planes all start to exchange places without so much as asking permission, moving in and out of focused resolution, and you discover you quite like it. You've been nailed again, eye-popped. Life has just been adjusted.

The power of art is the power of unsettling surprise. Even when it seems imitative, art doesn't so much duplicate the familiarity of the seen world as replace it with a reality all of its own. Its mission, beyond the delivery of beauty is the disruption of the banal. Its operational procedure involves the retinal processing of information, but then throws a switch and generates an alternative kind of vision: a dramatized kind of seeing. What we know or remember of sunsets and sunflowers and the form they take in Turner's or van Gogh's paintings seem to exist in some parallel universe – and it's not at all obvious which is the more vivid, the more real. It's as though our sensory equipment has been reset. So it's not surprising that sometimes, in the power surge, we get shocked.

But television doesn't like to be inconvenienced by the unanticipated. Filming needs careful planning. Each of our programmes turned on a crisis in the life and career of an artist, a moment of trouble in the creation of a particular painting or sculpture. En route to that climactic moment, though, we looked at other works, and lurking among them would often be something that threw me completely off balance. A picture I'd blithely thought of as a warm-up act for the big number, seen first-hand rather than through the wan medium of a printed reproduction or a dim memory, suddenly threatened, unnervingly, to be the main feature. Chastened, re-educated, I'd throw a small tantrum, want the programme turned inside out to make room for the epiphany. Directors would hear me out and try not to roll their eyes. Sometimes room would be made for this usurper, sometimes not.

There was, for instance, van Gogh's *Tree Roots and Trunks* (pages 344–5), painted during the last weeks of his life in the summer of 1890. Ostensibly a vole's eye view of densely knotted vegetation, the frantic patterning of the gnarled wood and choking greenery is so visually claustrophobic that it shuts us off from any possibility of landscape. Spatially and psychologically we get no relief, not least because the roots, some of them claw-like and skeletal, others metallic and mechanical, have been monstrously magnified, while trapped within their cage are miniaturized trees. Up is down and down up, far is near and near far. What we are really looking at, then, is a calculated image of disorientation, the painter's extruded ganglia bolting through the space.

Introduction

Nothing like this had ever dared present itself as a painting before. But in the Van Gogh Museum in Amsterdam, among the iris and sunflower big hitters, no one pays it much heed. There's little call for the postcard, and unless you wanted to strangle someone, you wouldn't want it as a silk scarf.

Then, just when I thought I'd seen them all, there was the Turner surprise. On a misty, late autumn afternoon we were filming at Petworth House in Sussex, home of the Earl of Egremont, one of Turner's most hospitable patrons. At the top of the house was the locked door of a library that had been given over to the painter to use as his studio. The custodian was generous enough to let me go through that door, and there were the book-lined walls much as Turner would have seen them – or, rather, ignored them as he worked; there, too, an easel set up in the place he favoured. As the November fog drew in, so did the whisper of his ghost, which may be why I was set up to see in a little painting in the long gallery downstairs something more than the *View of Chichester Canal* by which it was known to the Victorians (page 275). It's one of a sequence of four views in and around Petworth that Turner painted as wall panels, but they're hardly matter-of-fact topography. The park itself is drenched in rosy fairyland radiance, as stags, antlers locked, battle like some mythical incarnation of bewitched warriors.

So does that church on the horizon tell us we are somewhere near Chichester, or perhaps somewhere altogether different – inside the ageing painter's romantically fateful sense of the journey of life, for example? The scene is washed by such an unearthly light that the suspicion that the canal is something other than an expeditious route for lumber or nails becomes irresistible. In a tubby little rowing boat sits a small man in a dark coat and battered hat, very much as the painter was famously wont to do. So perhaps this picture is not a Turner but Turner. In 1827–8, when the painting was made, Turner had arrived at his own middle age. At right-angles to the picture plane – the imaginary window through which we look – a ghostly vessel sails directly down the canal towards us, mysteriously powered since its sails are furled and there's no sign of towing. This ship is no more a workaday sailing barge than Captain Ahab's Pequod was a blubber factory. Black masts reflected in the water, the ship glides towards us in the glimmer, ominous and inevitable. *Chichester Canal*, then, turns out to be an allegorical self-portrait, smuggled into the gallery of Turner's most powerful patron in the guise of a landscape; a cheeky, touching move.

And then, most unnerving of all, there was the apparition in Valletta, Malta. At the end of a long room, the Oratory of the Knights of the Order of St John, in a cathedral where the walls writhed with overwrought wooden carving, and whiskered

defunct warriors lay recumbent on tombs glittering with mother-of-pearl mosaic, Caravaggio, then a convicted murderer, depicted (as his get-out-of-jail-free token) the decapitation of the already dead saint John the Baptist. The figures are life size, and painted with such unnerving clarity that they seem to be unbound by any sort of separating frame. We feel we could walk to them at the end of the room, up on their stage overlooking the oratory. The picture is asymmetrically divided. On the left, gathered in a semicircle, is a group of figures, most of whom personify the traditional virtues of art: heroic beauty, gravity, authority. But they are about to engage in butchery, sawing through a dead neck. On the right of the painting is nothing except a rope dangling in the prison yard gloom, while two jailbirds corkscrew their necks through a barred window for a look. One of them bears a resemblance to the criminal painter, but Caravaggio is more emphatically present in the blood oozing from the martyr's neck, which forms itself into a signature; this is one of only two pictures that he ever signed. So the painting perpetuates horror; the artist signs himself in as a culprit; we, his own captives, attempt a look, torn between appalled recoil and stupefied admiration.

All three of these masterpieces not only register the presence of their makers, as if inviting – or daring – us to make a direct connection with them, they crucially feature the artists themselves within a creative drama: van Gogh, the manically enraptured painter of burgeoning nature throttled by his own creations; Turner, the meditative poet of the comings and goings of life; Caravaggio, the devout Christian and criminal, who understands the redemption of blood because he has direct experience of spilling it. *Power of Art* features eight of these moments of self-dramatization, when the artist, under extreme pressure, undertakes a work of supremely ambitious scope in which his own most essential beliefs are embodied. All of them are directly personal testimonies; all of them make claims for art that go well beyond the pleasure principle. They are works that seek to change the world.

They are not the norm. A great deal of supremely accomplished art has been created by artists who have preferred self-effacement to heroic self-dramatization, and who have wanted more modest goals for their work: the imitation of nature; the representation of beauty, or both at the same time. But since the Renaissance the most ambitious artists have wanted to be something grander than laboriously ingenious craftsmen-copyists. In their own eyes they are makers, not fakers. And they have been keen to throw off the condescension of patrons who regarded them as little more than ornamental craftsmen. 'He thinks he's Lord of the World,' Gianlorenzo Bernini's own mother complained to the Pope. And for such lordly creators, possessed in their own minds of a spark of divinity, it was important that

their art be acknowledged as noble; akin to philosophy, poetry or religion: a human necessity rather than an optional luxury. That impassioned conviction led them to assert the authority and power of art in the face of complacency from the holders of institutional power: popes, aristocrats, bureaucrats, moneyed patricians and their tame critics. So the way the drama of their creative life (written by themselves or by biographers) unfolded was typically combative: a conflict with obtuse patrons or their lackeys, the cowardly and conceited critics. The acts in the play are presented as ordeals over which the resolute but bloodied art-maker, possessed of his bright vision, may triumph even as he himself goes under.

It's those moments of high-wire tension in the drama of creativity that *Power of Art* sets out to capture: masterpieces made under acute stress. And it's a professional tic of art historians to write off these dramas of the moment of creation as so much stale rehashing of the romantic fantasies of the tormented artist; the corniest story in the book of the muse; a modern platitude about the artistic temperament that the old masters would have found unrecognizable. And of course it's quite true that for every van Gogh there's an imperturbable Cézanne; for every Jackson Pollock, a Matisse; for every painter driven by furies, countless more who have gone to work and lived their lives in a state of disciplined serenity. But the story of the saturnine artist contemptuous of convention, conscious of god-like powers, prey to melan-choly, quick to take offence, at odds with short-sighted or vain patrons, embattled with rivals whose mediocrity is matched only by their malice, begins centuries before the Romantics of the 19th century. It begins, in fact, almost as soon as there is any writing about Renaissance artists at all – with Benvenuto Cellini, the goldsmith, sculptor and autobiographer, and with Giorgio Vasari's contemporary biography of Michelangelo.

Of Michelangelo's divine powers Vasari leaves us in no doubt. He has been sent by God himself to earth to exemplify perfection in every form of art: painting, sculpture and architecture. When workers see one of his cartoons they pronounce it more divine than human. He argues with popes and dukes, achieves Herculean labours in painting the Sistine frescoes atop his famous scaffolding. And Vasari implies that Michelangelo was conscious of his own superhuman powers, since during his months in the Carrara marble quarries he contemplated emulating the ancients by carving a colossal image of himself in the mountains.

It was, in fact, the stupendous versatility and superhuman prowess of Michelangelo that provoked Cellini to write his own extravagant autobiography, *Vita* (1558–66). The latter's masterwork, the bronze *Perseus and the Head of Medusa*, 1545–54, was made for a place in the Loggia dei Lanzi in Florence, where the

dripping, severed head of the Gorgon (a technical achievement of such difficulty, as Cellini was at pains to point out, that his contemporaries said it couldn't be done) deliberately confronts Michelangelo's *David*. Every time Cellini can possibly invoke Michelangelo's praise for his own work he does, making sure that the goldsmith would always be thought about by posterity in the same breath as the greatest of the Renaissance masters. The immortality would rub off.

There's a difference, though. Vasari's presentation of Michelangelo is of the austere man-god up on his scaffold, loftily remote from the failings of common clay. Cellini's version of himself, on the other hand, is all too human: a diabolical incarnation of fleshly appetites, the first in a line of artists who imagined that their gift put them beyond the conventions governing lesser mortals. One of his first memories of himself is as a toddler grasping a scorpion by its claws and gleefully dangling it in front of his horrified grandfather. True or false, we'll never know – but from the start it's evident that Cellini wants to cast himself as someone who laughs at the fears of the mediocre and the pusillanimous. There is nothing, then, that Benvenuto won't or can't do. As well as goldsmith and sculptor, he is musician, poet, soldier, swordsman, cannoneer. To say sex and violence run riot in his pages is to understate the truth. Cellini is an unrepentant, outlandish orgiast, consuming men, boys, women, girls, whores, wives – pretty much anyone and anything going. With some women he is brutal, even sadistic. One of his mistresses, Catarina, has the temerity to get married, so Cellini takes a treble revenge, cuckolding her husband, forcing her to pose for hours in an unnaturally painful position and then beating her up. As regards his killings and multiple violent assaults, he is not only unapologetic, but evidently relishes the detailed telling of the deeds. Quick to take offence when he thinks his honour has been impugned, he has no compunction about telling popes and princes just where to get off when he has a mind to.

Running through the compulsively appalling tale is Cellini's sense of his own appetites and impulses as indivisible. The Benvenuto who stabs people in the neck and hauls young boys off to bed is the same Benvenuto who has what it takes to make unimaginable marvels in bronze. Or so he wants us to believe. He boasts, after all, that he would prefer to kill his enemies by art rather than by the sword – but the instinct to annihilate the doubters and jeerers was the same. So his life unfolds as a series of flung gauntlets that Cellini picks up and throws in the teeth of his rivals with demonic energy. And those Herculean triumphs achieved against impossible odds begin with the feat of writing the autobiography itself while under house arrest, in his fifties, for acts of sodomy. Denied pen and ink, he uses, so he tells us, what is to hand: a solvent of rubbed brick dust to make ink, and a splinter of wood from his

door as a writing instrument. Thus the tale of the bloody-minded hero, supremely confident of his own powers and supremely indifferent to the small-minded mortals who get in his way, can begin.

The famous climax of the story occurs at the moment when Cellini's bronze *Perseus* is ready for casting, only for the sculptor to fall so sick that he becomes convinced of his imminent death. At least, he believes, his work will survive and be recognized as the equal of Michelangelo's *David*. Something, however, goes terribly wrong with the molten metal, which 'curdles', the base of the alloy congealing. A man bent like an 'S' appears to the feverish master on his sickbed, intoning the doom of his great project. In response to the devilish apparition, Cellini leaps from the bed to rescue the work of nine years from disaster. The scene becomes operatic. A furnace explodes; a great rainstorm bears down on the beleaguered workshop. Two hundred pewter platters and kitchen pots are hurled on to the furnace to get the molten liquid to the right consistency. Amidst all this wildness the super-artist stays cool and, of course, the *Perseus* is rescued, made perfect – the *Vita* ensuring that no one who saw it would ever forget the superhuman manner of its creation.

Not all the stories that follow feature delusions of artistic megalomania of Cellini's calibre. But they do all track a tradition – from Caravaggio to Mark Rothko – of artists who have self-consciously cast themselves as heroic champions of the conversionary power of art. Each story features a work made under severe stress – from patrons (Rembrandt), from the political moment (David, Turner, Picasso), from a sense of self-vindication (Caravaggio, Bernini) and from their own exacting sense of what art should be and do (van Gogh, Rothko). Each of those moments tested the capacity of the artist not just to fulfil the terms of his commission, but to transcend it.

In rising to the occasion, each of the artists, as it happened, turned a new page in the history of art, to produce something unprecedented. In some cases, such as Rembrandt, Turner and Picasso, they created momentous history paintings, so massively complete an answer to the challenge of the moment that they could never be repeated, not by themselves and much less by apostles or imitators.

So the dramas that comprise *Power of Art*, then, are histories as much as art histories (and in any case, the distinction has sometimes been lost on me). At stake in their success or failure were the things that go to the heart of our individual and shared existence: salvation, freedom, mortality, transgression, the state of the world and the state of our souls. All of these works are, in their several and incommensurable ways, shockingly beautiful, and there's nothing shameful or trivial about that. But their creation – even, or especially, in the case of the abstract artist

Rothko – was not fundamentally driven by the reach for aesthetic effect. Famously, Picasso (who was not allergic to beauty) put it most trenchantly and self-righteously when he said that 'paintings are not done to decorate apartments; they are weapons of war'. The fact that for much of the rest of his career after *Guernica* (pages 384–5), he did little else but produce stuff that served perfectly well as interior decoration suggests how atypical these dramatic episodes of consummate public vocation were. But when they happened, in a bolt of illumination, the works tell us something about how the world is, how it is to be inside our skins, that no more prosaic source of wisdom can deliver. And when they do that they answer, irrefutably and majestically, the nagging question of every reluctant art-conscript, be they nine or 59, who's been dragged through a museum door, leaden-footed, sighing heavily, wistfully hankering for the football results or the fashion sales: 'OK, OK, but what's art really for?'

Caravaggio

PAINTING GETS PHYSICAL

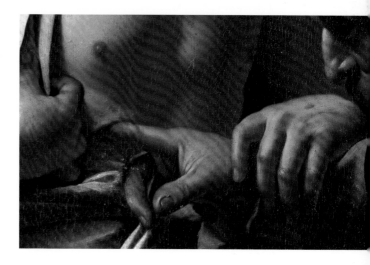

I

FROM THE START, there are only two things you need to know about Michelangelo Merisi da Caravaggio: that he made the most powerfully physical Christian art that has ever been painted, and that he killed someone. Do these two facts have the slightest connection? I should hope not, the art historians will tell you, horrified by the crassness of the question. The fact of the painter's crime, they will say, is merely a sensationalist footnote to his career as maker of pictures. Beware romantically reading the art from the life, or for that matter vice versa; the one has nothing whatsoever to do with the other.

But then you look at Caravaggio's shocking painting of himself as the severed head of the Philistine giant Goliath. And you see something that had never been painted before and would never be painted again: a portrait of the artist as ogre, his face a grotesque mask of sin. It's an image of unsparing self-incrimination and it certainly makes you wonder.

II

IT'S A COMMONPLACE about Caravaggio's pictures that, more than those of any other artist, the viewer responds to his figures physically. All the same, I wasn't ready to hold in my hand something that Caravaggio had held in his.

'Please,' said the wizened man with the beaky nose and the black cassock, nudging me in the ribs. 'Please, take.' I wasn't in the mood to be nudged. It had been yet another embarrassing day with Caravaggio, attempting to say something that illuminated his drama while painfully conscious that he did his own lighting, thanks very much; and that words were a feeble fluttering thing beside the muscular heft of his painting. In the cathedral oratory at Valletta, my back to *The Beheading of St John the Baptist* (pages 66–7), face to the camera, speech had never seemed so redundant. I wanted to be out of the musty dimness of that church. The bar stool at the Ship pub, from which Oliver Reed had terminally tumbled, was calling for an act of homage. I had had my fill of art.

Still, courtesies were called for. Rule number one of location filming is to show proper gratitude to those whose premises you have occupied with the self-important baggage of cable, lights, camera. Besides, the small man in the cassock was giving me a wry grin as he did his poking: 'Please, take.' So I sighed, looked and took.

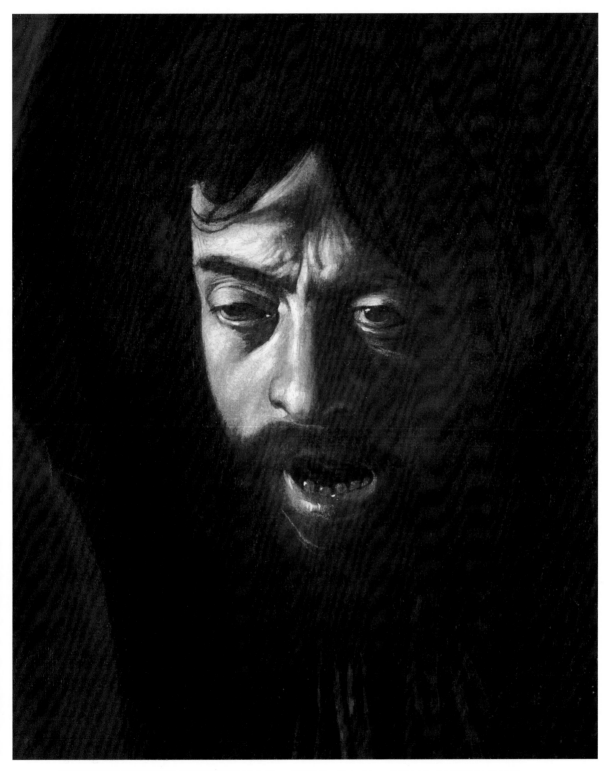

DAVID WITH THE HEAD OF GOLIATH (detail), *c.* 1605–6, oil on canvas (Borghese Gallery, Rome).

Caravaggio

In my hand was an ancient iron key about five inches long. The looped handle end had got furry in the way very old pieces of metalwork do, but the entry end sported massive squared-off teeth. I had used keys like this before when I'd been a Cambridge don and occasionally had to open oak doors with 17th-century locks. But why was I getting this key in the cathedral of the Knights of St John? I smiled uncomprehendingly back at the verger, now vaguely aware I had seen this particular key before. Indeed I had, just two minutes before. The gnomic figure in black now tightly grasped my free hand, as if I were a child and he my schoolteacher, and turned me round to face Caravaggio's painting. And of course, there it was: one of three keys hanging from the belt of the grimly handsome prison officer who was pointing to the basket in which the head of the Baptist was about to be deposited.

Caravaggio, his earliest biographers, Giulio Mancini and Giovanni Baglione, tell us, almost always used live models, and since the figures in the *Beheading* are life-sized, and he had painted the altarpiece *in situ*, there could be little doubt that he had done so in the space in which we were now all standing. He needed the keys – emblems of incarceration – to ramp up the nightmarish claustrophobia that manages to pervade even this huge painting. So he had posed his grizzled model and then, perhaps, asked for a set of keys to hang from the man's belt. The cathedral clergy were probably as accommodating to him as they had been to us, lending whatever was to hand. The key in my hand matched precisely, tooth for tooth, the one in the painting. 'See, yes, see,' said the verger. 'His.' I palmed the blackened thing, then I wrapped my fingers around its abraded shaft. I was nervously shaking hands with a 400-year-old genius-killer.

Caravaggio, the jailbird, was haunting me at the scene of my own venial crime – cutting him down to television size. But then Caravaggio is the most confrontational of painters, with everything calculated to be too close for comfort. His big paintings get in our face like no others because they are designed to rip away the protective distance conferred by high art. A blaze of light catches the figures, but around them is utter blackness swallowing up the comfort zone of art-gazing: frame, wall, altar, gallery. The great breakthrough of Renaissance painting had been perspective, the depth punched through the far side of the picture plane. But Caravaggio is more interested in where *we* are, in the space in front of the picture plane which he makes a point of invading. Looking at the outflung arms of Christ in his *Supper at Emmaus*, 1600–01, (National Gallery, London), you almost duck to avoid the impact. Caravaggio isn't a beckoner – he's a grabber, a button-holer; his paintings shamelessly come out and accost us, as if he were crossing the street and, oh God, coming our way. 'You *looking* at me?

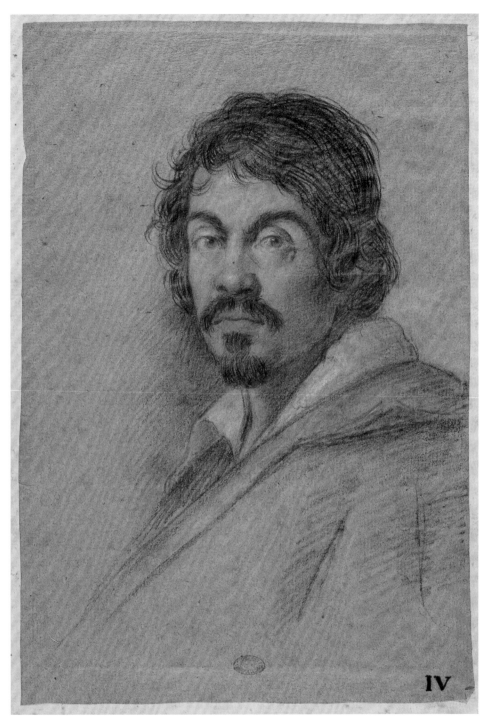

PORTRAIT OF CARAVAGGIO by Ottavio Leoni, *c.* 1621, charcoal on paper (Biblioteca Marucelliana, Florence).

Caravaggio

This is an artist who enjoys reminding us he's there. Unlike Rembrandt, he never does so by means of formal self-portraits, but got up as some player in one of his own painted performances. The only image we have of him out of character is Ottavio Leoni's drawing, which, with its mane of wiry hair, snub nose and large, piercing eyes, seems (especially in comparison with Leoni's drawings of Caravaggio's better-behaved contemporaries) to charge straight out of its demure format. Why did he like posing for some of his own pictures? It's possible that, 'naked and in need', as Giulio Mancini, the doctor who treated him and became his first contemporary biographer, describes him in his early days in Rome, he was the only model he could afford. (However, this seems unlikely since friends evidently posed for paintings well before Caravaggio had anything like a steady income.) But even if the practice began as a necessity, it went on as a choice. For Caravaggio's self-dramatization was a calculated gesture, as challenging and aggressive to the conventions of art as the contemptuous sweep of a dirty thumb over his lower lip. Over the 15 years of his career he appears as a 'sick Bacchus'; as a boy emitting a howl of pain as he's bitten by a lizard; as another screamer – the serpent-coiled face of the monster Medusa at the moment of her death; as a come-hither horn player at the back of a group of winsomely clad musicians; as a frantic bystander getting out of the way of St Matthew's brutal killing; as the curious holder of a lantern that sheds light so that wickedness can be done and destiny fulfilled – the apprehension of Jesus in the garden at Gethsemane; and, most unforgettably, at the very end as that monstrous head of Goliath, eyes bulging in their sockets, mouth agape, drool puddling at the slack lower lip, brow furrowed in stricken bewilderment around the puncturing wound from David's slung stone.

Appearing in one's own history paintings was nothing unusual. Michelangelo painted his own likeness, bearded and intense, as the flayed St Bartholomew in the Sistine Chapel, and Giorgione, whose work Caravaggio is likely to have seen in Venice, is known to have represented himself as David with the head of Goliath. It was one thing, though, to cast yourself as the beauteous hero, the forerunner indeed of the Saviour; quite another to appear as the colossus of depravity and sin. It was, after all, exactly at this moment in history that painters were at pains to present themselves as masters of learning, socially and morally ennobled by their calling, not as lowly craftsmen – and much less as fallen ogres. But then Caravaggio specialized in the unexpected. So he begins his string of self-images as a debauched Bacchus and ends it with a slain Goliath. In between that beginning and that ending every appearance he makes is in the guise of sinner. Now why would he want to do that?

III

IN 1592 THE 21-YEAR-OLD CARAVAGGIO arrived in Rome, an unknown Lombard from the small town of Caravaggio just eight miles outside Milan. He would leave it in a hurry in 1606, a fugitive from justice. Between those dates he transformed Christian art more completely than anyone since his namesake, Michelangelo.

In so many ways the Roman Church had been waiting for him. Assailed by the northern European Reformation, it was in dire need of a sacred visual drama that simple believers could respond to tangibly as if it were acted out in their presence. Much was at stake. Images were not just an incidental sideshow in the religious war between Catholics and Protestants; they went to the heart of the matter. For Lutherans, the Word written in the Holy Scriptures was everything. Printing had made that word, translated into their vernacular language, available to all believers, enabling literate Christians to have a direct, unmediated personal relationship with their Saviour. The claim of the Roman clergy, from the Pope down to the parish priest, that they alone held the keys to salvation, and that redemption could only be achieved through the mysteries and rituals of which they were the guardians, was dismissed by Lutherans as a wicked and presumptuous fraud. And at the heart of what they perceived as institutionalized deception were images: the pictures and sculptures of saints and madonnas, of the Saviour and even (the most shocking blasphemy, this) of the Heavenly Father himself. These were the idols, the painted mummery, by which the credulous were kept infantile, held in thrall by the Pope of Rome and his minions. They were, thundered the Lutherans, a plain violation of the second commandment, which forbade 'graven images'. So along with the secret distribution of vernacular Bibles, the most dramatic expression of the Protestant revolution was the destruction of images. On to the bonfire they went, in the Netherlands, Germany, England and in the reformed Protestant Swiss cities of Geneva, Basel and Zurich.

Shaken by the scale and fury of the destruction of images, it took little time for the Roman Catholic Church to mount a counter-attack. One of the major issues tackled at the Council of Trent, in its final session in 1561–3, was the role of sacred paintings in inspiring the faithful to worship, venerate and obey. Instinctively as well as intellectually the Church Fathers knew that, since the vast majority of men and women in Europe were illiterate, images were still the most powerful way to instruct the masses and hold their allegiance. To do otherwise was to condemn the poor and unlettered to ignorance, heresy and, ultimately, the damnation of their immortal souls. So instead of backing off from the making of sacred images, they would commission many more. Sensibly, they conceded that there had been abuses and

extravagances in some of the art that had found its way into churches: depictions of fabulous wonders done by dubious saints that were little more than fairytales; liberties taken with the likenesses of the Father and the Holy Virgin; even some gross indecencies that made images more like distracting entertainments than objects of reverence. All those corruptions would go. Henceforth, the Council decreed, sacred art would be in the spirit of the Saviour himself: modest and austere. It would forego the seductions and pagan profanities of worldly beauty for the supreme vocation of instilling piety.

The only problem was, no one quite knew what such an art would look like. In 1571, when Caravaggio was born, Michelangelo had been dead for just seven years. He and Raphael had been the only two masters in Rome who had seemed capable of expressing in sculpture and painting one of the Church's central doctrines: that the meaning of the Gospel was God's compassion, embodying his son in human flesh so that his sacrifice could redeem the sins of mankind. Inseparable from this core belief was the emphasis on the Incarnation and Passion as physical experiences. To convey the epic of Christ's body in a manner with which all believers could emotionally identify while still preserving the equally indispensable mystery of divinity was the most challenging element of the Christian painter's vocation. Michelangelo's *Pietà* of 1500, for example, was supremely successful at rising to this challenge. The Madonna is figured as a grieving mother with the broken torso of her son laid across her lap. The fact that the Virgin's features appear, if anything, younger than those of her son is rescued from incongruousness because we recognize transfiguration through divinity into a kind of agelessness.

In their separate styles both Michelangelo and Raphael were capable of reconciling the representation of mortal flesh and immortal spirit. But at the end of the 16th century when, under the papacy of Sixtus V, there was a great renewal of building and teaching timed to culminate in the Holy Year of 1600, and the churches of Rome were in urgent need of compelling images to inspire the faithful, it was embarrassingly unclear who could fill their shoes. The choice was obvious enough: fervent dreams or classical statues? An earlier generation, gripped by visions, had put beauty over nature and had specialized in stylized figures, elongated limbs and torsos, balletically torqued in space and coloured, like shot silk, by a fantasy palette of apricots, purples and rose pinks that seemed to come straight from some High Renaissance runway. At their weirdest and most wondrous the images produced by artists like Rosso Fiorentino and Jacopo Pontormo were unarguably beautiful, but too ethereally unmoored from nature to appeal to anyone not in on the arcane secret. Besides, to the sober Fathers of the Church, who were monitoring post-Trent

standards of piety and decency, these Mannerist confections seemed suspiciously sensual.

The alternative was a return to the statuesque classical grandeur and emotional simplicity of Raphael: finely drawn figures, harmoniously disposed in deep space. The only late 16th-century artists with the evident talent to achieve that revival were the Carracci brothers, Agostino and Annibale, the sons of a Bolognese tailor. But until the last two years of the century the Carracci were working in Bologna and remained virtually unknown in Rome. Besides, although Annibale in particular was wedded to what by Roman standards passed for realism, compared with Caravaggio – as a commission in the Cerasi Chapel in the church of Santa Maria del Popolo would make spectacularly clear – even he would seem like the softest, most cherubic idealist.

How could Annibale have known? How could anyone have known what was about to hit them? Caravaggio came out of obscurity, from the peculiarly grim darkness of Spanish-ruled Milan. The city was an embattled citadel, economically and spiritually. Its hardware walked the streets in the shape of swords, daggers and armour; its guns were mounted on the fortifications Leonardo da Vinci had designed for the Sforza dukes. But the most famous general of the faith militant was Carlo Borromeo, guiding light of the Council of Trent. It had been Borromeo whose unimpeachably simple life, even (or especially) as a prince-cardinal, combined with his attention to the poor had returned the Church to its pastoral duty of imitating the life of Christ.

What was wanted for the altarpieces of this newly populist Roman Church, then, were images that were also naturally simple and accessible – the remote grandeur of the Renaissance masters brought down to earth. But the talent available to achieve this was, to put it mildly, limited. Milanese painters such as Antonio Campi and Simone Peterzano certainly did dark and simple in the spirit of Borromeo's austerity, and they did their best with the obligatory nod to the local hero, Leonardo, delivering studiously drawn fruit, flowers and animals into the scenery. If modesty was the intended effect, they succeeded all too well, but it was at the expense of drama. It seems inconceivable that even the most willing worshipper could have looked at an altarpiece by Peterzano, caught his breath and felt he was in the presence of the living Gospel.

Then into Peterzano's workshop some time in the mid-1580s came a stocky, beetle-browed teenager, probably already with something of an attitude. He hailed from a dull region of flat pasture and distant horizons: sheep, mournful avenues of poplars, one standard-requirement local miracle (Virgin appears to country girl),

one grand basilica built to honour same, plus the odd fort and villa. But young Michelangelo Merisi (named after the sword-brandishing angel rather than the brush-brandishing genius) was not entirely a social zero. He had connections, albeit of a forelock-tugging kind. His father, Fermo Merisi, had been the architect-builder and household steward to the local marchese, living in Milan while doing the job. But any hope that his two sons might be upwardly mobile had been cut short by his death in the plague epidemic that swept through Milan in 1577. Fermo's widow, Lucia, and her four children had already been sent outside the city, to the small town of Caravaggio, to escape the epidemic. With properties sold up to settle debts, the best the older boys could hope for was the priesthood or some modestly respectable craft or trade. Giovanni Battista would become the priest; Michelangelo the painter.

Art history is constitutionally incapable of discounting influence, but aside from strongly lit figures in dimness, and the simplified cast of characters, it's hard to see much of what became Caravaggio in the example of Peterzano. Had he stayed in Milan, it's possible that he might have remained obscure since he served his time doing what apprentices had to do: grinding colours, dabbing in details. But before he was 21, according to his early biographers, Caravaggio had already become Trouble. He'd run through his small share of the proceeds from the sale of his mother's property, and ran around with toughs and whores in a city where street fighting was the favourite pastime. One biographer claims that he killed someone; but more credibly Mancini, the writer closest to Caravaggio's own lifetime, mentions a fight in which a prostitute's face was slashed. Refusing to snitch on whoever had committed the assault, Caravaggio did time in a Milan prison. A pattern had been set.

By the early 1590s Caravaggio had ended up, inevitably, in Rome, one of a restless, buzzing swarm of young artists hungry for work, fame and pleasure, not necessarily in that order. There he led a fly-by-night, testosterone-fuelled existence in rented rooms around the Campo Marzio, where other Lombards lived, drinking themselves stupid in rough-house taverns, abusing passers-by on the street and hunting down the action. Caravaggio's artist mates – Prospero Orsi, Mario Minniti and the architect Onorio Longhi – were no angels themselves, quick to get out their blades and constantly in trouble with the *sbirri*, the papal police. The whole gang of them liked to hang out with working girls, who themselves fought like street cats over territories, customers and the affection of their pimps.

Caravaggio's crowd weren't just hoodlums, though. Many of them were bright, talented and ferociously ambitious. They did fights and tarts, but they also did poetry, music, theatre and philosophy. If they were drunk a lot of the time, it was on

ideas as much as on sour wine. They even showed up at lectures put on by Federigo Zuccaro's 'Academy' of San Luca. Zuccaro may have been a mediocre portraitist and history painter, but he'd worked for princes, had drawn Queen Elizabeth I with stupendously flattering mendacity, and now presided over the Guild-turned-'Academy' as though it were a combination of his own court and an assembly of philosophically minded artists. In keeping with the high-minded aspirations of the institution, members were sworn to uphold lofty standards, both in their professional practice and in their personal lives.

Caravaggio is known to have gone to some of the meetings of the Guild-Academy, and later to have been a member. When he died, honour was paid to him by the members. But in his early years in Rome he hardly matched Zuccaro's prescription for the dignified artist, going round as he did in shabby-chic black, holes conspicuously showing. What work he had was hack stuff: routine heads and, since it was supposed to be a northern Italian speciality, fruit-and-flowers details for other artists' history paintings. In fact, Caravaggio was not just good at this second-order rendering of nature, but the best since Leonardo, and much the wittiest. The rosy-cheeked boy with the kiss-me-quick lips and plunging neckline, or Caravaggio's friend the Sicilian painter Mario Minniti at his poutiest, loaded down with a basket full of ripe-and-juicy, may both seem performances of cloying sweetness. But that, of course, is the point. You look at the dimpled peaches with their fine fuzz and then you look at the winsome youths and it's gigglingly obvious that they are the fruit. Poems and songs being written by the likes of Francesco Marino played on just that clichéd conceit. Touch me. Peel Me. Taste me.

All the same, and despite introductions from influential connections, such as the Marchese and Marchesa of Caravaggio, no one in a position to employ a young jobbing artist was as yet much impressed with the newcomer from the north. Pandolfo Pucci paid his artists so poorly – and fed them even worse – that he was known as 'Monsignor Salad'. The painter glorying in the name of Anteveduto Grammatica took Caravaggio on for a while to turn out 'heads'. It was only when he joined the shop of the most successful up-and-coming painter of altarpieces and ceilings, Giulio Cesari, that Caravaggio got an opportunity to do what counted: sacred history paintings. He may have assisted Cesari with some of the figures on the unfinished decoration of the vaults of the Contarelli Chapel in the church of San Luigi dei Francesi. But it all came to nothing. Depending on the source, Caravaggio spent some months in hospital either because he'd been kicked by a horse or because he'd fallen sick (or possibly both). By the time he had recovered, Cesari made it plain that he was no longer interested in having him back.

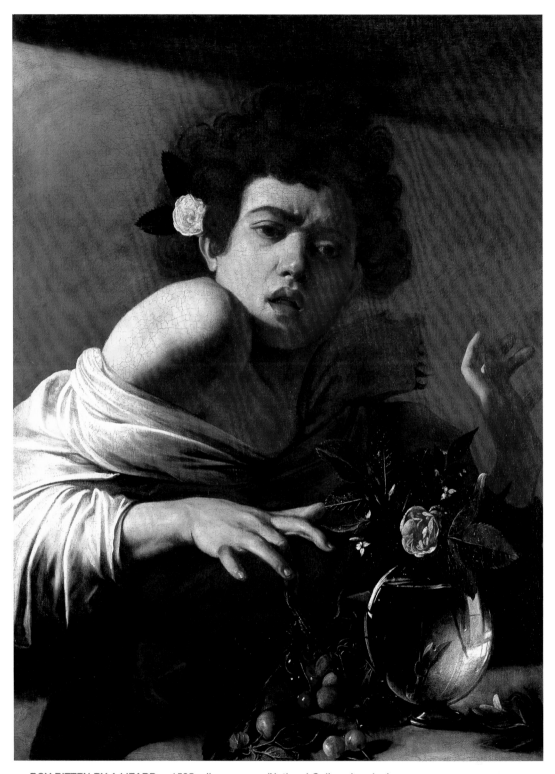

BOY BITTEN BY A LIZARD, *c.*1595, oil on canvas (National Gallery, London).

Caravaggio

To any dispassionate observer, two years after his arrival in Rome Caravaggio's prospects must have looked dim. But two surviving paintings from this early period don't suggest someone who had lost his way or his faith in his own powers. Quite the contrary, in fact. They suddenly announced the presence of a maverick talent, not least because they feature, bold as brass, Caravaggio himself, and in guises that were not exactly what Zuccaro's Academy of San Luca was hoping for.

Of course, if you had a mind to, you could read *Boy Bitten by a Lizard* as a warning against sexual mischief. Just in case you hadn't cottoned on to the bitten digit and the thorny rose, a smirking local would have told you that on the streets, 'lizard' was slang for 'penis'. The wound inflicted on the saucy lounge-lizard with the flower tucked behind his ear was, then, the bite of the inevitable social disease that visited innocents hooking up with the kind of girls Caravaggio and his pals favoured. Much more important than its snigger value, though, was the work's function as a composite portfolio of all the talents that Caravaggio was pitching. Here was someone who, from the detail of the waterbowl in which his own studio was reflected (making the painting a double-disguised self-portrait), was a dazzling master of illusionist naturalism – the first quality that those in the market for raw young talent would seek. But then the perfectly rendered moment of recoil – body thrown back facial features contorted in pain, skin flushed with a rush of blood – also advertised a master of body and face language, someone who could make visual the extreme passions in just the way Leonardo had demanded of any truly ambitious history painter. Then there was the way in which the picture was lit: a sharp, intensely concentrated light thrown over the figure. Doubtless it was just another of the countless genre scenes on offer in the market stalls and shops of Rome. Believe it or not, there had been other lizard-biting (and, still more ponderously obvious, crab-biting) pictures. But for those who had eyes to see, this was the work of a stunningly strange virtuoso.

Who got rapidly stranger? Perhaps it was when he got out of hospital that Caravaggio painted his *Sick Bacchus* (page 29). The very idea of it, never mind the way it was executed, was an outlandish challenge to the conventions. Bacchus, after all, was not just the god of wine and revelry, but one of the patron deities of dance and song; and as such he had always been depicted as a perpetual youth. Caravaggio, however, turned him into a literally sick joke. The lips are grey, the eyes leering, the skin unnervingly sallow, the overloaded wreath of vine leaves around his brow excessive rather than festive. By painting himself as overdressed party animal the morning after, Caravaggio up-ended the conventions. Instead of taking a model with all his human imperfections and translating him through the ennobling magic of art

into the embodiment of perpetual youth, beauty and pleasure, the artist took the mythical deity and turned him into a dressed-up mortal, horribly the worse for wear. It's a picture not of immortality but of its opposite: decay. With filth-rimmed nails he offers us a bunch of grapes, the bloom rendered so perfectly that we can see how far gone to rot they are. And the rot is not especially noble.

It's not *just* a joke; it's a revolutionary statement of intent. The whole point of art, according to its Renaissance theorists, was the idealization of nature. Caravaggio had just announced that his business would be the naturalization of the ideal.

Caravaggio brings off this unnerving marriage between the pure and the vulgar with a showy skill that no one had seen in Rome since Raphael. Traditionally, 'low-life' subjects – gypsies or tavern scenes – were given the low-light treatment. And because the old familiar stories of innocents taken down by the wiles of the shifty owed so much to the comedy of the theatre, painters who did that kind of thing treated their canvas like a crowded stage, filling it with hurly-burly knockabout to chuckle your way through. Mindful of their inferior place in the hierarchy of paintings – below histories and portraits – low-lifes were always modest little things, meant to be bought cheaply and hung in a back room. This condescension gave Caravaggio another convention to upset. Instead of the raucous comic crowd, he took a very small cast of characters and painted them near life-size so that they dominate the picture space rather than being swallowed up by a picturesque interior. It's the difference between watching a comedy unfold on a remote stage and having it happen inches away from your face. Instead of dwelling on the crudeness of the characters, Caravaggio washes them in the pellucid glow usually reserved for saints. So a turbaned gypsy fortune-teller, usually the personification of danger and corruption, is invested with almost as much peachy seductiveness as the young man whose palm she lightly fingers. Her chemise is fastened modestly to the throat and, like her turban, it could not possibly be whiter. The cheating young *bravo* about to take down his mark in a game of cards (page 32) differs from his gullible target only in his dress, the cocky plume (and the hand held behind his back) a sign of his worldliness. When he has a mind to, Caravaggio can do crones and ferocious old ruffians with such up-close relish that you can practically smell the onions and the dried sweat. But by avoiding caricature and holding the action at the moment before the denouement he manipulates suspense and makes the deceptions more credible. The punters are giddy with the beauty of the moment. So are we.

None of it would work without the reality effect that before long would make Caravaggio's reputation. And that startling immediacy owed everything to his strategically calculated lighting. His biographer Giulio Mancini tells us that he used

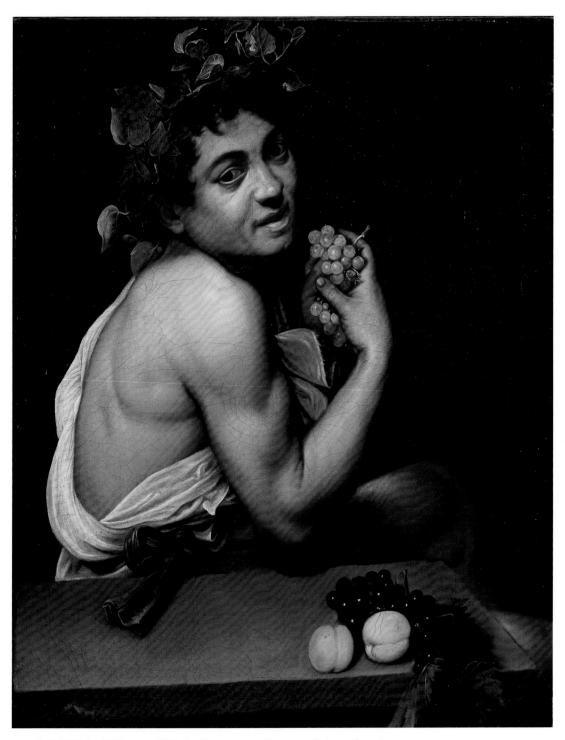

THE SICK BACCHUS, *c.* 1593–4, oil on canvas (Borghese Gallery, Rome).

a single, strong light source to illuminate figures. All the anecdotally distracting details of a background were either suppressed into an indeterminate dirty gold or grey-brown ground, or, later in his career, consigned to absolute darkness. Against the neutral ground, Caravaggio's figures stand out with cruel sharpness. They seem to occupy the room; you can feel a pulse, sense a breath. Modern writers such as David Hockney have argued that the crystalline clarity of those figures could only have been achieved with the help of a lens, perhaps a camera obscura that would have projected an inverted image on to a back wall. There is no supporting evidence for this theory, even from writers such as Giulio Mancini and Giovan Pietro Bellori, who describe Caravaggio's working methods. However, there's also no reason to preclude the idea. Caravaggio may have hung out with toughs, but they were clever toughs, and there were many in his circle who would have known about the new optics. And paintings like *Boy Bitten By A Lizard* play with inverted reflections. But, of course, using a lens or a convex mirror (one of the latter actually appears in a painting of the conversion of *Mary Magdalene*) to produce a focused image was one thing; translating it to the canvas with the kind of razor-sharp brilliance that Caravaggio habitually achieved was quite another, especially since he seldom actually drew anything.

That Caravaggio dispensed with preparatory drawing was not just a sign of phenomenal eye-hand coordination; it was tantamount to methodological insubordination. *Disegno* – the word that conveyed both the act of drawing and the conception of a larger design – had been prescribed by all the manuals of art theory and instruction as indispensable to the proper making of art. Drawing wasn't just technique; it was ideology. True, it was possible to invoke the Venetians – above all Titian – to argue that *colore*, colour, was not just an auxiliary element but a major constituent in the composing of pictures. And Caravaggio may well have visited Venice on his way from Milan to Rome in 1592. The most obvious anticipations of the intensity of his lighting and brilliance of colour are in the works of Giorgione and Lorenzo Lotto. But unlike them he was living and working in Rome, not Venice. And Rome was all about drawing. If, in the 1590s, you had walked through the collections of classical statues belonging to the Pope and the cardinals, or wandered among the ruins in and around the Forum, you would have seen eager, aspiring young artists sketching away: the Farnese Hercules, the Laocoön, the Apollo Belvedere. As for the Academy of San Luca, it was a truism that there could be no great monumental art without a rigorous training in the study sketches required for any independent composition.

All of which Caravaggio studiously ignored. No preparatory sketches, much less drawings from the antique, survive – if indeed they were ever done. He posed

his models, he eyeballed, he painted. The confidence to do that is all the more breathtaking in that Caravaggio was not really a painter in the Venetian manner like Veronese, who built his compositions from modulated blocks of colour. Caravaggio models his figures quite as solidly and sculpturally as if he had worked for years drawing those classical busts. But he's doing it with just eye and hand. If he wanted some guide contours for the composition, he used either the sharp stub end of his brush or perhaps a small knife to make small incisions on the surface of the canvas (and it was always canvases, never wood panels); the blade and the brush, perfect partners in Caravaggio's studio. With those unorthodox methods, plus a gift for perfect composition, he managed to transform 'inferior' genres into pictures that were monumental and dramatic. They were arresting enough for the picture dealer Constantino Spata (who also happened to be a drinking friend) to show them in his shop in the Piazza San Luigi dei Francesi. And there *The Card Sharps* was seen, and bought by someone who changed Caravaggio's life.

IV

FRANCESCO MARIA DEL MONTE wasn't the richest cardinal in Rome. But with his mere 200-odd retainers and servants he wasn't exactly a church mouse either. His family may not have been in the same league as the grandest aristocratic dynasties – the Farnese, Orsini, Aldobrandini and Colonna – who, loaded with country estates and urban palazzi, divided up Rome among them and took turns at supplying popes. But del Monte had something that nonetheless had made for a spectacular ascent to power and fortune: a connection to the Medici Grand Dukes of Florence. A winning combination of cleric and connoisseur, he had learnt courtly culture from the place and the man who defined it – Urbino and Baldassare Castiglione. Castiglione's book *The Courtier*, 1528, had sketched an ideal type, polished in the graces, learned in arts and sciences, generous, courageous and intellectually accomplished. Del Monte aspired to be all these things, and after he'd met Ferdinando de' Medici, the dynasty's cardinal, and had begun to work for him, he had a chance to show off those gifts and virtues. When Ferdinando succeeded to the Grand Duchy in 1588 he repaid del Monte's loyalty by promoting him to the cardinalship he had just vacated. First del Monte got the hat; then he was ordained as a priest! But this doesn't mean he was impiety dressed in scarlet. Del Monte, like his Medici patron, took an intense interest in the Order of the Oratorians, founded by Filippo Neri, whose mission was to return to the pastoral simplicity of the early Church: a Christianity of the streets and begging bowls. This would matter for Caravaggio.

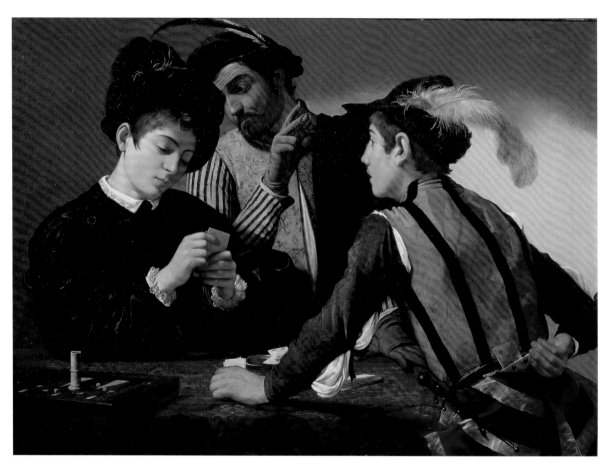

THE CARD SHARPS, 1596, oil on canvas (Kimbell Art Museum, Fort Worth, Texas).

But you couldn't take Urbino out of del Monte. He was hungry for culture – science and mathematics, as well as music, history, poetry and painting. And one way in which the cardinals of Rome established their place in the aristocratic pecking order was by cultural taste and patronage. Religious power in the Holy City was at this time represented by two factions: the Spanish, severe and high-minded, and the more liberal and worldly French. The Farnese, pro-Spanish and thus bitter enemies of the Medici-French connection, had their stable of artists, soon to include the stellar Carracci. So del Monte was on the look-out for promising talent. All he had to do was cross the street to Spata's art shop to see *The Card Sharps*. When he had seen it he must have known he had struck gold. Caravaggio was made an offer: board and lodging; studio space on the top floor of del Monte's Palazzo Madama; and, best of all, patronage, not only by the Cardinal himself, but by the network of grandees, some secular, some in the Church, who came to the palazzo for concerts, dinners and elegantly high-minded conversation.

Caravaggio moved into the Palazzo Madama some time in 1595 and stayed for six years. Many paintings he did during his time there reflect the heavily exquisite quality of the culture within the Cardinal's walls, drowsily poetic and ambiguously sensual: all lutes and fruits. Del Monte prided himself on his musical taste. He bought precious instruments, commissioned pieces from house composers and collected prize singers, some the sought-after castrati, who would perform madrigals in the emotionally loaded manner of Monteverdi. The favourite subject was – what else – love: love unrequited; love as distraction, torment, rapture. 'You know I love you, you know I adore you. But you do not know that I *die* of you,' sings Caravaggio's friend Mario Minniti, got up 'all'antica' in flimsy, deeply scooped muslin, dreamy, fingers strumming the lute. A vase of late spring and summer flowers stands beside him; a viol on the table lies on the score of the madrigal in question.

Obviously, they don't make cardinals like del Monte any more, for the atmosphere of *The Musicians* (page 34) is claustrophobically erotic, positively tumescent with anticipation: four barely dressed boys shoehorned into an impossibly tight picture space. It's been said demurely that the crowding is a sign of Caravaggio's erratic grip on composition, with the artist cramming too many figures on to a canvas that had originally carried a different painting. But of course he knows exactly what he's doing. Had he wanted to give the figures more breathing room and depth, he need only have reduced their scale. Awkward physical proximity is precisely the point. It's contact painting: thighs and hands and arms all doing *something*, tuning up, plucking grapes and, in the case of Caravaggio himself, at the back grasping his horn. The fact that the dewy youth on the left comes with a pair

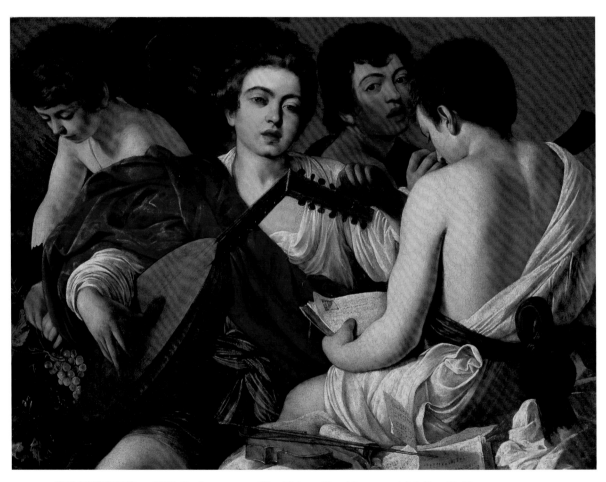

THE MUSICIANS, *c.* 1595–6, oil on canvas (The Metropolitan Museum of Art, New York).

of Cupid's wings is hardly more than a nod to allegory, a gesture that is a transparently unconvincing alibi against raised eyebrows in the palazzo. This is, after all, a cardinal's residence. Cupid-Boy has his long eyelashes modestly cast down; the figure at the front, almost on our lap, is studying the score, but then we're exposed to his pale back. Although he's just rehearsing, the Minniti-lutenist has already been so carried away by the passion of the piece that his flushed cheeks, heavy eyelids and red-rimmed eyes tell us he's been weeping. His lips are parted – although, since he's tuning the lute, presumably not in song – so perhaps it's Caravaggio himself whose black eyes and thick-lipped mouth are wide open with the music. The two of them stare straight at us. It's an outrageous flirtation; another of Caravaggio's invitational studies that had begun with the 'sick Bacchus', playing, as he would always love to do, both sides of the frame. Was there ever a moment when he was not conscious of art as a three-way game played by himself, his subjects and us, the onlookers?

<div align="center">

V

</div>

NO ONE IN ROME did the pull of the stare quite like Caravaggio. But that's because no one was so intelligently *interested* in the power of the stare. And what Caravaggio, the budding genius and tough-guy poseur, stared at a lot was himself. When, in 1645, an inventory was made of his few possessions it included, along with sundry weapons and a guitar, '*un specchio grande*' – a large mirror. Now studying yourself in a mirror was in fact a requirement of any artist wanting to master the *affetti*, the passions, to rehearse expressions that could then be used in history paintings. And since at the turn of the 17th century there had been a new emphasis – in music and poetry, as well as in visual art – on extreme feeling, such as horror, pity, adoration, shock, fear and sorrow, painters who wanted to experiment with an art of high emotion would do best to rehearse the attitudes and body language on themselves. That was one reason Caravaggio had done his lizard-bite.

It may be that mirrors helped Caravaggio focus his images, but it's also apparent that they helped him focus his mind. For they appear – along with self-images – over and over again in his work, functioning sometimes as an emblematic shorthand for the power of art itself, sometimes as the instrument of self-knowledge. That's why the most famous, desirable and dangerous prostitute in Rome, Fillide Melandroni, appears beside an image-less convex mirror as Mary Magdalene, the fallen woman on the point of conversion. She sees through this glass darkly to her salvation. But if art's for redemption, it's also for vanity. That's why Caravaggio poses the self-infatuated Narcissus gazing adoringly at his own face reflected in the stream. The compulsion to create a mirror image, to duplicate life, is at the root of

art, but the tragically cautionary story tells of the worm of self-admiration gnawing at that root.

So it's not surprising that, in 1597, Caravaggio turned a commission from del Monte for a gift to his old patron, Duke Ferdinando de' Medici, into a literally stunning manifesto on the power of the image. The decapitated, snaky-coiffed head of the female monster, the Gorgon Medusa, whose gaze turned men to stone, was a standard motif in European courts. Everyone knew the myth of the hero Perseus, protected and equipped by the goddess Athena with a mirrored shield that, when held up to Medusa, froze the monster in her own horrified gaze long enough for him to slice off her head. No self-respecting princely warrior could be without his own shield or helmet or breastplate engraved with the head of Medusa, the sign that he too would stun his enemies into submission. But the story had a sequel that had been taken as the founding myth of the arts, since Pegasus, the flying steed of Perseus, had dipped his hoofs in the blood of the Gorgon and struck them into the ground of Mount Helicon, from which the fountain of the Muses then sprang. The wellspring of art was the blood of the monster.

When you put all that learning together with the fact that the most famous illusionistic shield-painting of Medusa's head had been done by Leonardo da Vinci and had, until lost some time in the late 1580s, been owned by the Medici, it's obvious that del Monte himself assigned Caravaggio the job of making a replacement gift for the Duke. The chance of competing with, and even perhaps outdoing, Leonardo was, of course, irresistible to Caravaggio, all of 26, and he rose spectacularly to the challenge. His *Head of Medusa* was not just another virtuoso display of illusionism. It became a complicated, brilliant statement on the force of images.

Looks can kill, the painting says to us. This one certainly did. The stagey genius of Caravaggio, the peerless virtuoso of shock-horror, makes sure *we* feel the lethal surprise, for when we look at the painting we are seeing exactly what Medusa saw: self-image as death warrant. The first shudder happens. We get to survive, though, to admire the optical trickery of the artist. For although Caravaggio is actually painting on a bulging, convex, circular poplar-wood shield, he's used deep shadow to make it appear the opposite: a scooped concave bowl from which the ghastly head of Medusa more violently protrudes. The face swells almost to the point of explosion, with brows knitted in disbelief; eyes popping from their sockets (as ours feel they are doing when we look at it); cheeks distended; and the razor-toothed orifice (the predictable site of male nightmares) gaping open, tongue lolling against the shiny teeth, mouth forever frozen in its silent scream.

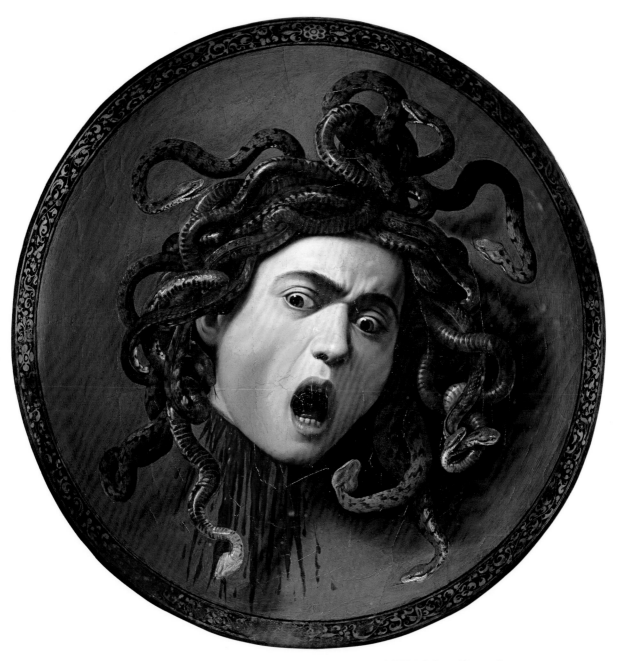

THE HEAD OF MEDUSA, c. 1598–9, oil on canvas mounted on wood (Uffizi Gallery, Florence).

Caravaggio

The thing, the picture, is repellently both dead and alive. Since the painting captures Medusa at exactly the moment of death, her skin is still rosy with life. And although she is self-petrified, the serpentine perm from hell continues to coil, seething with defiant reptilian vitality even as the head on which the vipers sit perishes. Caravaggio is having a really good time doing this. The glistening, segmented bodies and scaly skin of the snakes are highlighted, the better to convey the endless writhing – heads turning this way and that, forked tongues flickering in and out of the light.

Then there is the oddly stalactitic spray of blood depending like a collar from beneath the neatly sliced neck. For a painter so peerlessly adept at rendering the precise properties of every substance, liquid as well as solid, the detail seems at first sight oddly unreal, or else perversely stylized. Given his tastes and his way of life, it's a safe bet that Caravaggio would have been present at some of the gory public executions that took place in Rome; probably at the most famous of them all, the decapitation of the Cenci women for having planned the murder of Beatrice Cenci's incestuous father (while her brother had his flesh torn from him). So the artist knew what bloodshed looked like. But the coagulated collar of spikes had a point. Del Monte the amateur alchemist and nonpareil know-all would have known the tradition dear to physicians by which the blood of the Gorgons was also said to have been the origin of coral, used as a potent curative medicine and as a talisman or amulet worn round the neck to protect the wearer from evil and harm. It's a perfect theme for Caravaggio: life brought from death.

The theatre of cruelty was everywhere in Rome: not just decapitations, but public burnings of heretics, such as Giordano Bruno, and the grim weekly display of felons hanging from gibbets. Caravaggio was close to this violence. Now he was officially part of the Cardinal's household he could carry a sword, or rather have a boy servant carry it for him. This didn't prevent the police from trying to arrest him for wearing a weapon without a licence, provoking from Caravaggio a rather grand statement of his rights as a member of del Monte's retinue.

He was leading two lives, and they were not always kept strictly apart. On the one hand he was the privileged, famously gifted painter of the Cardinal, doing ceiling paintings for his suburban villa and much sought after by other Roman grandees. But he was also the unpredictable, sword-carrying, dagger-wielding eccentric with the hair-trigger temper. When his brother Giovanni Battista came to the Palazzo Madama to seek him out (hoping, the innocent, to encourage him to marry and have children), the painter flatly denied having a brother at all! Bewildered and, presumably, hurt by this repudiation, Giovanni Battista left without ever setting eyes on him. Then there was the company he kept: whores and

courtesans such as Fillide Melandroni and her Sienese friend Anna Bianchini, both often cited by the law for violent assaults. Despite the fact that there had been specific Church bans on the painting of women of ill repute, especially in sacred history paintings, Caravaggio repeatedly and lovingly used them as models. The whole power of his art, after all, turned on his utter determination to give physical presence to what had previously been wan stereotypes. So while shocked critics complained that a Magdalene was nothing more than a working girl drying her long hair, for Caravaggio that was precisely the point – especially since the learned would have remembered that, in her reborn life, Mary Magdalene had used her hair to dry the feet of the exhausted Christ in the house of the Pharisee. To have Fillide, the most scandalous teenage courtesan in the city, pose for a painting of Mary Magdalene, the orange blossom of her conversion held against her provocatively low and sumptuous décolletage, would not have been just an act of defiant nose-thumbing at the scruples of the Church. Caravaggio was using the palpable presence of the worldly woman to make the force of her conversion even more dramatic. A make-up pot and comb lie discarded on the table, and the convex mirror remains dark, save for a square patch of brilliant reflective light – the light that makes Caravaggio's art possible and gives hope of a redeemed life to the sinner.

Caravaggio might have won an argument with the frowning fathers about posing a courtesan as the Magdalene, but it was even more outrageous to use Fillide as the sainted *Catherine of Alexandria* beside the spiked wheel of her martyrdom, her index finger toying with the edge of what must have been Caravaggio's own duelling rapier. It was the complete opposite of the customary image of the saint as pallid, angelic virgin. She exudes power, even danger. This Catherine's eyes glitter as sharply as the weapon. But, if pressed, Caravaggio could turn any suspicion of indecency back on the obtuseness of the questioners. Why were the saint's throat and neck so conspicuously bare? To remind worshippers of her beheading, naturally! Why was she clad in the sumptuous velvet and embroidered damask that seemed more likely to be the kind of dress in which Fillide received her high-born Florentine lover and protector, Giulio Strozzi? Remember that Catherine was a princess, the picture of resolute calm, not of eye-rolling terror – someone, in other words, to reckon with!

Whatever mutterings there may have been about the liberties that Caravaggio took, del Monte at any rate ignored them, knowing that his star painter was in the process of creating an entirely new kind of Christian art: more palpably dramatic and emotionally direct than anything that had been produced since Michelangelo. So when it became urgent to find an artist to paint the two side walls of the Contarelli

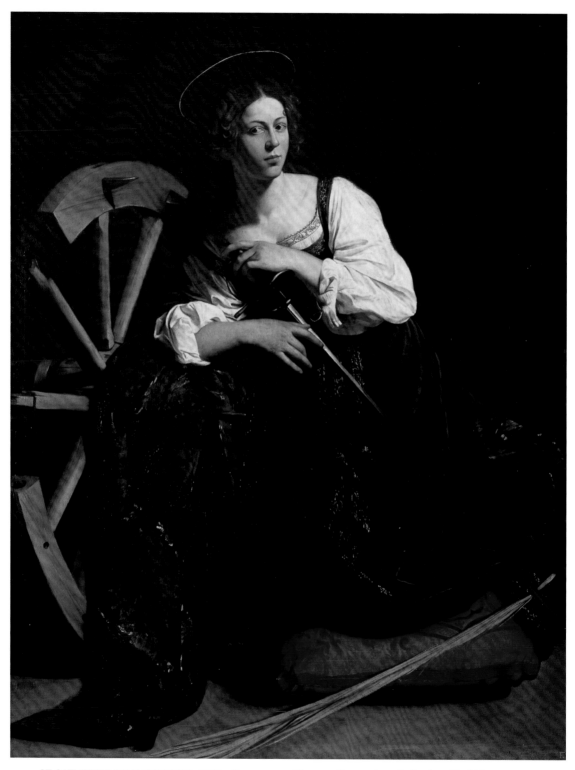

ST CATHERINE OF ALEXANDRIA, 1598, oil on canvas (Thyssen-Bornemisza Collection, Madrid).

Chapel in the church of San Luigi dei Francesi, just over the road from the Palazzo Madama, del Monte, who had the job virtually in his gift, knew exactly where to turn.

VI

IT WAS CARAVAGGIO'S MOMENT AND ROME'S, the two of them fitting like a hand in a glove. Pope Clement VIII's Holy Year of 1600 was fast approaching: a year of fervour, pilgrimage and grace, when absolution would be extended, indulgently, to sinners who normally would have been denied salvation – sinners like Caravaggio. But the Holy City itself needed respite. Caravaggio was a palazzo boarder, but he knew, every day and in every pore of his skin, the other Rome, the city of a hundred thousand dirt-poor, ravaged by plague, burdened by taxes to pay for the Pope's sorry little wars, bellies never full, watching the harvest and praying for a good one to make bread and pasta affordable. When the Tiber flooded in 1598, smashing the Ponte Santa Maria, later nicknamed the Ponte Rotto (Broken Bridge), it seemed as though Rome was in need of wonders.

And it was about to get them. The chapel whose walls had been assigned to Caravaggio was in the French church of San Luigi. The history to be painted was that of St Matthew because a French cardinal, Mathieu Cointrel, had made a bequest for his saintly namesake to be venerated, and had left elaborate, detailed instructions on how the scenes – of martyrdom and the calling of the tax collector by Jesus – should be handled: how many figures, the setting, and so on. The ceiling vault had been done in 1593 by Giulio Cesari, now known grandly as the Cavaliere d'Arpino, quite possibly with the young Caravaggio's help. But as Rome's favourite history painter, d'Arpino had been in constant demand and had failed to finish the rest of the chapel. The Superintendence of St Peter's had taken over responsibility for its completion and had handed the task to del Monte, who had nodded in Caravaggio's direction.

The opportunity must have been both exhilarating and terrifying. The *Matthews* would be by far the biggest paintings he had ever done, both in physical size and in public visibility. Everything he had painted up till now had been under his control, even when, like the *Medusa*, it had been for a special commission. Those works had been easel paintings, done directly from nature in his studio under strong light; pictures for which he determined the number of figures and their disposition within the space. Now, though, he had to conform to Cointrel's specifications and even perhaps to d'Arpino's precedent on the ceiling: a crowd of figures, saintly radiance, grandiose architecture, deep space. And he also knew that he might have done genre scenes and still-lifes and tarts dressed as saints to perfection, but this job would be the making or breaking of him.

Caravaggio

So Caravaggio set to work on *The Martyrdom of St Matthew* slaughtered beside his altar on the instructions of the Ethiopian king. He tried to fulfil the requirements of the deep architectural space of the church in which the murder had been committed: the massed extras, the translation of the martyr at the moment of death – and, perhaps for the first time in his life, he seized up. The instructions felt like chains. Caravaggio didn't do deep space, and he certainly didn't do a big cast of characters. The entire force of his dramatization depended on proximity, not distance; on compression, not expansive grandeur. It was all about direct, personal identification. How could the beholder identify with a crowd?

The more he tried, the tighter those confining specifications gripped, weighed him down. So, for the moment, Caravaggio gave up on the martyrdom and broke free to work on the left-hand facing wall where he had greater conceptual liberty to paint *The Calling of St Matthew* not least because the lines in the Gospel referring to this life-changing moment were so terse: 'And as Jesus passed from thence, he saw a man, named Matthew, sitting at the seat of custom: and he saith unto him, "Follow me". And he arose, and followed him.' The idea made sense to Caravaggio, who for his own reasons specialized in the possibility of redemption coming to the most unlikely and hardened sinner. Inspiration came as easily and as quickly to him as it had proved unattainable for the martyrdom: here he could paint what he knew; paint from nature; paint a scene from the actual life of Rome, the life he lived and that all those who saw the painting could immediately recognize.

So he took the table and one of the boys from *The Card Sharps* and set them down in a low dive with a high ceiling, filthy walls and an oil-paper window with one of the panes torn – the damage, of course, exquisitely rendered. The scene would have been instantly familiar to anyone coming into the chapel: the flash dressers; the table; the chink of coin being counted; receipts being checked; hard men and soft boys. They knew those low-end places. Caravaggio's genius for counter-intuitive vision was roaring along on all cylinders. And then, having broken one rule – the noble setting – why not break the biggest one of all? Instead of a composition where everything turns around the conversionary encounter between Christ and the tax collector, he made the episode seem, at first sight, almost incidental. We aren't presented with the group transfixed by the moment – some of the figures don't even see Jesus and St Peter coming through the doorway. One of them is slumped over the table and the money; his elderly neighbour, the spectacles an emblem of his moral as well as visual shortsightedness, doesn't bother to look up. Two customers with beards coming through the room? What do they want? Someone deal with them – tell them thanks, but we're busy.

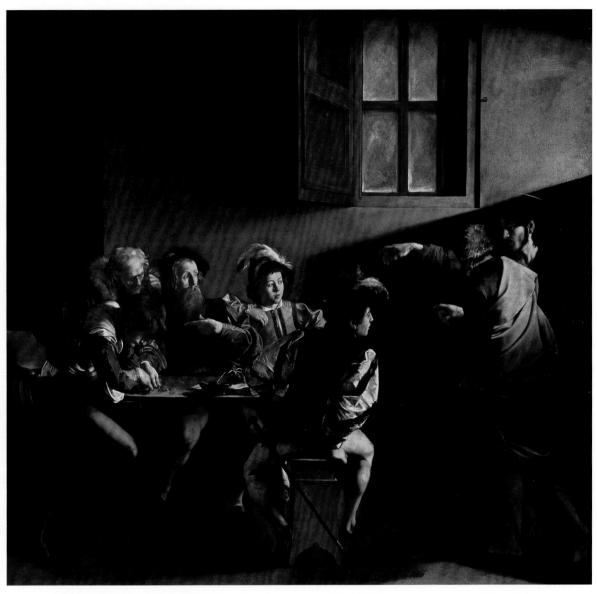

THE CALLING OF ST MATTHEW, *c.* 1598–1601, oil on canvas (Contarelli Chapel, San Luigi dei Francesi, Rome).

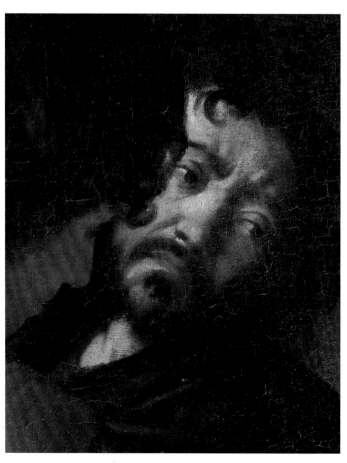

Right: THE MARTYRDOM OF ST MATTHEW, 1599–1600, oil on canvas (Contarelli Chapel, San Luigi dei Francesi, Rome).
Above: Detail showing Caravaggio.

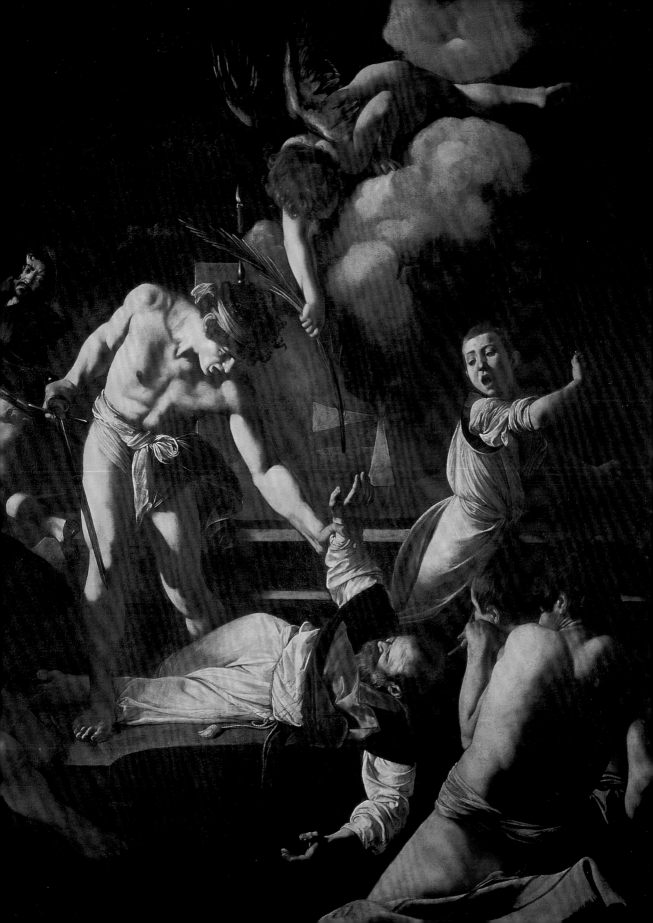

Then Caravaggio takes this tease of understatement just about as far as it can go. Rather than making Christ the centre of the painting, he obscures him, the better for the beholder to seek him out. Theologically, the move is perfect – especially for a Holy Year in Rome – because St Peter comes visually between us and Christ, just as he did institutionally through the papacy. But the move works psychologically as well, since the partial view of Christ's body concentrates attention on the one unmissable feature: the extended right arm with its pointing finger. It's the perfect union of the sacred and the profane – which is, after all, the heart of the story. The gesture is borrowed from the most famous passage of painting in Rome, a moment of sacred inception: God the Father's fingertip touch to Adam on Michelangelo's Sistine ceiling. From the pointing hand – rather than from the dirty window – comes a bolt of light, the light of the Gospel, flooding the face of the cherubic page-boy who ought not to be down here mixing with this scum anyway, and who seems ever so slightly to flinch from the light, his arm resting on Matthew's shoulder, instinctively and endearingly self-protective. The shaft of light travels on to the disconcerted features of Matthew himself, his cheeks suddenly flushed at being found out, and who answers the holy summons with a move that every Roman, every pilgrim would have recognized: 'What? *Me?*' It's possible, as some scholars have argued, to read the direction of the gesture as 'Don't you mean *him?*' – the slumped figure to his right. But to me there's no doubt that it's the bearded man who's about to become Matthew the apostle, for the richness of his dress, Caravaggio's own favoured black velvet, makes the conversion to humility all the more telling.

Something else has happened. For once Caravaggio isn't interested in direct eye contact between his characters and us: the gesture would be too cheaply ingratiating. What we do is come upon the scene as hidden witnesses, privileged eavesdroppers out there in the darkness of the chapel. And the fact that the figures are close to life-size makes the illusion of just happening on that very moment all the more heart-stopping.

Riding his confidence, knowing *The Calling* had worked, Caravaggio went back to *The Martyrdom,* feeling less shackled by Cointrel's list of specifications. He didn't ignore them entirely, however: the canvas is, by his standards, crowded, but instead of shrinking his characters within a deeply recessed and grandiose architectural setting, he brings the action almost unbearably close to our faces. Instead of some lofty church, there are a few stone steps to suggest an altar, along with a fleeing choirboy. And Caravaggio has thought hard about the way in which the two great paintings on facing walls emotionally rebound on each other. After the uncanny silence and stillness falling over *The Calling, The Martyrdom* is a pinwheel of chaos,

the figures flying out centrifugally from the one adamantly fixed figure of the nude assassin. It was typical of Caravaggio to make the only still figure, the muscled nude at the fulcrum of all this gesticulation, the embodiment of evil. His outstretched arm gripping Matthew's wrist so that he can strike again (a rivulet of blood, this time painted realistically, is already spurting through the martyr's white robe) is the satanic pair to the extended arm of Christ on the opposite wall. In another stroke of theatrical genius, a moral tug of war is going on. Matthew's expiring body is sinking into what seems to be a black baptismal pool, his left arm and hand foreshortened as if gesturing in our direction for help. But down swoops the angel towards him, bearing the martyr's palm in the hand that will also carry him to his heavenly reward.

Which leaves us mortals somewhere in the middle, floundering, shrieking (for this is as noisy a painting as *The Calling* is quiet), the strobe lighting flickering from body to body and face to face to maximize the panic. But at the back of the crowd (the same notional distance behind the action that we are in front of it) someone pauses in flight. Sweaty, dishevelled, hair matted, brows knitted, Caravaggio casts himself as the cowardly sinner, knowing that he should, for the sake of his own skin, get away from the scene of the crime, and fast too – but at the same time he can't not look. His only saving grace is that he holds a lantern. He is, after all, and against his nature, the bringer of light.

VII

THE CONTARELLI CHAPEL *MATTHEWS* OF 1601 made Caravaggio. Even foreign artists and writers, such as the Dutchman Karel van Mander, knew about his achievement. But they also knew about his equally famous shortcomings:

> There is a certain Michelangelo da Caravaggio who is doing extraordinary things in Rome...this Michelangelo has already overcome adversity to earn reputation, a good name and honour with his works... But one must take the chaff with the grain; thus he does not study his art constantly...[but] after two weeks of work he will sally forth for two months with his rapier at his side and his servant boy after him, going from one tennis court to the next, always ready to argue or fight, so he is impossible to get along with... This is totally alien to art.

Not, however, to Caravaggio's kind of art: contact painting, the kind that burst right through the canvas, obliterating the protective threshold of distance and depth in

order to come and get us. It's an art in which all the niceties of decorum were contemptuously ignored and aesthetic slumming was unceremoniously kicked out of the door. The ruffian poor, to whom all those Fathers of the Church paid lip service, were now actually featured at the centre of the action instead of being relegated to socially entertaining bit parts – to the role of the token destitute on whom redeeming miracles were graciously performed. Although it would have been (and still is) more convenient for the dignity of art to imagine the delinquent Caravaggio – wounded in fights, sometimes giving as good as he got, and keeping deplorable company – as an entirely different person from the maker of stupendous sacred paintings, the truth was that the latter could not have existed without the former. The genius was the thug.

But he was *such* an unmistakable genius that the rich and the mighty lined up to protect him from the consequences of his misdeeds. As they saw his star rise, so they began to pay him more and to compete for his services. Paradoxically, it was precisely Caravaggio's use of live models from the streets – the habit that made him notorious to the academicians of San Luca and elicited denunciations for leading impressionable young painters astray – that helped make the grandest churchmen feel they were somehow bringing into being an art of renewed Christian humility. Caravaggio's all-too-evident familiarity with the world of the poor was a particular virtue in Holy Year, when Church leaders, in imitation of Christ, were supposed to be washing feet, embracing misfortune and anointing sores. Cardinals on the whole didn't go in for much sore-anointing. Now Caravaggio could do it for them – he could be their virtual slummer for Christ.

The idea must have especially appealed to Tiberio Cerasi who, as Treasurer-General to Pope Clement, was immensely wealthy and wanted a funeral chapel (he died while it was being decorated) in the church of Santa Maria del Popolo. At the edge of the Piazza del Popolo, the church was the first that pilgrims entering Rome from the north would have visited, so Cerasi would have known that his chapel would be seen by the multitudes. He was determined, then, to hire only the very best; and to show that in this context he could unite opposing factions he assigned the altarpiece to Annibale Carracci, the favourite of the pro-Spanish Farnese family, and the walls to Caravaggio, attached to the pro-French del Monte.

Caravaggio signed the contract even before he had finished *The Martyrdom of St Matthew*. This gave him a mere eight months to do another major piece of public work, something that would prove the Contarelli paintings weren't just a flash in the pan. But the fact that the only painter he considered a serious rival – Annibale Carracci – was also involved in the project must have been a spur. So many of his

strongest paintings had been kick-started by the works of artists whose company he aspired to be in: the lost Leonardo Medusa; d'Arpino's vault paintings for the Contarelli Chapel; and now he was to share the stage with not just the greatest member of the Bolognese Carracci dynasty, but the one most praised for his naturalism. Ironically, though, at this time Annibale had never been less earthy. His edge was softening, his colours brightening; his lode-star was evidently now Raphael's classicism. So his *Assumption of the Virgin*, *c.* 1590, was all winsome and wholesome: a golden-haired Madonna borne aloft by the power of pure cheerfulness, peekaboo seraphs peeping from her skirts, apostles acclaiming the show with grandiose gestures. Caravaggio's paintings on the other hand – another martyrdom (*Peter*) and another conversion (*Paul*) – offered bituminous darkness lit by lightning-strength glare. If the *Assumption* was effortless uplift, these were earth-rooted, tensed with pain and labour, weight and work, grunting and groaning. As if he needed to, Caravaggio rubbed home the difference by echoing the outstretched arms of Annibale's *Virgin* in the out-flung arms of Paul as he receives the light of faith. But he is flat on his back, his eyeballs burnt by the epiphany.

Yet there had been another false start. Initially, daunted (as with *The Martyrdom of St Matthew*) by what he'd taken on, Caravaggio produced a strangely over-burdened and wooden *Conversion of St Paul* which the Fathers responsible for the Cerasi Chapel rejected. And, as with the Contarelli Chapel, a setback had the effect of concentrating Caravaggio's creative intelligence. The rethink must have begun with the space itself, much narrower and more confining than the Contarelli Chapel. All the instincts of post-Renaissance art were to respond to spatial confinement by using perspective to open up the space. With the theme of Mary's ascent to heaven, Annibale had naturally followed this precept, so his painting was full of bright light. But Caravaggio's best moments were often counter-intuitive. Instead of trying to defeat the cramped room optically with smaller figures and illusions of deep space he did exactly the opposite, bringing his massive figures of men and beasts right to the very picture edge so that, immense and lumbering, they seem, alarmingly, about to fall into our personal space. A shoed hoof, a meaty derrière, the sharp edge of a shovel and a chapped elbow are pushed right in our face. Instead of relief and depth, we get holy claustrophobia.

How it works! Witness was never closer, the distance between observer and event never more successfully annihilated. We are positioned right beneath the inexorable, grinding, wheel-like machine of men hoisting Peter, who considered himself unworthy to be martyred in the same position as Christ, to his upside-down crucifixion. The genius of the thing is that it's not a done deed, but a permanently

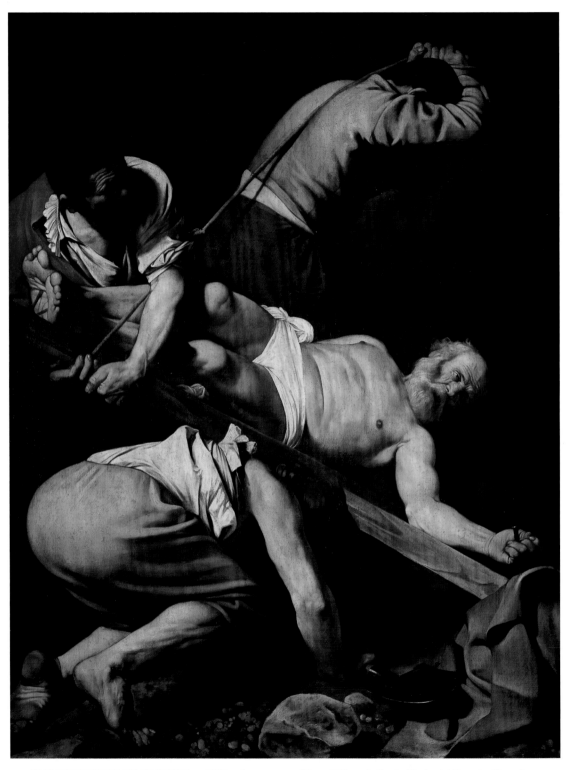

THE CRUCIFIXION OF ST PETER, *c.* 1600, oil on canvas (Cerasi Chapel, Santa Maria del Popolo, Rome).

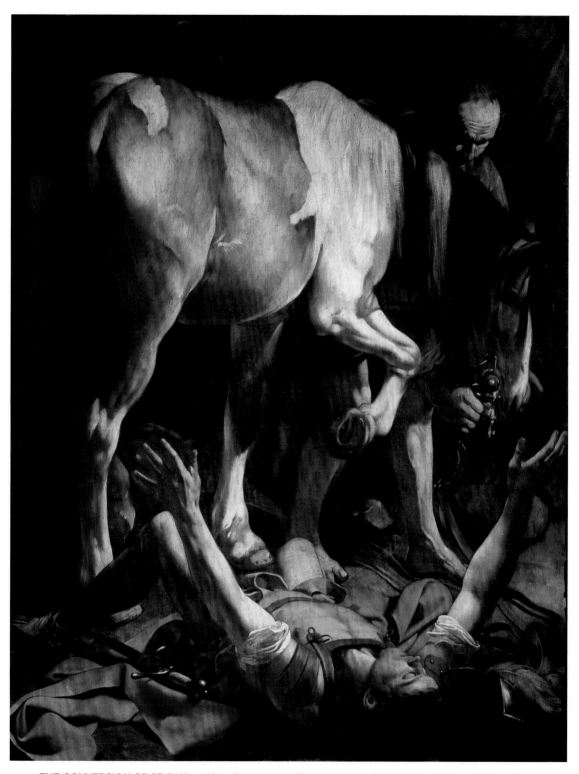

THE CONVERSION OF ST PAUL, 1601, oil on canvas (Cerasi Chapel, Santa Maria del Popolo, Rome).

relentless *doing*: a heaving and lifting, yanking and cranking that seems to go on and on for ever, which is of course how the Church wished believers to experience it, especially in St Peter's own city. It also wanted ordinary people to feel implicated in the sin at the same time as feeling assured of salvation if only they remained obedient to St Peter's successors. So Caravaggio gives us the people of Rome as they had never been seen before in sacred art (the Carracci certainly had never dared put them there): bulky bodies, filthy calloused soles, faces in darkness (they have not yet seen the light), to divert our attention to the straining force of muscle, tendon and knotty veins. However, the effect of imagining the crucifixion as, first and foremost, manual labour, emphasized by the glint at the edge of the shovel, is not to damn the labourers but to have us identify physically with them. And to identify too with their victim, the apostle whose head is one of the greatest of Caravaggio's achievements: mouth opened in a moan to register the pain of his pierced hands, eyes expressing acceptance and – the most stunning detail of all – wisps and strands of fine hair flying away from the side of his head as he is hoisted to his consummation.

If the Peter of the Piazza del Popolo is – aptly enough – all about the people, the Paul is all about power. Both pictures are deceits for Christ: the ancestor of the rich and grandiose popes represented at the moment of his greatest humility; and the unswerving embodiment of the faith militant represented at the moment of prostrate impotence, thrown from the saddle of his worldly power to persecute. With the latter, Caravaggio has a moment of blinding insight of his own, parting with centuries of Pauline iconography, including his own earlier version of the saint, as the usual bearded elder. Caravaggio thinks instead of the local cops: young, brutal, stubble-chinned, strapping swaggerers like the *bravi* he fell foul of all too often. Taking years off Paul, of course, only makes the stunning force of the light that had thrown him all the more potent. It's a *literally* dazzling conceit.

Once again, Caravaggio isn't separating his own life from his art, but rather bringing his gift for raw-boned heft to his one-man revolution in sacred painting. He uses the narrow space and our viewing angle to force us *down*, as if he were pushing us bodily to the ground (he had lots of practice) so that we find ourselves beneath the piebald's raised hoof. Instead of the routine angels that crowded his first effort, there are just three characters: horse, groom and floored apostle. But as with *The Calling of St Matthew*, the shock of the painting is in the light that floods over the horse's body and bounces back from Paul's torso and face so that its strength reflects in the heavily veined leg and creased forehead of the gentle groom, enfolding him too in its saving illumination. The attributes of Paul's worldly power are broken:

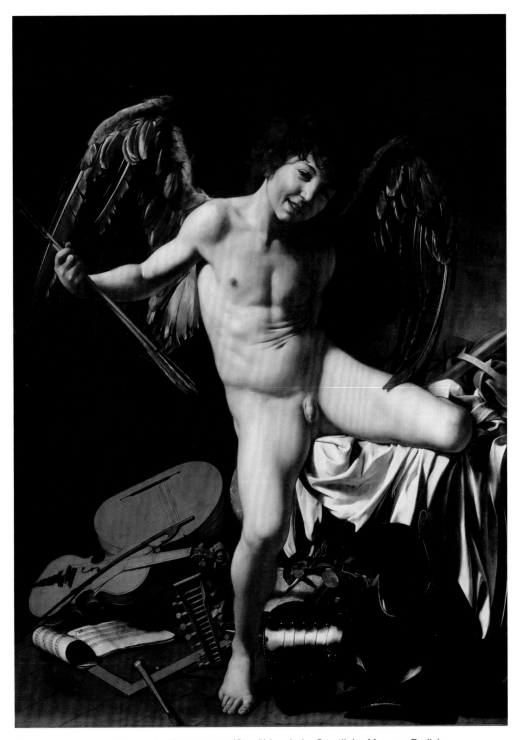

AMOR VINCIT OMNIA, 1598–9, oil on canvas (Gemäldegalerie, Staatliche Museen, Berlin).

plumed helmet thrown off, armour straps unfastened, and the eyes that had sought out Christians to harass are now an extraordinary yellow, as if the cornea had first been scorched by the light, then covered, as the Gospel says, with a filmy cataract. Blinded, he will in three days be rewarded with the first true sight of his life.

VIII

FOR A FINE, SUNLIT MOMENT, around 1601, Caravaggio must have felt invincible. Cardinals were fighting for his services. Some time that year he agreed to work for another wealthy cleric with a worldly eye, Ciriaco Mattei, and may have moved into his palazzo, although he is still said to have been with del Monte in October. It wasn't beyond Caravaggio, revelling in the competition, to swap studios just when the mood took him. The more outrageous he became, the better his patrons seemed to like it. For Marchese Vincenzo Giustiniani he did the kind of full frontal Cupid no one had ever seen before – not on canvas, at any rate. He's supposed to come from the world of the gods, but was an Eros ever so here-and-now? He's a full-frontal pubescent street kid, with tousled hair, juicy lips and a wicked grin, as though he knew that the divine attributes – those clip-on eagle's wings and the prop arrows – had been rented (like him?) for the day. So it takes an act of absurdly willed primness to insist that this *Amor Vincit Omnia (Love Conquers All)* must nonetheless be a high-tone allegory, celebrating the patron's cultural virtuosity: the musical instruments and score; the architect's T-square and compass; the hero's armour. Yes, the score and the T-square display a 'V' for Vincenzo (and virtuoso), but that's also the letter formed by the boy's spread thighs on their rumpled sheet, with the hairless little spigot-willy plumb in the centre. No wonder the picture was kept behind a green silk curtain, although whether Giustiniani did so for prudence or for the mischief of a staged revelation to chosen guests we'll never know.

What's on display is Caravaggio's way with surrogate touch. The tip of Cupid's own wing brushing the outside of a creamy thigh is an invitation to experience secondhand the delicate caress. But at the same time that he could do these visual soft porn teases, Caravaggio could make the physical exploration of touch the expression of impeccable theology. Was not the heart of the Christian mystery, after all, the incarnation of the son of God, his presence made manifest in flesh? To truly believe, then, meant to press that flesh.

So for the touchy-feely Vincenzo Giustiniani Caravaggio also painted the most shocking *Doubting St Thomas* ever made in Christian art. All decorous euphemisms are abandoned. The proof being in the probing, Christ's hand with the stigmata on its back steers the horny finger of Thomas deep into the lipped,

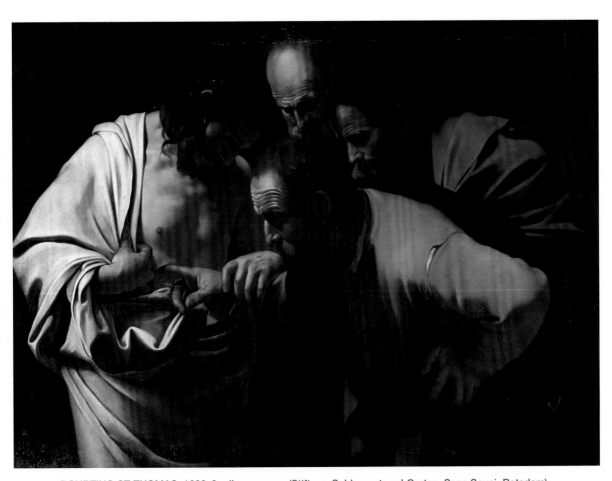

DOUBTING ST THOMAS, 1602–3, oil on canvas (Stiftung Schlossert und Garten, Sans Souci, Potsdam).

almond-shaped wound in his own body, burying it up to the joint. The filthy nails and rough skin of the apostle make this penetration both invasively shocking and sacrificially tender: almost, one is tempted to say, akin to the equally probing intimacy of the sexual act. Revelation and belief are written in the arched eyebrows and creases of Thomas's brow, and in the clinical intensity of the stooped apostles' transfixed gaze, as if they are observing a medical procedure. To make true believers, Caravaggio's picture says, it's not enough to direct the eyes; you must also register the spectacle viscerally, on your flesh. Hairs should stand up on the neck; goose-bumps rise on the skin.

It's not that Caravaggio is a wilful demystifier, rather that his mysteries and miracles happen in the here and now; and in the presence of ordinary people seen close up and unbeautified, their clothes worn and torn, their hands and feet grimy, their mouths agape, their brawny limbs flung about. It was one thing for the priesthood to utter pieties about the renewal of Christian simplicity, of washing, in imitation of the Saviour, the unwashed; it was quite another for a painter to rub their noses in the unsavoury reality of the street poor. But then Caravaggio was truly unique in being the only painter in Rome whose life actually bridged the world of the cardinals' palaces and the great churches and that of the gambling dens, whorehouses and wine shops of the *popoli*. To be able to bring the one world to the other was his great gift to the Church, but it came with risks.

Sometimes they paid off. The church of Sant' Agostino, for instance, commissioned Caravaggio to paint a *Madonna of Loreto* celebrating the village to which the Virgin's house (complete with Madonna and Child) had been miraculously airlifted. Loreto had long since become a place of mass pilgrimage for the humble and credulous, and images of the Virgin usually featured her seated on the roof of the airborne house. Caravaggio is in no mind to break the spell; rather, by bringing it so firmly down to earth – to the doorway of a Roman street, in fact – he wants to maximize its closeness to the lives of the pilgrims. So the Madonna hasn't just landed in the Roman countryside; she's picked up the genes. She has the voluptuous form, thick black hair, olive skin, heavy eyelids and Roman nose of a local beauty – in fact Caravaggio's local beauty, his model and mistress Lena Antognetti. Her Jesus is to scale: a sweetly pot-bellied *bambino* of the kind that Roman mothers still worship, though less sacramentally.

The conversion of the Madonna from ethereal to earthy, however, is the least of the painting's original qualities. Always thinking about the bond with the viewer, Caravaggio had yet another of his outrageous insights. Instead of *assuming* beggar-pilgrims kneeling at the feet of the Virgin, why not actually feature them doing so,

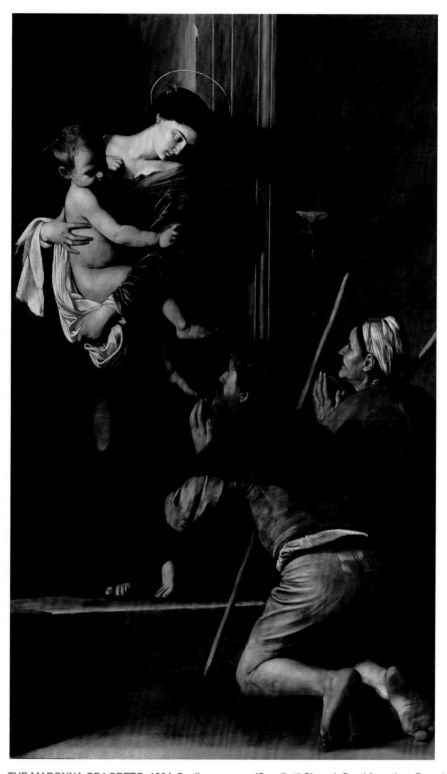

THE MADONNA OF LORETO, 1604–5, oil on canvas (Cavalletti Chapel, Sant' Agostino, Rome).

thus once again stripping away the threshold between our world before the image and the world within it? Pilgrims can be imagined coming to this painting, looking at it from below (for that's the way Caravaggio has angled the viewpoint) and seeing before them their painted brother and sister mendicants, complete with the rough, torn feet of the wayside. The Virgin's own balletically turned white foot balancing on its heel only serves to emphasize the grimy ones of her devotees, all corns and calluses. Presented to us so graphically that we can practically smell them, those feet are the kind of detail meant to be edited out of art, especially art dedicated to the higher devotion. But for Caravaggio there can be no higher devotion than the reverence of the footsore.

Those feet passed muster. Two other pairs did not. The first of these, huge and burly, were even more aggressively confrontational than those of the pilgrims of Loreto, and they were intended for one of the most dignified commissions that had come Caravaggio's way: the altarpiece that would complete the ensemble of *Matthew* paintings in the Contarelli Chapel. Caravaggio had been asked to replace an unsatisfactory sculpture by another hand of St Matthew being inspired by an angel to write his Gospel. This third painting would, in effect, make the Contarelli Chapel his own, eclipsing his old master d'Arpino whose ceiling vault would vanish into insignificance. But, perversely (since the saint was hardly depicted that way in *The Calling of St Matthew*), Caravaggio made him into a clod whose doltishly bewildered expression and ungainly tramp's feet thrust out aggressively into the beholder's space. Aghast at the affront, the St Peter's office responsible for completing the chapel rejected the painting. This was the second time (after the *St Peter* in the Cerasi Chapel) that this had happened to the man who had become a *pittore celebre*, an acknowledged 'famous painter', but he took the blow on the chin and painted the tamer alternative still to be seen in the Contarelli Chapel.

For the first time, too, the word 'indecent' was uttered in connection with the 'maestro'. In August 1603 Cardinal Ottavio Paravicino described his paintings as somewhere (dangerously) 'between sacred and profane'. But if Caravaggio over-heard these murmured reservations, it hardly slowed him down in his headlong determination to humanize the Gospel. Given that the church of Santa Maria della Scala in Trastevere was located in one of the poorest quarters of Rome, where the clergy were famous for pastoral care among the working people, Caravaggio might have thought that his unvarnished approach to *The Death of the Virgin* would be sympathetically received. His conception of the piece was shockingly simple. Traditionally, the period following the Virgin's death had always been thought of as a mere sleep or 'dormition' prior to her ascent to paradise. As such, Mary was

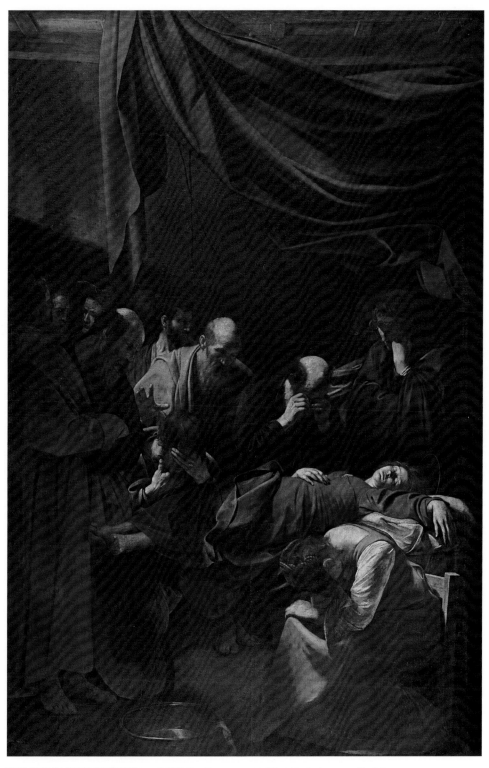

THE DEATH OF THE VIRGIN, *c.* 1605–6, oil on canvas (Musée du Louvre, Paris).

preserved from the corruption of mere humanity. Just as her conception of the Saviour had been immaculate, so her departure from the world was similarly fleshless. The trouble was, Caravaggio didn't really do fleshlessness; he did flesh; and in this case, unambiguously dead flesh – the body, it was said, of a drowned prostitute (*meretrizia*) from the brothel quarter of the Ortaccio, fished out of the Tiber. So beneath its red dress Mary's body is crudely bloated; her skin is greenish, and yet another pair of feet have been left offensively bare and, of course, none too clean.

The painter was out to provoke not shock, but rather pathos and grief. This unequivocally dead Mary allowed him to render the expressions of the apostles – miraculously gathered round her bier after their dispersion – and the lamentation of Mary Magdalene as authentically tragic. If the Virgin were merely suspended in a sacred snooze pending her translation to heaven, the grief might seem disproportionate. Yet faced with a true death, a definitive exit from the world, the crushing sense of loss becomes credibly overwhelming. But the Fathers of Santa Maria in Trastevere, horrified by the indecencies, didn't see it that way. The painting came down, to be bought for the Duke of Mantua five years later by Peter Paul Rubens, who was so spellbound by its emotional intensity and so apparently bent on vindicating Caravaggio that he exhibited it for a week before having it sent to Mantua.

IX

IT WAS CARAVAGGIO'S THIRD REJECTION. Not so long ago it had been he who was turning jobs down. Now he could ill afford to lose them. But as the pace of new commissions slowed, the tempo of his assaults and imprisonments in the Tor di Nona speeded up. When not in jail he was living in shabby rooms in the Campo Marzio, with just a few sticks of furniture, his swords and daggers, guitar and fiddle, and a dog he called 'Crow', whom he taught to do a party piece, walking on its hind legs. In his fancy, but torn and filthy, black velvet Caravaggio cut a figure of elegant menace, stalking the mean streets around the Piazza Navona with tough-guy mates, such as Onorio Longhi. The *sbirri*, the papal police, knew him only too well for his short fuse and his relish in brandishing his blades and screaming insults at passers-by, especially if they happened to be painters whom Caravaggio had written off as pathetic mediocrities and parasites – which is to say pretty much everyone except himself, his pals and the select few, such as Annibale Carracci, whom he truly respected. 'We'll fry the balls of scum like you' was one of the choice items of verbal abuse sent the way of one of his victims, who probably got the feeling, as he looked and fled, that the *cervello straniere* – the crazy-brain – just might do that!

How could the *pittore celebre* behave so outlandishly? How could he not?

Caravaggio

Caravaggio was all of a piece. The animal aggression; the in-your-face invasion of body space; the revelling in outrage, sexual and social; the embrace of the socially unwholesome; the shameless self-dramatization that made him come at you out of the blackness, in a bolt of violent light; the cocksure sense of invulnerability that somehow also went along with compulsive self-implication – all this was what made him, at the same time, the most necessary, but also the most explosively uncontrollable, painter that Rome and the Church had ever taken on. It needed him for the same reasons that, in the end, disgraced and destroyed him.

And Caravaggio himself was incapable of riding his fame to respectability and reliability. It wasn't enough that (even with the setbacks of the rejections) he had succeeded; he needed to take down the mediocre competition, especially if they had had the gall to land commissions from which he had been excluded. The worst, apparently, was Giovanni Baglione, who went around wearing a gold chain of honour and had been hired to paint a Resurrection for the Gesù, the new showplace church of the Jesuits. Although Baglione thought enough of Caravaggio to write a later biography that, given their relationship, is surprisingly even-handed, the esteem was definitely not mutual. Some time in the late summer of 1603 Baglione's follower Tommaso Salini, known to everyone as 'Mao', had been handed some verses about the two of them that, it was implied, were doing the rounds. They weren't exactly Great Poetry, but then they didn't need to be to get this kind of message across:

...Giovan Bagaglia, you're just a know-nothing
Your pictures are just daubs
I warrant you won't earn
A brass farthing with them
Not enough for cloth to make breeches
So you'll have to go around
With your arse in the air...
Maybe you can wipe your arse with them
Or stuff them up Mao's wife's hole
So he can't screw her any more with his big mule's prick
Awfully sorry I can't join the chorus of praise
But you're quite unworthy of the chain you wear
And a disgrace to painting...

And more in this vein. Mao showed them to Baglione, and in September 1603 Baglione sued the likely authors, Caravaggio and his friend and fellow artist Orazio

Gentileschi, for libel. During the trial they were both locked up in the Tor di Nona, which would soon become home from home for Caravaggio. The evidence against him was circumstantial (no one had seen him actually write them or dictate them to the friends who probably did), but no one was fooled. His defence could best be described as enigmatically unrepentant. He claimed disingenuously never to have heard or seen any verses or prose, in Latin or Italian, that attacked Baglione, although evidently he made no secret of the fact that he rather approved of the views they expressed, saying that no one he knew rated Baglione at all. Asked whom he *did* rate, Caravaggio produced a list of those he considered 'skilled'. It included Annibale Carracci, d'Arpino and, rather surprisingly Federigo Zuccaro, the erstwhile dean of the Academy of San Luca and the epitome of empty refinement.

The trial rolled on inconclusively for months, during which Caravaggio and Gentileschi remained first in jail and then under house arrest pending judgment. A great deal of evidence was presented about boys allegedly hired by Gentileschi and Caravaggio to distribute the verses, but nothing conclusive was decided.

In any event, this risk of a serious jail sentence (or, worse, time in the galleys) failed to cramp his style. The next 18 months saw Caravaggio in and out of the Tor di Nona, his short temper getting him into trouble repeatedly. In April 1604 at the Moro tavern a waiter named Pietro da Fusaccia put a plate of eight artichokes, four cooked in butter, four in oil, in front of him. 'Which is which?' asked Caravaggio. 'No idea,' said Fusaccia. 'Why don't you smell them?' Perhaps it was the way he said it. 'Listen, *becco fottuto*, fucked-over cuckold, do you think you're talking to some *barone*, some bum?' Evidently it was a rhetorical question. Caravaggio threw the plate at the waiter's face and, so Fusaccia said, started to draw his sword. That weapon-happy impulse got him into further trouble with the *sbirri*, who twice stopped him. After he satisfied them that, as someone protected by the Cardinal, he was entitled to carry a weapon, the officer let him go, but he made the mistake of wishing Caravaggio a good night – to which the reply was, *'Ho in culo'* – up my arsehole. Off he went again to the Tor. In July 1605 he was arrested again for breaking into the house of two women, Laura and Isabella, and smashing its windows

Later that month, while standing in the Piazza Navona, a notary called Mariano Pasqualone was attacked from behind with what some said was a hatchet, others a sword. Although he lost a lot of blood, Pasqualone somehow survived. The assailant, dressed in a black cape, fled into the darkness. But no one was in much doubt about his identity. Pasqualone had made the mistake of worrying about the virtue of Caravaggio's model and girlfriend, Lena Antognetti, who was said to 'stand in the Piazza Navona' – which presumably meant that there wasn't in fact much virtue to

worry about. But Pasqualone, smitten, went to her mother, explained about the long modelling sessions her daughter had with the notorious artist and promised to make an honest woman of her. The mother went to see Caravaggio. And Caravaggio went – we can safely surmise – berserk. Words were exchanged between the two men on the Corso, Caravaggio fuming that, since Pasqualone refused to wear a sword, he was unable to challenge him to a duel. So as an alternative he took direct action, in the Piazza Navona, and then fled all the way to Genoa where he was offered commissions to paint for aristocratic villas. No matter what Caravaggio did, no matter what appalling crimes he managed to commit, there would always be *someone* prepared to turn a blind eye if they could get their hands on one of his paintings. It was just as well. When he got back from Genoa he found that his landlady, Prudenzia Bruna, had locked him out and had his few belongings confiscated with a view to a sale that would cover his six months' arrears of rent. Caravaggio's reaction was to break her windows and to threaten to break her.

He was a homicide waiting to happen, and in May 1606 it did. Caravaggio and his crowd had had run-ins before with the Tomassoni brothers from Terni, sons of the captain of guard of the great papal-aristocratic clan of the Farnese. Gian Francesco Tomassoni was the *caporioni* (ward boss) of the area around the Campo Marzio, and his younger brother, Ranuccio, was a swaggerer with a crew of tarts, famously skilled with dagger and sword, and possessed of as much attitude as Caravaggio. Police reports, court statements and Caravaggio's early biographers disagree about the precise cause of the fatal quarrel: some say (since the violence took place near the tennis courts on the Via della Scrofa) that it was all about a game or a bet; others that this was just a convenient location to settle a row after Caravaggio took offence at something Ranuccio had said about his girl, probably Lena. At all events, the fight was a classic all-out Roman rumble between two small gangs: the Tomassonis against Caravaggio and a friend, Petronio Troppa, who was a Bolognese 'captain'. It ended when Ranuccio took a slashing wound, after which Caravaggio stuck him – depending on how we read the reports – in the belly or in the groin. Tommasoni was taken to his house near by, where he bled to death. Caravaggio was himself badly wounded but managed to escape, hiding out in the hills of the Roman countryside with benevolent and powerful protectors, probably the Colonna family, among whom were his old patrons the Marchese and Marchesa of Caravaggio. It was probably the Colonnas who smoothed his way in the autumn of 1606 to the Spanish territory of Naples. The papal authorities had proclaimed Caravaggio subject to a *pena capitale* – literally a price on his head – so it was urgent to get him beyond the reach of their police or any eager bounty hunters.

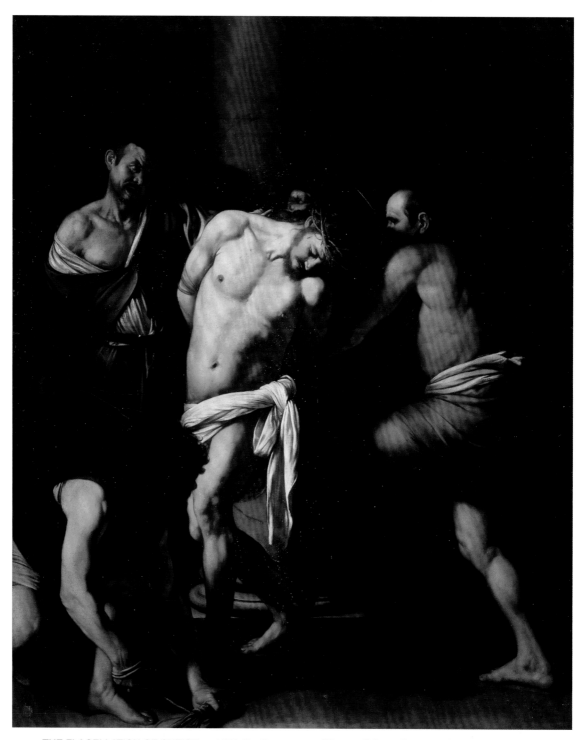

THE FLAGELLATION OF CHRIST, *c.* 1606–7, oil on canvas (Museo di Capodimonte, Naples).

He stayed in Naples for nine months, turning out dark and stunning altarpieces, such as *The Flagellation of Christ* and *The Seven Works of Mercy*, 1606–7. The Neapolitan altarpieces are conspicuous for their compassion and tenderness, even – or especially – in *The Flagellation*, where our pity is touched through the enactment of unsparing, almost unhinged, cruelty. Caravaggio was already something of a name when he arrived in the city, and through this succession of powerful, sombre works became more so. In Naples there were generous patrons, a string of commissions and – *mirabile dictu* – no fights and no spells in prison. It seemed possible, for a while in late 1606 and early 1607, that he would stay, obliging the devout merchants, financiers and ennobled bureaucrats of the port city, steadying his talent and his temperament and making them work in tandem for the greater glory of God and himself.

But nothing was ever quite that simple for Caravaggio. The following year found him in Malta, the island fortress of the Holy Order of the Knights Hospitaller of St John. Through the Marchesa of Caravaggio, he secured an introduction to the Master of the Order, Alof de Wignacourt, who held out the possibility that on the island he might not merely have his crime overlooked but become a Knight himself. Caravaggio's social status as the son of a master builder and steward had always been ambiguous: neither evidently genteel, nor exactly bourgeois. Other Roman painters, such as d'Arpino, liked to flaunt their status as *cavalieri*. Now the fugitive murderer would be transformed into a Knight of St John and thus be made untouchable.

X

ON 14 JULY 1608 the black cape with the eight-pointed white star of the Order of St John was set over Caravaggio's shoulders and, being compared to the first painter of antiquity, Apelles of Cos, he was formally proclaimed a 'Knight of the Obedience'. Along with the honour came, thanks to the Grand Master, a gold collar and two slaves. Normally Caravaggio's crime – known to Wignacourt – would have been an insurmountable obstacle, but the Grand Master had the knighthood of talented non-nobles in his personal gift; he had applied to the Borghese Pope Paul V for an exemption in Caravaggio's case, and it had been duly granted. In the months between his arrival in October 1607 and his elevation Caravaggio had vindicated his reputation with portraits of Wignacourt and another Knight of the Order; a greenish snoring baby purporting to be a Sleeping Cupid (more clip-on wings); and an intensely moving *St Jerome*, his torso twisted in the act of writing, and a skull, a crucifix bearing the Saviour and a candlestick – one of Caravaggio's great still-life ensembles – lying on his plain wooden table.

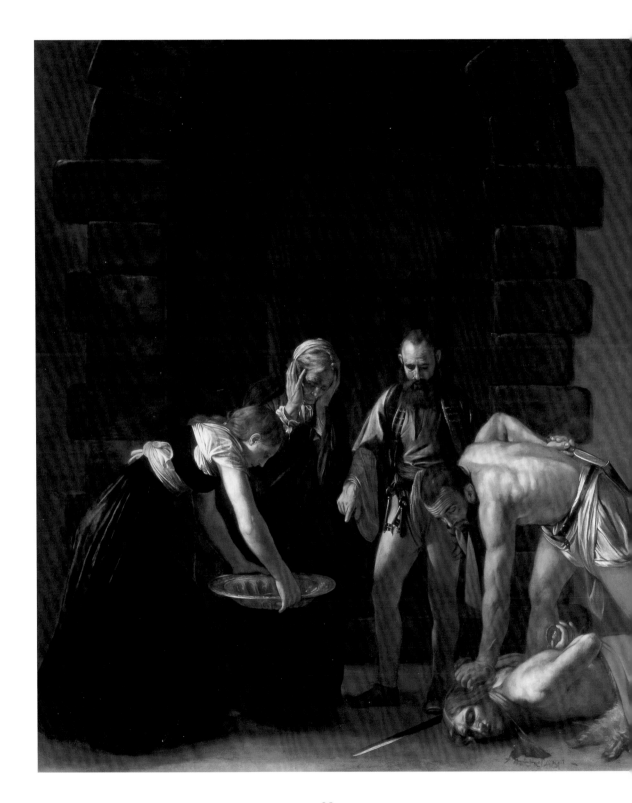

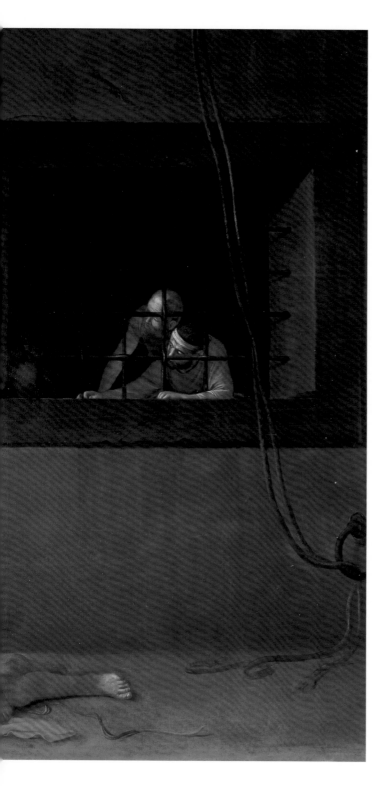

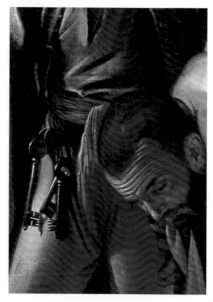

Left: THE BEHEADING OF ST JOHN
THE BAPTIST, 1608, oil on canvas
(St John's Cathedral, Valletta, Malta).
Above: Detail showing the warder's keys.

Caravaggio

But it was with *The Beheading of St John the Baptist* that Caravaggio effectively paid for his admission into the Order. At 17 feet wide it was not just the biggest painting he would ever make, but incomparably the greatest – perhaps the most moving, profound and complex history painting of the 17th century. And the reason it was all those things was that Caravaggio had so personal a stake in its display of calculated murder, sacrifice and rebirth – so personal, in fact, that he signed his own name in its new form as Fr (*Frater*, that is Brother of the Order) Michelangelo. And he signed it in the gushing blood of the Baptist – thus transferring, with his brush, his own identity from murderer to martyr.

The oratory, whose eastern wall Caravaggio's painting almost fills with its over-life-size figures, was not just a place of ceremony and prayer. Beneath the floor were buried those who had died fighting the good fight against the Turks, who occupied virtually the entire eastern Mediterranean. So the oratory was, among other things, a mausoleum of chivalric martyrs, and the John (himself slaughtered at the whim of an oriental despot) that Caravaggio was painting for them would thus have specially sacred significance. But it was also, as Caravaggio would have known, the court-house of the Order where delinquent Knights were tried and, if convicted, condemned. Behind the far wall would have been, at the time Caravaggio was working there, the cell in which the prisoners were held.

So even by Caravaggio's standards, an uncanny liquidation of the boundary between art and life was enacted in his painting. It wasn't just a matter, as in the Contarelli Chapel, of sustaining the illusion of a continuous space that the beholder could enter without the obstacle of a framing threshold to cross. The grimly empty prison yard where the scene of chilling horror is being enacted and across whose stones the martyr's blood is spilling is, as the art historian David Stone recognized from old prints, the same site used to hold and execute judgment on criminals. Push the logic further, though, and the Knights in whose name that justice was carried out would be in the position of Herod and Salome's slaughterers. So, notwithstanding Caravaggio's need to please his masters and brethren in the Order, a ribbon of ambiguity runs through this enormous painting, scheduled for completion by the Feast of the Decapitation of St John the Baptist on 29 August 1608.

And that ambiguity is, not least, about art itself. For, with the exception of the anguished old woman holding her hands over her head – or perhaps her ears to avoid hearing the order to saw through the Baptist's neck – the semicircle of figures represents a fiendish inversion of the traditional personifications represented in art. The heroic nude (like the very similar figure in *The Martyrdom of St Matthew*) is a ferocious butcher, gleaming blade behind his back; the figure of gravity and

authority, the grizzled prison officer, is the implacable and impatient agency of decapitation; and the embodiment of beauty, her exquisiteness concentrated in the delicate flesh tones of her exposed arms, is the trophy-carrier of murder. And as with all his very greatest masterpieces – the Cerasi *Peter*, for example – Caravaggio has integrated into his conception the element of time: the figures constitute a chain of action that, since it is yet to be initiated, becomes completed in our own horrified imagination and so goes on and on in an unsparing *perpetuum mobile* of savagery. It's the extreme quietness with which this horrifying spectacle ineluctably proceeds that turns it into a true nightmare, a horror in which evil is permanently frame-frozen. There are no histrionics. The painting says bleakly: in places like this, this is just what happens. And we are, through the rolling centuries, meant to know what he means by places like this. The painting may have been made for the Knights of St John in the summer of 1608, but assuredly, to anyone who goes to see it in Valletta, it is not only for the anachronistic crusaders.

It was also made for the two prisoners corkscrewing their necks through the barred lunette window in the otherwise bare right side of the painting; which is to say for Caravaggio himself (whom I suspect may be loosely represented in one of their faces) and for us. For the notional distance behind the picture plane from where they are making their attempt to rubberneck the scene is pretty much the same as ours in front of it. What they represent is confinement and impotence. In fact, those keys hanging from the officer's belt, one of which I had held in my hand, are, as the classical tradition had it, the *claves interpretandi* – the keys of under-standing. The power of this art is a confession of the limits of all art. A masterpiece painted at the very highest pitch of all Caravaggio's skills is nonetheless a confession of impotence before the beautified barbarism it pictures.

Except in one respect: that of the ultimate meaning of the martyrdom itself, a foreshadowing of the redemptive sacrifice of Christ, and thus the means, through the shedding of blood, to rebirth. Who would better understand the urgency of that expiatory sacrifice than a convicted murderer who had himself been given the precious chance – through this very painting – of exactly such an opportunity of another life? The blood sprays, as it had done with the *Medusa*, and from it comes the same kind of coralline coagulation that turns an act of evil into one of healing. The source of art, as with Medusa, becomes the source of life. No wonder, then, that as it flows over the ground, it forms itself into Caravaggio's *new* name, the name of his redemption: 'Fr Michelangelo'.

Which should be the end of the story, should it not? But of course it can't be. Caravaggio, who had just painted one of the most sublime outcries against cold

power, was unable to arrest his own hot temper, and barely four months after being admitted to the Order got involved in an altercation with a fellow Knight. Imprisoned in solitary confinement, he managed (suspiciously) to climb out of his 12-foot-deep dungeon with the help of a rope, and then to find a boat conveniently waiting to take him due north to Sicily, his next place of refuge. Had he been captured and sent for trial, he would then, as a delinquent Knight, have been incarcerated in the very cell that he had painted in *The Beheading*! On 1 December 1608 the Knights gathered in the oratory to hear that, although he had been summoned four times, Caravaggio had failed to appear before their tribunal. He was therefore 'expelled and thrust forth like a rotten limb'. Above the Grand Master as he pronounced the sentence would have been the greatest thing Caravaggio had ever done. It was no mitigation.

XI

HE WAS IN SICILY FOR A YEAR. An old friend from the rat pack days in Rome, Mario Minniti, who'd posed with fruit and lute for Caravaggio, was now the Great Painter in Syracuse and would have helped with both commissions and hospitality. But Minniti couldn't have done much to give Caravaggio what he needed more than anything else: peace, pardon, rehabilitation. If his reputation followed him on the run, and gave him work, so did his offences – and they gave him no respite. His jumpiness shows in the big Sicilian altarpieces, done at Syracuse and Messina to which he moved. Lately art historical revisionists, over-eager to correct anything that smells of romantic melodrama, have tried to make the case that Caravaggio's Sicilian works aren't a descent from the inspirational summit of the Malta *Beheading* or the Roman paintings of his glory years, but are just different: darker, quieter, if anything more soberly touching. It's not an entirely perverse over-correction. In *The Burial of St Lucy*, 1608, *The Adoration of the Shepherds*, 1608–9, and *The Raising of Lazarus*, 1609, there are passages of profoundly moving, chastened simplicity. But while it's possible to read the sketchier, brushier technique that Caravaggio has adopted for these paintings as evidence of a deliberately simplified manner, that judgement too is the result of romantic projection. It's just as likely that some of these rougher works are simply unfinished; Caravaggio may well have been hurrying to complete them because, with increasing desperation, he needed to. Aside from their almost monochrome wan-ness, what they almost all have in common, big as they are, is a sense of the action being re-enclosed inside a frame: hushed and impenetrable, sealed off behind the picture plane from the devotee. This was a new way of painting for Caravaggio all right. But it was not a better way.

Caravaggio

The fact of the matter was that in Sicily he was jumpy and unsettled, and with good reason. The list of those with scores to settle had grown. Whatever it was that he had done in Malta, whomever he had offended (if not the whole Order), he had just added formidable enemies to his pursuers. His only chance for salvation lay with the possibility of pardon back in Rome. That was where he wanted to be and where his art was meant to hang. And somehow he heard that, such was the faith in his making of marvels, there were indeed well-placed eminences working on just such a pardon: Cardinal Francesco Gonzaga and, still more decisively, Cardinal Scipione Borghese, the art-loving nephew of Pope Paul V.

So in October 1609 Caravaggio sailed north again in the direction of that hope, returning for prudence's sake to Spanish Naples. The fact that his old patroness, the Colonna Marchesa of Caravaggio, the woman who had first introduced him to the art world of Rome, was also then in Naples, at her villa in Chiaia, could hardly have been a coincidence. The Marchesa was a link with Rome, perhaps a bridge to his longed-for pardon. His earliest benefactress would be his latest, perhaps last, chance as the brilliant arc of his career descended now into the glittering bay.

Which may be why his guard was down as he was leaving the Osteria Cerriglio on 24 October. For at that moment he was jumped by unknown assailants, his face mutilated and his body so badly beaten that he was left for dead. News of his supposed death was sent to friends and patrons, who must have been shocked but not surprised. Who, then, would want Caravaggio dead? More to the point, who did *not* want Caravaggio dead? First there were the artists in Rome whom he'd abused verbally and physically; then Mariano Pasqualone, the notary whom he'd done his best to kill in the Piazza Navona; the powerful and well-connected Tomassoni family who had lost a son and brother to his sword; and more recently the injured party in the Maltese affray who, through the artist's escape, had been denied redress and judgment?

But there were also people who wanted him alive, and working for the Church and for themselves. So the paintings that Caravaggio did as he was convalescing amidst the jasmine and lemon trees of Chiaia (although the attack had been so violent that his face and body never seem to have really recovered) were in some sense his vindication, a demonstration that, though he'd been inches from death, he could still turn on the old magic. The brushy gentleness of the Sicilian altarpieces was banished again. Instead there was a return to his sharpest, most brilliantly dramatic manner, yet this time without even a hint of flash. These paintings, some of them done for the men who would get him his pardon – especially Scipione Borghese – were images of redemptive suffering and, yet again, decapitation, as if he couldn't get

the image of his own *pena capitale,* his capital sentence, out of his mind. There was an excruciating martyrdom of St Andrew, face agonized; and another head of St John the Baptist, this time on a platter, with a conspicuously ungleeful Salome pensive rather than jubilant at her dubious trophy. It was as if Caravaggio wanted to give the victors pause. For the shepherd boy hero in his *David with the Head of Goliath,* is likewise wistful, the most conflict-ridden David ever to be imagined in either marble or paint.

This went against the grain. But then Caravaggio's whole career, his whole life, had gone against the grain. He had been a brute, but one capable of devout sublimity. The worst things he had done, the blood he had spilt, defied belief, but the best things he had done on canvas had always been designed to summon it. So now, on the edge, as he must have hoped, of a resurrection from the bloody mess at the Osteria Cerriglio, he turned everything upside-down yet again in a bid for understanding – not just from the cardinals and the Pope, but from us, and perhaps from himself.

In the work of other hands – not least the other Michelangelo – David had embodied the union of godly virtue and heroic strength, the qualities the Florentines liked to imagine they saw in themselves and their city when they passed the great statue on the Piazza della Signoria. And since in Christian tradition David was the ultimate progenitor of Christ, his depiction was also associated with the triumph of good over evil, of saving grace over satanic transgression. To see David, pure, heroic and divine, was to see what Christian art was *for*: beauty as the agency of salvation. So even if Michelangelo did not inscribe his own features on his statue, everything about his vocation, its God-touched genius, was invested in the perfection of the form. Others were more literal. In a painting that has not survived, Giorgione is known to have represented himself as David: Big George, the conqueror of pagan sin.

Now that would hardly be credible in Caravaggio's case, would it? And yet the exercise in role reversal is more complicated than it first seems. For could it be that, as others have argued, *David with the Head of Goliath* is in fact a double self-portrait? His youthful upper body washed with light, David is the blessed Caravaggio that *was*, the Caravaggio of his prodigious beginnings, the maker of Christian beauty (the slingshot of his conquest has been assimilated into the loose shirt tied about his waist, a piece of white fabric as exquisitely tactile as anything the painter had ever rendered). But that same light flows downwards on to the face of the ogre, the Caravaggio that *is*, the bisexual goat, the murderer, the immense encyclopedia of wickedness.

One of Caravaggio's earliest biographers wrote that the model for David was in fact his 'Caravaggino' – the 'little Caravaggio who lay with him', and in some

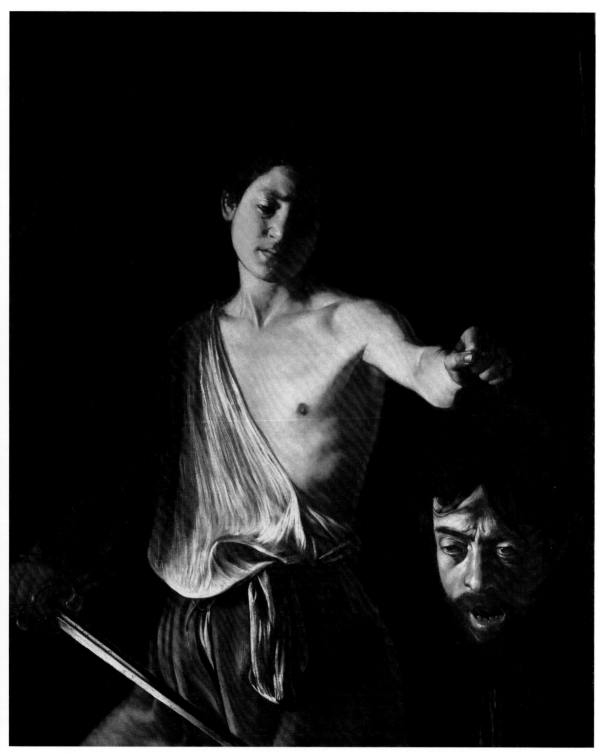

DAVID WITH THE HEAD OF GOLIATH, c. 1605–6, oil on canvas (Borghese Gallery, Rome).

literal sense this might be right; but of course it in no way precludes the deeper possibility of his being the painter's wishfully thought alter ego. They are bonded, the beauty and the beast, not least by the raking light that holds them both as tightly as David grasps Goliath's head. Instead of presenting the stark opposition between heroic victory and vanquished evil, they seem united by tragic self-knowledge. In fact, the distribution of virtues and vices in a painting that reaches to everything that counts most – sex, death and redemption – is surprisingly even. David's sword, as every commentator has noticed, points – indeed touches – his own groin (the place where Caravaggio finished off Ranuccio Tomassoni), while the shirt end hanging below his waist forms itself into an unsubtle phallic length. While the young David had been the personification of godly courage, notoriously the old King David was a lecher and a judicial murderer who sent to his death the inconvenient husband of the Bathsheba whom he coveted and took to his bed.

Nothing is as simple as it seems. There are no pure heroes, no irredeemable villains. For despite the unappetizing drool, the bared teeth, the sallow skin and the hooded eyelids, what is so striking about Caravaggio's self-portrait is that – unlike himself as the decapitated Medusa – what he sees in the mirror, for the last time, is in fact not a monster but a man; evidently a man capable of monstrous things, but a man for all that. Even the entry wound – which, had Caravaggio wanted to make gory, we can be sure he would, is oddly abbreviated into the frown of a man who, at the moment of his death, is struggling to comprehend something significant. The Caravaggio-Medusa had been a testimony to the lethal art of reflection, but on her face is written the horror of denial. Goliath likewise seems to have been taken by reflection at the instant of extinction, yet somehow the knowledge survives the killing; for the head held by David is still disturbingly alive, the mouth open in a terminal bellow.

Once again – as with the spurting blood of Medusa and the blood of John as he lies on his fleece – the pumping spray from Goliath's severed neck is the substance of translation from evil to atonement; from unpardonable to pardoned sin; the baptismal medium of rebirth.

XII

BUT TO BE SHRIVEN, absolved, reborn, Caravaggio first had to get to his pardon – to Rome. On 10 July 1610, encouraged by news of the progress of his cause, he boarded a felucca sailing north from Naples.

Then followed the famous denouement, so terrible that, were this not the life and death of Caravaggio, it would be unbelievable. The ship put in at the small port

of Palo, just west of Rome, where the local commandant had either not heard of Caravaggio's impending pardon or mistook him for someone else. He was thrown in jail yet again, only securing his freedom by paying whatever money he could lay his hands on. By the time he was free the felucca had sailed north again, taking with it the parcel of paintings intended for the cardinals and patrons, especially Scipione Borghese. One of his biographers claims that he actually saw the ship sailing away, carrying his painted vindications with it. Desperate to retrieve his work, Caravaggio then attempted to follow the course of the felucca further north, away from Rome and up the Tuscany coast to the Spanish garrison town of Port' Ercole on the peninsula of Monte Argentario. Just how he got there is unknown. It was too far to walk, a horse would have cost him money he didn't have, and a donkey would have been far too slow. Besides, he was feverishly sick. Burning from the illness, he collapsed on the beach near Port' Ercole and was taken to the local hospital run by monks, where, as his biographer writes, 'without the aid of God or man he died as miserably as he lived'.

Some time later, Scipione Borghese would have uncrated the fine parcel of paintings that Caravaggio had made in Naples. Among them would have been *David with the Head of Goliath*. Now the Cardinal would have been quite used to Davids, and even more used to severed heads, which were a speciality of the day. But he would never have seen a head quite like this: a self-portrait of the painter, set in utter darkness, flooded only with the light of tragic self-knowledge. Some time, a long time before, Scipione must have been accustomed to hearing confessions. Now he was seeing one – one that implored absolution.

The *pena capitale* placed on Caravaggio four years earlier had promised a reward for anyone turning in the fugitive murderer's head. Now Caravaggio was, in the guise of Goliath, turning himself in. 'Guilty as charged', the head seems to say. 'Can I have my reward, my pardon, my rebirth now?'

'Mi dispiace,' I like to imagine the sympathetic Cardinal saying. 'Sorry; tremendously sorry, but you're too late.'

Bernini

THE MIRACLE WORKER

I

WHO CAN LOOK at Bernini's *Ecstasy of St Theresa* with an innocent eye?

On a scalding Roman summer afternoon some years ago a trio of sandalled nuns came into the dark church of Santa Maria della Vittoria and approached the Cornaro Chapel in the left arm of the crossing. I was sitting in one of the pews opposite, unsettled as usual by what I was seeing – intermittently illuminated rapture. Every so often a coin would clunk into the pay-for-light box, and the most astounding peep show in art would proceed: the saint's head thrown back, her mouth, its upper lip drawn back, opened in a moan, heavy-lidded eyes half-closed, shoulders hunched forward in both recoil and craving. Beside her, a smiling seraph delicately uncovers Theresa's breast to ease the path of his arrow.

The nuns stayed for ten minutes, stock still, then two of them genuflected, crossed themselves, as well they might, and left the church. The third sister, small, round, bespectacled, sat down in another pew, dipped her head in prayer and occasionally caught my eye as I tried not to wonder what she was thinking and feeling. Bernini's sculpture, after all, is a spectacle that hovers on the moving borderline between sacred mystery and indecency. Scholars have fallen over them selves to warn us that what we are looking at could not possibly be a moment of sensual surrender, Bernini being so famously devout and the saint herself insisting in her autobiography that the 'pain is not physical but spiritual'. Typical is the authority who writes that to see the work as being in any way erotic 'limits it severely' – although, equally typically of this kind of comment, he doesn't bother to say why. We are left with the wagged finger and imputation that, if we are to understand Bernini's intentions, we had better banish any such modern vulgarity from our heads. It is utterly unhistorical, these interpreters insist, to imagine that the Pope's architect, the supreme sculptor of Rome, a man who practised Jesuitical discipline every day, could conceive of representing the mystical levitation of a saint as a moment of orgasmic convulsion. But as a matter of fact, the modern anachronism is not the union of body and soul that so many 17th-century poets and writers obsessed about, but its demure separation into sensual and spiritual experience. Ecstasy in Bernini's time was understood, and experienced, as sensuously indivisible. You only have to read the poetry of Richard Crashaw or John Donne (the Dean of St Paul's), or the verses of Bernini's notoriously hot-blooded contemporary Giambattista Marino, to

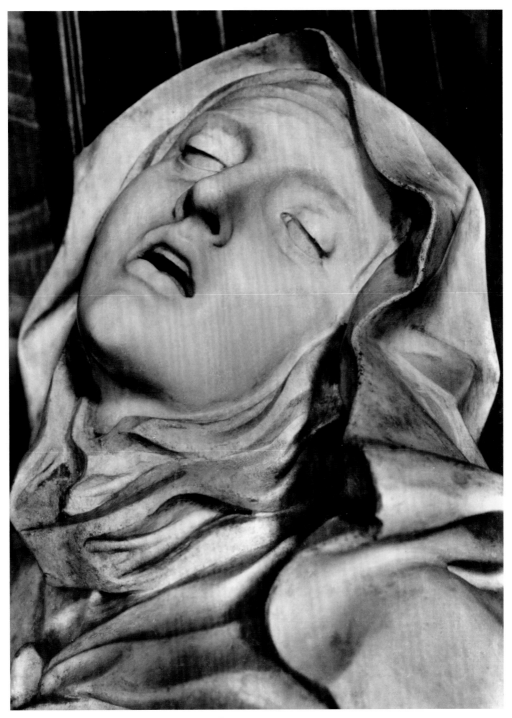

THE ECSTASY OF ST THERESA (detail), 1644–7, marble (Cornaro Chapel, Santa Maria della Vittoria, Rome).

grasp that in the early 17th century the yearning of the soul for possession by the divine was always understood as working through the extreme sensations of the body. Immediately after her denial that her experience with the angel was physical, Theresa herself adds that 'the body has a share in it, even a considerable share'.

So misunderstandings have been inevitable because Bernini calculated them. A century after he had made this most miraculous and emotionally overpowering of all his works, a French aristocratic connoisseur passing through Rome on the Grand Tour, the Chevalier de Brosses, took one look at the saint in the throes of her paroxysm and made a remark that has become infamous for its smirking cynicism: 'Well, if *that's* divine love, I know all about it.' But the Chevalier may (deliberately or accidentally) have understood more than he affected to know: that the intensity of Theresa's ecstasy, the representation of the transport of the soul, in fact, had everything to do with carnal knowledge, especially Bernini's own.

II

BEFORE BERNINI, sculpture's preoccupation had been with immortality. When modern sculptors looked at, and learnt from, antiquity what they saw was the translation of mortal humanity into something purer, chillier and more enduring: gods and heroes. Beauty, according to the ancients and the 'moderns' (of the 16th and 17th centuries) who revered them, was the form by which celestial ideals otherwise hidden from mere mortals were made visible. The vocation of art was to give that beauty form; the point of sculpture in particular was to make it weightily tangible, monumentally imperishable. In the jousting between the champions of painting and those of sculpture as to which better conveyed the vitality of living bodies, sculptors claimed that their third, tactile, dimension was inevitably superior – to which the painters retorted that this could hardly be the case, given that their working material was colourless, bloodless stone. The sculptors argued back that the natural grace imparted to the human form through the whiteness and hardness of marble was ennobling; that art was all about editing. Paint was gaudy and clay was common; stone was pure. In fact, the more the recalcitrance of the stone was respected as the sculptor worked at it with his chisel, the nobler would be the ultimate result. The success of sculpture was measured by the correction, rather than the imitation, of mortal, blemished nature.

Michelangelo's self-appointed mission, famously, was to tease out from the marble those ideal forms he believed lay trapped within it. So the heroic power of his *David*, 1504, lies precisely in its inhumanly frozen immobility. Only with the frail and broken body of Christ in the Vatican *Pietà*, 1498–9, did he uncharacteristically aim

at pathetic naturalism, but that body lies across the lap of a Madonna whose ageless, perfect beauty makes her less, rather than more, of a credible mother. But then Michelangelo was not much interested in the rendering of common bodies, still less in the imitation of workaday faces. His passion was to approximate men to gods. So no matter how grand the subjects – Pope Julius II, for example – he never bothered with so much as a sitting. When asked about the notorious failure of his Medici portrait busts to resemble their sitters, he brushed off the objection by commenting that in a thousand years no one would know (or, he implied, care) what those people looked like.

Gianlorenzo Bernini, on the other hand, cared a great deal about likeness, to the point where he redefined it as more than appearance. True likeness – the kind he wanted to capture in his sculptures – was the animation of character, expressed in the movements of bodies and faces. Perhaps because Bernini was also a formidably gifted painter (when he died, in his eighties, no fewer than 200 paintings were ascribed to him) he rendered the perennial dispute between the two art forms moot. If pictures could generate the sense of being in a warm-blooded, living presence, so, he thought, could sculpture. Stone could be made to pulse with natural action. Out of the smooth, chill marble would spring human drama.

Bernini took the *stat* – the Latin for their usual condition of 'standing' – out of statues. His figures break free from the gravity pull of the pedestal to run, twist, whirl, pant, scream, bark or arch themselves in spasms of intense sensation. Taking breathtaking chances with risky drilling, Bernini could make marble do things it had never done before. He made it fly and flutter, stream and quiver. His figures, liberated from the block-like sprites, charge into hectic action. Most of them are naturally yeasty, on the rise, and their natural drift is into the air and light. Add the rush of water, as Bernini did with his dazzling, exuberant fountains, and the artist becomes a second Lord of Creation, the supreme play-master of the elements. So on Rome's Ponte Sant'Angelo, Bernini's angels trip into the sunlight. Within the basilica, his bronze columns supporting the canopy – the *baldacchino* – over St Peter's tomb – aren't static; they writhe and seethe with organic life, bees and leaves teeming on their surface. Beyond the *baldacchino,* at the farthest end of the basilica, the *cathedra Petri* – the throne of St Peter himself, the seat on which the entire Church of Rome institutionally rests – is held aloft on the fingertips of the apostles, as though it were a holy lilo bobbing on a cushion of celestial helium.

It's magic. And that was precisely why, after his death, Bernini would be attacked by artists such as Sir Joshua Reynolds for being a cheap sorcerer, a specialist in theatrical trickery, who for the sake of wowing the worshipper – had,

unlike Michelangelo, debased the purity of his chosen material. The two classicist gripes against the Baroque Bernini were that he was emotionally overloaded (a sin against classical restraint) and that by going to such great lengths to imitate the surfaces and textures of other materials – steel, fur, skin – he had betrayed the integrity of stone. The more he made marble impersonate some other substance, the critics complained, the further from the sublime he took the beholder and dragged him down to earth.

It's certainly true that Bernini, more than any other sculptor before or after him, had the miraculous gift of translation. His work was indeed a denial of the unyielding rigidity of stone, and he was unapologetic about his determination to make it supple and elastic. According to the contemporary writer Filippo Baldinucci, Bernini liked to boast that in his hands marble could become as impressionable as wax and as soft as dough. Bernini's marble does indeed seem to mutate into other substances: fibrous rope; brilliant steel; locks of hair – different *textures* of hair, even, from coarse and thick to fine and silky. Pulsing veins stand out on a tensed muscle; the iris of an eye seems – impossibly – to hold a catchlight; the jaws of a ferociously barking dog stretch to reveal its fangs; a wind shakes the fronds of palm trees. Through understanding the way light could strike a highly polished surface, and how deep incising with a fine drill-head could supply shadow, he could even make the skin of a figure appear to sweat. All of this made Bernini an exceptional dramatist, and just as his talent as a painter played into the colour that we imaginatively sense in his stone figures, so his third career as writer, producer and actor of Roman plays meant that he was committed to sculpture as a high performance art. His contemporaries marvelled at this virtuosity, and believed that his unearthly powers as the Great Transubstantiator were a sign that he must have been kissed by God.

III

FALSE MODESTY was definitely not one of Gianlorenzo Bernini's failings. But since there had never been a time when he had not been hailed as a human marvel, it's surprising he wasn't more swollen-headed. His father, Pietro, a Florentine, was himself a sculptor, whose arrival in Rome from Naples in about 1605–6 was perfectly timed. Pietro was no more than classically competent, but at a time when there was a dearth of talent and a wealth of job opportunities – for the papacy was in the midst of a confident building and renovation boom – his light was usually able to shine amidst the mediocrities. (Not always, however: one of his tombs was judged to be so poorly worked that he was obliged to recarve it.) On the anxious edge between acceptance and rejection, Pietro soon realized that his most priceless asset

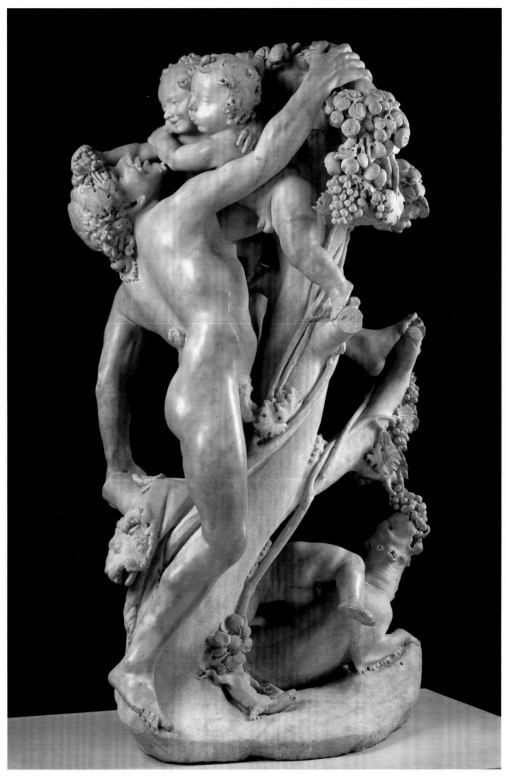

Above: BACCHANAL: A FAUN TEASED BY CHILDREN, 1616–17, marble (The Metropolitan Museum of Art, New York).
Overleaf: AENEAS AND ANCHISES, 1618–19, marble (Borghese Gallery, Rome).

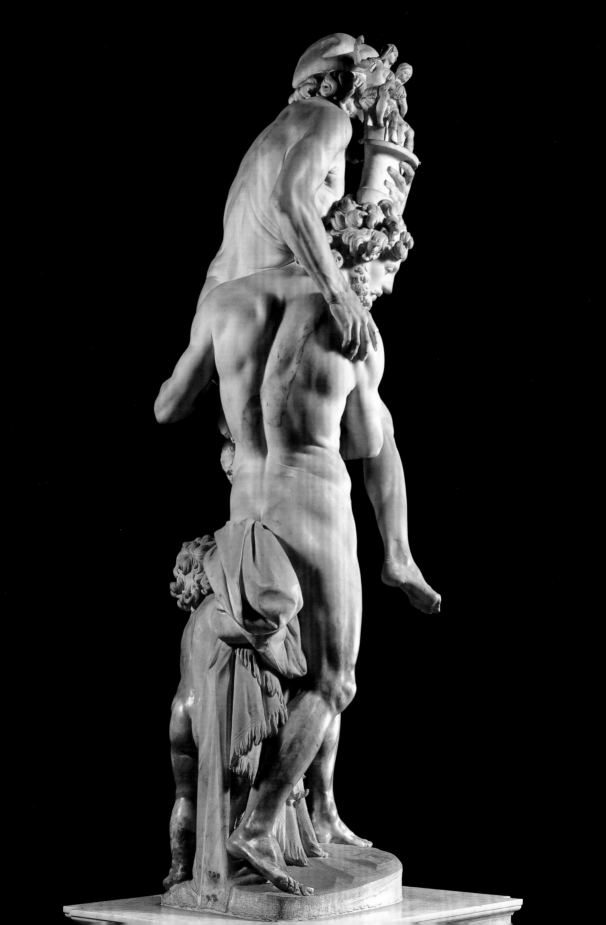

was the precocious talent shown by his son, born in 1598. So Gianlorenzo was co-opted to supply vitality in the form of romping cherubs, full of the hot breath of life, in what was otherwise a blandly conventional sculpture in the church of Santa Maria Maggiore. The same adolescent instinct for lusty animal mischief plays through a pair of scamps tormenting a massively phallic faun. Glee and pain in tandem would be one of Bernini's trademarks.

The child Gianlorenzo, paraded and promoted by his father, was singled out as extraordinary. Brought before the Borghese Pope Paul V, the eight-year-old did a shrewdly ingratiating lightning sketch of *Saint* Paul 'with free bold strokes' that moved the astonished Pope to hope that he was looking at the next Michelangelo. Twelve silver medals, as many as the small boy's hands could hold, were then dropped into his palms. To nurture his talent, Paul V appointed Cardinal Maffeo Barberini to watch over the young Bernini and to shape his education. The cardinal was so smitten that he remarked to Pietro, 'Watch out, Signor Bernini, the pupil will surpass his master,' to which the proud father replied, without any apparent testiness, 'In that case, Your Excellency, why should I care, for the loser then also wins!' This father-son bond, with all its ambiguities and shifting weights of pride and obligation, may have made Gianlorenzo's virtuoso sculpture of Aeneas fleeing the burning city of Troy, with his father Anchises in his arms, more than just an episode from the Trojan War. The different musculatures – the son's virile and athletic, the father's touchingly slack, the infant's chubby with puppy fat – are all exactly described.

Years of what all sculptors had to do – study and draw from classical models – followed. Even boy wonders had to learn the rules. But Bernini was later famous for saying that 'those who never dare to break the rules never surpass them', and there was something else apart from antique busts and torsos that he was evidently looking hard at – himself. For all three of the great masters of 17th-century dramatized realism – Caravaggio, Rembrandt and Bernini – the mirror was almost as important a tool of their work as the brush, etcher's needle or chisel. The aim was to unfreeze the expression of the passions from the artificial restraints imposed by classical models; to lend to the natural mobility of the face and the movements of the body the greatest possible authenticity. And while they were being their own models for this process of reanimation, they discovered the intensity of their own identification with the story. Self-dramatization made the artists simultaneously actors and audience, the producer and consumer of the performance.

Bernini was only 15 when he made his first experiment in this ego-play, *The Martyrdom of San Lorenzo*. St Lawrence was the librarian and archivist of the early

Church, who had been roasted alive on a red-hot griddle. Since the saint was Bernini's namesake, the project was personal, but he took this identification to extremes by placing his own leg against the side of a hot brazier. Either he looked in a mirror while he was performing this exercise in tutelary masochism, or he had someone hold it as he sketched the expression of pain on his own face. But the look of St Lawrence is a peculiar mix of agony and ecstasy because Bernini is trying to catch a literal turning point in the story of the martyrdom. According to popular hagiographies, at the height of his suffering Lawrence the librarian turned to his tormentors and told them, since one side was done, to turn him over. No wonder he became the patron saint of cooks.

That moment is not just one of macabre drollery, but one of profound alteration. For as St Lawrence went on cooking, so the legend had it, the smell of scorching human flesh turned, miraculously, into the most intensely sweet fragrance. Brutish nostrils quivered; incredulous pagans were converted; souls were saved. It's this precise moment of transformation, at once spiritual and carnal – Lawrence's body arched in a mysterious union of pain and pleasure – that Bernini tries to seize, and that he would repeat almost 30 years later in *The Ecstasy of St Theresa*. Fire, the natural medium of the sanguine humour (which was certainly Bernini's), played a critical role in both those pieces. That had been the element that champions of painting's superiority over sculpture had bragged could never be reproduced in stone, which is why the teenage Bernini went to such lengths to render the licking flames so realistically that the coals seem in our mind's eye to glow red.

There's something almost perverse about the way the prodigy loved playing with fire. Bernini scorched himself again, this time on a forearm, so that he could get the expression of tongue-rolling, screaming horror on the face of *The Damned Soul* (his own face) as he glimpses the burning hell to which he has been condemned. The spectacle is literally hair-raising: the damned soul's locks, standing on end with horror, are modelled as if they were tongues of flame. Beside the physiognomic pyrotechnics of damnation, the paired *Blessed Soul*, 1619, with her eyes lifted to heaven, is pure anti-climax.

IV

HOW COULD THE CARDINALS NOT NOTICE such a prodigy and compete for his services? The learned and rich Maffeo Barberini, whose palazzo was being decorated on a scale to rival those of popes and kings, had been deputed to watch over Bernini; but once the young man's gifts had been established, he was outbid (for the moment) by Scipione Borghese, who had the advantage of being nephew and close

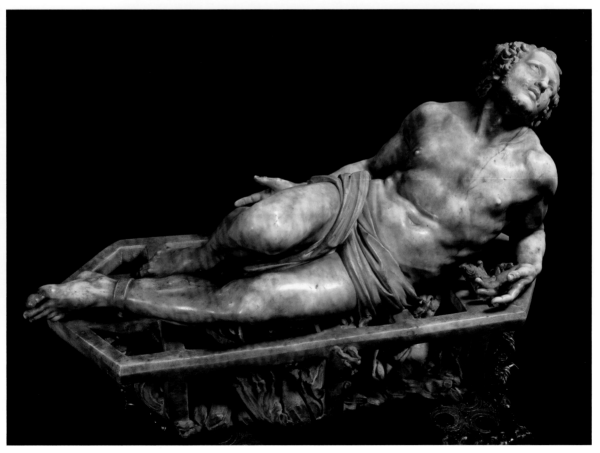

Top: THE DAMNED SOUL (detail), 1619, marble (Palazzo di Spagna, Rome).
Above: THE MARTYRDOM OF SAN LORENZO, 1613, marble (Uffizi Gallery, Florence).

adviser to the Pope. The princes of the Church were complicated eminences. Socially and culturally they were aristocrats; many of them hugely rich, lavish in their entertainment, unforgiving in their exercise of power – indeed, often entangled with the powers (French and Spanish), contesting for influence in Rome. As Rome under the popes of the Baroque age became more aggressively confident, with new churches being built and old ones renovated, the authority and power of the cardinals rose along with that of the papacy. They swaggered for Christ. And they needed a brilliant stable of artists to help them do the swaggering.

But they also prayed. At the same time as they were diplomats, politicians and patrons, many of the great figures of the Church were intensely serious about their spiritual responsibilities and personal devotions. They were sincere followers of the new theology that preached the original simplicity of Christ, the pastoral care of the poor and a Christianity for the common people. Intrinsic to that was the reassertion of the fundamental importance of the incarnation of Christ – the Word made flesh – and a search for visual ways to make that fleshed gospel immediate to believers. That was why so many princes and prelates were prepared, time and again, to overlook the crimes of Caravaggio, for there was no painter (except perhaps Annibale Carracci) who could match him for conveying the bodily weight of the Christian epic. And that was why Scipione Borghese in particular was prepared to help ease Caravaggio's way to a pardon and how he ended up with some of his greatest late paintings.

Up on the Pincian Hill above the Piazza del Popolo, Scipione was building a spectacular villa, in conscious competition with the Palazzo Barberini. Its style was to be akin to what was thought to have been the decoration of Hadrian's Villa: polychrome marble halls housing a collection of antiquities. But the ancients were to be complemented by the moderns. Since another of the relentlessly ongoing arguments fashionable in cultivated circles revolved around whether the ancients or the moderns were superior, the Villa Borghese collection, which had both, could function as a theatre for the debate, with Scipione as the presiding arbiter.

So the cardinal, who had certainly seen the fountain statuary that Bernini had created for Cardinal Montalto – a furious Neptune ploughing the waves with his trident as though spearing sharks for dinner – wanted to grab the 20-year-old genius for his own. Bernini repaid this vote of confidence with a procession of dumbfounding masterpieces – *The Rape of Proserpine* (page 95); *Apollo and Daphne*, (pages 96–8); and *David* (page 93), for which he once again used his own face and body as model. Together they announced a revolution in sculpture; but that revolution was also embodied in the portrait bust that Bernini made of Scipione himself (page 91).

Bernini

Although Bernini worshipped Michelangelo (who did not?), the philosophy of this bust is the opposite from the Renaissance master's heroic idealism. Michelangelo wanted to make god-men; Bernini wanted to make men-men. So the cardinal is carnal: meaty, a bull-like head atop a plump upper body, packed so tightly into his chasuble that – a classic Bernini detail – one of the buttons can't quite make it through the hole. By using all the tools in his repertoire – small drills, rasps, broad and fine chisels – Bernini could vary the surface textures of different areas of the head and face. The curled fringe poking from the edge of the cardinal's biretta, the ends of his moustache and the thick locks of his goatee (both separated and curled together, as if the cardinal enjoyed the twist), convey hair that's been lovingly oiled and pampered. The blubbery, turned-out lips, fleshy ear lobes, chipmunk cheeks, falling jowls and neck wattle give a sense of the hearty bon viveur; the hungry consumer of rich food and clever artists. Bernini even made sure that the cardinal's cheeks and nose are polished smooth enough to suggest a film of sweat, the natural effusion of a big man in a hot city.

There's something else that's revolutionary about Bernini's bust of Cardinal Scipione Borghese, 1632. Instead of a portrait of an Eminence, in which dignity and authority are paramount, we get an actual human presence. Bernini sitters, so Baldinucci tells us, didn't sit. Rather like the best modern portrait photographers, the sculptor wanted them to speak and move, convinced that any kind of conscious pose froze their personality. Conversely, the more animated the figures were, especially in mid-speech, the more accessibly visible their character became. Whether or not Bernini could convey that social animal, the conversational Scipione, depended on his establishing the kind of informal relationship with the cardinal that would allow him to relax. And there was something about Gianlorenzo, people found – handsome, witty, learned and intensely serious in his vocation – that made him irresistible. The two became friendly enough for Bernini to do a droll little caricature of Scipione, which presumably the cardinal must have seen. The eyes twinkle.

It was through a stunning piece of fine motor-control dexterity that Bernini managed to trap that twinkle. He achieved it by cutting very deeply at the contours of the iris so that the shadows created make the minute pupils appear to hold a catchlight. Catchlights in the eye were, of course, the speciality of the most talented painters, including Bernini himself. The way reflected light – from a window, for example – fell on the pupil of an eye enabled Rembrandt to write a whole book of character, alert or wistful, confrontational or quiet, in the eyes of his sitters. But to achieve the same kind of expressiveness in marble had seemed inconceivable until Bernini.

The effect literally hangs by a thread, the slenderest filament of stone holding the pupil in the gouged iris. But Bernini was by temperament a risk-taker, and there were times when he paid for it. Ironically, in a portrait bust so packed with delicate effects, it seems to have been a straightforward hammer tap with the chisel that produced a sudden terrifying crack right across Scipione's forehead, extending all the way round to the back of the neck. It was the virtuoso sculptor's nightmare, and there had been no way to predict the disaster. Millennia before, when strata of primordial limestone were being transformed by colossal forces of heat and pressure into marble, particle shifts had made for interior instability. Bernini had just found one of these faults. He brooded on ways to disguise the crack, which gave the cardinal's head the appearance of a freshly tapped boiled egg, but to no avail. In the end there was nothing for it but for him to make a replica. The original had taken him months; the second Scipione was done over 15 days and nights, almost non-stop.

But once again it allowed Bernini – still in his twenties – to test the warmth of the relationship between artist and patron by playing an elaborate joke on Scipione. When the day came for the unveiling he produced the cracked version, and took his time enjoying the look of horror on the cardinal's face before pulling a cloth away to reveal the replacement. The two busts are still together in the Palazzo Borghese. Somehow (and I can't say why) it's the cracked original which seems more richly realized.

V

BERNINI COULD AFFORD this act of cheekiness because he had already established a reputation as the greatest sculptor in Europe. Scipione had achieved exactly what he wanted: a series of astounding modern masterpieces that, while invoking items from his own collection of antiquities, brilliantly surpassed them. Bernini's *David*, for instance, borrowed some of its energy from Scipione's *Gladiator*, but for sheer whirling dynamic force left the classical sculpture in the dust. It was also, of course, in implicit competition with earlier versions, not just Michelangelo's, but also Donatello's lissom hero with the head of Goliath at his feet (1408–9), which, since he was the son of a Florentine sculptor, Bernini would certainly have known.

The difference, of course, is that Bernini's *David* is an all-action hero, caught just before the instant of the sling's release. (The rendering of that sling and the braided fibres of the rope are a *tour de force* of illusionist chiselling and drilling.) Michelangelo's *David* seems to be gathering all his powers for the combat; Bernini's *David* is at the point of discharging it. The veins in his arm protrude through his skin

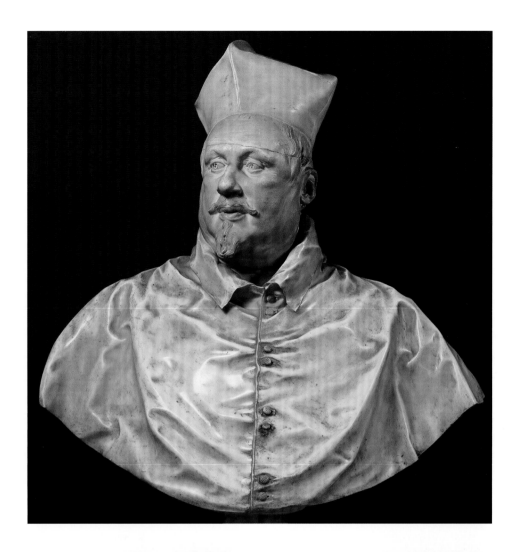

Top and above: BUST OF CARDINAL SCIPIONE BORGHESE, 1632, marble, the cracked version (Borghese Gallery, Rome).

with the muscular effort. He pivots on the ball of his foot almost like a discus thrower, his left heel raised to apply more spinning force. But Bernini has achieved this effect without sacrificing the sense of intense mental concentration: body and mind in perfect synch. The face of Michelangelo's hero is impassively beautiful, but Bernini's works: brows furrowed, jaws clenched, lips pursed. And those features are so precisely registered because, of course, they are Bernini's own, seen in a mirror held for him, according to Baldinucci, by Cardinal Maffeo Barberini.

The absorption of the maker in the subject is total – not just psychological, but physical too. Gianlorenzo, who prided himself on his athleticism, had practised the slingshot (or something very like it) to get the look of the tensed and contracted muscles right. He had slain the giants – Donatello and Michelangelo – and there is also a sense in his whiplash *David*, of conveying what the sculptor ought to be aiming for: not an elaborately stately and studious craft, but – after proper planning, preliminary drawing and the creation of terracotta models – a furious liberation of instinctual animal motion.

And there was another feature of Bernini's performance as David that further revolutionized the genre. Because the sculpture discharges so much energy, it seems to generate the space into which it moves so that the force field of its impact keeps expanding – towards Goliath, towards us. As with Caravaggio, there's never a time when Bernini isn't conscious of the spectator, who becomes not just a silent starer, but an actively engaged participant, moving around the piece and seeing it work in different ways from different perspectives (even when, as seems to be the case, its back was originally against the wall of the room). Centuries on, this understanding of sculpture as presenting not one but multiple images to us, each in a state of mutating motion as we move about it, might seem a truism; but in the 1620s it broke all previous conventions. Bernini had discovered a way to make marble movies.

This gripping sense of continuous motion meant that Bernini – who as a writer and presenter of plays must have thought about body language – could do stone drama like no one else. And the violent onrush of action, which in *David* just implies another figure – Goliath – turns into actual collisions in the two great mythological pieces that made his fame: *The Rape of Proserpine* (page 95) and *Apollo and Daphne* (pages 96–8). That Bernini understood very well the brutality of sexual wrestling is suggested by a study drawing of the rape, in which Proserpine is pulled over Pluto's thigh, he straining to nail her, she flailing frantically to get loose. The sculpture doesn't quite achieve that degree of raw entanglement, but it nonetheless turns the standard classical genre of abducted Sabine women into an act of savage possession. Only Bernini would think of conveying the unequal struggle by having Pluto's

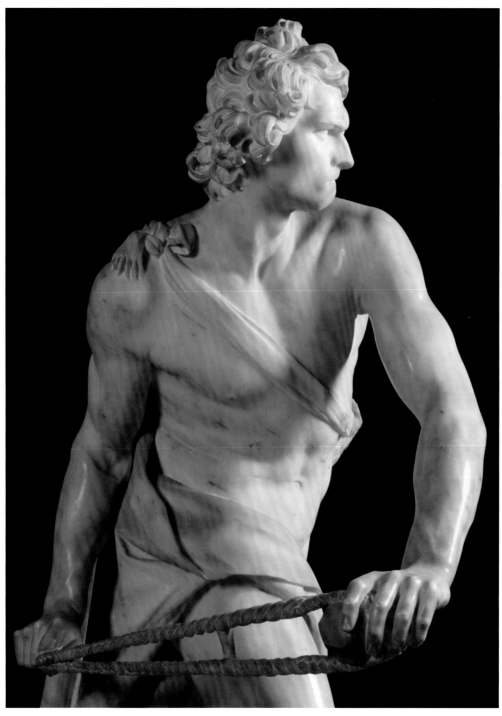

Above: DAVID (detail), 1623–4, marble (Borghese Gallery, Rome).
Overleaf: THE RAPE OF PROSERPINE, 1621–2, marble (Borghese Gallery, Rome).

paw-like fingers dig deep into Proserpine's thigh, his chisel carving the deep indentations. Only Bernini the playwright would engineer much of the fury through sound: Proserpine's shrieking and crying, indicated by both her open mouth and the tears dropping from her eyes; and all three shaggy heads of the dog Cerberus, guarding the gates of Pluto's underworld, barking as if to drown the victim's screams.

One small detail, often overlooked, registers both the ferocity and the pathos of the battle. Pluto's face seems at first sight to be almost amused by the desperation of his victim as she squirms and struggles in vain against his hefty, muscular torso. But the smirk of male power is challenged by the telling distortion of Pluto's features at the top left corner of his face, where the cheekbone meets the eye socket. The skin is being pulled down by Proserpine's attempts to claw at her abductor's eye. Against the odds, she is doing what she can to counter-attack.

The sexual equalization, thanks to the gods and to the account given in Ovid's *Metamorphoses,* goes a stage further with *Apollo and Daphne.* Apollo may be modelled on the acme of beauty-made-visible – the classical *Apollo Belvedere* in the Vatican – but his prey still eludes him. Even more than in the *David*, this is a frozen split second, Apollo's 'gotcha', thwarted by a lightning metamorphosis as Daphne's body seems to climb into the sky like the tree she is instantly becoming. As usual, Bernini gave careful thought to maximizing the beholder's direct, physical partici-pation in the drama. As the sculpture was originally installed, the visitor would have entered the room and then, as if following the god, have seen nothing but Apollo's back and the wind-blown flying cape that signalled his sprint. Overtaking the god – frozen in shock, as if in real time – he would then have felt the literally screeching halt, with Daphne's mouth opened wide in a scream.

So we are witnessing two marvels: the transformation of fingers into sprouting twigs, with the tips of the nymph's perfect toes rooting in the soil, and the stupendous capacity of the sculptor (helped by a gifted assistant, Giuliano Finelli) to render the nanosecond with such material vividness. Once again, the story is written in bodily proximity, all the more sensual because the two figures are neither completely detached nor completely united. At several cunningly calculated points it is not clear where Apollo ends and Daphne begins. Her spray of laurel (the trophy of victors, after all) that sprouts against Apollo's barely covered groin acts as a sign of his sexual urgency and so magnifies the drama of his frustration. At the precise point where Apollo's left hand clasps Daphne's hip it meets the rough sheathing of bark (perfectly modelled by Bernini) into which the nymph's thighs and groin are disappearing. The deep shadow between tree and skin only makes that sense of unreachable consummation more tantalizing. It's the greatest tease in all of sculpture,

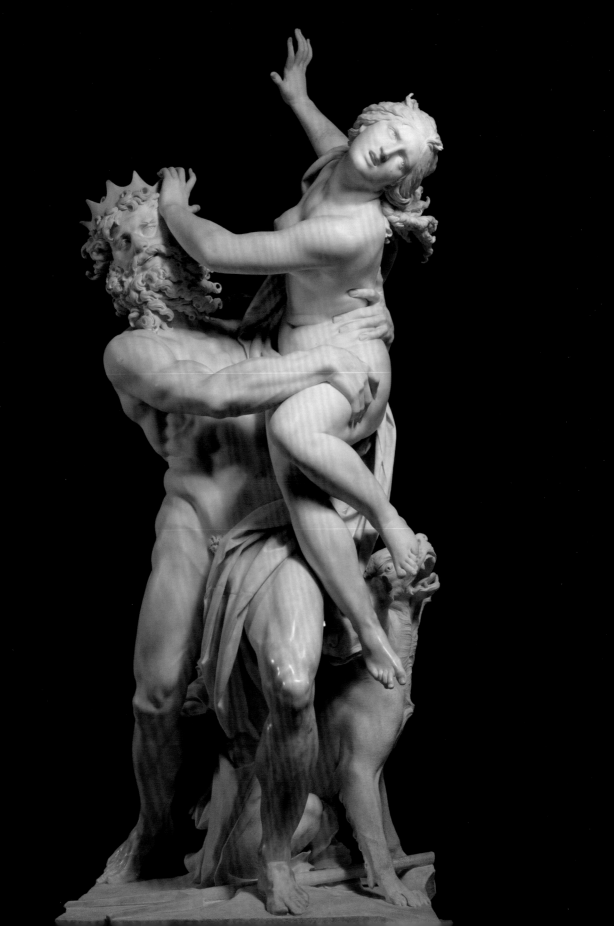

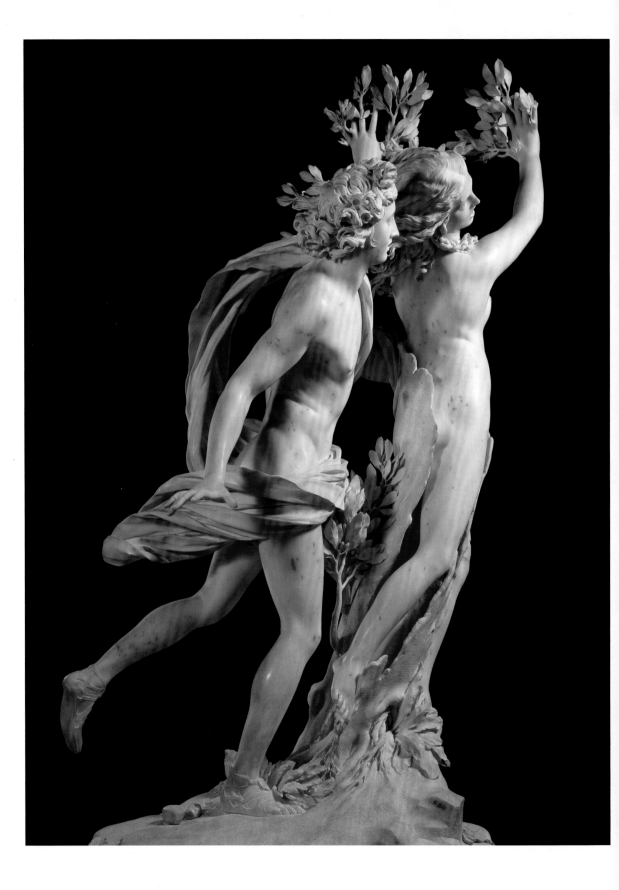

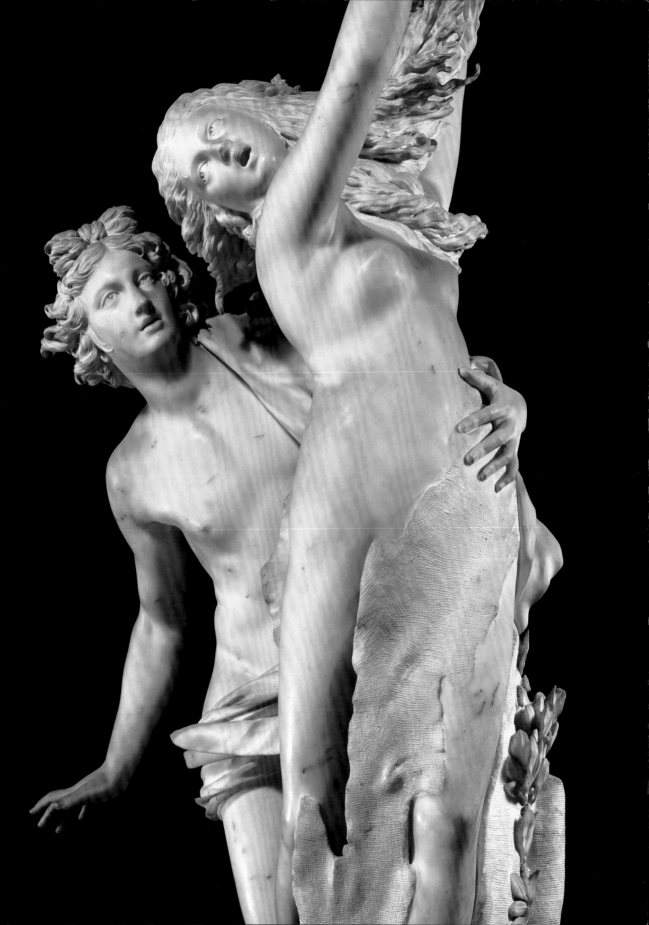

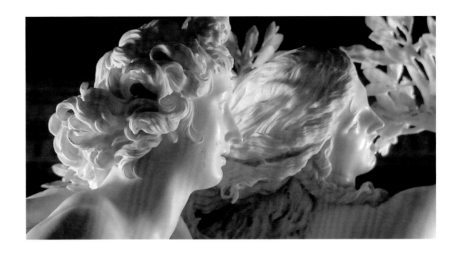

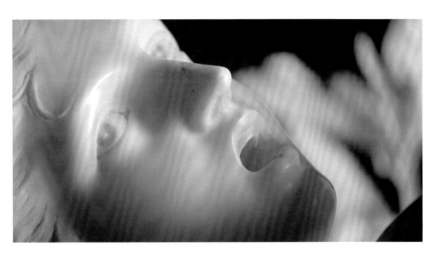

Previous pages: APOLLO AND DAPHNE, 1622–5, marble (Borghese Gallery, Rome).
Above: Details from the work.

for it's impossible not to sense the erotic charge of the nude exactly at the point where it has become unavailable. So much for divine omnipotence.

Contemporaries responded to the sensual electricity. A French cardinal let it be known that he didn't care how fine the sculpture was, he would never have had it in his own house since so beautiful a nude would surely arouse anyone who saw her. Bernini is said to have been pleased when he heard that! Cardinal Barberini, who was rapidly becoming Scipione's rival as friend and patron, felt obliged to add a ploddingly moralizing couplet in stone at the foot of the sculpture lest people get the wrong idea:

The lover who would fleeting beauty follow
Plucks bitter berries, and leaves his hands hollow

The risky reputation of the sculpture did nothing, of course, to deter crowds of people from flocking to the Villa Borghese to see it. 'As soon as it was finished,' Baldinucci wrote, 'such an acclamation arose that all Rome rushed to view it as though it were a miracle…when he walked around the city, the young artist…caught everyone's eye. People looked at him and pointed him out to others.'

When, in 1623, Maffeo Barberini became Pope Urban VIII he pounced and, unlike Apollo, got his way. Bernini was called into the papal apartments and given a famous acclamation: 'It is your great good luck, Cavaliere [for Bernini had been knighted in the Order of Christ by Urban's predecessor, Gregory XV], to see Maffeo Barberini Pope, but we are even more fortunate in that the Cavaliere Bernini lives in the time of our pontificate.' It was now no longer just a matter of making sculpture for a private patron, even one as grand as Scipione Borghese. What Urban VIII had in mind for Bernini was nothing less than the remaking of Rome – its secular buildings, churches and fountains – always with the busy-bee emblem of the Barberini on it. Even for the officially acknowledged prodigy, brimful of self-confidence, this must have been a giddy prospect. But Urban VIII, who was himself charismatic, erudite and forceful, made it clear that nothing would change in their personal relationship. Bernini was to be the Pope's adviser, confidant and trusted companion. In 1629, at the age of 31, he became official architect of St Peter's.

VI

BALDINUCCI GIVES A VIVID PEN PORTRAIT of what Bernini was like at this moment of professional coronation, to which we can add his own beautiful, moodily glamorized self-portraits. (He was, after all, a star actor as well as an artist.) Gianlorenzo had the

thick dark hair and swarthy complexion of his Neapolitan mother, Angelica, although he found the sun intolerable and would do everything he could to avoid it. The self-portraits – even for an artist who'd spent time looking at himself in the mirror – suggest just how conscious he was of the power of the concentrated stare, especially since 'his eye was spirited and lively, with a piercing gaze beneath heavy eyebrows'. When giving orders to assistants, Baldinucci writes, 'he terrified by his gaze alone'. We know that Bernini could be witty and easy-going; after all, he was the prankster who wound up Scipione, and the theatrical impresario who loved to terrify an audience in, for instance, his play, *The Flooding of the Tiber*, by making the river appear as though the waters were about to cascade over the stage and drench the audience – until they suddenly drained away against a concealed low bank. But the image he wanted to project – and that was true enough – was of someone who was consumed by the sacred demands of his vocation. When Pope Urban urged him to marry so that he could bequeath some of his gifts to another generation, he replied that his sculptures were his children. Once embarked on a work, Bernini gave everything he had to it: going without food, drink or rest, and becoming totally absorbed in the creative effort. His assistants would try to drag him away in his own interests, but were often deterred by their master's notoriously short fuse. He liked to talk of himself as burnt by that fire he had carved in his early work. It was the heat, he said, that made him angry; he declared that 'the same fire that seared him more than others also impelled him to work harder than people who were not subject to the same passions'.

The trouble was, with such a weight of new responsibilities in St Peter's, it was impossible for Bernini to practise his art as a solo act. Even with the Borghese masterpieces, he had called on sculptors such as Finelli (a master of the small drill) to help him with fine detail. But now, with so many tasks to tackle simultaneously – tombs, statues and the greatest challenge of all, the creation of a lofty bronze canopy or *baldacchino* over the altar, which was itself over the tomb of St Peter – Bernini needed to devolve and delegate to an entire workshop of assistants. Sometimes he managed this with finesse, and sometimes he didn't. Finelli had been so angry at Bernini's failure to give him proper credit for his fine work on the *Apollo and Daphne* that he walked out of his master's workshop and didn't come back for 20 years. (Even then, much later, Bernini had the cheek to boast on his own account about exactly the details Finelli had accomplished.)

There was one project at St Peter's above all others on which he urgently needed help: the *baldacchino*. As with the *David*, as with so many of the projects in his career, he was both creatively provoked and dogged by the ghost of

SELF-PORTRAIT, *c.* 1638, oil on canvas (Borghese Gallery, Rome).

Michelangelo. (Perhaps there were times when he wished Pope Paul had *not* tipped him as his modern reincarnation!) In this case, the challenge was the immensity of the great dome, begun by Bramante and completed by Michelangelo, directly beneath which lay the central point of the crossing. The canopy, then, needed to be a structure that didn't look ridiculously puny beneath that vast vaulted space. Yet it also had to be light and transparent enough for worshippers to be able to look beyond the altar towards the choir.

Conceptually, as usual, Bernini's imagination needed no assistance from anyone. The previous canopy, made by Carlo Maderno, his predecessor as architect of St Peter's, was a relatively modest but rather beautiful affair in which the canopy itself was supported by four angels. Bernini, whose lifelong obsession was uplift – the defiance by solid materials of their own weight – sketched four soaring, serpentine bronze columns set on polychrome marble pedestals. Their spiralling twist – known as 'Solomonic', from the apocryphal legend that the first Christian emperor, Constantine, had transferred columns from the Temple in Jerusalem to the earliest St Peter's – would give the massive columns an extraordinary sense of vitality, as if they were themselves snaking vines reaching to heaven. That impression would be reinforced by densely covering their surface with all manner of living things – laurel leaves (recycled from the *Apollo and Daphne,* but this time cast from actual leaves), Barberini bees and even mischievously romping *putti* peeping around the columns. It was Pope-and-the-Beanstalk (with the Heavenly Father rather than the Ogre at the summit), a fantastic piece of theological entertainment that could simultaneously be grandiose and graceful, awesomely solemn and a lot of fun, much like its designer.

But it was one thing for him to sketch the design and make wooden models; quite another to forge and engineer the immense structure. He need only remember the near-disaster of Scipione's brow to be reminded that accidents did happen, especially when working at speed, and the pressure was on for him to have at least the columns standing in the year following the rededication of the basilica in 1626 – the 1300th anniversary of the dedication of the original St Peter's. He did indeed manage to complete the first stage by 1627 (although the entire *baldacchino* was not unveiled until 1633). But those columns could not have been forged and erected without the assistance of a large team of workmen and a number of master builders.

Among the latter was one figure who already had decidedly mixed feelings about Bernini: the architect Francesco Borromini. A year younger than Bernini, Borromini always thought of himself as the Cavaliere's senior in both practical architectural knowledge and experience. Borromini had worked for Bernini's

predecessor, Carlo Maderno, whom he revered as the classical link between Michelangelo and the present age – indeed, such was Borromini's devotion to Maderno that he expressed a wish to be buried beside him. When the whipper-snapper genius was appointed by Urban VIII to fill Maderno's office, Borromini had two reasons to smart at what he evidently thought was a usurpation. First, Bernini seemed intent on upstaging Maderno; and second, since the newcomer appeared ignorant of the practical craft of building, Borromini thought the 'Cavaliere' had not earrned that status. If anyone should inherit Maderno's mantle, it ought to be him. Bernini's manner – by turns flashily exuberant and frighteningly quick-tempered – almost certainly grated on Borromini, who was neither of these things. He was instead inward-looking, morose and more than a touch paranoid. The two of them were oil and water.

However, Borromini had no choice but to work for Bernini, preparing many of the drawings for the *baldacchino* and certainly overseeing the technical issues of its construction and erection. This is not to say that Bernini was an absentee architect; quite the opposite, since he is reported to have worked like a demon to get the massive structure built for the Pope. But Borromini would later complain that Bernini didn't give due credit to all those other hands, not least his own, without whom the great work could never have been accomplished.

VII

BY THE 1630S Bernini was a little drunk on his own success. As Urban VIII's favourite, he could do no wrong, and was designing the façade of the spectacular Palazzo Barberini – again calling on Borromini to help him. The tombs of the great and the good – including the one the Pope planned for himself – were his to command, as well as spectacular fountains. So he took what he needed from his assistants: technical expertise, manual labour, specialized craft and, in one case, a wife.

Matteo Bonarelli had come to Rome from Lucca around 1636 and joined Bernini's workshop, where he had the usual details – angels and such-like – farmed out to him by the Cavaliere. His wife Costanza was, however, evidently no angel, nor especially constant. The affair between her and Bernini was apparently not his first, since Baldinucci writes of the romantic adventures, very much in the plural, of his youth. The 'youth', however, was by now nearly 40, and his liaison with Costanza Bonarelli was obviously more than just a fling. He was, as his son Domenico candidly wrote, '*fieramente inamorato*' with her. We might blandly translate *fieramente* as 'wildly' were we not to remember that Bernini himself thought his dominant element was fire.

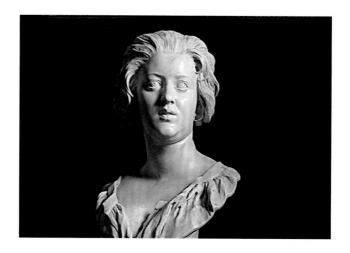

Top: BUST OF COSTANZA BONARELLI, *c.* 1635–7, marble
(Bargello Museum, Florence).
Centre and above: Details from the work.

It's not necessary to have their love letters to demonstrate the intense heat of that passion, since we have something far more eloquent: a portrait bust of Costanza, created at the height of their affair in 1637, that was like none that had ever been sculpted. Ancient Roman sculptors had encompassed a wide range of social types and expressions from emperors to courtesans. But since then, portrait busts had been made exclusively for aristocratic and ecclesiastical patrons and tombs. This, of course, did not preclude sculptors as gifted as Bernini from personalizing them with all kinds of expressive details, the way he had done with Cardinal Scipione. But this was the first (and, until the 19th century, the last) portrait made of an intimate, and everything about it is marked with intense and possessive desire. It's the marble equivalent of one of the love sonnets of Shakespeare or Donne, fraught with the emotional compulsion of the maker. Through Bernini's capacity for rendering different personal qualities at different angles of viewing, Costanza becomes more than an idealized embodiment of adoration – she is, rather, a richly complex object of consuming love.

There's something about lovers' passion that makes them want to show off. Bernini has carved Costanza so lovingly that it's as though he yearned, however recklessly, to revel in the display, while he relived, with every move of the chisel and drill, the gazes and the caresses his mistress had drawn from him. So Costanza's hair, drawn up in a plait at the nape of her neck, is lustrously thick; but from its loose gather falls a single lock for which the term 'kiss curl' was never more appropriate. Costanza's eyes are wide, her cheeks full and peachy; and her chemise falls open, more deeply on one side than the other, in the sexiest invitation in the history of European sculpture.

What gives the bust its sensual vitality is the frankness with which Bernini has depicted his lover, not as the passive recipient of his adoration, but, on the contrary, as spitfire. The sculptor was already the famous maker of many miracles, but one of the most astonishing was his depiction of his mistress as his hot-blooded equal. Matteo Bonarelli may have been a fairly lowly assistant, but his wife came from an old family, the Piccolomini, and in the bust she exudes strength of character, dignity and pride. Costanza breaks all the rules for the depiction of women in the 17th century. A virtue of the sex was supposed to be their quietness. But Costanza is shown, her beautiful mouth open, in the act of speech, enormous eyes not lowered, but wide open, blazing. Whatever she's saying is quite evidently not deferential, and it's this feistiness that the sculptor, uniquely in the art of this period, wants to relish and celebrate. Those eyes, the edges of the lower eyelids deeply cut to suggest the moistness of the vitrea and a perfect shadow rendered below the orbital bone, are

among the most stunning things Bernini ever did. And as one moves about the bust, another marble movie spools out: the mercurial moods of Costanza. Frontally, she is confrontational; in three-quarters profile, softer, almost amorously tender, still talking; and as we move behind her, the jawline softens further into vulnerability. Costanza is literally multi-faceted.

But not an inconstant Costanza, Bernini must have supposed; for as protean as those moving aspects are, they cohere somehow into a single personality, the one her lover thought he knew and possessed. But there came a day when someone approached Bernini and whispered (doubtless nervously, given the Cavaliere's reputation for hot temper) that his mistress was, alas, also sleeping with someone else. That someone else was his younger brother, Luigi.

He was the brother Gianlorenzo trusted. Trained by their father Pietro not just as a sculptor, but also as an architect, mathematician and hydraulic engineer, Luigi had designed sets for Bernini's plays and acted alongside him. He was the one Bernini went to for advice on technical and engineering matters, especially concerning the works in St Peter's; and the movable organ that Luigi had designed for the basilica had been hailed as a famous marvel of the Bernini brothers. So Gianlorenzo must have been incredulous at the rumour of his betrayal. That evening, at the family table, he announced that the next day he would be going to the country to see to some business. But instead he went to Costanza's house, in time to see his brother emerge with her *mezza vestita* – which means, probably, not half-clothed but in her nightdress. In the violent fight that followed Gianlorenzo, trying to kill his brother with an iron crowbar, succeeded in breaking two of his ribs. At home Gianlorenzo made another attempt to kill Luigi, this time with his sword, and when the younger brother took sanctuary in the church of Santa Maria Maggiore, Bernini was left vainly trying to kick the door in.

He had not yet exhausted his rage. That same afternoon a servant was sent to the Bonarelli house. He found Constanza in bed and there, fulfilling the orders he had been given by Bernini, he cut her face to ribbons with a razor. So the same hand that had fashioned the most beautiful head in the history of sculpture had – through a surrogate – mutilated the living flesh it had celebrated.

The penalties for these crimes and transgressions were unequal to their cruelty. The servant was arrested, tried and sent to prison for his assault. Costanza, the victim, was, as the art historian Sarah McPhee has discovered from the archives, sent to prison on charges of adultery and fornication. Luigi Bernini, the philanderer, was exiled to Bologna for his own safety. Distraught, their mother Angelica implored the Pope, through Cardinal Francesco Barberini, to intervene and somehow restrain

Gianlorenzo, who thought and acted, she said, as if he were 'Lord of the World'. Bernini was indeed penalized – by a 3000 scudi fine, about the sum he would have received for one of his busts. But his patron and friend Urban VIII then waived the fine on the understanding that now, and to prevent any recurrence of such unfortunate episodes, the Cavaliere *would* marry. This turned out to be something short of severe corrective punishment, since the intended bride, Caterina Tezio, was reputedly the most beautiful woman in Rome. Bernini did indeed go through with the marriage, never (as far as one knows) strayed again, and had 11 children by Caterina.

At the height of his love affair with Constanza, Bernini had painted them as a double-portrait. Now taking the sword with which he'd wanted to run through his brother, he cut Costanza from the canvas. Some sources claim she was re-created in a *Medusa*, the embodiment of monstrous evil, her hair a nest of vipers. But, happily, the bust made when Bernini felt differently about his lover was preserved from obliteration or mutilation by Caterina's refusal to have it in their house. It was instead sold to a Florentine buyer, and ended up in the Bargello Museum, ignored by almost every tourist.

VIII

THE BLOODY END TO BERNINI'S AFFAIR with Costanza occurred in May 1639. And it was around the same time that his career, hitherto a Roman rocket, stalled in flight. The two years with Costanza had also been the time when Bernini had been engaged on a project for St Peter's that matched the *baldacchino* for lofty ambition, and that attracted the same muttering. Back in 1612 Pope Paul V had decided that a bell-tower should be built at each end of the façade of the basilica, framing the dome and summoning the faithful. Bernini's predecessor, Carlo Maderno, had designed those towers as relatively modest edifices, rising a single storey above the roof level of the cathedral. But, as usual, Bernini's imagination when he took over the project in the late 1630s inspired him to think higher and grander. With an eye – as always – to Michelangelo – he declared that his bell-towers would be three storeys high, over 200 feet above their pedestals, soaring to frame the dome. They would also be six times heavier than Maderno's intended towers. But they would have to be built on unstable, swampy subsoil, and once again Bernini was under pressure to erect them in a hurry: by 29 June 1641, the feast day of St Peter and St Paul.

Two months after the unveiling, a visitor reported: 'They say that the Cavaliere Bernini who has undertaken to build a campanile at St Peter's has failed and that the great weight of the tower will bring the façade down. This having come to the notice

ST PETER'S BASILICA, WITH BERNINI'S CAMPANILE, *c.* 1635, mural, anon (Quartiere delle Guardie Nobili, the Vatican, Rome).

of the Pope, he called Bernini to him and severely reprimanded him for not having wanted to take the advice of anybody.' This was both untrue and disingenuous on the part of Urban VIII. Not only did Bernini seek advice, he got plenty of it from people whom Baldinucci describes as 'master builders', all of whom assured him there would be no trouble with the foundations, nor with the weight and height of the towers. But Borromini's subsequent charge that, 'ignorant of architecture' at that time, Bernini had not listened to the right *kind* of advice – namely his – may well have some justification. Whether or not Bernini was the supremo of the arts in Rome, his exceptionally low boiling point, his headstrong convictions and his unparalleled power and personal access to the Pope might well have disposed those whose counsel he sought towards telling him what he wanted to hear. Despite his reservations after the fact, there's no doubt that Urban VIII was an enthusiast of his architect's ideas for the bell-towers. Bernini naturally wanted what the Pope wanted. Up they would go.

But the crack happened, and this time, unlike the parlour game with Scipione, it was no joke. The Pope's withdrawal of favour from the architect-sculptor who until recently could do no wrong was crushingly demoralizing for Bernini. He was acutely aware of ill-feeling towards him in Rome; jealousy, he doubtless told himself, of all the commissions he had garnered during Urban's pontificate, and of his commanding position in all the arts. He was not so naive or so deaf as not to hear the muttering that the Cavaliere, the man to whom everyone in search of a commission had to defer, would finally be undone by hubris. Bernini's initial response to the chill was hysterical. One source has him taking to his bed, fasting almost to the point of death. Work was cancelled on one of the bell-towers and suspended on the other, which had progressed to the top storey. The reasons were partly financial. Urban VIII's treasury had been drained for funds needed for a toy-soldier war he had rashly undertaken to seize a neighbour's territories. The adventure backfired when the enemy's troops advanced on Rome. Heavy taxes were imposed, angering Romans, who now blamed Barberini extravagance for their hardships. The Pope did not need the controversial campanile to remind his suddenly innumerable enemies of his overreach. The ladder by which Bernini had scaled the heights had been knocked from under him. To be thought of as a Barberini favourite was to court hatred.

But as difficult as things were for the Cavaliere with an enfeebled and alienated patron, they were much worse without him. In 1644 Urban VIII died and his successor, Innocent X, ascended the throne of St Peter, accompanied by a reputation for austerity and a well-known determination to undo the excesses of his

profligate predecessor. Both the men and the projects favoured by Urban now came under frosty scrutiny. And nothing seemed more excessive than Bernini's surviving bell-tower.

This, at any rate, was what Innocent X's own favourite architect – Francesco Borromini – was telling the new Pope. The cracks had not gone away; indeed, they seemed to be spreading to the façade of the basilica itself. A committee of inquiry was established to look into the damage, and Borromini, for so long in Bernini's shadow, presented the committee with what he thought was damning evidence of his rival's lack of thorough preparation, including a spectacular drawing of the damage and its progress through the foundations. Bernini had now taken soundings at and beneath the foundations to see how serious the problem was, which gave Borromini the opportunity to write witheringly of his rival's amateurishness: 'The prudent architect does not first erect the building and then do a sounding to see if there's a crack in the foundation.'

By the end of 1645 there were three cracks in the façade of St Peter's. There seemed no danger of the tower, much less the entire façade, collapsing, but Bernini's reputation and authority were destroyed. He was never allowed to defend himself in person before the committee. On 26 February 1646 the Pope's decision was announced. The remaining bell-tower was to be dismantled, the stone to be saved for the construction of an alternative and sounder design.

The demolition took 11 months. If Bernini had walked anywhere near St Peter's, which, since he retained his official position as architect despite the debacle, he must have done, he would have heard the work, seen the winches and pulleys, the columns and capitals stacked on the roof. Reports differ on how he survived this public humiliation. An English visitor, Nicholas Stone, wrote that Bernini once again collapsed into despair, 'sicke to deathe and [at once] dead as it was reported'. The truth was that he was down but very definitely not out. Commissions still came in – though the most important of them were from abroad, rather than in Rome. Bernini even rallied sufficiently to write a play satirizing Innocent X and his nephew Cardinal Camillo Pamfilj – a piece so caustic that someone remarked it was a miracle he had not already been imprisoned. In the same vein of bitter self-vindication he went back to make a sculpture, for once (since no one would have commissioned it) a startlingly uningratiating nude, big-breasted, thighs parted: the naked *Truth Unveiled by Time*, supposedly being revealed by Father Time, hence her expression somewhere between sunny optimism and unhinged ecstasy. But he never got round to finishing it because, as things turned out, time was indeed on his side.

IX

BY NO MEANS EVERYONE in Rome had given up on the Cavaliere, notorious adulterer, incompetent master builder and has-been sculptor though he might have seemed in the late 1640s. A walk through St Peter's towards the *baldacchino*, taking a look at the great statue of St Longinus in one of the niches of the crossing; or past the spectacular Triton fountain he had designed in the Piazza Barberini just before Urban's demise – all this should have been reassuring enough for patrons to bet that the genius would recover his powers and his lustre. So his estrangement from the new Pope was an opportunity for lesser eminences to secure Bernini's services for themselves. And Cardinal Federico Cornaro, from an old aristocratic dynasty, grabbed it. The Cornaros were patrons of the austere order of Barefoot Carmelite Sisters, and the plan was to build a family chapel in the church of Santa Maria Maggiore, up on the Quirinal Hill, devoted to their famous reformer St Theresa of Avila. Just a few years earlier Cornaro would have had to wait his turn, for King Charles I of England and Cardinal Richelieu both wanted busts from Bernini. But everything had changed. Bernini wanted – and seized – a chance for vindication. It helped, of course, that Cornaro was willing to lay out the huge sum of 12,000 scudi for his chapel – more money than was spent on an entire Borromini church. So Bernini could, if he wished, pull out all the stops: he could create not just a sculpture, but a spectacular architectural setting (to stop the mouths of critics who said he was no builder), and perhaps include some painting as well. It could be a theatrical ensemble of all the arts and, if done well, the greatest drama he had ever created.

And its star player was – for Bernini – irresistible. Theresa of Avila had died in her native Spain more than a half century earlier, in 1583, but she had been canonized only in 1622 by Urban VIII. Even so, she was the last of the 'modern' saints still to be without a dedicated chapel in Rome. For even after her death – as during her life – there was always something slightly worrying about Theresa: her emotional extremism, the contortions of her body graphically described in her autobiography, those raptures in which she had levitated up the walls of her cell with nuns hanging on to her habit. Perhaps they were, after all, the delusions of an unseemly hysteric? No wonder, then, that when Urban gave the Spanish the choice of either Theresa or San Diego (St James) of Compostela as their patron saint, they overwhelmingly chose San Diego.

Even if he had already read Theresa's autobiography, it seems likely that the bookish Bernini would have gone back to the *Vita* to refresh his memory and seek ideas. One imagines his eyes widening as he read it, since although her ecstasies were sanitized as 'mystical', and although the book is an odyssey of the awakening of

Theresa's soul, the stirrings of that soul make themselves felt entirely through the convulsions and yearnings of her body. Theresa's soul, in fact, has a physical anatomy: 'The soul doesn't try to feel the pain of being wounded by the Lord's absence, but sometimes an arrow is plunged into its most vital organs, its entrails and heart so that the soul doesn't know what is happening; what it wants.' Now this was something that Bernini, the supreme dramatist of body language, could work with.

Perhaps, too, there may have been a penitential element in the commission for him. He was the virtuoso who had committed sin and crime, had then been disgraced, and who was now leading a life of strict Christian discipline, tending to the fate of his own soul. Who better understood the transit from the carnal to the spiritual? Theresa, after all, had had her own rocky journey in the same direction. There was something about her that stayed Jewish, even after her grandfather's conversion (and many secret relapses). Her father, the high-end textile merchant who had over-compensated in the usual way by marrying into an old Christian family, still had to deal with a vivacious, headstrong, material girl who went in a big way for clothes, jewels and perfume. Anxious about all this worldliness, he confronted Theresa with the choice between marriage and convent. Theresa chose the latter, although not out of an immediate surge of piety: she had heard there was more, not less, freedom in a convent than locked away as the wife of a Spanish *hidalgo*. As a novice, she would still be able to receive visitors – even men visitors.

Life behind the convent walls, however, turned out to be less sociable than she might have expected. The habits were coarse and black, the food grim, the prayers relentless. So Theresa did what angry teenagers do: she became bulimic, stabbing her gullet with an olive twig, vomiting, wasting away. At one point she became so ill that the nuns thought her dead, wrapped her in a shroud and sealed her eyelids with wax. Her father, brought in haste to the convent, thought differently, saying, 'My daughter's not for burying'. After four days of unconsciousness her eyes broke the skin of wax, fluttered and opened. She was alive, though barely. Once again, Theresa's account is startlingly anatomical. 'My tongue was bitten to pieces since I was so weak and hadn't eaten, not even water would go down the throat. My bones felt as though they had been dislocated and my brain was totally confused. I was twisted up in a knot from all those days of torture and couldn't move my arms, legs, feet and hands any more than if I had been a corpse. I think that all I could move was my little finger.' Theresa began to have visions, but the wrong ones. To mark her resurrection, she threw a party and received a male visitor with so much avid attention that she was subjected to warnings, first from a frowning Christ, then from a giant toad that crawled slimily across her cell floor.

It was not until she was in her forties and the exuberant girl had turned into the middle-aged sister, constantly battling her demons, scourging herself, that something overwhelming happened to Theresa. She had spent the day praying and had begun to sing the hymn '*Veni Creator Spiritus*' – 'Come to me Divine Spirit' – when, of course, He did.

'A rapture came over me, so suddenly that it almost lifted me out of myself. There was no doubt about it because it was very obvious. That was the first time that the Lord gave me the favour of a rapture. I heard these words "Now I want you to speak not with men but with angels".'

It was this experience of bodily 'lift' that must have leapt from the page into Bernini's imagination. He knew perfectly well that Theresa went on to be a famous reformer of convents, imposing austerity, poverty and simplicity on her Carmelite sisters, endlessly on the road, tangling with the Church to get her convents established. But that Theresa, the politician-cum-spiritual general, wasn't the Theresa whom he could dramatize in the Cornaro Chapel. What he wanted was the Theresa of the ecstatic uplift, rising (as she had written) clear off the floor. Distressed by the levitations, she had ordered the nuns to clutch her habit and pin her down – but up she went anyway, sometimes vexed with God for causing her embarrassment.

So many of Bernini's body-dramas had featured this tortured ascent – his teenage Lawrence, arching from the grid-iron; Daphne's trunk rising into the sky. His entire conceptual philosophy of sculpture was a breaking free from weighty immobility. Now it was time for him to give form to Theresa's levitation, unlike Daphne, not in resistance to penetration, but in craving for it. His most ambitious elevation – the St Peter's bell-tower – had come crashing down in ignominy. Now his Theresa would rise and take with her the resurrected reputation of the calumnied Cavaliere Bernini.

For all his sensual past, Bernini understood that when Theresa wrote of her raptures she meant the longing of her soul for consummated union with God. But the way she wrote about it was as if that anatomically palpable soul experienced viscerally a great opening, a penetration in which pain and pleasure were inseparably mixed:

Very close to me...an angel appeared in human form...he was not tall...
but very beautiful and his face was so aflame that he appeared like one of those
superior angels who look as though they are completely on fire... In his hands
I saw a large golden spear and at its iron tip there seemed to be a point of fire.
I felt as if he plunged this into my heart several times so that it penetrated all

the way to my entrails. When he drew it out he seemed to draw them out with it and left me totally inflamed with a great love for God. The pain was so severe that it made me moan several times. The sweetness of this intense pain is so extreme that there is no wanting it to end and the soul is satisfied with nothing less than God. The pain is not physical but spiritual even though the body has a share in it – in fact a large share in it.

Everything Bernini had done thus far must have seemed a rehearsal for this supremely delicate and difficult task. He had done kindly fire, he had done experiments with flame, with agony and pleasure, and no one had ever looked harder at what bodies do in the grip of intense sensation. No one had ever translated carnal knowledge so daringly into marble, making it melt, writhe, braid, leaven the stone so that it defied its own density. To raise up Theresa, Bernini drew on another of the skills he had, over the decades, brought to perfection: the variation of surface texture. The cloud bearing the saint would be roughly worked, not just for the illusion of mysterious vapour, but so that the brilliantly polished body and robe would shine the more radiantly. To keep her airborne would mean hollowing out the rock-cloud and fastening it to the chapel wall with hidden braces and bars.

There was a risk that everything might snap, that there might be another crack disaster. But it was a paltry risk beside the one that Bernini decided to take with the rendering of Theresa's face and body. What did rapture, after all, look like? Bernini knew perfectly well what it *didn't* look like: all those altarpieces featuring heaven-beseeching, rolled-up eyes! What, instead, if they were rolled *down*, the way he had seen ecstasy written on a woman's face? What if he carved this woman, who herself had dared to describe her experience so graphically, as if at the height of her sexual pleasure, utterly abandoned to a flood of sensation, straining towards her spiritual consummation, body and soul indivisible? Who would dare challenge him? He would take his own, ample carnal knowledge and turn it into a sacred shock.

Bernini took the chance, mingling the real and the ideal. His Theresa, it hardly needs saying, is no middle-aged nun rising up the wall in her habit like an untethered balloon, nuns clinging to the hem. This woman is unforgettably beautiful, a match for the beaming seraph. They are, in their way, a couple. We see his exposed breast, infer hers. The smiling angel aims his arrow (rather than a spear) not at her breast, but significantly lower on the torso. From her half-opened mouth with its upper lip tightly drawn back we know she has already been penetrated; that the angel has already pulled the burning shaft from her body and is poised to enter her once more. But how could Bernini make visible the tide of ardent feeling washing through

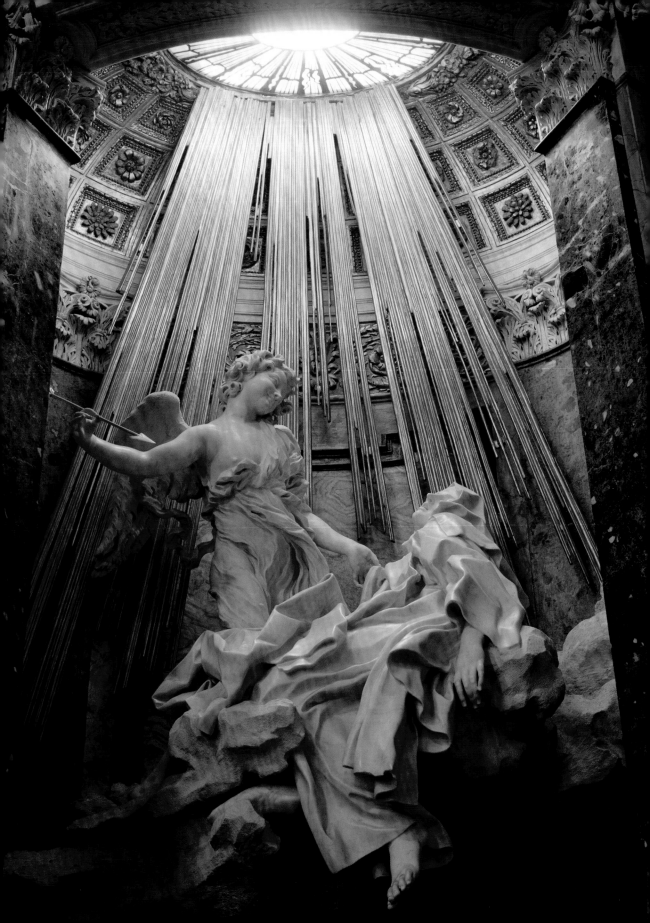

Previous page: THE ECSTASY OF ST THERESA, 1644–7, marble
(Cornaro Chapel, Santa Maria della Vittoria, Rome).
Above: Details from the work.

Theresa? Here he has the crucial conceptual insight of the entire drama. He turns her body inside-out so that the habit – the protecting garment of her chastity, the symbol of her discipline – becomes a representation of what is taking place deep within her. It is, in fact, the climactic shudder itself, a storm surge of sensation cresting and falling as if the marble had been molten. These billows pour themselves from the smiling angel directly into Theresa's robe, where they join an ocean of undulating waves that fold into hollows and crevices. One such darkly unfurled opening makes itself into a suggestive form between the saint's draped thighs.

But there is no visual innuendo: what we are looking at could hardly be less sly or furtive, and this startling candour precludes a snigger rather than provokes it. Staring is mandatory. Theresa's levitations in Spain, after all, were not solitary happenings. Witnesses from within and without the convent beheld the disturbing, exhilarating mystery, and in the Cornaro Chapel Bernini has used all his showman-ship to ensure she makes an unforgettable spectacle of herself. He not only envelops her with a burst of sun-rays so that her face and body seem to catch the divine fire; he actually pierces the back wall of the chapel so that a hidden natural light source pours down radiance from above. With this perfectly calculated stage lighting in place, he not only concentrates our rapt gaze, but makes the act of looking a theme of the work. For on each side of the Theresa drama members of the Cornaro family, most of them long since dead, look down on the marvel from boxes draped with illusionistically rendered fabric, made from the most expensive *giallo* – golden yellow – marble (page 119). (Theatre boxes had, in fact, just come into use in the Cornaros' native city of Venice, and Bernini, the producer-impresario, may have known about them.) Some watch the couple, while others, including Federico himself, talk about the drama and its meaning, inviting us into the heart of the matter.

Which begins within a woman's body, but ripples out to shake the cosmos. Above Theresa, Bernini's favourite romping cherubs cavort and beam at the happening; and from still further up, a painted illusionist heaven opens in a cloudburst of joy. The force of the event shivers down from the summits of paradise to the very threshold of the underworld, where, in marble inlay, the earth splits, the graves gape and the skeletal dead clamber forth.

Everything that Bernini has in his repertoire is summoned to create what Baldinucci calls a *bel composto* – a beautiful, perfectly integrated fusion of all the arts: colour, motion, light, even a sense of the heavenly choir pouring music down on the scene. And the talent for which he has been most criticized, the one that has brought about his disgrace – architecture – becomes, in the Cornaro Chapel, a vindication thrown back in the teeth of his critics. The fiercest of those critics, famous for his

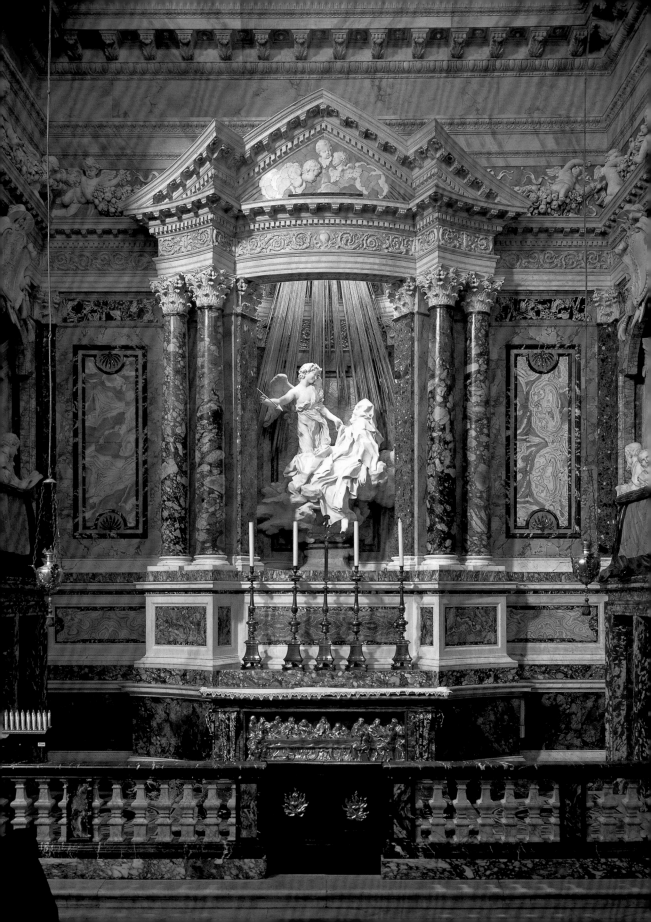

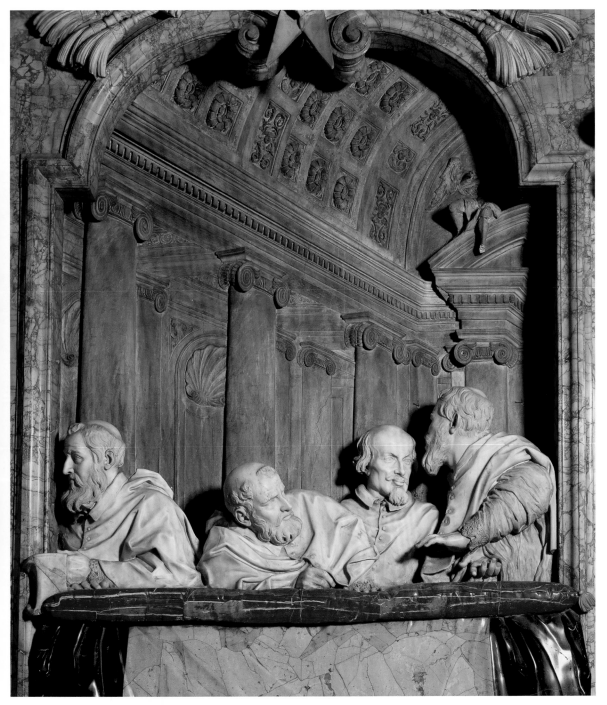

Above: THE CORNARO FAMILY, 1644–7, marble, overlooking *The Ecstasy of St Theresa* in the Cornaro Chapel (Santa Maria della Vittoria, Rome).
Opposite: ALTAR OF THE CORNARO CHAPEL, marble, 1608–20 (Santa Maria della Vittoria, Rome).

undulating walls and ceilings, his dizzying exercises in architectural improbability, had been Borromini. So Bernini takes a leaf from his rival's book to create a convex miniature temple. But the ecstasy happening within is so uncontainably explosive, the earth actually moving, that the temple swells, buckles, bulges and finally splits, like the architectural equivalent of the bursting womb, the opening cavity seeming to push its miraculous content right over the proscenium edge and towards us, the speechless beholder. And you imagine Bernini, when the work was done, standing back, contemplating his *bel composto* and daring anyone to top it. No one ever did. Not even himself.

The Cornaros loved their 12,000 scudi chapel: cheap at the price. Word circulated that in Santa Maria della Vittoria the Cavaliere was very definitely back on form. Borromini's moment of gloating had been brief. When the two of them competed – around the same time that Bernini was working on the *Theresa* – over a fountain in Innocent X's proprietorial square of the Piazza Navona, the competition was almost painfully unequal. And this fountain couldn't have been more crucial. It was to be the setting for a raised Egyptian obelisk that, in the Holy Year of 1650, would be crowned with the Pope's dynastic device of the dove of the Holy Spirit, a symbol of the triumph of the Church over paganism. Fountains were not really Borromini's thing: too playful, perhaps insufficiently capable of the arithmetical and optical complexities with which he invested his churches. For Bernini, on the other hand (whose father Pietro had also been in charge of the renovation of Rome's hydraulics), their multimedia dazzlement – the play of light through water, the combination of sight and sound – was a challenge to his instinctive theatricality. In fountains such as the Triton, done for Urban VIII, he showed that he could marry power and play.

But the fountain in the Piazza Navona would be overlooked by the Pope's family palazzo and their church of Sant'Agnese – renovated by Borromini. So he had no choice but to make some sort of submission himself, which, from the surviving drawing, was the most conventional thing that ever came from his superlatively off-kilter mind: water merely falling from scallop shells at the base of the obelisk. He might have thought that with Bernini so out of favour with the Pope, he would at least be spared the galling prospect of his rival creating a work right beside his. He was wrong. A sympathetic ally, Prince Niccolò Ludovisi – for Bernini still had many friends in high places – smuggled the sculptor's model for what would become *The Fountain of the Four Rivers*, 1648–51, into the palazzo of the Pope's sister, where he was being entertained, and set it on a table for the Pope to see as he walked in to dinner. The ambush worked. One look and the Pope was said to be 'quasi-ecstatic', commenting: 'This is a trick of Prince Ludovisi…but those who do not wish to have Bernini's designs executed had better not see them.'

It was, like Theresa, another levitation. This time the obelisk – a finger of the sun's fire – would be raised on high, supported by a rough-hewn rock grotto that was to be hollowed out, and through which the water of the four rivers, symbolized by statues representing the Nile, Ganges, Danube and Rio della Plata – would freely flow. God's natural creation – palm trees, lions, crocodiles – would feature in the elements beneath the soaring, fused power of his spiritual light. The project looked very fine on paper; even finer in a terracotta model. But the critics thought that another bell-tower fiasco was in the offing; that the travertine block from which the grotto would be carved would crack even before it had to support the additional weight of the obelisk. Nothing of the sort happened. Just before its completion in 1650, Bernini took Innocent X to see *The Fountain of the Four Rivers* and did a Scipione on him, pretending to apologize for the tardy work that made it impossible to see the piece with flowing water. As the Pope was about to depart, disappointed, a great gushing was heard and the Cavaliere, like Moses, brought forth water from the rock.

After the double vindication of *The Ecstasy of St Theresa* and *The Fountain of the Four Rivers*, Bernini went from strength to strength. He served not just a succession of popes, but also foreign monarchs, such as Queen Christina of Sweden and King Louis XIV of France, who were elated to have the greatest sculptor in the world produce their likenesses. The look of Rome – the experience of Christian Rome, both outside and inside St Peter's – is unimaginable without his procession of masterworks. Pilgrims approach St Peter's over the Ponte Sant'Angelo bearing his angels, are enfolded in the embrace of the 'arms' of his colonnade, proceed past his equestrian statue of the Emperor Constantine, up his great processional staircase and into the basilica, where they can stand before the tombs of Urban VIII or Alexander VII, and file past the *baldacchino* to the focal point of the *cathedra Petri*, the seat of St Peter's itself.

Borromini, too, built churches of head-spinning beauty, created from contrapuntally musical forms that swim and undulate, but in austerely undecorated marble (page 122) – while Bernini's churches are shamelessly profuse and rich with colour. Although he went on working after Innocent X died, Borromini's moment had passed almost before he had properly seized it. Eaten up with paranoid bitterness that he had never had his just deserts, he ended up committing suicide, botching the attempt but dying all the same.

Bernini never did finish *Truth Unveiled by Time*, possibly because he felt that he no longer had any need of that vindication. His reputation as an inexhaustible marvel, the greatest sculptor since Michelangelo, was secure. And he was a famous paragon of Christian virtue: a father of 11 children, no whisper of scandal,

Above: SAN CARLO ALLE QUATTRO FONTANE, ROME, 1638–41, ceiling designed by Francesco Borromini.
Opposite: SANTA ANDREA AL QUIRINALE, ROME, 1658–78, ceiling designed by Bernini.

THE BLESSED LUDOVICA ALBERTONI, 1674, marble (Altieri Chapel, San Francesco a Ripa, Rome).

conspicuous for his relentless and austere devotions. So the Naked Truth with her voluptuous body and ardent smile, remained in his studio when he died in 1680 in his eighties. But, close to the end of a long career, a ghost from his time of trouble unexpectedly returned to haunt him in the incorrigible form of his now middle-aged brother Luigi, arrested in 1672 in the precincts of St Peter's in the act of 'violently sodomizing' a young man. The scandal was such that Bernini agreed, as an act of family penitence, to carve the tomb of another nun, *The Blessed Ludovica Albertoni*, in the church of San Francesco a Ripa in the poor Roman quarter of Trastevere. To help the sullied cause of the Bernini family with Pope Clement, he would do the work gratis.

Another work to erase sin: time, then, for another nun-in-ecstasy; time, in fact, to cue up the winsome cherubs beaming at the scene. But this time the saint was in her death throes, laid out on a mattress. Her hips are raised, her right hand is pressed into her breast and again her habit writhes with sensuous agitation. Initially, Bernini wanted not just to open her habit a little, but to split it right down the middle with the drama of her dying passion. In the end, he retreated from that violent gesture. Perhaps, in his mid-seventies, he wasn't as confident of treading the fine line between sensual and spiritual feeling as exquisitely as he had more than 20 years before.

It was said that, every so often over his long career, Bernini could be found at the Cornaro Chapel, kneeling in prayer before what he called the 'least bad thing I have ever done'. Some of us stubborn heathens may have a hard time kneeling when we see Theresa caught in her spasm of rapture. But we stare and stare nonetheless – as we stare at no other sculpture ever made. Perhaps the force of the spell comes from the realization that Bernini has made visible and tangible something that, if we're honest, we know we all yearn for, but about which there has been more bad writing, more excruciating cinema, more terrible poetry than anything else. No wonder critics and scholars tie themselves in knots to avoid stating the obvious – that we're witnessing the most convulsive drama of the body that any of us experience between birth and death.

Which is not to say that Theresa is caught in a mere erotic spasm. It's precisely because this ecstasy is *not* just an anatomical effect, but a fusion of physical craving and (choose your word) emotional or spiritual transcendence that the sculpture possesses us more and more the longer we gaze at it. So perhaps that French connoisseur of the arts wasn't being sly at all when he remarked, 'If that's divine love, I know all about it', but actually doffing his hat to Bernini for using the power of art to achieve the most difficult thing in the world: the visualization of bliss.

ROUGH STUFF IN THE HALLS
OF THE RICH

I

YOU'RE A PAINTER. What's the worst thing that can happen to you: neglect, derision, disgrace? Worse than all these misfortunes is to have to mutilate your masterpiece, the bravest thing you've ever tried. That's what happened to Rembrandt in 1662.

Once he had been Amsterdam's strutting cock of the walk, the showy dazzler in a city that couldn't get enough of him. Over and over he had confounded expectations, and expectations adjusted accordingly to whatever it was he had done. Rembrandt had been master of a handsome house, head of a workshop full of pupils, husband of an amiable, propertied wife, and owner of a collection of treasures that included Mantegna drawings and samurai helmets. In his thirty-fourth year he had looked in the mirror (he enjoyed doing that) and had seen Titian, northern style. So he did his own likeness, *Self-Portrait Aged Thirty-four*, modelled after portraits by Raphael and Titian, leaning on a ledge, all silky insouciance, the swag of his mutton chop sleeve falling over the stone as if he were a Venetian noble; as if, in fact, he was Titian himself.

But that had been 20 years before. By 1660, in his fifties, Rembrandt was living in a modest dwelling on the Rozengracht, opposite a pleasure garden. There were drunks in the street, knife fights on the corner. The tongue-cluckers now saw him as someone from whom things had fallen steeply away: credit, property, the benisons of the mighty. God did not distribute fortune idly, so the truisms of the pious had it. Thus, in some fashion, Rembrandt's fall from grace must have been ordained as a caution against sinful pride.

But then, as if to spite the knowing, there came a chance for the encumbered old reprobate to change everything. The elite of Amsterdam, at this moment the richest city in the world, needed a monumental history painting for their grandiose and exceptionally white new town hall. Their first choice for the job, Govert Flinck, had unexpectedly died. So they turned to his erstwhile master, Rembrandt van Rijn, who in his time had created history paintings of heart-stopping power. Why should he not do so again? He had better! The town hall picture would be one of a series illustrating the history of the remote ancestors of the Dutch, the ancient Batavians. Together the cycle of histories would remind Amsterdammers (who in their splendour were apt to yawn at instruction) that, while they were now themselves masters of an empire, their history began with an act of virtuous insurrection against

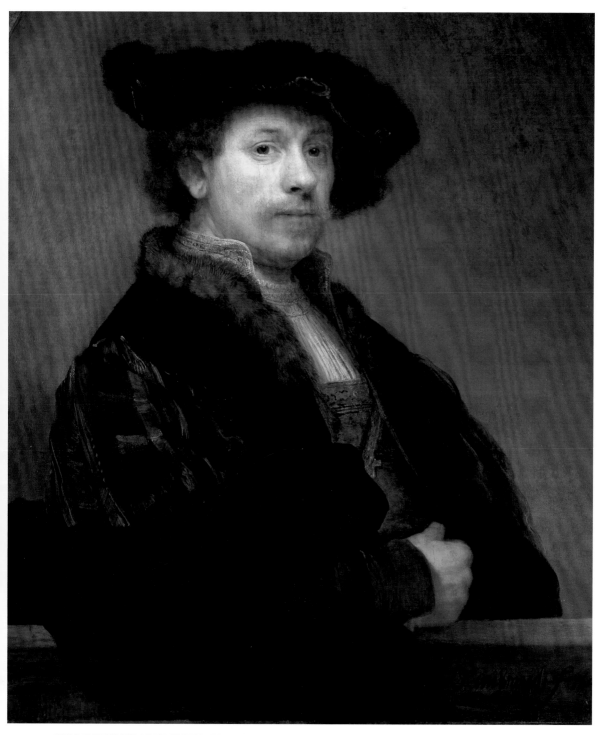

SELF-PORTRAIT AGED THIRTY-FOUR (detail), 1640, oil on canvas (National Gallery, London).

the arrogance of the Roman Empire. Rembrandt's commission would be the most important, for it would show the Batavian leader Claudius Civilis at the very moment of swearing his brethren to pledge their lives to the liberty of the Fatherland. So the job could hardly have been more propitious. If it succeeded, it would wipe the smirk off the faces of those who had written him off as an uncouth has-been. *The Conspiracy of the Batavians under Claudius Civilis* (pages 176–7) would be his *Last Supper*, his *School of Athens*, the one for which he would always be revered and remembered. And it would net him a cool 1000 guilders.

So Rembrandt pulled out all the stops. Everything he had ever learnt about painted storytelling – the scooping of deep space, the drama of selective lighting, the emotive weight of loaded pigment – went into the enormous picture. The result was a history painting like none that had been seen before: attack painting, raw and barbaric, with coats of paint trowelled on, allowed to puddle and crust, then gouged back. And it's a picture, above all, of light; but the opposite kind of light from Vermeer's crystal visions that bathe the humdrum in pellucid grace. Rembrandt's sallow light burns dangerously, phosphorically. It's a light from which to stand back or risk a scorching.

For the ruined painter, it was a gamble at the edge. Everyone knew about Rembrandt's ruffian audacity; his regrettable imperviousness to the niceties of decorum, personal and professional. But with all those reservations, the civic worthies must still have been unprepared for what they got from his hand. They let it hang in the town hall for a few months in 1662, thinking perhaps that it was better to have an embarrassment than a vacancy. Then they must have decided that its confrontational coarseness was a bit much. A decision was taken. Rembrandt's painting was not, after all, wanted; tremendously regrettable, but there you are. Down it came. Rolled up in disgrace, back it went to the artist, who received not a penny for his pains. Someone else, someone more predictable, Juriaan Ovens, was hired to fill the space. He knocked off the replacement in record time. It might have been the worst painting on public display anywhere in the Netherlands. But no one complained.

What was Rembrandt supposed to do with his white elephant? The monster had been custom-designed to fit precisely into an arched space in the processional gallery running around the great ceremonial Hall of the Burghers. It was much too big for even the grandest reception room of a private Amsterdam canal house. If Rembrandt wanted to rescue something from the shambles by finding a buyer, he would have to cut it down to residential scale. Under the blade it went.

In fact, artists in the 17th century were a lot less squeamish than their modern counterparts about the physical sanctity of their work. It was not that unusual to cut

away pieces of canvas to fit a hanging space. At some point both *The Night Watch* and *Aristotle Contemplating the Bust of Homer* were pruned in ways that have compromised, though not fatally, their original conception and visual drama. It's more than likely that someone other than the artist did those reductions. But what the *Claudius Civilis* faced was far more extensive than a pragmatic trim. In his impoverished desperation, Rembrandt had to sacrifice four-fifths of the surface area of the painting, irreversibly altering the way the beholder would experience the work. With surgery that drastic, the miracle is that so much of that original idea of the picture survives in the mutilated remnant.

Claudius Civilis is the mythic icon that never was. If you're a Dutch parent and you want to tell your children about why your history is special, about how your people came to be the way they are, through ordeals of war and suffering, faith and freedom, and if you want them to see the painting which, ruin though it is, begins to tell that story, you'll have to take them to – Stockholm. Sixty-five years after Rembrandt's death, in 1734, someone from a Dutch-Swedish family finally bought the unwanted canvas for 60 guilders, about the price of a fancy bed. So the painting that more than any other in the 17th century is about homeland, the tribe seen at its glowing moment of self-recognition, is now in permanent exile 600 miles north of the place for which it was created. It ought to have been Amsterdam's crowning glory, the painting that everyone visiting the city would traipse through the chilly chambers of the town hall (now a royal palace) to see. But it got away. And nothing quite like it would ever be made again – not in Holland, not anywhere.

II

THIS IS SHOCKING because it's hard to think of any painter who for so long had such perfect pitch for nailing exactly what it was that his fellow citizens wanted from their art – which was, more than anything else, a picture of themselves. To a degree unthinkable anywhere outside the Netherlands those pictures tell the truth, done as they are *naer het leven* – from life – rather than from a preconceived notion of ideal form. Which was just as well, since Rembrandt seldom did peachy-smooth beauty. It bored him. Instead he did the rough truth of our rumpled impurity. This obstinate devotion to unedited human nature would be his greatest claim to glory. But it would also cost him dearly.

Not, however, around 1630, when Rembrandt first arrived in Amsterdam from his native town of Leiden. He'd been one of two youthful prodigies from that provincial city, packed with Calvinist piety, classical erudition at the university and textile money, who'd been anointed by the Prince of Orange's cultural majordomo,

Constantijn Huygens, as the heroic future of Dutch art. According to Huygens, Rembrandt van Rijn, the miller's son, and his friend and rival Jan Lievens would be the pair who would finally put an end to the Italians patronizing the Netherlanders as ingenious masters of naturalist illusions, incapable of reaching the noble summits of history painting.

To Huygens, Rembrandt's genius lay precisely in his gift for bringing together earthy nature and exalted drama. There was no disputing his gift for rendering the surface and texture of material life. None of his contemporaries could match him for catching the glint of a steel breastplate, the sheen of a pearl earring or the patterned snowfall of a lace jabot. But Rembrandt was also a peerless translator of the human passions into the expressive languages of body and face. In his brush or etcher's needle every wrinkle could speak consternation, every fine hair on an ancient head grieve. Those emotions – the whole gamut, in fact – had been intensively rehearsed on Rembrandt's own face in the mirror. The grimaces are usually thought of as exercises in making *tronies*, character heads, which sold on the Dutch market as a distinctive genre and were neither portraits nor miniature histories. For Rembrandt, though, they were never just mugging, but rather studies in extreme feeling that he could then transfer to the biblical paintings that made his name and fame. No Judas, the silver coin of his betrayal thrown on to the floor of the Temple, was ever so racked with tormented guilt; no nailed Christ ever opened wide his mouth in such excruciating animal agony.

What Huygens may have seen in the young Rembrandt was the instinct to make something morally noble, something profound, from low materials, the common stuff of life. Street people, toothless and grimy, the stubble grey on their chins, their eyes rheumy and their noses crusty, were turned by Rembrandt's hand into apostles and Pharisees. Wasn't this the story of the Dutch Republic itself: the stupendous miracle by which (under the dispensation of God Almighty, and after decades of resistance to the Spanish overlords) the ordinary had become extraordinary?

So if – as seems possible, since it was painted in the year of their acquaintance, 1629 – Huygens saw Rembrandt's panel of the artist in his studio (pages 134–5), he might well have recognized it as a big little thing, a work whose artful complexity and philosophical power are belied by its apparent simplicity.

At first sight the painting seems to be a sketchy snapshot of daily routine, an omnium gatherum of the tools of his trade. The doll-like painter is dressed in his working tabbard and slouch hat. In his hands are brushes and the mahlstick, used to steady the brush for fine detail in much the same way as a snooker player uses a cue rest. By his side is the stone for grinding pigment. Palettes hang from a hook on the

wall. The room itself is ostentatiously bare. The massive easel at the centre stands unsteadily on cracked planking. In one corner, wall plaster, suffering from the Rhine damp that penetrates the streets and houses of Leiden, peels away, exposing brick. But this calculated stripping back, the clearing away of the usual classical clutter – busts and the like – that declare Artist's Studio, only enhances the feeling that in this elementary, empty room something momentous is coming to light. And so it is. For this impoverished space is also a temple: the place where a young man comes, reverently, to an old and solemn thing: the making of art.

It's show-and-tell. Through the exercise of its own hand-cunning, the painting both proclaims and demonstrates, with stunning economy, what art is all about: the union of craft and imagination. Rembrandt's handling of that rising damp with the flaked-away skin of plaster is itself a display of bravura painting in miniature; the finest of fine motor control, a universe of illusionist picturing compressed into a tiny sliver of panel. (Throughout his career Rembrandt could, as needed, work with the fine touch of a watchmaker or the heft of a bricklayer.) So much, then, for craft. But at the heart of the painting is something much grander; so grand, in fact, that the gingerbread man with the perfectly circular currant eyes is augmented by it, literally mantled in the trappings of his vocation. He seems both child and man, apprentice and master – ageless, the personification of art itself. And he is caught not in the run-of-the-mill business of painting, but mid-work, brushes clutched in one hand, gazing at the huge panel (the same format, but notionally much bigger than the one we're looking at) whose content is forever hidden. Craft, after all, has its mystery.

For literal-minded explicators this has to be a specific moment in the process of painting – after the composition is blocked in in monochrome dead tones and before the detail is worked up. Actually, if this were the case, he would surely be a lot closer to the easel. But Rembrandt is never the slave of literalism and the panel is both less and more than a how-to manual. Gingerbread Genius seems to be in the grip of a trance: the minuscule black eyes, touched in with the very tip of the finest squirrel-hair brush, are puncture points behind which the germ of an idea is forming. The substance of that idea Rembrandt, the supreme teaser, has made discernible only as a burning glimmer on the edge of the panel: a free vertical mark achieved with a single confident stroke, the kind of mark that the ancient Greek painters, so Pliny the Elder, their first historian, tells us, competed to perfect. (*Nulla diem sine linea* – no day without a line – was the motto of classical discipline.) That mark alone, then, exemplifies everything a gifted painter should practise: dexterity, discipline and imaginative spark. Who in Rembrandt's lifetime would manage that? Only the Catholic enemies – Rubens in Antwerp and Velázquez in Spain, the latter

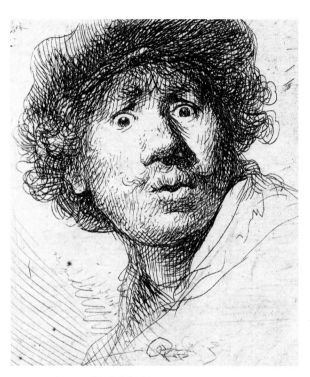

Above: SELF-PORTRAIT IN A CAP WITH EYES
WIDE OPEN, 1630, etching (Rembrandthuis
Museum, Amsterdam).

Above: ARTIST IN THE STUDIO, *c*. 1629, oil on panel (Museum of Fine Arts, Boston).
Opposite, right: Detail of the artist contemplating his work.

condescending to the Dutch by depicting them as the gallant losers surrendering the city of Breda.

But they would not be losers – neither on the battlefield, nor on the sea, nor in the studios. Rembrandt – whose greatest works would always be driven by the high poetry of ideas – would, Huygens hoped, give the lie to the old caricature of Netherlanders as essentially mud-and-money-folk, their boots on the ground, supremely competent but ultimately prosaic artisans, terrific at cattle, cottages and cheese. What Huygens saw in Rembrandt was someone else altogether. With his street casting – moth-eaten vagabonds, stooped dotards, cow-eyed slatterns, scrawny hounds, fat-arsed drunks with their breeches down – Rembrandt could create dramas far more emotionally compelling than those peopled by the antique models taken by refined classicists. The stilted artifices of high scriptural narration practised in Italy (Caravaggio, much admired by Dutch painters in Rome, being the exception) would be replaced by a Protestant art of warts-and-all humanity.

So in his *Samson and Delilah,* instead of the standard naked beefcake Samson, a figure usually modelled on classical sculptures of Hercules (glutes from Olympus), the counterintuitive Rembrandt covers up his juvenile lead – who is in any case a far cry from SuperJew. Somehow, the dressed Samson seems more, not less, vulnerable than the nude stereotype. That this disconcertingly un-hulking late adolescent might yet be a sleeping lion is suggested by the careful tread and apprehensive gaze of the Philistine soldier tiptoeing down the stairs, terrified of a betraying creak, his veins bulging with the tension.

The centre of the conflict is not, in Rembrandt's version of the story anyway, blood and guts so much as heart and head. For the Philistine seductress – re-imagined, of course, as a Dutch bar girl with a double-chin, too much cleavage and filthy toenails – is in a state of conflict right up to the instant of her treachery. Rembrandt has a stunning insight on how to visualize that inner turmoil. With one hand Delilah holds the locks of hair she is about to shear off, dooming her lover to blindness and impotence. But with the other hand she fondles the glossy tresses, as if still in love with what she is about to destroy. In one throwaway gesture Rembrandt gets to the heart of the matter: the tragic inseparability of amorous tenderness and brutal betrayal.

Of this emotional conflict (entirely invented by Rembrandt, though perhaps with help from contemporary playwrights in Holland, where the Samson story was a perennial hit) our post-coital strong man, both lover and child, blissfully out of it between the embrace of his lover's thighs, is oblivious. But then Rembrandt adds one more poignant detail: he wills us with his paint-dazzlement to notice the elaborate

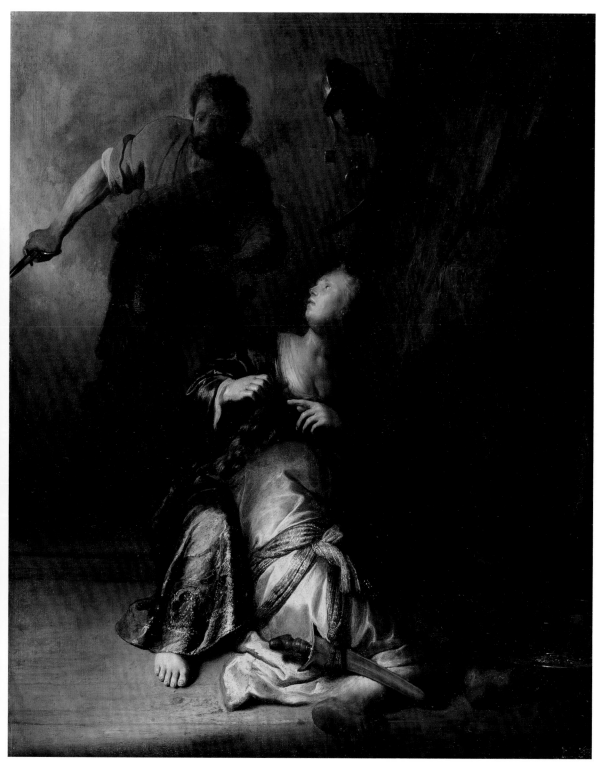

SAMSON AND DELILAH, 1629–30, oil on canvas (Gemäldegalerie, Staatliche Museen, Berlin).

knot on Samson's sash. The dense swirl of green and gold ties him to Delilah and his fate so tightly that it can never be loosened, only cut. The knives are out.

III

REMBRANDT WAS THE DRAMA KING, then, and still in his early twenties. Only his friend Lievens came close to sharing such spellbinding gifts of visual theatre. So Rembrandt was bound to seem indispensable to the Dutch court at The Hague. By the late 1620s the power of the young Dutch Republic was militarily and economically formidable, but culturally still insecure. The Stadholder (more of a presidential than a royal figure), the Prince of Orange, Frederik Hendrik, looked to his relatives across the North Sea, the House of Stuart, for his model of sophistication. King Charles I owned Rembrandts and, on the strength of his budding reputation as the Dutch answer to Rubens and Van Dyck, Rembrandt was given the job of painting the portrait of the Princess of Orange, Amalia von Solms. Still more auspiciously, he was commissioned by Huygens to do an entire series of paintings of Christ's Passion for the Stadholder. He could, had he wished, have gone to live in The Hague and become first and foremost a courtier-artist.

But he didn't. Rembrandt went instead to Amsterdam, changing for ever not only his own history but the history of painting. To make that move was to take a bet on the commercial future over the courtly past: he simply went where the money was. Around 1630 the boom city was in metamorphosis – a backwater herring and grain port was turning into the supermarket of the world. Amsterdam had already become the hub of the first global economy, extending from the East Indies to Brazil. Bulk buying had done the trick. With hard money, the Dutch bought up entire provinces of Polish grain and Norwegian forest, often years in advance. The whiskered classes, Swedish and Polish, living high on the hog and well beyond their means, seized the ready, in return for which the Dutch got cheap timber, hemp, pitch and iron. Those materials were then converted into no-frills ship construction, the vessels carefully designed to be manned by smaller crews and have bigger cargo holds. That in turn translated into reduced freight costs, which meant that the warehouses and markets of Amsterdam could offer discounts so steep that it made no sense for importers to go direct to the source, be it Malacca or Murmansk. If you needed Russian fur, Italian silk, English wool, French wine, Swedish copper or German cannon; leather or steel from the Spanish enemy; nutmeg, mace or pepper from the East Indies; or a shipment of one of the new mass-market addictions, tobacco and sugar – you had to go to Amsterdam to get it. By 1630 the city was awash with money.

So Rembrandt went and got it, doubtless driven by the certainty, shared by tens of thousands of immigrants, that he would be living in the next Venice. The physical face of the city was becoming transformed by the three elegant new concentric rings of canals on which elaborately gabled houses rose. The gables of Amsterdam houses, once stepped in brick, now surrendered to the more curvy flourishes of 'neck' and 'bell' forms, often in limestone. These canal houses were tall and narrow, but they were also deep, and within them the living rooms begged for decoration: heavy cabinets and linen presses, leather-covered chairs, mirrors, painted tiles, maps of the world that the mercantile Dutch were conquering and, in unparalleled profusion, paintings. Although they never marked it explicitly, the Dutch were living through one of those mysterious moments when raw wealth gets converted into a surge of cultural creativity. The traditional patronage of princes and nobles had been replaced by the first popular art market. You could buy a picture of a boor goosing a busty serving girl, or a willow-hung stream with fishermen, for two or three guilders, the weekly earnings of a carpenter.

It was a fresh beginning for art. By clearing out images from churches as idolatrous violations of the second commandment, the Calvinist Reformation had effected a revolution in the way painting was experienced, used, seen. Although images were no longer perceived as the auxiliary of salvation – for that, the Protestant theologians said, had been preordained by God – the demand for them was too deeply ingrained in Netherlandish culture to be weeded out altogether. But it was now displaced by the sensuous recall of the pleasures and perils of the earthly world; and Rembrandt, it turned out, was very good at both. The secular and the sacred weren't that cleanly separated. Ghosts of piety stalked the visual samplers of the material world. Death's heads and hourglasses were set amidst symbols of worldly appetites, such as musical instruments and gleaming goblets of pale wine. Toothless crones lurked at the sides of voluptuous whores. Even the normally rumbustious Rembrandt would etch Death haunting a young couple. No one could best him in the art of mixed feelings, possibly because no one experienced them so acutely.

Rembrandt seized the commercial moment. When he arrived in Amsterdam in 1630 it was in the guise of entrepreneur and investor as much as painter, and he soon hitched up with the dealer Hendrick van Uylenburgh. They did art in all its lucrative variety: original paintings commissioned, copies made of other artists' works, prints engraved and etched, and pupils taken – at a premium – for instruction. Rembrandt prospered, turning out not just portraits but a succession of dynamic, all-action histories that threw out decorous classical poses in favour of

pulse-pumping shock effects. His inspirations were Rubens and – via the Utrecht painters, such as Gerrit van Honthorst and Hendrick ter Brugghen, who had been in Rome – Caravaggio. Big figures, flung through space, come at each other and at us. Things drop through space: a goblet of wine, a sacrificial knife, the piss of a terrified baby. Everything gets rethought. Ganymede, usually a lissome youth abducted by Jupiter, is transformed into a chubby toddler complete with oversized scrotum, crying his eyes out, watering the world as he gets hoisted aloft by the talons of the eagle-god. Isaac's eyes, usually covered by a cloth as Abraham is about to cut his son's throat, are replaced by the patriarch's immense hand forced down upon his son's face. Love and violence were never far away in Rembrandt's histories. In the rooms of the showiest new canal houses such great machines of terror and exaltation, if the businessmen had the brass to buy and show them, would have marked the collectors as men of bold discernment.

But the stock-in-trade of Rembrandt, Uylenburgh & Co was portraits. Partly because he wanted it so much himself, Rembrandt had no trouble identifying with the hunger of the nouveaux-riches of Amsterdam to have full-length or three-quarter-length celebrations of themselves every bit as grand as those of Italian or English aristocrats. But he was also a boy from Leiden, where sermons warning against the God-defying wickedness of brazen opulence formed the standard pulpit repertoire. The Dutch – even Amsterdammers with their conspicuous relish of the good things in life – were proud of *not* being idle, overdressed nobility. The Almighty, the patriotic legend went, had blessed them in their long war against Spain precisely because of their old-fashioned modesty, frugality and sobriety. Complacent luxury had brought down empires before them – woe betide those wallowing in vanity lest they go the way of Babylon!

So if Rembrandt was to oblige his wealthy, pious patrons to the utmost of his ability, he had to perform two apparently contradictory tasks at the same time: he must celebrate, but he must also caution. First he had to take all his peerless skill in rendering the stuff of wealth – lace, silk, linen – to make those surfaces rich in reflection and sensuous texture. On top form, Rembrandt, a shameless dresser-up himself, could paint like a fashion shoot, using his fine motor skills to make gorgeous poetry out of textiles, his brushes licking the surface to make the starched folds of an exuberant ruff or the glitter of gold filigree running through muslin. In one virtuoso passage in a portrait of a man in a turban, in the Metropolitan Museum of Art in New York, he manages to convey the translucent layering of chiffon-like fabric in which the portly pseudo-pasha is draped (possibly by Rembrandt himself, who liked to dramatize sitters with glamorous theatre costumes and props). Sometimes,

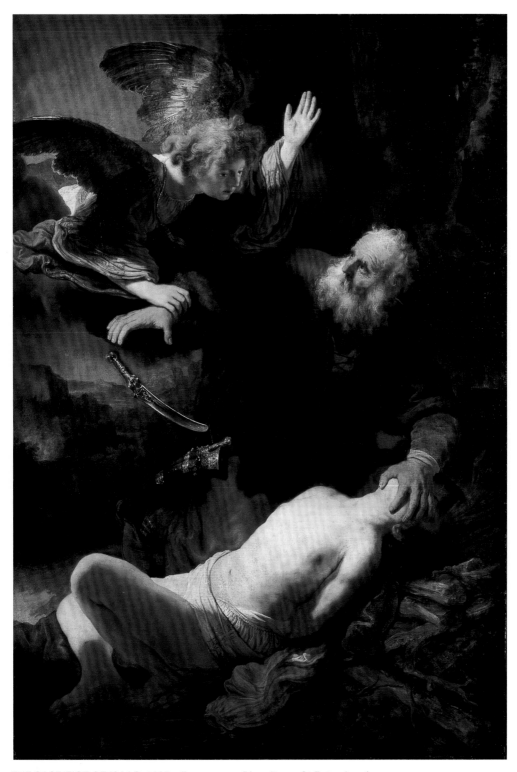

THE SACRIFICE OF ISAAC, 1635, oil on canvas (Hermitage, St Petersburg).

to catch the precise texture of a fabric – say, the perforations of lace – he used both high finish and rough scraping within the same area, scratching back white paint with the stub-end of the brush.

But then, in deference to all those finger-wagging sermons warning of the wages of luxury, Rembrandt had also to make sure his sitters were not just clothes-horses. So face and body language needed somehow to undercut the vanity of dress and to embody the redeeming virtues – humility, chastity, civic energy, conjugal fidelity, grace, thrift – without which not just individuals but the Republic itself would be doomed.

Rembrandt understood that social comportment was a costume drama. But Amsterdammers (at least in his hands) conducted the show with a difference. In High Renaissance Italian portraits – and in those of the Baroque courts of Spain or France – the clothes wore the wearer, inseparable from the mask required to identify rank and authority. Thus the Mask of Regal Care was established by the sombre hues of Castile; the Mask of Earthly Divinity, for the Stuarts, by the cavalier iridescence of watered silk; the Mask of Martial Fortitude by the glint of steel. But in Holland the wearer wore the clothes and, since there were no set attributes to identify a shipbuilder, an irontrader or a cloth merchant, only their tools or their stock, portraitists such as Rembrandt were free to individualize their sitters.

No painter ever mapped physiognomy, and the work that merciless time makes of it, with quite the same avid and detailed relish. Other artists would, for reasons of tact, have hesitated to make so much of the crow's foot or the bulbous nose. The cosmetically averse Rembrandt, however, saw these not as compromising the moral nobility of his sitters, but as describing it. In his sympathetic eye there were no grotesques. When he did nudes, they were symphonies of cellulite. When he inspected the carnival of faces that was mercantile Amsterdam he saw only indi-viduals. Uncovering that human personality meant, always, looking through the mask. So no one stared harder at the droop of an octogenarian eyelid, the tightness of hair pulled back into a linen cap, the slight oiliness of a prosperous proboscis, the overlapping folds of a jowl, or the wateriness of the eye's vitreous membrane. No painter had ever made those ordinary faces become so materially, so fleshily, present.

This is never mere anatomical inventory. Rembrandt understood that we read each other emotively: that the arc of an eyebrow, the angularity of the chin, the prominence of cheekbones hammer on an already tuned keyboard of sympathies and distastes. Although he had at his command the full repertoire of technique, from the slickest finesse to the broadest brush, with which to register these nuances, it's often when he's at his roughest and freest that Rembrandt engages our sympathies most

fully, managing to convey the illusion of close familiarity. Sketchiness, after all, is an invitation to collaboration. Our sensibilities complete what the artist has begun. And we only look that attentively at those to whom we've already given our sympathy.

The 83-year-old Aechje Claesdochter's eyebrow, the folds of skin hanging loosely over the lid, is made with a pattern of jabbing strokes of the brush (page 145). And the slight instability it gives to her gaze softens the toughness of the old-tortoise face, lending it a quality of wistful resignation to what inevitably awaits. Patient resignation in preparation for death was a standard item in the Protestant literature of the pious life: chapters were devoted to matrons and widows. But Rembrandt manages to make Aechje's sideward look specific to her own meditations on mortality.

Vitality was even more important. Amsterdam, after all, was wind-and-water driven, full of racing energy. So just as Rembrandt's faces are caught either with their masks slipped or in the imperfect process of assuming them, so his bodies are seldom in repose. Even when his sitters sit, they're never sedentary. A 'scholar' (who may be just a learned gent) at a desk looks sharply up from his writing as if momentarily interrupted. A shipbuilder is so engaged in his drawings that he has trouble with the distraction of his wife's entry to hand him a letter. Others move more conventionally – but how they move! A well-heeled couple stride towards us, their motion signalled by their raised heels and the flying tassels on their shoes.

What Rembrandt is inventing, then, is the flamboyant theatre of bourgeois life. Even in Flemish Renaissance painting the moneyed had sat at their counting desks with piles of coins, scales heavy with symbolic weights, and redemptive Bibles before them; or else they had stood in conjugal felicity, images of the Virgin behind them. But in Rembrandt's hands the lords of the market are set free to inhabit – at least during the moment of their immortalization – the richly moneyed life. They preen, preach and prate. But they don't pose; they live.

The fur trader *Nicolaes Ruts*, for example, is almost alarmingly in our presence (page 144). Doubtless it was his idea to have Rembrandt paint him self-branded, wearing his inventory on his head and body. The artist obligingly features the Russian sable falling like a river of luxury down Ruts's torso. But there's sly mischief in this exceptionally hairy painting. Ruts's sharply trimmed whiskers and glittering eyes make him seem somehow kin to the smooth-backed rodents whose pelts he buys and sells. It's not just Ruts who breathes through the oil paint; so does the fur. Rembrandt works the paint with minute white strokes so that at the edges of the trader's sleeves hairs rise electrostatically, as if a hand, our hand, has just travelled through them.

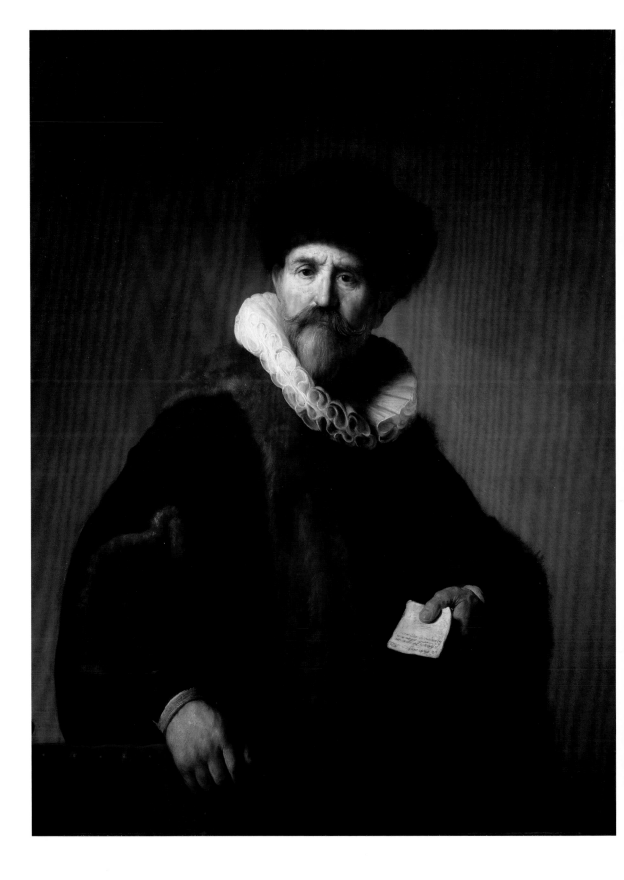

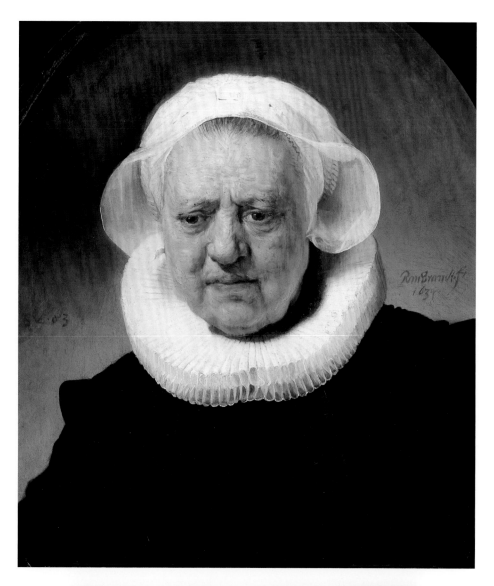

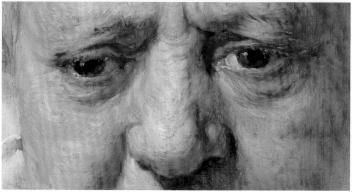

Opposite: NICOLAES RUTS, *c.* 1631, oil on panel (The Frick Collection, New York).
Top: A PORTRAIT OF AN EIGHTY-THREE-YEAR-OLD WOMAN (with detail above), 1634, oil on canvas (National Gallery, London).

In tune with his patrons, Rembrandt knows better than to make Ruts merely a fashion accessory of his own business. He must also be doughty citizen, venturer in Muscovy. So he paints him three-quarter length, the format reserved, outside Holland, for princes and patricians – even though Ruts is just a businessman, and a slightly dodgy one at that. He becomes a modern action man, all edgy impatience, body stopped in three-quarters torque, head turned against the direction of the torso, set off by the high-voltage ruff billowing and curling from shadow to light. But the dynamo in the office must also be the Solid Man of Commerce. So deep shadow beneath Ruts's chin gives him an air of thoughtfulness; his pink eyelids speak of careworn nights, sleep sacrificed for his fellow investors. A fat thumb rests securely on a contract (or bill), the indicator of a man whose credit is sound. The very substance of the panel support on which the portrait was painted – mahogany, the most precious of exotic timbers – suggests someone whose wealth was beyond question

Except that it wasn't. A month before he died Ruts, portrayed by Rembrandt as an unimpeachable combination of commercial efficiency and creditworthiness, had to file for bankruptcy. The portrait was initially kept by his children on the staircase of their house: a gloriously meretricious filial piety. The American banker J.P. Morgan, who later came to own the painting, would have disapproved. Or then again, perhaps not.

IV

BY THE TIME HE PAINTED his *Self-portrait Aged Thirty-four* in 1640 Rembrandt had not only become the limner of the precociously imperial metropolis, but was embedded in its success story. Since 1638 he had been a householder, owner of a property that, while located in the same street – Sint Anthoniesbreestraat – as the house of his master of ten years before, Pieter Lastman, and his erstwhile partner, Hendrick van Uylenburgh, was a decided cut above the customary lodging of a mere painter. The handsome house proclaimed status, fame, honour. It was of three storeys, with a classicized stone-faced entrance. Through the doorway the hall was lined with classical busts and a display of small landscapes (some by the master) and genre scenes of tavern carousing. A room leading off the hall was an art gallery in itself, with dozens of pictures by Rembrandt's favourites: seascapes by Jan Porcellis and Simon de Vlieger and fantastic landscapes by the visionary Hercules Seghers from whom Rembrandt had learnt so much. On the next floor were Rembrandt's own north-facing studio, a smaller workshop and a room devoted to his astonishing 'cabinet of art and curiosities'.

Rembrandt

For Rembrandt had become an auction addict, pouncing whenever he could afford a treasure (and sometimes when he couldn't), envious when a desirable item was out of reach. Apart from his paintings, his albums of prints and drawings in which the greatest masters were represented – Lucas van Leiden, Bruegel, Dürer, Mantegna and Titian – were both reference archive and inspiration. But the chamber of curiosities was also crammed with exotica: Japanese armour, Far Eastern nose-flutes and poison-dart blowpipes, Caucasian leather, Persian textiles, Turkish powder horns, Javanese gamelan bells and shadow puppets, zithers, tropical coral and shells. Rembrandt had become Amsterdam's equivalent of an eBay addict, unable to stop himself whenever anything intriguing came his way. He even fell for the old bird of paradise trick, owning a footless specimen (which he faithfully drew). The attraction was the rather beautiful fable that the footless bird had to stay permanently aloft, sleeping perforce on the wing. The mundane truth, of course, was that the taxi-dermists expertly cut off the creature's feet precisely to perpetuate the fantasy.

Although some of these objects – the Turkish and Persian textiles especially, and one of the Japanese helmets – appear in his paintings as props, Rembrandt's urge to collect came from a deeper craving for the marvellous. The assembly of the cabinet of curiosities – an encyclopedic collection of objects, both natural and artificial, from remote time and place, which enabled the owner to possess in a single room, magus-like, the substance of the whole world – was a passion of gentlemen connoisseurs throughout Europe, among whose company the miller's boy could now place himself. Although Rembrandt hardly ever travelled beyond Amsterdam, he had a globe-trotting sense of wonder. Lions and elephants, turbaned Turks and his own versions of Indian Mughal miniatures all appear in his drawings. He was, then, a combination of the exotic and the domestic, and when he dressed his wife, Saskia van Uylenburgh, in elaborately brocaded satins, or plumped a turban on his own head, a poodle at his feet, Rembrandt was both at the same time.

It's hard to think of another artist who, in painting, drawing and prints, had the urge to record the rhythms of married life so thoroughly, so informally and so intimately. Bernini, who carved his illicit, wayward mistress, never did the same for his virtuous wife Caterina. David divorced his wife, the better to devote himself to revolutionary zeal (page 228). At various times both Turner (unmarried, mistress on the side) and Picasso (unhappily married, mistress on the side) let it be known that they thought art and marriage were bad for one another. Not Rembrandt, for whom, during the brief eight years of their life together, image-making and family-making evidently sustained one another. So we have multiple Saskias – Saskia looking askance, Saskia hand on brow intently returning her husband's scrutinizing gaze,

Saskia asleep in bed, Saskia awake in bed, and Saskia in her last year, her face drawn by sickness.

And, astonishingly, we have in one double-portrait etching made in 1636 two years after their marriage, an image that both observes the orthodox conjugal pecking order (husband looming in the foreground, dutiful wife the smaller figure) and undercuts it. This is all the more surprising because Rembrandt, who evidently had an eye and an ear for the conventions of married life, painted two double-portraits of wifely subordination. The shipbuilder's wife interrupts her husband's musings; the Mennonite lay preacher's wife meekly submits to her bull-like husband's 'admonition', nervously crumpling a handkerchief from the dutiful strain of it. But with this one self-portrait etching Rembrandt reinvents the genre by having Saskia in the presence of, in fact the subject of, her husband's labours. She stares into the mirror with that faintly amused look that Rembrandt evidently enjoyed recording (Cupid's bow mouth pursed between the downy-pillow cheeks). And although in the format of the print Saskia is notionally and perspectively 'behind' Rembrandt, the mirror image with the two of them aligned at 90 degrees to the picture plane makes us read her, as the artist intended, as seated *opposite* him. When he is finished with his drawing, the hand with its instrument held with odd looseness between index and middle finger yet moving instinctively over the sheet, we feel Rembrandt will turn back to his wife.

If it's too modern to think of them as partners, then it's also difficult not to think of them as accomplices. In what? Not, at any rate, in the presentation of a conventionally solemn Protestant marriage (judged by the *Self-portrait with Saskia in the Parable of the Prodigal Son*, page 151). Although dressing up for a story was nothing unusual, modelling yourself as the Prodigal Son carousing in a tavern, teeth showing (poor form this) mid-cackle, sword hilt priapic, with your wife posed as a whore, her ample derrière planted on your lap, certainly was. This was another first: Rembrandt revelling in the scandalous. Although it's been done, it takes interpretative earnestness beyond the credible to read the scene as an unambiguous moral warning, even if Rembrandt did load the scene with stock reminders of the price to be paid for dissipation: the 'reckoning' chalked up on the slate; the peacock emblem of vanity sitting right behind Saskia; the measured glass signifying moderation even as it was ignoring its own advice.

It's hard not to read the painting as an up-yours response to the mutterings coming from Saskia's relatives up in Friesland about the painter's extravagance in running through her legacy from her father, the late lamented burgomaster of Leeuwarden. While it's true that Rembrandt's propensity for rebellious behaviour is

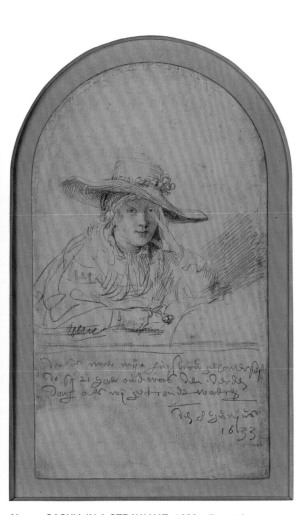

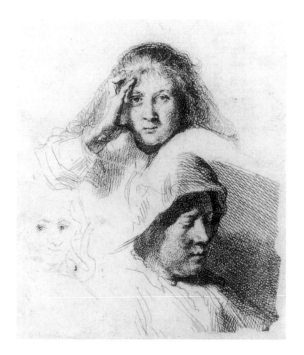

Above: SASKIA IN A STRAW HAT, 1633, silverpoint
on vellum (Kupferstichkabinett, Staatliche Museen, Berlin).
Top right: SHEET OF SKETCHES WITH A PORTRAIT OF
SASKIA, *c.* 1635, etching (Rijksprentenkabinet, Amsterdam).
Right: SELF-PORTRAIT WITH SASKIA, 1636, etching
(British Museum, London).

the stuff of legend rather than history, it's equally true that, riding the crest of his fortune, he liked painting Saskia not as a demure *huisvrouw*, but as a gentle force of nature, his flower child (page 149). In the very first drawing he made of her, on their betrothal, she wears a straw hat, wisps of coppery curls falling down her cheek, while she holds a wild flower with a drooping head. When he painted her as Flora – the patron saint of courtesans – it was with spring blooms in her hair and a wand entwined with daisies and gillyflowers. She was Rembrandt's fertility fetish. In 1635, when the worst plague epidemic anyone could remember was taking hundreds of lives every week, Saskia would hold the reaper at bay. She would bear them children. But then, things didn't always go according to the design of art. Of their three children, two were buried as infants. A few years later he made an etching of a skeletal Death climbing from an open grave to confront a young couple, one of whom wears the plumed hat in which Saskia had often posed. From beneath the hat tumbles a mane of fine hair. In her right hand she holds a gillyflower as if in propitiation. You know it won't work.

<div style="text-align:center">

V

</div>

THERE WAS NOTHING TO SUGGEST, though, that tragedy was around the corner. In 1639 – the same year that Rembrandt etched *Death Appearing to a Wedded Couple* – he pulled off the coup of painting the most eligible bride in Amsterdam, Maria Trip. She was the heiress to one of the great Dutch fortunes: the iron and munitions empire of her father, the late Elias Trip. Originally from the old south Holland town of Dordrecht, Trip had been famous – as arms manufacturers tend to be – for his sobriety and piety. When Rembrandt painted Elias's widow, Aliljdt Adriaensdr, he took pains to represent her as an impeccably starchy matron, her bony neck encircled by an unfashionably dated millstone ruff to which the painter gave the full treatment and then some. Painting her daughter (page 153) obliged him to summon up all his talent for crushing subtlety. He advertises the Trip grandeur by the classical arch in which Maria stands, emphasizing her fortune by the spectacular multi-layered scalloped lace falling collar and the heavy gold thread rosettes that embellish her black satin dress. But he also takes care to paint her milky-pud face as perfectly artless, the half-formed smile innocently tentative, the pearls at her throat the emblem of virginity, not riches. Rembrandt had this rich-but-modest act down stone cold. He seemed to be in such perfect synch with his patrons that he must have thought the marriage of convenience would go on for ever.

Not least when, around 1640, he landed the enviable commission to paint one of the militia companies of harquebusiers – for their new headquarters and

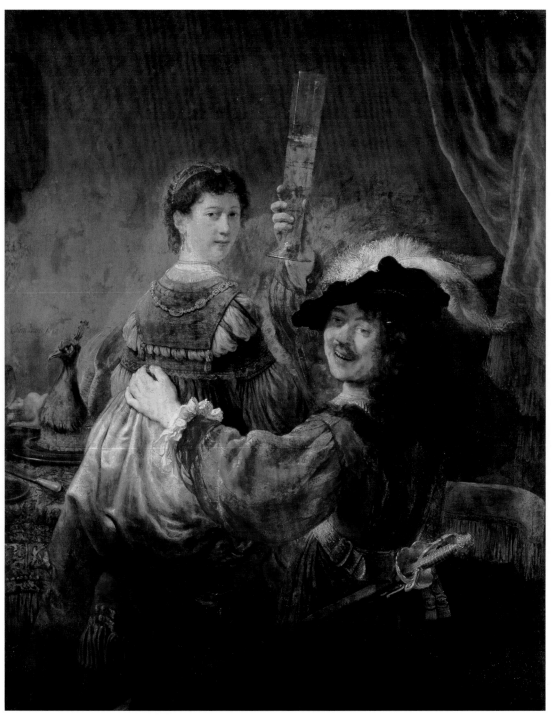

SELF-PORTRAIT WITH SASKIA IN THE PARABLE OF THE PRODIGAL SON (THE PRODIGAL SON
WITH A WHORE), *c.* 1635, oil on canvas (Gemäldegalerie Alte Meister, Dresden).

SASKIA IN A RED HAT, *c.* 1634–42, oil on panel (Gemäldegalerie, Kassel).

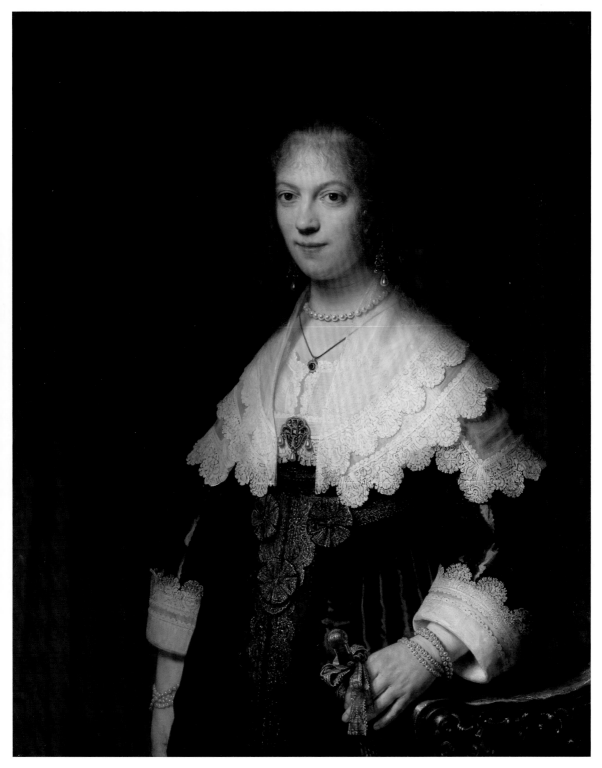

PORTRAIT OF MARIA TRIP, 1639, oil on canvas (Rijksmuseum, Amsterdam).

shooting range. This was the high point of his public esteem, for Amsterdam was a corporate city, ruled from town halls and board rooms rather than from palaces. And there was a larger sense in which group portraiture represented Dutch painting par excellence because the Republic was (for all the prowess and authority of the princes of Orange) not an absolute monarchy, but a commonwealth of collectives: town councils, guilds, regents of poorhouses and orphanages, militia companies of citizen-soldiers. Grandiose portraits of princes were an insignificant genre in the Netherlands; it was group portraits that proclaimed who the Dutch were.

So the painters who got these commissions were effectively the official artists of the city, much as court painters were to the monarchies. But they had to earn their status and their substantial fees (collected from each of the represented figures) by rising to a testing set of compositional challenges. Their first responsibility, if they were to be paid, was to produce acceptable individual likenesses. But the artists also had to negotiate the delicate matter of the pecking order of the patricians. A captain, for instance, had to appear more prominently than his lieutenants, who in turn took visual precedence over the sergeants and ensigns. Then there was the issue of whether or not to show the figures interacting, however stagily. It helped if the occasion to be commemorated was a militia feast, when eating and drinking became a celebratory statement that the grim war inflicted on the Dutch had failed to subdue either their liberty or their high-spirited appetites. In the hands of Frans Hals in Haarlem the ensemble could be informalized in jubilations of brilliant colour and dashing forms with no loss of ceremonial bravura. Finally, there was a vaguely understood obligation for the artist to represent, somehow, the shared ethos of a particular company, whether of philanthropic benevolence or martial energy.

When second-rate artists tackled the genre, each of these obligations got in the way of the others. Respecting the precedence of rank (unless you had the ingenuity of Hals) made credible human interaction difficult. Some of those sergeants down the table at a militia feast would either have to have their backs to the viewer or be turned in some unconvincing way as if suddenly asked to pose. And in Amsterdam's case the sheer number of figures involved made the task of enlivening a civic image almost impossible. Most group painters either elongated the rectangle to get every-body in (jostle jostle, nudge nudge), or else stacked them up in terraced rows looking much like a school football team. Every so often a low set of steps might be introduced, with some of the juniors draped over them at an angle to the horizontally arrayed officers. But the effect was still numbingly two-dimensional. In a famous dismissal the art theorist Samuel van Hoogstraten, once Rembrandt's

pupil, described those rows as looking as though they could be 'beheaded with a single blow'.

Eight years before he received this commission Rembrandt had brilliantly overcome most of those challenges when he had painted eight surgeons witnessing Dr Tulp's public anatomy lesson. Tulp had himself provided the concept of the piece, in which the doctor exposed the tendons and musculature of the flexor muscles of the corpse's hand, while demonstrating that same movement with his own left hand! The *coup de théâtre* (this was, after all, an anatomy *theatre)* gave Rembrandt the chance to design the scene as a drama of the riveted gaze, an inner core of surgeons lined up in arrow-head formation, craning their necks at the corpse and at the doctor, uncannily reminiscent of the astounded figures in Caravaggio's *Doubting Thomas* (page 55). An outer group looks more ambiguously at Tulp's anatomy book, at him or – making a sombre comment on mortality as well as dexterity – at us.

But the militia company of Captain Frans Banning Cocq was a test of a different magnitude, and not just because it involved twice as many figures (pages 156–7). The painting was to be installed in the big, first-floor ceremonial hall, in the headquarters of the harquebusiers, occupying the central space on the long wall facing the windows that looked out over the Amstel river. By the time that Rembrandt got to work, having had to build an improvised gallery in the yard of his house to take the enormous canvas, four of the seven paintings commissioned from various artists had already been installed. All of them had observed the basic rules: make decent likenesses of all the paying customers, and have the odd one or two nod or say something to each other. Take no risks, offend no officer.

But Rembrandt, of course, was incapable of not taking risks. So he threw away the old formulae altogether and reconceived the militia piece as an action drama packed with the same turbulent dynamism he had thrown into his histories. The figures would be there all right, but they would be subordinate to the action itself, the cone of energy, with Banning Cocq at its apex, exploding out of the picture plane to the furious accompaniment of a barking dog, a beating drum and the shooting of guns – all coming our way!

Rather than a shallow line of figures spread across the picture space parallel to the plane (the 'window' of the painting), Rembrandt thinks the unthinkable and changes the axis so that the movement is not from side-to-side but from back to front. The event, after all, is the 'march out' of Banning Cocq's company, so that's what the figures do, pouring from the deep, colonnaded archway (that formed the entrance to their headquarters), mustering and getting into position for their march across a small bridge and into the city streets.

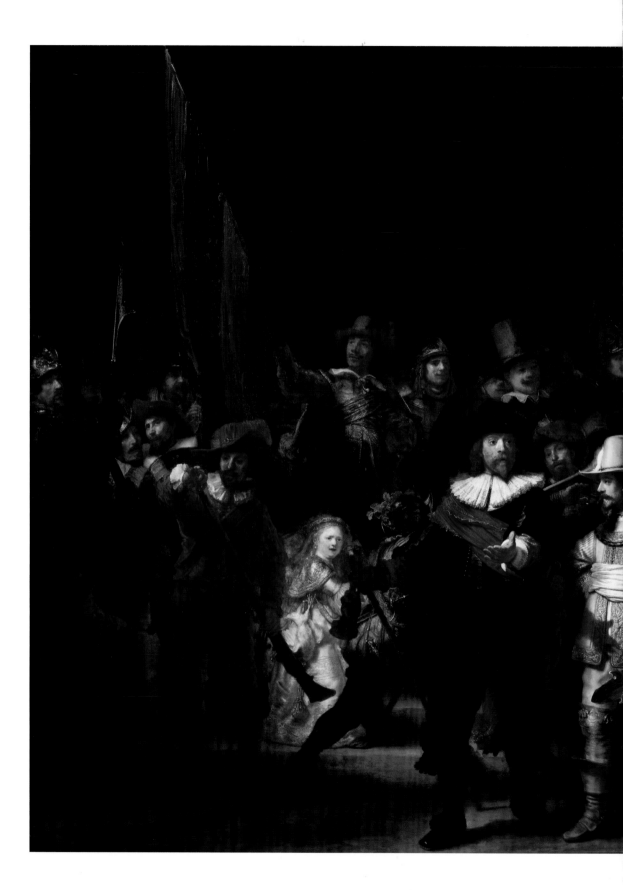

Left: THE NIGHT WATCH, 1642, oil on canvas
(Rijksmuseum, Amsterdam).
Above: Detail showing the artist peering up between two
militiamen.

It's all propulsive energy: a haphazard crowd turning into a unit. And it was all a lie. The citizen soldiers of the Amsterdam militia hardly did any fighting at all in the endless slogging war against Spain, leaving that to mercenaries and professionals on the frontier. But the more Amsterdam glittered with prosperity, the more it needed to cling to the old myths: that in times of danger its steadfast burghers would rally to the cause of the city and the homeland. And even though the captain and the lieutenant, Willem van Ruytenburgh, gorgeously got up in yellow with his French boots, were as close to being Dutch aristocrats as made no difference, the fact that the company were mostly cloth merchants gave them a shared sense of being the salt-of-the-earth, old-fashioned patriots from which the virtuous Fatherland, with God's grace, had been fashioned. To feed the fantasy, Rembrandt even throws in three figures – the red-costumed figure muzzle-loading the harquebus at the left; a dwarfish figure, face hidden, helmet crowned with oak leaves, actually firing the weapon (unrealistically, or the lieutenant would have had his fine hat blasted); and another helmeted militiaman, behind the lieutenant, blowing the hot powder from the pan – to act out illustrations from the standard drill manual used by the troops.

But the fantasy works. Although the action seems hectic and confused it swirls through the canvas space, back and forth, along the diagonal armatures provided by the lines of spear, gun and sword (pointing right), and flag and gun (pointing left); like the turning spokes on a great wheel, at the hub of which is Banning Cocq, the commander himself. Through paint wizardry Rembrandt has even managed to overturn the laws of optics, which say that dark colours must recede while light ones project. But with the tassels on his hose flying, the heel of his back foot lifted and his mouth opened, Banning Cocq gives the order to move forward and does so himself, the command falling as the shadow of his hand on the lieutenant's coat. The captain's hand and his second-in-command's 'partisan' spear are foreshortened, the better to intrude into our space. With the blue and gold tassel on the partisan, Rembrandt has overturned yet another stale convention, which held that the closer it was to the beholder, the finer the brushwork had to be, leaving rough stuff to the rear. But the startling illusion of the roped cloth has been created by his broadest, freest painting.

The entire piece, then, is a composite of countless artful calculations – including the artist's own self-portrait, reduced to a single directing eye (and a bit of his equally unmistakable nose), placed between the ensign holding the flag and the handsomely helmeted young figure to his left. That eye is looking up at the great blue and gold standard of the harquebusiers, one of the keys to the entire piece, along with the 'X' formed by the pikes at the right of the painting, the heraldic emblem of Amsterdam. The picture is infested with these nods and winks, but take

any small piece of the painting away and the whole thing collapses. It looks like a commotion, but the genius of it is its tight discipline, which is, I think, pretty much how Rembrandt felt about the great city that was sustaining him. So the painting *is* Amsterdam: a rush of freedom contained by purpose, direction and order. Everyone does their thing, but somehow they do it *together*.

Rembrandt had taken a tremendous gamble that, although his great painting was like no militia piece that had ever been made before, the sheer spectacular force of it would give the officers the illusion that yes, this was always what they had really had in mind. But while *The Night Watch* did not run into the storm of complaints of legend, and while Banning Cocq at any rate liked it enough to have a copy made, Samuel van Hoogstraten, a precocious 15-year-old in Rembrandt's studio at the time, later remembered that not everyone was uniformly thrilled by the master's piece of visual theatre. It was in fact in that year, 1642, that the climate of reception for Rembrandt went from invariably warm to tepid.

VI

FOR THE FIRST TIME since being crowned as the boy wonder by Huygens, Rembrandt had to deal with a complaint. One of his patrons was so unhappy with his portrait that he refused to pay the artist. This was unfortunate since the sitter happened to be Andries de Graeff, who, along with his brother Cornelis, sat at the centre of a great web of power and patronage in the city. We don't know exactly what it was about the portrait that caused de Graeff to withhold his 500 guilders, but one might presume that the painter's increasing habit of painting freely and loosely failed to chime with the patrician's sense of his stately self-importance. He wanted, perhaps, a painting done in the grandest manner of Van Dyck or Rubens. What he got was Rembrandt's rough edge – which was the highest compliment the artist could pay to his subject. The dispute became ugly. To get his fee Rembrandt had to submit to the humiliation of an arbitration committee of his peers, who sat in judgement on the quality of the likeness.

Two years later, when Huygens (who also had had run-ins with Rembrandt when the artist was consistently late in delivering the Passion paintings) published his own catty little verses on the painter's inability to achieve a likeness, Rembrandt took revenge on the critics with a crude but eloquent little *Satire on Art Criticism*. With a few lines of his pen, Rembrandt gathers a bunch of connoisseurs. One of them – the figure in the tall hat at the right – is caught doing what connoisseurs do, holding a finger to his lip while he peruses. But *what* he peruses, the object held high by the servant looking over his or her shoulder, is mischievously ambiguous.

It could of course be a painting – but it could also be a mirror. To their left the stooping figure wearing the gold chain of honour that artists such as Rubens acquired from noble patrons wears an unmistakably simian face. And seated on a barrel the arch-critic, whose features are not 100 miles away from those of Andries de Graeff, has sprouted asses' ears. Rembrandt knows enough of his classics to ridicule the classicists. Midas, the king whose touch turned all to gold, sprouted those same ears, which function simultaneously as cupidity and folly. It was also a convention to represent those who had calumnied the great Greek painter Apelles as sprouting asses' ears. But in this case the painter lets us know exactly what he thinks of the critics and connoisseurs, and does so, cheekily, with his breeches down, wiping himself on their wisdoms.

It's important not to predate or predetermine Rembrandt's troubles. But the year of *The Night Watch* and the de Graeff dispute is also the year of personal sorrow, Saskia's decline and death. The artist etches that wasting illness with deeply scored lines, and then, when she dies, does something unusual. He returns to a portrait begun many years before, in the springtime of their marriage, *Saskia in a Red Hat* (page 152). It's the only painting of Saskia in which there is no trace of a smile. Her head is turned in what for Rembrandt was an unusually hard-edged profile, like a Renaissance cameo. For the last time he has loaded her with fabric and fur; pearls and silver are roped about her neck, her ears, her arm. It's as if he can't stop festooning her with jewels, turning her into lost treasure. The vermilion hat, with its great plume rising into the darkness, is the last poignant flourish of their days of dress-up flamboyance. Saskia pulls the fur cape about her as if to ward off the chill of mortality. But it's too late.

To notice that in the middle and late 1640s something does change in Rembrandt's work is not to indulge in romantic projection. It's impossible to miss that alteration, the shift towards more pensive subjects. It's as if the artist has turned down the volume of the world. Rembrandt's dark light begins its slow, moody burn. The din of the parade fades away. Often the artist leaves the house on the Sint Anthoniesbreestraat (which is beginning to give him debtor's headaches) and walks out of the city along the Amstel towpath to sketch cottages with low, overhanging roofs, cows, boats, windmills, concealed lovers embracing. The big rowdy gestures, the gorgeous fabrics, the action dramas melt away to be replaced by images of lyrical simplicity. Instead of a portrait gallery of the rich and powerful, there are maids at open doors caught between innocence and budding sexuality. Liberated from the obligations of social glitter, Rembrandt can paint more freely, rough and dense where he needs it, loose and fluid in other places, often within the same painting. In

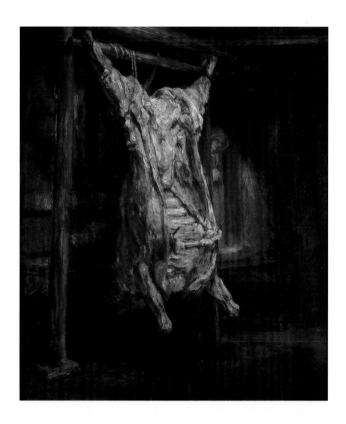

Top: THE SLAUGHTERED OX (detail), 1655, oil on canvas (Musée du Louvre, Paris).
Above: SATIRE ON ART CRITICISM, 1644, pen and brown ink drawing (The Metropolitan Museum of Art, New York).

the exquisite image of his mistress (later common-law wife) Hendrickje Stoffels holding up her shift as she gingerly tries the water, Rembrandt canvasses all his skills to intensely sensual effect. His fine brush barely licks the surface of the panel to describe the rippling break of water at Hendrickje's calf, or the soft corkscrew curl falling over her bare shoulder. But for her shift he loads the paint on with a knife, the heaviness of the paint making the delicacy of her flesh all the more tantalizing. It's a picture (almost certainly done for private delectation) that manages to be at the same time modest and arousing, concealing and exposing. Most scandalously of all, in the unmodelled smear that is her hand Rembrandt abolishes the boundary between oil sketch and finished painting.

This was in 1654. There's no inkling that as he entered middle age Rembrandt deliberately and self-consciously set out to flout conventions, even though he was summoned before the church court for fornication with Hendrickje. (He sends her along for a miserable humiliation while staying away himself.) But where his painting was concerned, Rembrandt was prepared to use the same expressive freedom he'd lavished on her for full-length portraits of wealthy patrons who desperately mattered, such as the playwright and heir to a cloth-dyeing business Jan Six. Six is also given the public-private treatment. Caught as he is on the threshold between an interior and an exterior, his heavy-lidded gaze is dreamily introspective, while the outward, active man is expressed in the brilliant flurry of pure paint that describes a glove pulled on to a hand. Six seemed to like the result well enough – but not enough for him not to pass on a heavy IOU note to a third party who would be less patient with Rembrandt's arrears.

It's not that his increasing habit of rough handling was the problem; but equally it may not have helped. For around 1650 Holland was undergoing a cultural sea-change. After 80 years of war, a peace had been signed with Spain that finally recognized the independence of the Republic. Although a maritime war with England would follow, there was still a sense that the Dutch Republic, and Amsterdam in particular, had come into its own historical moment: the hub of a formidable global empire. A second generation of patricians, less devoted to piety and simplicity, were coming of age. They had travelled more widely – in Italy and France – and were more attuned to cultivation of classical taste. They faced their houses with stone pilasters, built country villas with rotundas like the Venetians, dressed more brilliantly, bred glossy pedigree horses to hunt with, listened to Italian opera rather than Dutch organ music, and worried less about the sins of display that their forefathers and their forefathers' preachers had warned would turn the Fatherland into Sodom and Gomorrah. For the first time the gravity and decorum of the

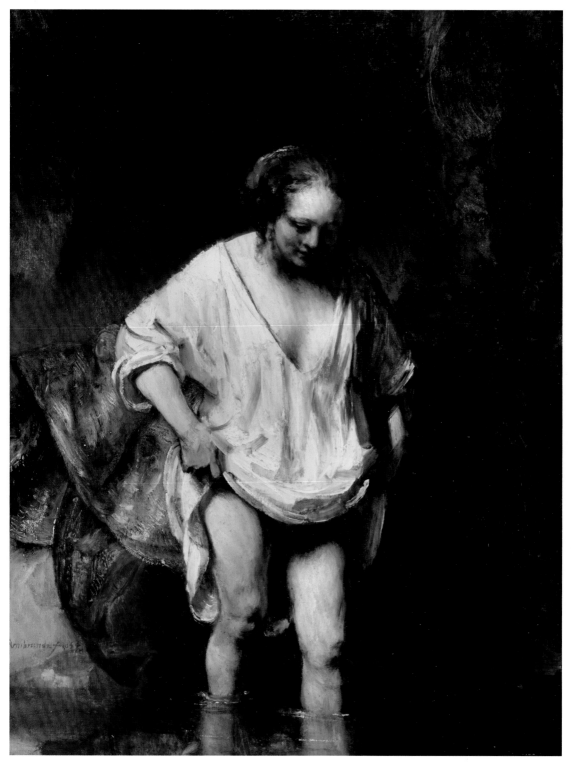

HENDRICKJE BATHING IN A RIVER, 1654, oil on panel (National Gallery, London).

classical tradition was prized above simplicity, energy and piety. What Rembrandt offered was raw poignancy, a kind of earthy emotionalism that increasingly was thought embarrassing if not downright eccentric. An Apollo and Apelles Society was founded in the mid-17th century to bring the highest and most refined standards of classicism into Dutch culture, and to purify it of its vernacular clumsiness. When it held its inaugural banquet, Rembrandt, needless to say, was not present.

But then look what he's doing to one of the prize emblems of pedigree Dutchness: the cow. In the hands of society painters such as Aelbert Cuyp fine, fat cattle are a fashion accessory of the well-bred horsemen who encounter them on perfectly groomed steeds. The cattle graze; the late afternoon sky ripens into golden effulgence. The scene is landowner's bucolic, slick with charm. Now consider what Rembrandt does with an ox (page 161): he turns it into raw meat, then uses his palette knife like a butcher, opening up the carcass, exposing ribs and sinew and hanging bags of glistening fat. Bloodstains streak the trunk, and the legs are roped and splayed in an animal martyrdom. Eat of *my* body, says the slaughtered trunk. Butcher's shops had been done a century earlier by Netherlandish painters, but never with this savage gleefulness; it's as if Rembrandt was taking aggressive pleasure from rubbing their noses in the plain truth. Many of the well-heeled preferred to avert their gaze.

But Rembrandt still had champions, among both patrons and poets who wrote admiringly of his uncompromising naturalism. If the fashion in landscapes was for refined grandeur, nonchalant riders beneath big clear skies, Rembrandt would paint, as if it were still the 1620s, a murky little winter scene of clogs, dogs and big skirts in the bone-biting chill. If the acceptability of nudes depended on their striking a poetically Italianate pose, then Rembrandt would draw or etch them in an anti-pose, with items of clothing (a cap, a fallen shirt) half *on*, so that they were now simply half-naked women just trying to keep warm by a Dutch stove. If artists liked to paint themselves in the dress of gentlemen, then he would do himself in a coarse brown smock, big hands stuck confrontationally in the belt; everything beginning to look worn, and a stare that asks if we want to make anything of it.

He was still not looking for trouble. With his debts mounting, along with difficulties in meeting mortgage arrears on his house, Rembrandt needed all the commissions he could get. But at least once – for a Sicilian collector, Signor Ruffo – he painted a meditation on the mixed feelings of the patronized: *Aristotle Contemplating the Bust of Homer*. The glittering gold chain, painted so thickly in crusted gobbets of ochre and white that it actually stands out from the surface of the canvas, and from which the medallion image of Aristotle's patron, Alexander the

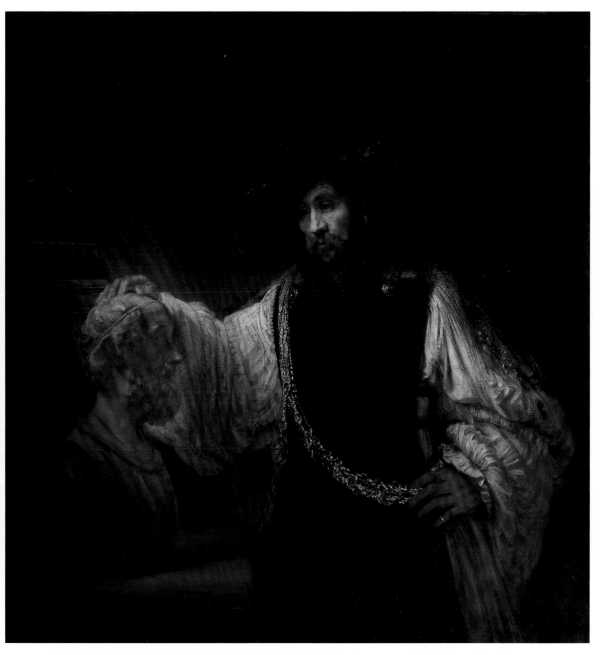

ARISTOTLE CONTEMPLATING THE BUST OF HOMER, 1653, oil on canvas (The Metropolitan Museum of Art, New York).

Great, hangs, is both a token of honour and an imprisoning rope of obligation. No wonder Aristotle wears an expression of wistful ambiguity as he touches the head of the blind poet Homer. For Homer, so the legend went, was also spurned so badly that he was forced into beggary, and only survived destitution when he was allowed to teach. Homer's sin, the stories went, had been to produce a kind of epic poetry that offended through its coarse directness; its appeal to the sensations. But this is a painting that extols touching. With one hand Aristotle fingers his chain, the centre of his conflict; with the other he touches the seat of Homer's poetry, his imaginative muse. And the way Rembrandt lays the paint down speaks of an urge to do Homeric painting: palpably physical, in the massively loaded creamy strokes that create Aristotle's sleeve, a great onrush of flowing sensation.

It's a painting that invokes an archaic rough music against the thin proprieties of classicism. When Rembrandt sent the Sicilian connoisseur a second image of the blind Homer, mantled in darkly tragic gold, his mouth open in the act of teaching, the sightless eyes black, just like the artist's version of his own at the very outset of his career, Ruffo refused to pay on the grounds that he believed the thing to be unfinished. Rembrandt wrote back contemptuously that it was obvious that no one in Messina knew much about art. It was the patrons, the critics, who were really blind.

VII

AND THAT WAS *AFTER* HIS RUIN, which came gradually but inexorably. By the middle of the 1650s Rembrandt was running out of favours. Notes for his debts were passed from patient and charitable friends to the impatient and the unsentimental. Many of the well-placed in Amsterdam wanted their money before he became a hopeless cause – he was already a notoriously truculent, old-fashioned, unreliable artist who had outlived his day and (as one of his high-minded critics would say after he died) would let his paint run down the canvas like dripping dung. Seriously in arrears with the loan repayments on the house, Rembrandt kept hoping his ship would come in; instead, a vessel in which he had invested came to grief, carrying those hopes down with it. In 1656, citing 'losses at sea', he was forced to endure the humiliation of a *cessio bonorum*, a form of bankruptcy that, by surrendering his property to the commissioners, drew a line around the extent of his creditors' claims. The commissioners would then auction off his property to satisfy those debts.

Auction by auction, hammer blow by hammer blow, everything except his talent was taken from Rembrandt. Gone was not just his household property – furniture, silverware, mirrors, beds, chairs and chests, as well as all those curiosities,

oriental and natural – but also the personal archive of art he had collected over the years. These prints, drawings and paintings had helped make him what he was: a *Tobias* by his old teacher Pieter Lastman, long since dead; paintings by his old friend and rival Jan Lievens from the Leiden days; drawings by Mantegna; prints by Lucas van Leiden. The chain of the craft had been broken. Just to make it worse, the art collection went for a fraction of what it was worth.

As the auctions relentlessly continued through 1657, it became evident that the proceeds would nowhere near satisfy the demands of the creditors. Rembrandt could no longer protect his house in the Sint Anthoniesbreestraat. Early in 1658 it went on the block, and was eventually sold for 2000 guilders less than he had paid for it. On 22 February the painter was finally granted some money from the sale, which he took from the clerk of the court and handed right away to the creditor standing next to him. The family – Titus, Rembrandt's surviving son by Saskia; Hendrickje and their daughter Cornelia – moved together into a small house on the Rozengracht. There, Hendrickje and Titus would manage all of Rembrandt's affairs and deal in his art, for the bankrupt was now legally disqualified from doing so himself.

And how does he paint himself at this moment of abject humiliation? Like a sovereign, lustrously robed, enthroned (page 168). With his thighs confrontationally apart, the mass of his belly and upper torso seems to swell before us like a genie, the bulk of his authority bearing in on us, pressing against the picture plane. An expression of lordly amusement plays about Rembrandt's eyes at all of us little people who imagine we know something about art and go on and on about it. In his huge hand he holds a silver-topped cane that looks like no mahlstick that has ever been imagined, much less used. It is, rather, the commanding baton of a field marshal, the wand of a magus, the sceptre of a king. He's hardly the image of the humbled and dis-possessed. And in the manner of its execution – the paint heavily loaded on like regalia – the self-portrait is a study in absolute impenitence. Its paint lays down the law.

But Rembrandt's position in Amsterdam was anything but magisterial. For the most prestigious and lucrative city commission of the day, the paintings that would decorate the new town hall, his erstwhile pupils and assistants, such as Ferdinand Bol and Govert Flinck, had been chosen, not their old master, the unpredictable back number. Rembrandt's only direct experience of the town hall had been to go to the Chamber of Insolvency, through the doorway with its admonishing carvings of rats scrambling through the debris of empty chests and worthless bills of credit.

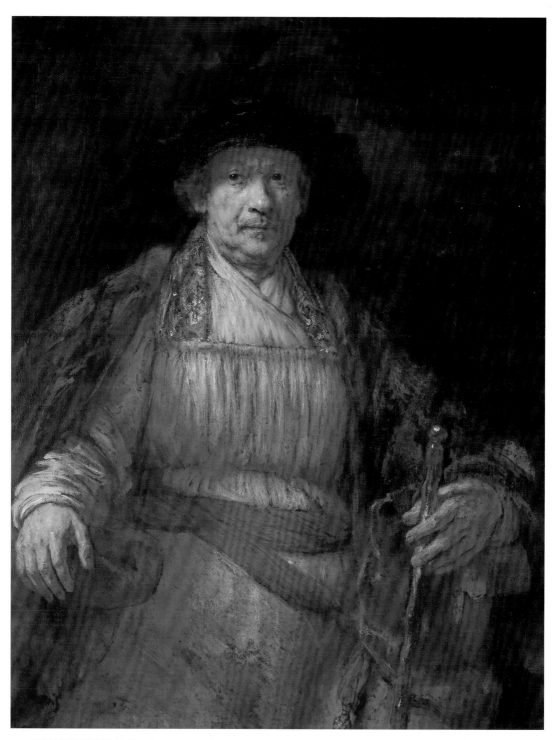

SELF-PORTRAIT, 1658, oil on canvas (The Frick Collection, New York).

The entire building, for that matter, was an exercise in moral instruction as befitted its severely classical form, simultaneously a boast and a warning. The old town hall, a warren of chambers beneath an old-fashioned gabled front, had been nothing more than a Gothic relic from a much smaller provincial Amsterdam. But now the city was, economically at any rate, the centre of the world; mistress of a spectacularly successful trading empire that stretched from New Amsterdam on the Hudson to New Zealand at the Antipodes, charted, taken and defended by an invincible fleet. In the year of the peace with Spain, 1648, a decision was taken to replace the old building with a structure more suited to Amsterdam's sense of its grandeur. Providence seemed to approve, since four years later it burnt down. Rembrandt, who was much fonder of Gothic ruins than of neo-classical colossalism, drew the ruin shortly after the fire (page 170). He never sketched the new town hall.

It was the façade that was the brag, with its Maid of Peace holding her optimistic olive branch over Dam square, and the rear pediment carved with figures bringing the tribute of the four continents to the city. Within the building, in every chamber and on every wall were the sober warnings from history – some carved, some painted, from the Bible or ancient Rome – against complacency, corruption and hubris. In the room where magistrates pronounced the death sentence was a sculptural relief showing the Roman consul Brutus ordering the death of his own sons for plotting against the Republic. Govert Flinck, who was a famously dab hand at this kind of thing, had done Marcus Curius Dentatus dressed in utmost simplicity, resisting the bribes of the overdressed Samnites by brandishing an outsize turnip at them, together with a *Solomon Praying for Wisdom* for the council room of the burgomasters. If what you wanted was handsomely modelled, brightly coloured, crisply contoured figures, gracefully composed and placed in noble architectural settings – works that could hold their own with Italian paintings – then 'Apelles' Flinck, as the verse hacks called him after the supreme painter of Greek antiquity, was your man. For the *Solomon* he was paid the princely sum of 1500 guilders, more than Rembrandt had earned for any work other than *The Night Watch*. It was Flinck who had become the master of the Official Style.

It was not surprising, then, that the prize of the town hall commissions – a cycle of eight paintings to run around the gallery of the great ceremonial space, the Burger-Zaal – went to Flinck. The paintings of the Batavian rebellion against Rome, chronicled by the Roman historian Tacitus, were meant to serve as a double reminder to all succeeding generations of Amsterdammers and Hollanders who would come to see them, first of the provisional nature of all imperial power, and second of their own origins in virtuous rebellion. And if the Amsterdam town hall was a kind of

Top: THE TOWN HALL ON THE DAM, AMSTERSDAM by Gerrit Berckheyde, 1672, oil on canvas (Gemäldegalerie, Meuemeister, Dresden).
Above: RUINS OF THE OLD TOWN HALL, 1652, pen drawing (Rembrandthuis Museum, Amsterdam).

anti-Versailles, a palace for a king-less empire, so the Batavian paintings were supposed to celebrate the glory of the 'true republican freedom' that the oligarchs of the city claimed to uphold. It was important, then, that the leader of the Batavians, the veteran soldier Claudius Civilis, who had fought for Rome but had switched sides in response to the oppression of his native people, was depicted as a quintessential republican hero: a fellow citizen, decorous, sober and resolute, rather than a domineering prince. Setting and painting had to be a perfect fit: solemn, restrained, ennobling.

The only problem was the way in which Tacitus had described Claudius Civilis himself and the event that was to be the centrepiece of the cycle: the swearing of allegiance by the rebels at a nocturnal feast in the depths of a sacred grove. The leader himself was famous for his blind eye, lost in battle; and the scene in which he took the oaths of the Batavians – and spoke to them – was one of 'barbarian' drinking. Needless to say, this was not the way in which their descendants, the elite of Amsterdam, wished to be identified. But the reliable Flinck made his one drawing that satisfied all the demands of decorum without losing the momentousness of the event (page 174). The obligation of art to avoid dwelling on unsightly deformity was respected by putting the turbaned Civilis in profile. Flinck shows him half-nude, complete with heroic torso and rippling calves, his right hand extended to a fellow conspirator (also a helmeted deserter) in the fraternal oath, described by Tacitus, vowing to fight or die for liberty. Around them in the grove are outlined eminently respectable figures, while a kneeling maidservant pours the libation. It's classically elegant, just what the burgomasters ordered.

But on 2 February 1660, Flinck died and everything changed. The scope of the Batavian cycle was reduced to four, each painting to fill one of the lunettes at the corners of the gallery. Lacking another Apelles, the burgomasters decided to distribute the commission among four artists, one being Rembrandt's old colleague from Leiden, Jan Lievens, who, after working in England for the Stuarts and in Antwerp, had come back to Holland. But for the dramatic moment of the oath-swearing, against all the odds they turned, after 18 months of procrastination, to Rembrandt van Rijn.

We'll never know why the momentous decision was made, or with what reservations and trepidation. It may well have hinged on a change in personnel at this time within the councils of the city. Perhaps one of Rembrandt's old patrons was his belated champion. Whatever the reason, he seized his chance. But he was not so grateful as to be satisfied with acting as a stand-in for one of his own former pupils! If those who commissioned him assumed they would get a painting scrupulously

worked up from Flinck's drawing, they were deluded. As for Rembrandt, whose entire fate and fortune rested on this great opportunity, he must have thought back to that other public commission, *The Night Watch,* in which he gambled on confounding conventions and had triumphed. Why? Because however unorthodox he had been, he had stayed true to the high *ideas* behind the commission, in that case the martial energy of the citizenry. By throwing restraint to the winds he had given his patrons a modern drama from the epic of freedom. Now he would paint them an ancient version.

It wasn't that Rembrandt was impervious to the monumental nature of the space he would have to fill. He knew he couldn't repeat the fissile scatter-bomb of *The Night Watch.* This painting had to be solemnly majestic at its immovable centre – the person of Civilis himself. But he also needed to surround this focal point with the liberated fever of insurrectionary energy that Tacitus had so vividly described. Two models for a solution came to mind, from opposite ends of the art historical canon that – even stripped of his collection – he carried around in his head. The first was, of course, Leonardo's *Last Supper,* which (from a drawn copy) we know Rembrandt was familiar with, and in which the still centre of the Saviour is surrounded by all kinds of animation, sacred and profane. To Rembrandt, the faint whiff of blasphemy in the borrowing would not have mattered a jot. What was Civilis if not another kind of redeemer? And Rembrandt was, after all, the specialist in making biblical figures seem to walk right off the contemporary street. The second model he may have had in mind was quintessentially Dutch: the militia feasts, the one group portrait he had not himself tackled, but which in their union of festive riot and serious patriotic purpose he could reimagine as directly descending from that first night banquet in the woods.

Rembrandt, though no bookworm, always seems to have saturated himself in the texts that he wanted to reinterpret, so in all likelihood he went back to Tacitus for inspiration. And it must have been the Roman historian's grudging admiration for the sheer force of barbarian energy that convinced Rembrandt, more than ever, he was the right man for this particular job. Tacitus described the 'barbaric rite' of the oath-swearing, which did not, to Rembrandt's eye, look at all like the sedate handshake of Flinck's drawing. He began to imagine something altogether more virile and violent – a clash of naked swords, an ancient cup brimming with wine.

And then, as with all his most powerful works, he put himself in the position of the beholder, imagining, like Caravaggio, the physical experience of coming on this huge work hanging high in that arched wall space. The remoteness of it, and the darkness shrouding the gallery, on the face of it constituted a problem. So

Rembrandt co-opted the architecture as an accomplice in the sense of wonder. Instead of a forest grove, he would set his table of conspirators in a vast and lofty hall, its arches open to the woods, where leaves and branches, the symbols of reborn liberty, would penetrate the window openings. In front of the action he would create a threshold of processional steps leading up to the feast itself. People would walk along the dim gallery and see the golden blaze up high at the end of it: a burning, beckoning apparition. Their gaze would then enter the night space of the painting itself, and be transported back through the centuries to AD 69. After that, guided by the flanking figures, the eye would climb the wide processional steps towards the brilliant heart of the history, the consummation of light swimming on the table: the birth light of Dutch freedom.

We know just when it was that Rembrandt's sublime vision came into focus: October 1661, since he did a cursory sketch of it on the back of an invitation to a funeral. Tragically, this is all we have of the complete work: a minuscule glimpse of Rembrandt's most ambitious masterpiece.

So the remnant that exists today has been shorn of the compositional magic that surrounded it. And after the great painting was returned to Rembrandt from the town hall and cut down, the surviving fragment was, moreover, heavily reworked in a not altogether successful attempt to make it more self-contained. But what's left contains more than enough to take the measure of Rembrandt's astounding – and fatal – audacity. For his embrace of wild freedom drastically affected his sense of casting. Instead of the respectable, solemn gathering of elders and warriors that featured in Flinck's drawing and in earlier prints of the famous scene, Rembrandt has gathered, in what looks (if you were one of the High Mightinesses of Amsterdam) distressingly like a brigand's lair, an outlandishly motley crew. It features swarthy Orientals (one of whom, wearing a gold chain, looks to my Jewish eye suspiciously familiar); a grinning old man, mouth uncouthly agape, evidently deep in his cups; a druid-like high priest; and a handsomely whiskered young man. And in their midst Rembrandt perpetrated the greatest outrage of all: Claudius Civilis, the bandit-king, with the cicatrice of his blind eye, the eye that was supposed to be hidden behind a discreet profile, aggressively flaunted in the face of the spectator. He is the man-mountain up whose cliff face the eye must ascend, the summit made even loftier by the piled-up tiara of his headdress. At the centre of its band Rembrandt has painted an opaque golden circle, like a third seeing eye – the organ of imagination.

The way he has posed and robed Civilis, weighing him down with dense layers of rich impasto, encrusting and bejewelling him, adorning him with silk and gold, is

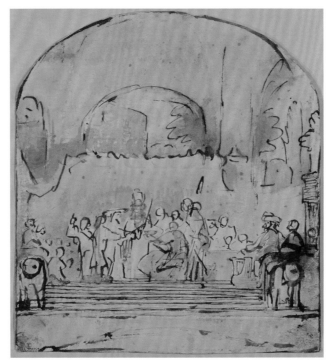

Top: THE OATH-SWEARING OF CLAUDIUS CIVILIS by Govert Flinck, 1659, pen drawing (Kunsthalle, Hamburg).
Above: STUDY FOR THE CONSPIRACY OF THE BATAVIANS UNDER CLAUDIUS CIVILIS, *c.* 1661, pen and bistre, wash (Staatliche Graphische Sammlung, Munich).

of course the way he had painted himself four years earlier as the sovereign of what he adamantly surveys. Rembrandt at this moment is Civilis, his brush fleshing out the charismatic power – except that very little of the effect seems to be created with either brush or palette knife. The ferocious application of paint, not just in the body, beard and face of Civilis himself, but in the cursory, slashing strokes that barely describe, even summarily, some of the other faces, is likewise an act of inspirational defiance. In these astonishing passages, unprecedented in the history of art and not to be seen again for another 200 years, Rembrandt commits an act of ideology, but the one he must have thought he had been hired to depict: barbarian freedom. Just as almost 30 years earlier, in *Artist in the Studio*, he had taken pains to show off his illusionist skills in the patch of peeling plaster, so in the *Civilis* he achieves, despite the sceptics, a masterpiece of craft-painting in the elaborate goblet, both filigreed and transparent – the cup from which the elixir of liberty is drunk.

Like *The Night Watch*, it's a cacophonic clamour: with the ring of steel, the shouts of allegiance and bloodthirsty glee, and the eructions of the gut roaring through it. It's the militia feast turned savage: heady and awe-inducing, intimidating and celebratory, hypnotic and alienating, sophisticated and primitive. Rembrandt paints a raucous anthem to primitive liberty: gouging, plastering, stabbing. Carefully considered, the *Civilis* nonetheless has the force of tribal passion beating through its heart. Although the man-mountain dominates at its centre, the exuberant coarseness of the other figures, some reverent, some bandit-like, celebrate, with no holds barred, the simplicity of Dutch origins. This is who you were, the picture dares to say; this is who you ought always to be. Everything you think is important, this town hall with its acres of marble, the great imperial city itself, may sink beneath the waters as abruptly as it arose. But if you remain faithful to yourselves, your liberty, that which you hold dear will endure.

Thirty years before, the young Rembandt had drawn a line of light at the edge of his panel to indicate the fire of his idea. Now he turns that line through 90 degrees so that its brilliance stands at the edge of the table. It's the most intense of all his hidden light sources; no lantern, but a vaporous gold, the fire of barbarian freedom, throwing its radiance up towards the countenances of the conspirators, who are transfigured by the illumination.

Rembrandt had given the high-ups at the town hall a republican altarpiece, the greatest group portrait imaginable. But that wasn't at all how they wished to see themselves, or their ancestry. To be sure, they liked mouthing their defence of liberty (against the kings of Spain, France and England, even against the overweening princes of Orange). But they were themselves co-opted oligarchs, not democrats,

and if rebellion was a useful myth, it needed careful de-fanging so as not to bite them back. So of course there must have been any number of objections to Rembrandt's explosion of a painting: its undiplomatic representation of a titanic hero when the Gentlemen-oligarchs were trying to govern without the Stadholder-Prince of Orange; the incomprehensible coarseness with which the characters were depicted, so very unlike their High Mightinesses. After living with the shock of it for a while, it was determined that it was, all in all, not something suitable for the noble place in which it was displayed.

VIII

REMBRANDT'S VINDICATION had failed. There are many reasons to grieve over this, only some of them having to do with the poignancy of his biography. For what ended abruptly with the rejection of the *Claudius Civilis* was the reinvention of history painting. In Rembrandt's hands it had been liberated from the stifling decorum of classicism, a manner meant for the delectation of a cultivated elite. Instinctively, Rembrandt had not only opened it up to the depiction of ordinary people; he had, in the sheer visceral fury of his storytelling, made it something that Amsterdammers might, had they had the chance, have come to cherish and identify with, at least as much as the more difficult *Night Watch*. Rembrandt's 19th-century admirers were not, for all their Romanticism, entirely wrong about him and his inseparability from the experience of common humanity. And when, finally, in the hands of Goya and Delacroix history painting did get reinvented, their god, Rembrandt, was to some extent always standing behind them.

Something, then, had ended before it had properly begun. But not Rembrandt's own career. Another seven years were left to him in which, despite the rain of personal sorrows that fell on him – the death, in succession, of Hendrickje, Titus and Titus's wife Maddalena – he produced a range of visionary work that continued to revolutionize what painting could do and might be. And although he would never again secure the patronage of the patricians at the very centre of power in Amsterdam, he still had admirers of his rough earthiness, some of them wealthy and influential. Two commissions, both undertaken in 1661–2 while he was also working on the *Claudius Civilis*, survived its failure and were, indeed, entangled with its peculiar vision. The intended hanging position of *The Sampling Officials of the Cloth Drapers Guild*, his last group portrait, high up on the walls of their chamber, caused Rembrandt to revisit some of the optical calculations he had made for the town hall, so that he arranged his figures about a table seen from below, their animated authority elevated to the beholder. It was, in some ways, *Civilis* minus the

barbarian fury. And although one group of patricians would cast him out from their house, another – the great Trip dynasty, whose matriarch and daughter he had painted in the early 1640s – hired him to paint a marriage pair to decorate their spectacular double house on the Kloveniersburgwal. Significantly, however, it was not the young plutocrats who were to be portrayed, but the venerable patriarch and matriarch of the family, Jacob and his wife Margaretha de Geer. For those two Rembrandt could safely indulge all his gift for sombre majesty, a great whirlpool of deep brown paint describing Jacob's gown. In the portraits in the National Gallery, London, the two of them appear – like himself – rough-hewn; wandering ghosts from an already distant, heroically plain Dutch past.

When he died in October 1669, among the unsold and, it must be assumed, unfinished works of those last years was a *Simeon with the Christ Child in the Temple*. It depicts the infant Saviour brought by the prophetess Anna to the High Priest, who had hoped he would not die without first setting eyes on the Saviour. Rembrandt has imagined the old man, eyes closed, perhaps blind, but his face flooded with light pouring from the child – the light, of course, that of the Gospel truth. Simeon dies, then, having seen the light. The gentlemen of the town hall, alas, did not.

Beside the *Simeon* in the gallery of the National Museum in Stockholm hangs the mutilated *Claudius Civilis*, the most overpowering ruin in the history of European painting. But then Rembrandt, looking over and over again at his own face, never ceased to believe in the tragic power of ruins. In the presence of what's left of the *Civilis*, nor should we.

Previous pages 176–7: THE CONSPIRACY OF THE BATAVIANS UNDER CLAUDIUS CIVILIS, c. 1666, oil on canvas (Nationalmuseum, Stockholm).

David

AIRBRUSHING
THE REVOLUTION

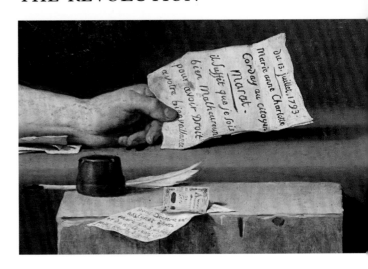

I

IF ART CAN MAKE YOU HAPPY, can it also make you good? If it can move you to ecstasy or tears, should it also move you to be a stand-up citizen? Can modern secular painting have the conversionary power of Christian masterpieces: the power to save souls, not from sin, but from selfishness? Ought the power of art lend itself to the art of power?

To all these questions Jacques-Louis David replied with an adamant yes, at least during the time of his life that mattered most, the time when France was being remade in revolution. It was then he believed that the right kind of art could transform a mere gallery of spectators into a moral community. So his pictures – a parade of heroes, victims and martyrs – throbbed with the command to Belong. Enter our world, the paintings said, a great and grand place, and you will escape the lonely randomness of individual existence; you will come within the tent of virtuous citizenship. To exert that magnetic attraction, art, David knew, needed to be much more than a vehicle of pleasure. It had to tell gripping tales; it had to shock, enthrall, exhilarate and sometimes terrify. It had to change lives and with them history itself. Burning with this certainty, but executing it in images of superlatively controlled passion, Jacques-Louis David invented modern visual propaganda.

One painting above all others was his supreme Passion piece, the one he called, in theatrical homage to the assassinated martyr of the Jacobin Revolution, 'To Marat, At the Moment of his Last Breath' (page 220). It's a work that's still eye-widening but also deeply unsettling; a painting that realized, however briefly, all of David's faith in the missionary force of modern icons. Before his *Marat*, as if before an image of the Saviour, people once sighed, sobbed, swooned. It was, and still is, the most potent political fetish ever to have come from the hand of a painter.

II

DAVID WOULD COME TO THINK OF HIMSELF as a new man in a reborn nation. But the mission to which he devoted himself was, in some ways, very old: the delivery of moral salvation. It had been what painting was *for* during the centuries when its major patron was the Church. To make an icon meant, literally, to make a copy, and it was close proximity to those secondhand Passions, torments, miracles and martyrdoms that the Church hoped would make penitents out of the sinful. That

SELF-PORTRAIT, 1791, oil on canvas (Uffizi Gallery, Florence).

would be how David would see himself as well: an instructor in virtue. Making copies of the great men and moments that had redeemed humanity (or the French bit of it) from the old régime would be an exercise in mass re-education. The majority of people at that time were, after all, unlettered. Their illiteracy had kept them slaves. Images of the truth, delivered like a thunderbolt on ignorant or jaded sensibilities, would set them free.

The man was made for the moment, and vice versa. David was admitted in 1766, aged 17, to the Royal Academy of Painting in Paris at a time when patrons and painters alike were having second thoughts about art's obligation to distract, amuse and arouse. France had just lost a calamitous world war against the British, its imperial possessions in Canada and India going forfeit to the ancient foe across the Channel. To the critics of the court, Louis XV, under whom these serial disasters had unfolded, had become (albeit in whispers, for the Bastille was still very much in use) a byword for indolence and luxurious self-indulgence. His favourite painter, François Boucher, was supremely accomplished at what he did – but what he .did was diversion, and it came, like *Mademoiselle O'Murphy*, 1751, with a coyly blushing derrière. The flowers, like the blooms on the floor, were plucked but fragrant. However you looked at it, the painting was the handmaid of pleasure but, like the girl, available only for private entertainment.

For the first time, though, painters like Boucher, who specialized in come-hither shepherdesses or soft-core deities flirting on fluffy billows, were coming under fire from critics for contributing to the effeteness of the elite. The amorality of the eye and its appetite for pastel-hued lies, it was implied, had led to the softening of other kinds of essential tissue. Boucher, wrote the philosopher and critic Denis Diderot, had 'everything but the truth [for]…where have you ever seen shepherds dressed so elegantly, so luxuriously? Where has there ever been…in one place, in the countryside, under the arches of a bridge, far from any dwellings, women, men, children, bulls, cows, sheep, dogs…?… You feel the complete absurdity of it all and yet you can't tear yourself away…it's such an agreeable vice.' Boucher excelled, Diderot complained, 'in turning the heads of…young people, worldly types…who are strangers to true taste; to true ideas, to the severity of art.'

The fate of art, its corruption by easy-going facility, had already become, then, a public, even a national, issue – so much so that towards the end of Louis XV's long reign even his mistress and empress of the arts, Madame de Pompadour, asked for painting that would be more than bon-bons. A stronger, darker, more virile art was needed – one that would reconnect the aristocracy with its martial ancestry, replace the cushion with the saddle and restore the nation's potency.

MADEMOISELLE O'MURPHY by François Boucher, 1751, oil on canvas (Wallraf-Richartz Museum, Cologne).

There was an ancient and perennial debate, conducted inside the Royal Academy and by the critics in the gazettes and journals, as to which of two paragons of painting, both dead for a century, personified what painting should be. In one corner was Nicholas Poussin, the epitome of classical rigour, whose scenes from the Bible or antiquity breathed moral dignity and grandeur. Poussin's figures seemed to wear the expressions, to utter the cries that were heard in performances of the great tragedies of Racine and Corneille. His lines were hard and his colours subdued so that the occasional splash of brilliance was seen to tremendous effect. His atmospherics were thunderous and majestic. To see a great Poussin was to be exalted.

But then, in the other corner, was his counter-divinity of painting, Peter-Paul Rubens. Where Poussin was stone, Rubens was flesh; where Poussin fulminated, Rubens sang. Poussin was austere, Rubens pinkly voluptuous. Where Poussin was economical with colour, Rubens wallowed in its gorgeousness. Poussin was geometry, Rubens the seducer of the rippling curve, the purveyor of succulent fatties. But while Poussin's heirs were pallid disciples, Rubens's – inspired by Jean-Antoine Watteau's delicate love lyrics – were never short of work. Country chateaux and the town houses of the high aristocracy were full of gentle pastoral, amorous romps supplied by painters such as Jean-Honoré Fragonard, the Lagrenée brothers and, of course, the ever-obliging Boucher.

To whom, one day in the early 1760s, the fatherless boy Jacques-Louis David was presented. Boucher happened to be a distant cousin of his mother, who was now Widow David since his father, an iron merchant, had been killed in a pistol duel when Jacques-Louis had been just nine. So a pair of kindly uncles, both architects and builders, had taken charge of the boy's prospects. They'd sent him to the best of schools and hoped to make out of him something sensible, upwardly mobile – perhaps a lawyer or an architect. But, lamentably, the boy was set on painting – for which, they conceded, he seemed to have an uncommon gift. But the genial Boucher declined to take him on. He was, he said, too old to be a teacher and he had enough pupils already. But he told the lad to come and see him from time to time. He would, he added, be happy to teach him the secret of his warmth.

Warmth would not be high on the list of qualities for which David would become famous. The greatest of his paintings more often send a chill down the spine. But when he chose, David could be as cosy as the next painter of vulnerable humanity. At the very outset of his career he was not above doing some house decoration for a famous ballet dancer, Mademoiselle Guimard, and painted her as Terpsichore, the Muse of Dance, all rosy pastels and robin's egg blue. He was, before Ingres, the greatest portraitist France had ever produced, and he learnt

something of that craft from the Dutch genre paintings that were everywhere in France in the second half of the 18th century. In the 1780s, when he was turning out tragedies of slaughter and sacrifice, he was also painting glowing little portraits of his own small children.

But the master to whom David was sent by Boucher, Joseph-Marie Vien, was more interested in old stone than in domestic sentiment. Vien fancied himself a serious student of classical antiquity, even though he was not above using it, disingenuously, as window dressing for mild parlour erotica. But Vien had the classicist's credentials. He had been to Rome, walked the Forum, steeped himself in the texts that promoted a return to antique solemnity. On his shelves were the art historian Johann Winckelmann's *Thoughts on the Imitation of Greek Works in Painting and Sculpture…*(1755) and copiously illustrated volumes about the recent excavations at Pompeii and Herculaneum. Fluted columns and classical costumes based on those Roman reliefs made appearances in his work just around the time that David arrived in his studio.

There was, in any case, an air of brooding intensity about the young man that made him seem promising material for the return to classical gravity. The moodiness deepened after a fencing match in which David received a slashing wound on the left side of his face. The wound never healed properly, and on its site developed a benign fleshy tumour that twisted his mouth and made him look as though he'd taken too much of a peach at one bite (page 229). Although disfigurements were two a penny in 18th-century France, it was also the period when the 'science' of physiognomy, in which characters were read from faces, was in vogue. There was something about David's pulled-round mouth that made people uneasy in his presence. 'Gross David with the swollen cheek' was what his English enemies would later call him. What's more, this was the golden age of elegant conversation. Wit and polished raillery mattered. They made and lost friends and connections; opened or shut doors to advancement and reputation. But David was a stammerer whose speech people often had trouble in understanding. He could never manage easy banter, so he claimed that it was in any case the drone of the frivolous. Instead he would create an art in which majestic bodies would do his talking for him, and speak with the awesome solemnity of Cicero.

Louis XV died in 1775, widely unlamented. With the succession of his grandson came a new seriousness in official taste. Louis XVI may not have known, or cared, that much about art – not as much as he did about hunting, clocks and locks, at any rate – but he took good advice and appointed as his Superintendent of Building (and thus of the arts) the Marquis d'Angivillers. The marquis was typical

of the public-spirited nobility of his time: he was a reform-minded patriot whose deepest wish was to see the regeneration of France through a return to history and the classics. Henceforth, the duty of art would be not to please but to educate. So the Royal Academy to which David had been admitted, with its studios in the Louvre, was beginning to be not just a school of skills, but a school of public morals.

The two places that counted for most in this programme of re-education through pictures were Rome and the Salon Carré of the Louvre itself, where, since 1748, a biennial public exhibition of new paintings was held by the Academy. For any aspiring young painter, a study period in Rome was indispensable. It was there that, through drawing classical sculpture, they would return to the first principles of harmonious form, compare the Ancients and the Moderns (Raphael), and absorb the high seriousness with which art should be taken. Then, on their return, they would transfer that seriousness into their own work – preferably, d'Angivillers hoped, on subjects from French as well as Graeco-Roman history.

If they succeeded well enough, they would be rewarded by having their work exhibited at the Salon, where, for a month from late August to late September, it would be seen by tens of thousands of spectators – and not just from the highest echelons of the elite either, but by anyone who could afford the modest price of admission. Contemporaries describe the crush of the spectators, market women and fishwives rubbing shoulders with the 'grandees' of the law courts, the Church and high society. What was being created in Paris was something entirely new in the art world: a public. They would be David's people; his good citizens.

III

BUT NOT YET. First he had to prove himself. And his early efforts were more earnest than assured. The subjects were high-minded: lots of Roman architecture (columns, arches) and death-bed scenes, the latter one of the most popular of all subjects since they included sacrifices and tears. David took a shot at one of the most famous of all – the slow suicide of the Roman philosopher Seneca, ordered by his former and faithless pupil, the Emperor Nero. Subjects like this – with their sly dig at the obtuseness and barbarism of rulers – allowed the liberal nobility to indulge themselves in knowing winks and nods without the inconvenience of the Bastille. But David's version, *The Death of Seneca*, was overcrowded melodrama, complete with Big Drapery and meaninglessly half-naked women. It shouted 'tragedy' so hard that it ended up as bathos – all gesticulation and no genuine feeling.

He wasn't that bad; but there was nothing yet to distinguish David from the mob of young painters who were all competing for the Prix de Rome, the chance to

THE DEATH OF SENECA, 1773, oil on canvas (Musée du Petit Palais, Paris).

go to the fount of inspiration and become the next Poussin. David kept on not winning the prize, and when he did get it, at the age of 26, he was no longer a prodigy. Later he spoke of his experience amongst the ruins (especially at Pompeii) as if he had been operated on for cataracts. But the five years he spent at the French Academy, where his master Vien was Director, were a slog. He turned out bulky, academic nude figure studies and over-the-top imitations of funeral friezes, all dutiful rather than inspired. Some of the best things David did in Rome were informal drawings of cattle, countryside and churches. Perhaps the sheer weight of Roman art and history was intimidating as well as inspiring. Granted that the whispered message from the stones was of imperial decay and that republican energy and austerity were needed to reinvigorate indolent empires, just how were artists to supply it? How was *he* to make his presence felt amidst this work of renewal? Contemporary accounts describe him, nearly 30, falling into a depression. 'If this melancholy settles in,' wrote a worried Vien, 'I shall be the first to advise him to return to [France].'

But David was simply too blessed with brilliant technique for commissions not to come. An altarpiece for a church in Marseille shows him shopping for influences: Caravaggio (of course), Bernini's *Damned Soul*, a Raphael Madonna, a Rubens saint and a Poussin leper all on the same big canvas. Jackpot! They loved it. An equestrian portrait of a Polish count (a nod to Van Dyck) shows him dazzling with fol-de-rols and fetlocks. But in 1781 he managed to produce what everyone – even the impossible Diderot – acclaimed as the kind of painting France had been waiting for: monumental and heart-rending. When the crowds saw his *Belisarius Begging for Alms* there was a sudden outbreak of wet hankies in the Salon.

David was already a political animal, slipstreaming himself behind a cause célèbre that had already been aired in a novel about the Roman general Belisarius, unjustly blamed for military disasters. Repudiated by the Emperor Justinian, the loyal general had been reduced to begging in the streets. In France, it was Count Lally-Tollendal who, after two years in prison as the scapegoat for defeat in India, had been executed. Jean-François Marmontel's novel *Belisarius,* 1767, had expressed the analogy between ancient and modern injustices so clearly that it had been banned. But the subject wouldn't go away. David's version, though, was by far the most directly affecting and potentially subversive. The blind veteran, using his helmet as a begging bowl, an angelic child helping him, the two of them beneath sombre classical columns, was a certified tear-jerker. The villainy responsible for his plight was nowhere to be seen, but it was, plainly, the churlishness of kings. David's additional detail of the soldier raising his hands in shocked recognition of his old

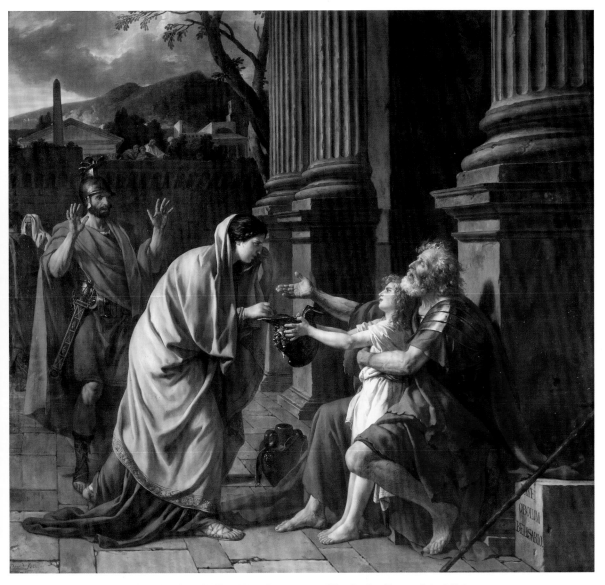

BELISARIUS BEGGING FOR ALMS, 1781, oil on canvas (Musée des Beaux-Arts, Lille).

THE GRIEF OF ANDROMACHE, 1783, oil on panel (Ecole Nationale Superieure des Beaux-Arts, Paris).

general, though stagey, completed the moral melodrama. It had everything: Poussinesque sobriety of line and colour, the beauty of youth, the virtue and charity of women, wounded patriotism, anger against injustice, a temple, an obelisk, bare feet, calloused hands and tender hearts. And it moved Diderot to proclaim that its young(ish) creator had what most counted: '*de l'âme*', soul. Although the chief accolades that year went to a *Death of Leonardo in the Arms of Francis I* by François-Guillaume Ménageot, David's picture was admired enough to get him a studio in the Louvre as a full member of the Academy.

Expectations were high now, and they were regularly fulfilled. In 1783 David inaugurated the series of dead heroes that would culminate exactly ten years later with the dead Marat. This time, in 1783, it was the Trojan hero Hector, a corpse with a perfect six-pack, mourned by his beautiful widow in *The Grief of Andromache*. In two years David had found a sure-fire formula: another plumed helmet (this one with horse's tail attached so that instructionally inclined parents could quiz their offspring on Hector's fate in the *Iliad*); beauteous heroine with eyes raised to the gods; sorrowing child reaching for maternal comfort. The trick was to graft on to a message from antiquity (which could easily turn into a dull lecture from the classics) a sensational family soap opera, something with which everyone in the tear-stained 1780s could easily identify. And David, whose gift for family portraits was as remarkable as his way with stone and steel, would sustain that union of patriotic gore and domestic upheaval – blood and sobbing – all the way to his imperishable revolutionary masterpieces.

D'Angivillers had noticed. For the next Salon, that of 1785, David was commissioned by the court to paint a scene from the story of the Horatii. The subject couldn't have been better for him, and he went back to Rome to paint it. A war between the Roman Horatii and an enemy tribe, the Curiatii, is averted by a match of heroes, three a side; last one standing wins. For the Romans, a father offers his sons as patriotic sacrifice. But into this steely calculus comes the complication of family tenderness. One of the Roman sisters, Camilla, is engaged to one of the Curiatii. When her fiancé's body is brought back after the fight, she openly mourns and is killed for her treacherous softness by her only surviving brother, Horatius. When he's accused of murder, their father publicly defends him for doing his patriotic duty! A drawing of the father standing protectively in front of his impenitent son, his daughter's body thrown on the steps, suggests that, initially, this was to be David's horrifying subject. But he turned instead to an earlier moment in the story, when the father, gripping the naked blades in his hand, swears his sons to fight or die for the *patria*.

Left: **THE OATH OF THE HORATII**, 1784, oil on canvas (Musée du Louvre, Paris).
Above: Detail showing the family nurse holding two of the Horatii's sons.

It's the manifesto of fraternity, of patriotic male bonding: three boys fused into one, the hand of one clasped around the armoured waist of his brother, their legs in muscular lockstep, right arms outstretched in the oath of allegiance to father and Fatherland. From the patriarch's shoulders flows a cape the colour of blood, a brilliant note in the sombre scene. The action is contained within the claustrophobically shallow, stage-like space and proceeds, one, two, three, a minuet of fury and death (for this had already been a ballet): three arches, three brothers, three swords, three women grieving like the wailing Niobe of classical friezes. Sabina, dressed in blue and gold and seated in a chair draped in another blood-hued cloth, is a Curatii girl married to one of the Horatii. She grieves in the certainty that she will, inevitably, lose either a husband or brother or both. Beside her, Camilla (in virginal white), anticipates the death of her fiancé. Both girls are doomed by divided loyalties, torn hearts. A third woman, a nurse, holds the two boys. The head of one is shielded from the spectacle, but the other one, who is evidently a future patriotic sacrifice, watches wide-eyed. While he was painting *The Oath of the Horatii*, David's wife was giving birth to the second of their two boys. Sons were very much on the painter's mind, then… as patriotic fodder.

The painting was like nothing anyone had ever seen: a revolution in art well before David had anything to do with a revolution in the state. He knew that he had an enormous hit on his hands. Friends and pupils in Rome drummed up publicity. By dribs and drabs people were allowed into the studio to see the great work. And when he sent it to the Salon, David knew that – despite being a royal commission that had very specific size requirements attached – the *Horatii* was both late and too big. He nonetheless demanded, and got, central positioning in the Salon. None of this necessarily made David a revolutionary four years before the fall of the Bastille. It certainly established him as someone decidedly short on deference protocol. One has the sense that, despite now receiving all the official favours he could ask for, David's sense of audience lay elsewhere than the government and the court. Sixty thousand people, after all, crammed into the Salon of 1785, where the *Horatii* put everything else in the shade. Henceforth he would make pictures for something called 'The Nation'.

IV

THE *HORATII* WAS A CLARION CALL TO ARMS, but as yet, even in 1785, it was still unclear that there would be a political battle, much less a social war. All that changed a year later when, in response to a fiscal meltdown caused by the American revolutionary war, a deliberative assembly was summoned to consider taxes that

might be levied to stave off bankruptcy. The members of that 'Assembly of Notables', drawn from the aristocratic elite, were not, in fact opposed to abolishing their tax-exempt status. But they wanted something in return, and that something was a share of sovereignty. They wanted an election, the calling of a legislature.

What they got from that legislature, the Estates-General, which met at Versailles in the spring of 1789, was altogether more than they had bargained for: the annihilation of their privileges, of their entitlement to be thought of as a separate order. Instead of three orders – nobles, clergy and commoners – there would be just The Nation. Two years later, in the throes of revolutionary fervour, David would depict the moment of that transformation. Locked out from their meeting hall on royal orders, the deputies of the 'third estate', along with defectors from the other two orders, reassembled in an indoor tennis court. Having already decided to call themselves the 'National Assembly', they were sworn by the Mayor of Paris, Sylvain Bailly, to remain united until France had been given a constitution. The scene (pages 208–09) became in David's fertile imagination a moment of literally electric power: lightning, seen through a top window, strikes the roof of the Chapel Royal; an immense gust of wind blows umbrellas (not to mention the political status quo) inside-out and whirls like a tornado through the high, empty space of the court, which becomes filled with light and pure fresh air: the breath of new political life.

This, however, was still two years ahead, and in the years running up to the Estates-General David was no fire-breathing radical. In fact, he was well-off, fashionably famous and received in the most stylish cultural circles. In 1787, for the Trudaines, liberal nobles who held court in one of Paris's more glittering salons, David painted the kind of thing that would have made them feel sombre and virtuous: another death-bed with contemporary overtones. Convicted of disrespecting official gods and corrupting the youth of Athens, Socrates is about to take his medicine and drink the hemlock. *The Death of Socrates* is quietly coloured, another boxed-in drama of speak-and-act martyrdom: speech and silence in perfect dramatic balance. Socrates (for the poison is slow-working) continues to pronounce even as he dies, but Plato, slumped at the foot of the bed, grieves in quiet, bitter resignation.

David was now less dependent on the favours of the crown, for he was the darling of rich, liberal aristocrats. From one of them – the famous chemist Antoine Lavoisier – he took the huge fee of 7000 livres for a double-portrait of him and his wife (page 199). It didn't matter that Lavoisier also happened to be one of the Farmers General, who collected the kingdom's taxes with the help of a private army, creaming a nice portion off the top for themselves. There was, after all, another

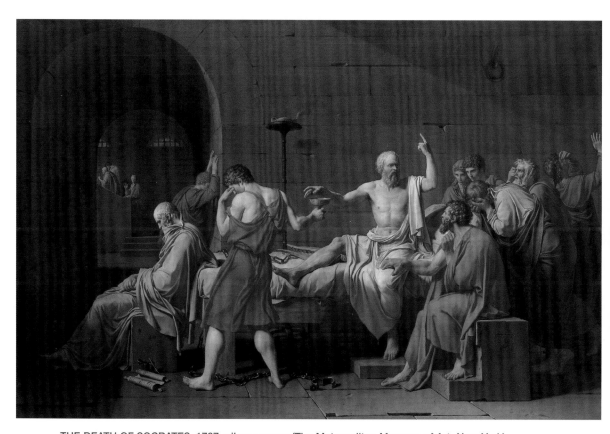

THE DEATH OF SOCRATES, 1787, oil on canvas (The Metropolitan Museum of Art, New York).

ANTOINE-LAURENT LAVOISIER AND HIS WIFE, 1788, oil on canvas (The Metropolitan Museum of Art, New York).

Lavoisier, the liberal-minded scientist and good egg who spent time and money eradicating malaria on his country estates. So David, who was clearly won over by his sitters (the wife, Marie-Anne, being a drawing student of his), paints them as a modern conjugal romance. Marie-Anne, who had married Antoine when she was just 13, is depicted as a true partner – which, as the supplier of his technical illustrations and translator from English, she indeed was. Both are by the standards of the day, dressed elegantly but not ostentatiously in dark hose and delicate muslin. The operative word was 'nature'. Marie-Anne's long, curled tresses escape from her powdered wig; the gesture of her hand on her husband's shoulder is informal, natural. They are the picture of high-minded but unstuffy decency; the kind of people who ought, really, to be running the new France.

But the revolutionary moment wasn't about transferring power to good eggs. It was about breaking them. Elections to the Estates-General had opened a Pandora's box of excited expectations. Recent harvests had been catastrophic, and bread prices had gone sky-high. The popular assumption was that somehow an elected assembly of The Nation would, by ending privileges, right all wrongs and fill hungry bellies. The implied message was: votes feed you. But of course they didn't. Through the spring and summer of 1789 much of France, especially in the towns and cities, continued to starve. And then the next trigger of revolutionary violence kicked in: paranoia. Continuing misery had to be somebody's fault: the finger was pointed at people who had merely pretended to sympathize with the Revolution but were in reality ceaselessly plotting to overturn it. Top of the list, of course, was the court at Versailles. Louis XVI had finally accepted the oath in the tennis court by which the old Estates-General of the three orders had become a single National Assembly. But the Paris newspapers, suddenly liberated from censorship, suspected (with good reason) that Queen Marie-Antoinette, who had become a symbol of depravity, was plotting with her own brother, the Emperor of Austria, and with the King's own brothers to liquidate the Assembly by military force. When the King dismissed the minister who had endorsed the National Assembly as the sole legitimate source of legislative power, a spark flew and hit powder.

Literally. It was 12 July 1789. In Paris there were cannon at the Invalides garrison; and it was rumoured that the Commissioner of Gunpowder, none other than Lavoisier, was moving barrels to the ancient, eight-towered fortress of the Bastille, whose guns pointed directly into the streets of the Faubourg St Antoine – the heart of radical Paris. In the colonnades and gardens of the Palais Royal – an oasis of liberty, where quacks, acrobats, whores, pamphleteers and speechifiers jostled together just a stone's throw from the Louvre – a young provincial lawyer,

Camille Desmoulins, stood up on a lemonade vendor's table and shouted to the people that the dismissal of the minister was a declaration of war on the National Assembly, on the people. Now royal troops would be marching on Paris to massacre them, receiving lethal assistance from the guns and powder already there. The people's only defence was to take arms pre-emptively themselves.

Two days of fires, attacks and slaughter followed, in which the militia of the National Guard, controlled by the Marquis de Lafayette took over Paris. The culmination was the storming on 14 July of the Bastille itself. Although over the generations the fortress had become, through the brilliantly promoted writings of those incarcerated there for offending king or government, the symbol of despotism, by this date it contained just eight prisoners. The stronghold was defended by 78 Swiss guards and veterans, and there was indeed an arsenal of gunpowder. The commandant, Louis de Launay, his fort surrounded, attempted to negotiate a peaceful capitulation. But the usual chain of events ensued: confusion, a shot from no one quite knew where, panic, rage, accusations of deliberate deceits, a massacre and then a headlong attack. By the end of the day the Bastille had been taken, and de Launay's head had been hacked off with a knife on the streets of Paris as he was being transferred to the town hall. Lafayette, the National Guard and that vaguely defined, amorphous, seething, still infuriated, still deeply suspicious mass called 'the people' was in charge of the great city. When a messenger brought news of the event to the King at Versailles, he famously asked, 'Is it a riot?'

'No, sire,' was the answer. 'It's a revolution.'

V

AND WITH THAT, the word itself was revolutionized. Up until that moment it had had the cyclical sense of its etymology: a return to some earlier state of justice or freedom. Histories of the 'Glorious Revolution' in England had described the recovery of rights usurped by King James II's absolutism. Even the American Revolution claimed to have restored liberties that had been taken from free-born men by the British tyrant. But in 1789 there was a sense of true slate-wiping, of beginning again. In August, liberal-minded nobles, such as Lafayette and Mirabeau, gloried in the liquidation of their ancient privileges and in the *naturally* noble title of Citizen.

If this new thing, this Nation, was to be truly reborn and established on solid foundations, then those who had never known public life, much less participated in it, had to be educated into citizenship. The old rituals of royalty, nobility and Church ceremony were now not only redundant, but actually dangerous to the new order. In their place must come a whole new set of outward signs of national union and

fraternal citizenship, beginning of course with the tricolor. In the jittery days and months after the fall of the Bastille, the answer to the suspicious question on the street: 'Are you of The Nation?' was answered by wearing the sash or cockade. Lives could depend on these indicators of allegiance. In November 1789, when Versailles was invaded by a revolutionary crowd that had marched from Paris, Lafayette, who wanted to ensure the royal family's safety, wrapped them in the flag and put cockades on them before taking them back to the city to be 'restored to the bosom of the people'.

Where was Citizen David amidst all this feverish activity? For a while, the documentary trail goes cold. The stammerer with the swollen cheek was not one to make speeches, although, writing of the November humiliation of the Queen at Versailles, he thought the people 'should have cut the carcass to pieces'. He had become famous as the painter of the *Horatii,* a painting embraced retrospectively as heralding a revolutionary call to arms, and positioned himself as a reformer by launching attacks on the Academy as a bastion of the old order. When a group of artists' wives came to the National Assembly to sacrifice their jewellery to 'The Nation', David's wife, of course, was among them.

But as the first revolutionary Salon approached in August 1789, David had some seriously embarrassing patrons and paintings to explain away. One of the two paintings he had meant to show had been painted for the youngest and most reactionary of the King's brothers, the Comte d'Artois, an intimate (it was said with some smirking) of the Queen's, and the man most responsible for trying to launch a coup against the Assembly. It was a silkily erotic *Paris and Helen,* a teenage love moment, with Helen's perfect Greek breasts on display through her diaphanous chemise, and the tow-haired, rosy-lipped Paris's virility barely concealed by a red ribbon dangling from his seducer's harp. If anything, the Lavoisiers were even more compromising, since Antoine, as Commissioner of Gunpowder, had barely escaped lynching during a riot on 6 August. The Lavoisier double-portrait suddenly disappeared from view, as did its subjects, while the customs hall of the Farmers General was pulled down by a celebrating crowd. Four years later, during the Terror, the Lavoisiers would be arrested: Antoine was guillotined, although his wife survived. David was on the committee that signed the death warrants. Evidently, fraternity had its limits.

And it didn't do to make too much of the fact that the history painting that did survive to be shown at the Salon of 1789, *The Lictors Bringing Brutus the Bodies of His Sons* (pages 204–5), had actually been another crown commission. The time depicted was the years of the foundation of the Roman Republic. The Consul

Lucius Junius Brutus (not to be confused with the later assassin of Julius Caesar, Marcus Brutus) has discovered that his own sons are involved in a plot to restore the discredited Tarquins, who had been kings. Principle had vanquished family sentiment, and Brutus had ordered the execution of his own children. Their headless bodies are seen at the back of the painting, the blood-red ribbon on their ankles and feet a shorthand of their fate.

It's a horrifying story: the Horatii made even more implacable because the bond between father and sons has been severed along with their heads. That shearing of family ties in the name of political correctness, the sovereignty of patriotic duty over weak sentiment, is physically represented by the undecorated Tuscan column that comes between Brutus and the women of his family, repeating even more adamantly the gender divide that had made its appearance in the *Horatii* and would be a theme of almost all David's paintings to the very end of his life. The greatness of the painting lies in the uncertainty of its creator's sympathies, and the transference of that tension to the viewer. (A few years later, uncertainty could get you a date with the guillotine.) Brutus and the lictors remain in the shadows; the women are lit by their passionate distress. Brooding grimly and implacably in that darkness, Brutus has his back turned to the bodies of the children killed on his orders. But the tragic conflict raging within him is given away by the gesture of his right foot twisted over the left, a piece of body language that David borrowed from the figure of the prophet Isaiah in Michelangelo's Sistine frescoes.

All the pent-up agony of the literally brutal consul is released in the tormented figures of mother, wife and sisters, who this time are not merely passive and crumpled as in the *Horatii*, but thrown bodily into their horror like figures from a Greek tragedy (or, indeed, from Voltaire's deeply subversive play about Brutus, which had had its first performance the year before). One of the sisters faints dead away, another holds her hands before her face to prevent herself seeing the spectacle of death. Where it had been the father, Horace, whose hand commanded the centre of the composition in the earlier painting, this time it is the exquisite, pathetic hand of the mother of sacrificed children. She is washed by light, while the Mother of Death, the stonily enthroned statue of Mother Rome, the Republic, sits implacably in the shade, coming physically between the father and sons, between natural feeling and civic duty.

Perfectly calculated though this drama of torn allegiance is, David has one more shocking visual coup with which to stun the spectator. Set on the tablecloth, its colour a lake of blood-red, is a still-life: a basket of needlework and cloth, the symbol of hearth and home, of family life, and of feminine duty and care. But at

THE LICTORS BRINGING BRUTUS THE BODIES OF HIS SONS (detail), 1789, oil on canvas (Musée du Louvre, Paris).

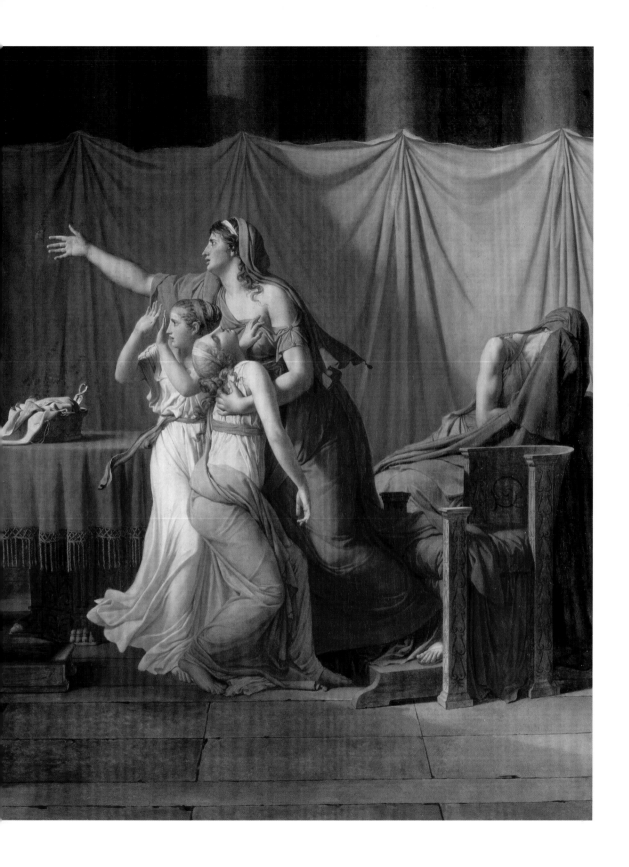

the centre of the basket, painted with all David's dazzling gift for still-life, is a pair of scissors, their blades gleaming with dull menace. At least some of his audience – those such as Maximilien Robespierre and Georges Danton, who had gone to the hothouse Paris *lycées* and imbibed classical learning – would have instantly recognized the symbol of *atropos*, the cutting of the thread of life by the Fates. Never was the French term for still-life – *nature morte* – more apt.

For all its ambiguities, the *Brutus* was David's declaration of allegiance, especially since it was seen at a time when the National Assembly was obliterating the old France. Although he'd been working on the painting a year before the Estates-General and the fall of the Bastille, the dramatic events of the Revolution had changed the significance of the *Brutus,* and he knew it. Amazingly, like the *Horatii*, it had been a royal commission! But now the whole thrust of the picture had become profoundly anti-monarchical, represented by the incorrigible, corrupt, licentious and despotic Tarquins, the villains off-stage, who had indirectly brought about the tragedy. And it was just the beginning.

VI

IN ONE RESPECT – its emphasis on divisiveness – the *Brutus* was tragically prophetic. France was on the verge of what would turn into a civil war, with entire regions and great cities like Lyon in armed revolt against the Paris government. But in the early years, the inspirational rallying cries were all about unity. Even as the acts of the revolutionary legislatures were marginalizing entire groups like the clergy, making them in effect un-citizens, the rhetoric of orators and journalists pretended that the event was one long love-in, with families dancing round the Liberty Tree and fraternal kisses exchanged beneath the tricolor. No true citizen would use the impersonal *vous* for 'you' any more. Instead, it was a patriotic duty to *tutoyer*, to use the personal *tu*, which previously had been reserved for children, family, lovers and pet dogs.

Two citizens were serving the Revolution in their own way. From his print shop on the Left Bank Jean-Paul Marat, frustrated scientist, physician, hot-air balloonist and more recently hot-air journalist, was working the rich seam of revolutionary paranoia. Marat was now *L'Ami du Peuple*, the Friend of the People, which meant that in his eponymous paper he specialized in Enemies of the People. By this was meant the un-citizens lurking behind doors and masks, the unrepentant friends of the old order (including, naturally, the she-wolf Queen and her fat, two-faced husband), who played for time while conspiring with European despots to start a war to undo the Revolution; aristos such as Lafayette and Mirabeau, who pretended

to be supporters of the Revolution but were actually plotting with the court; and countless priests and fake patriots, all of whom needed unmasking if the *patrie* was to be saved. To denounce was a patriotic duty; to remain neutral a crime.

While Marat was busy weeding out, Jacques-Louis David was gathering in. In March 1790, en route to a revolutionary oath-swearing ceremony in Brittany, he had already begun to make sketches for a commemorative painting of *The Tennis Court Oath, 20th June, 1789* which had launched the Revolution and sealed the fate of the old absolute monarchy. One of the principal figures of that moment, Edmond Dubois-Crancé, described it in the Jacobin Club – named after the Jacobin convent where the revolutionary leaders met – as the day when centuries of errors had been overthrown. Its example would, he said, one day make 'the entire universe free'. That was the way revolutionaries talked. Then Dubois-Crancé went on to propose that the Jacobins commission from David, 'this French patriot whose genius has advanced the Revolution', an immense painting, 30 feet by 20, that would record the seminal moment for posterity. The work would be hung in the National Assembly. But an oversize drawing that David would also make would be engraved and distributed in an edition of 3000 throughout France. The image would be the icon of the national dawn.

David must have had a giddy sense that history was catching up with art. The deputies at Versailles had actually imitated the gesture of oath-taking, arms extended, that had been popularized by the *Horatii*. Now he was being asked to recycle it again: art replaying history that had imitated art. It was enough to make his patriotic head spin. But if he had any anxiety at all that this would be a colossal exercise in wishful thinking, that *The Tennis Court Oath*, with its figures all reaching towards the focal point of Bailly's oath, some with their arms around each other, was in direct contradiction to the alarming fissures opening up every day in the body politic, he suppressed it. If the divisions between monarchists and would-be republicans, between moderates and militants, were becoming embittered, all the more reason to give French men and women an image around which they could rally.

But the huge picture still had to do many things. It had to be a symbolic epic; hence the famous thunderstorm, umbrellas blown inside-out, and the trinity of clergy at the centre (personifying the monastic clergy, the parish priests and Protestants, all of whom were now just Constitutional Christians). It needed to personify the union of young and old (hence the famous octogenarian Père Gérard – who was actually a well-to-do Breton gentleman farmer who liked dressing up as a peasant); and the union of politicians and people (hence the spectators in the

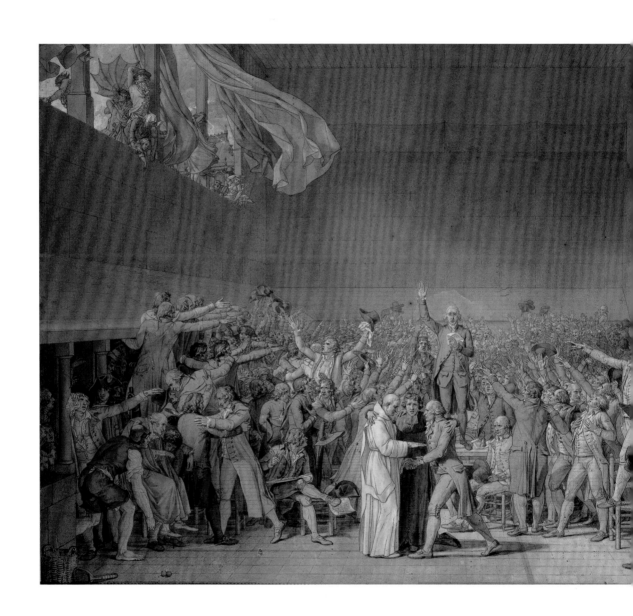

Left: THE TENNIS COURT OATH, 20TH JUNE, 1789, pen washed with white highlights on paper, 1791 (Musée National du Château, Versailles).
Above: Study for THE TENNIS COURT OATH, with painted portraits of the revolutionaries, 1791, pen and ink and watercolour on paper (Musée National du Château, Versailles). From left to right: Dubois-Crancé, Gérard, Mirabeau and Barnave.

galleries and at the windows – National Guardsmen and children, for whom David's own boys seem to have been the models). But as contemporary history (David's first), it also needed recognizable likenesses of the most famous personalities to whom teachers and parents all over France could point when instructing the innocent, the apathetic and the deluded about the Great Day. '*There*,' they would say, 'see the great orator Mirabeau challenging the lickspittles of the crown to take on the might of the assembled People. See *there* the furrowed brow and calm composure of the mighty Formulator, the Abbé Emmanuel Sieyès, whose "*What Is the Third Estate?*" began the momentous process of transforming commoners into citizens. *There* Mayor Bailly himself on his table. And *there* [hiss] on the extreme right the wicked deputy Martin d'Auch, who alone among the gathering signified his refusal of the oath by arms crossed over his chest!'

But at the same time as doing this kind of reporting, the painting had also to sustain the monumental grandeur and physical nobility of David's Roman pictures. So David began, startlingly, with nudes; the real in the form of the ideal. The figure that turned into Maximilien Robespierre, the small-town lawyer who became the leader of the Jacobin Terror, with both hands clasping his breast in the gesture of passionately transparent sincerity, was actually drawn by David as a naked Roman soldier or gladiator, clad only in a helmet. Others were prettied up, sometimes imprudently. Even as David was giving Antoine Barnave, the orator from Grenoble, one of the most beauteous profiles he ever painted, and the famously and spectacularly pock-marked, charismatically ugly Mirabeau the features of a glamorous lion, complete with Herculean shoulder-blades and buttocks, the two were coming under ferocious fire from Jacobin militants for being royalist plotters, vicious creatures of the traitor-Queen.

Many of the 'heroes' most prominent in David's sketches were, then, embarrassingly unmasked as villains, false friends or even outright enemies of the Revolution, even before he had a chance to finish it. Although a painting on that scale would in any case have taken longer to prepare and execute than anything in his previous career, having observed plot after plot denounced and exposed by Marat and the Jacobins, David may well have decided on cautious deceleration.

Perhaps all these difficulties with personnel is why the great drawing of *The Tennis Court Oath* succeeds most spectacularly where there are no figures at all: at the optical centre of the composition, a huge void in the echoing space between floor and galleries. It's a vanishing point in which something, although invisible, materializes: an idea. For David wants us to register this space as flooded with wind, light and heroic noise – the elements on which onrushing Liberty is invincibly borne. So, more

than anything else, *The Tennis Court Oath* is a portrait of the atmosphere of liberation.

None of this, however, saved the painting from being a political anachronism well before David got anywhere near its completion. For paranoia (along with hunger) was rapidly replacing spontaneous fraternity as the engine-driving revolutionary fury. Instead of arms outstretched in the same direction, there was an epidemic of finger-pointing. It was becoming Marat's and Robespierre's revolution rather than Lafayette's, divisive rather than inclusive. Not all the suspicions of betrayal were unfounded. Marie-Antoinette *was* secretly writing to her brother, the Austrian Emperor Leopold, imploring him to intervene, if necessary by means of an invasion, and liberate her husband and herself from their captivity to the Assembly and the 'mob'. All the demonization of the King and Queen seemed vindicated when they were arrested at Varennes in a botched attempt to flee over the border, and brought back to Paris as virtual prisoners.

Remarkably, after this episode, neither France nor David could quite bring themselves to give up entirely on the possibility of a chastened constitutional monarchy. Louis 'of France' took the oath to a new constitution in the Legislative Assembly. David accepted a commission to paint a portrait of the King teaching his son that constitution. Later, David would indignantly reject the suggestion that even as late as March 1792 he had contemplated collaborating with the King, even inventing his retort that 'the painter of Brutus was not born to paint kings'. But the *six* drawings of the portrait-to-be show that he lied (page 225). At some point, though, it became politic to abandon the project. The war that Marie-Antoinette had wanted had duly arrived in the spring of 1792, and increasingly the King and Queen – despite all their protestations to the contrary – were seen as a fifth column inside a country facing steep odds against the professional soldiers and mercenaries of the King of Prussia and the Emperor of Austria. In the summer of 1792 National Guardsmen from Marseille, singing a song that had been composed on the eastern front (and originally called the 'Song of the Warriors of the Rhine') camped in Paris.

Allons, enfants de la patrie. Come, children of the Fatherland.
Le jour de gloire est arrivé The day of glory has arrived

they sang. And on 10 August the day of glory turned into a day of bloody violence, when Swiss guards protecting the royal family at the Tuileries Palace were massacred, the monarchy declared abolished, the ex-King and Queen (now known simply as the Capet family) imprisoned pending trial, and France declared a Republic, One and Indivisible.

VII

FRANCE'S TRANSFORMATION was also Jacques-Louis David's. He had always been someone who believed that public engagement drew from humans their noblest qualities. He was, then, prime revolutionary material. But, inhibited perhaps by his lack of eloquence, he had held back a little. From 1789 to 1792 David had presented himself, first and foremost, as Citizen *Artist*, someone whose principal target was the 'feudal Academy' (which under d'Angivillers had been meritocratic enough to bestow favours, stipends and commissions on him). And perhaps, like millions of Frenchmen, he still alternated between exhilaration and anxiety at the prospect of a committed revolutionary life. What if it all went wrong? What if he found himself on the wrong side? In 1791, around the time he was working on the doomed *Tennis Court Oath* picture, David had painted the first of only two self-portraits (page 183). It's an image of the revolutionary as a free force of nature, a one-man storm – and David's brushwork, normally so slickly polished, is as calculatedly loose and free as his hair. His look is intense, as if suddenly interrupted between one hectic, dangerous task and another; a man – like France itself, living in a state of heightened awareness; jumpy; vigilant; full of charged, but unfocused, Romantic energy. It was a long way from the coolly composed neo-classicist.

But then composure was not a high priority of the Jacobin Club during the bloody autumn of 1792, when David heard Danton rage against the gang of tyrants who were advancing on the beleaguered seat of liberty. The *patrie* was in danger. The Prussians were halfway to Paris, with only an untested, largely conscript army to stop them. The declaration of the Republic and the imprisonment of 'Louis Capet' and his wife, along with the round-up of anyone associated with the 'feudal' order, meant – as David the classicist knew – that a Rubicon had indeed been crossed. There was no going back, no compromise with 'the tyrants'. It was total war – them or us. When crowds and children sang the 'Marseillaise' – 'before us, tyranny has raised its bloody standard' and soldiers were coming 'to cut the throats of our sons' – they believed every word. The city itself was undefended, except by the pikes and muskets of the revolutionary guards. Marat warned everyone from the shrieking pages of his *Friend of the People*, that there were false patriots, spies, traitors, even within the Convention itself, who needed winkling out. They should be denounced, arrested, exterminated. Some of them were already in the prisons – old aristos, priests, political devils who were just waiting for the Prussians to free them so that they could wreak revenge on good republicans. They had to be dealt with before that could happen. So in the third week of September the jails were broken open and prisoners mercilessly butchered. Marat for one thought this was a necessary cleansing, an act of political sanitation.

Prudence as well as principle likewise demanded a speedy trial for the ex-King, lest he become a rallying point for the disaffected within France and a target of liberation for the enemy. David, who had taken the plunge and been elected as a deputy to the National Convention for Paris, took his seat on the 'Mountain', the high benches from which men such as Robespierre and St-Just denounced the trial as a farce, arguing instead for the summary execution of someone who was, given his bloodline, biologically incapable of citizenship. He was a malignant anomaly that needed merely to be eradicated. When the moment came, David voted for his former patron to be found guilty and put to death for his manifold crimes against the people. That vote was his decisive plunge into a life of total politics. It didn't matter that he was still a mumbler. Indeed, flowery eloquence was becoming officially suspicious, just as Robespierre was admired for his icy logic and conciseness.

David and his art belonged to the Republic now, indivisibly. And there was much important work to keep him busy. Some deluded souls may still have had hankerings after the old rituals of royalty and Church. David needed to offer the crowds spectacles and images that would stir them to their new allegiances. He had already had a taste of how what began as mere painting could turn into tests of allegiance. When anyone – revolutionary guards, children at school – swore loyalty to the Revolution, they did so with the oustretched Roman salute of his Horatii. The unpowdered short-hair crop popularized by his *Brutus* (based on a copy of a Roman bust he owned) was now officially sanctioned as the patriotic haircut for men (notwithstanding Robespierre's fastidious attachment to his powdered and ribboned wig). Even before the creation of the Republic, David had acted as producer of political street shows, such as the transfer of Voltaire's remains from a church to the new Pantheon of heroes. And in the winter of 1793 an assassin's knife supplied another important commisson.

One of the most militant Jacobins, Michel Lepelletier, who had spoken and voted enthusiastically for the death of the ex-King, was murdered by an ex-royal officer while sitting in a café in the Palais Royal. The fact that Lepelletier was a former aristocrat (there were any number of these), who had not just repudiated his own caste but had been among its most enthusiastic persecutors, was doubtless the cause of his being targeted. But it also made Lepelletier an instant republican saint: someone who had seen the light and traded in the vestiges of 'feudal egoism' (the favourite phrase of the time) for the spotless life of a citizen. He was, then, the first of the Republic's martyrs.

David's job was public sanctification: the embalming and presentation of the body in a republican version of a lying-in-state, so that reverent crowds could file

past. Then that event – and the body – had to be preserved in a great painting that would be both inspiration and lesson, and could be engraved for mass circulation. David had been doing death-beds ever since his early *Seneca*. Now he had the chance to give it his all. Lepelletier, who was (as can be seen from a contemporary drawing) one of the most spectacularly ugly of the Jacobins, with an enormous beak-like nose and bug eyes, was, needless to say, turned into a fine-boned paragon of classical beauty. Art's duty, in David's neo-classical philosophy, was to clean up the accidental disfigurements of nature and replace them with ideal forms. In this way the *inner* beauty of Lepelletier – his bravery, his virtue – would transform his features into those of a republican hero. The victim's stabbed and torn body was cosmetically patched up (with the wound, however, carefully preserved) and it was laid out on a bed in the Place Vendôme, on the pedestal that had once carried the equestrian statue of Louis XIV. In his painting, *The Death of Lepelletier*, David, who was quickly warming to his new job as showman-schoolmaster of the Republic One and Indivisible, added a brilliant touch: the sword of Damocles, sharp, brutal, suspended literally by a thread, over the recumbent body of the Great Martyr.

VIII

DAVID WAS NOW IN THE HEROES-AND-VILLAINS BUSINESS (in some sense he always had been). But the thing about revolutions, especially this one, was that you were never quite sure which was which. The prisons – and the tumbrils – became full of yesterday's unblemished patriots who had turned out to be today's traitors. Inconveniently, many of the most notorious of the two-faced had been prominently featured in David's *Tennis Court Oath*: they included Bailly and Barnave, both of whom ended up on the guillotine. Only Robespierre and Marat, the journalist whom David had included in his preparatory drawing, watching from the gallery where he was scribbling away on a tablet, were apparently unimpeachable.

But then, in the aftermath of the execution of the King, an all-out power struggle erupted both inside the National Convention and in the regions of France that resisted the Jacobin version of revolution as dictatorial, punitive and fanatical. What were claimed by revolutionaries such as Robespierre as emergency war powers (including the suspension of the constitution) were, the opposition said, actually instruments of a new tyranny. By the summer of 1793 almost half the departments of France were in revolt, either political or military, against the Jacobin-dominated revolutionary government in Paris. Inside the Convention deputies who had voted for clemency now saw themselves locked in a battle with the Jacobins for the soul of the Republic. Their leaders were called Girondins after the region around

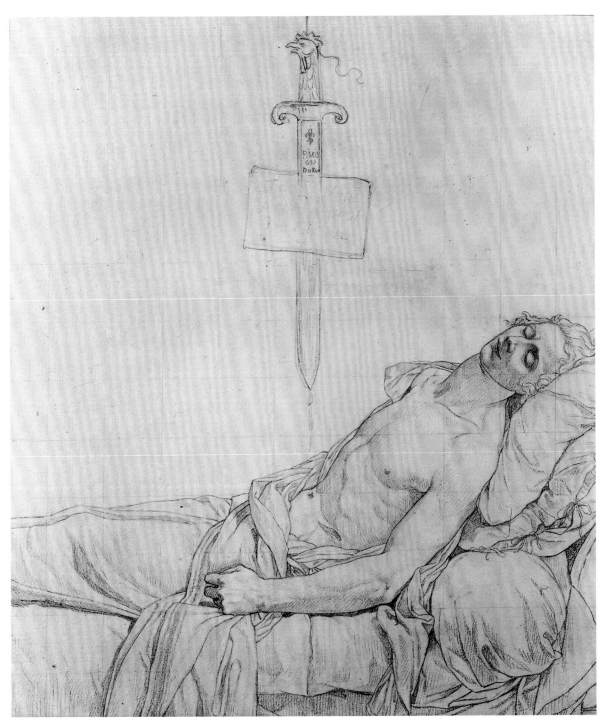

THE DEATH OF LEPELLETIER by Anatole Desvoges, *c.* 1793, drawing after David (Musée des Beaux-Arts, Dijon).

Bordeaux where many of them came from. But what they stood for was decentralized power, the liberty of the provinces. David was a Parisian through and through.

Their first pre-emptive attack (and their last) was on the man whom they judged most widely hated and feared – Marat. Now a deputy himself, he was regularly demanding heads (especially theirs) so that the Republic could be safe. But the Girondins' attack backfired catastrophically. Depicting himself as a 'martyr' for the liberties of the press, and the victim of traitors, 'charlatans' and (naturally) 'egoists' who were trying to gag his exposures of their conspiracies, Marat was arrested, tried – and acquitted! He and the Jacobins, including David, with whom Marat had become friends, made the most of the vindication, staging an elaborate 'triumph' at the Cordeliers Club in which Marat's head was garlanded with roses. Two months later he took a more complete revenge on his incompetent prosecutors. In a three-day *coup d'état*, in which militant citizen soldiers from the Paris districts aimed cannon at the Assembly, the Girondin deputies and other 'moderates' were expelled from the Convention. Now, instead of constitutional government in France, there was to be 'revolutionary government', including special tribunals empowered to hear denunciations, make arrests, try suspects and pass sentence on them without the benefit of anything resembling due process or legal defence. No mercy would be shown to enemies of the Republic, either within or without its borders. In Paris the tempo of the guillotine quickened. And the now untouchable, euphoric Marat upped the ante of heads. Thousands, not hundreds, he said were needed before the *patrie* could feel secure.

Someone was taking him seriously. Charlotte Corday d'Aumont, from a family of minor gentry, lived in Caen in Normandy. She was clever, articulate, virginal and steeped in the tragedies of her ancestor Pierre Corneille, in which acts of agonized self-sacrifice were committed for noble ends. Charlotte was about to write another of these dramas. Like countless people who hated the Jacobins, Corday thought of herself as a republican, but she also believed that Robespierre and his allies had trampled on the Revolution's liberties rather than sustaining them. She had applauded when the local municipality in Caen had denounced the Paris Jacobins, 'engorged with blood and gold', for trying to subject France's provinces to their dictatorship. And she had been horrified when the local priest, who had given the last rites to her mother, was guillotined in Caen as a 'refractory' who had refused the oath to the Republic). The last straw for her may have been the arrest and incarceration of the Girondins in the grim prison of the Conciergerie. Charlotte had met one of them, Charles Barbaroux, handsome and magnetic, when he had visited Caen. The Girondins' inevitable date with the tumbrils had now become personal

for her. Besides, had she not heard with her own ears local politicians calling for the death of the monster Marat, whose disgusting and insatiable appetite had been fed with blood. 'Let Marat's head fall,' it had been said, 'and the Republic will be saved.' It was, then, a patriotic duty.

On 9 July Charlotte boarded a coach for Paris. Meanwhile, her quarry was suffering. It was a broiling summer and Marat's acute psoriasis, which on hot days turned his rash-afflicted skin into a mess of itching, flakes and scales, was now crucifying him. But the discomfort would not slow down the patriotic work of denunciation. In his house on the rue des Cordeliers he was looked after by his mistress Simone Evrard, who prepared lotions of kaolin to be smeared over Marat's tormented body. When the heat became unendurable he would take to his shoe-shaped bath and work, a vinegar-soaked bandage wrapped around his brow, right arm draped over the side, at a desk improvised from an upturned wooden crate. On the wall with its fake painted columns was pinned a map of the French Republic. A pair of crossed pistols hung on the same wall and beneath them, painted in large letters, an inspiration or warning, '*LA MORT*' – Death!

This is how David found him on 12 July when he went to the house in the rue des Cordeliers to pay a fraternal call. The journalist and the painter were perhaps united by more than their devotion to militant Jaobinism. They were both disfigured and acutely conscious of the hatred and ridicule this provoked from their enemies. They both had histories of battles with the old royal academies. Marat's experimental papers on igneous fluids had been rejected by the Academy of Sciences, turning him from a supplicant into a permanent enemy; David had had to battle through what he thought was favouritism to earn respect and commissions. And, astoundingly, both had worked right up to the eve of the Revolution for the King's brother, the Comte d'Artois – Marat as physician to his guards, David as the painter of his soft-porn *Paris and Helen*. (That connection probably did not feature much in their later conversations.) Marat was now the hunter of traitors, and David was about to become a member of the political police committee – the Committee of General Security – that signed death warrants, dispatching the convicted to the guillotine. And there was something about Marat's ostentatious simplicity, his posturings as Friend of the People – wearing his famous ugliness (compared by one of the Girondins to a toad) confrontationally, augmenting it with his dirty old ermine shawl – that appealed to David's sense of the theatrical. When he was attacked by the Girondins in the Convention, Marat's response had been to point a pistol at his temple and threaten to blow out his brains. David loved this kind of thing. It was straight from his paintings.

It was quite natural, then, for him to be one of the two deputies sent by the Convention to enquire after the health of the Friend of the People, since Marat's acute condition had forced him to absent himself from the Assembly. David was shown into the bathroom where, he reported to the Convention, Marat was 'writing his thoughts for the safety of the *patrie* in his tireless manner'. David ventured to hope that the Citizen would soon recover from his indisposition, to which Marat, with typical churlishness, replied that ten more years of life did not concern him. His only desire, he said, was to be able to say with his last breath that 'the Republic is saved'.

He was not to get his wish. A day before David's audience in the bathroom, Charlotte Corday had arrived in Paris. The city was decorated and, despite the ferocious heat, in a celebratory mood, preparing for the festivities of Bastille Day, two days later. On the 12th Charlotte wandered through the Palais Royal, the gardens where the Revolution had begun precisely four years earlier. The colonnades were wound with ribbon and flags. There were placards bearing emblems David had designed as inspirational propaganda. There were still hacks and whores, but the hacks had to toe the Jacobin line, and the whores had to disguise themselves as seamstresses. But there were certainly ironmongers in the arcades, and from one of them Charlotte bought a long-handled kitchen knife. From another stall she acquired a black hat and green ribbons. Green had been the first colour of the Revolution of 1789, signifying the springtime rebirth of freedom. Now it would be dangerous to sport it. But that was the least of what she was contemplating.

Charlotte was put out by news of Marat's illness, since she had wanted to kill him in the Convention itself. But she was not put off. If she had to do the deed at his house, so be it. That evening she wrote a farewell to her father, and a letter to her Girondin mentor Barbaroux explaining that she felt compelled to kill Marat so that many more might live. The shame and the crime, she said, would be in not doing anything. A third letter was for Marat himself, bait to get an audience: a promise of information about enemies of the Republic in Caen. Then Charlotte sewed her apologia and her baptismal certificate to the inside of her dress.

The next morning, bearing the letter, she attempted to see the Friend of the People, but was stopped at the door by the vigilant Simone Evrard. Disconsolate and uncertain what to do, Charlotte wandered around the streets for a while, resolving eventually on another attempt. This time she showed up in the evening at the time when bread and news (which were much the same to Marat) were being delivered. Charlotte got a foot in the door with her story and letter. Simone was still uncertain as to whether this was a good idea, but was overruled by the voice from the bathroom calling down, 'Let her in'.

They talked for about 15 minutes. Then Marat needed more kaolin, and Simone went to prepare it. Victim and assassin were alone. Charlotte recited a list of the names of her 'traitors', to which Marat grunted in satisfaction, 'Good, I will have them all guillotined within a week'. That did it. Charlotte reached inside her dress, and had time for one decisive lunge. It hit Marat near his clavicle, and, amazingly, given the haste, cut through the carotid artery. By the time he was shouting for help, his blood was pumping into the bath. When Simone and Marat's assistants came to his aid with a tourniquet it was already too late. A scuffle ensued in the room: one of them threw a chair at Charlotte, another pinned her down by her breasts. But she meant to be captured. When news spread in the tight and militantly Jacobin district, there were screams and shouts as she was taken to the Abbaye prison. A woman yelled that she would like to dismember the monster Corday and eat the pieces. In prison, glorying in her deed, Charlotte made arrangements to have her portrait painted before she mounted the steps to the scaffold. When she did so, it was in the scarlet dress of a parricide. The falling rain made the dress cling to her. Women spat on her as she passed, but one young writer disaffected from the Jacobins said the sight of her was so overwhelming that he was in love with her for a week after her execution.

IX

WHEN NEWS OF THE ASSASSINATION was brought to the Convention there was an immediate outbreak of shouting and sobbing, grand eulogies and laments taken from stage tragedies. Given the success of David's funeral and painting for Lepelletier, it was inevitable he would get the call. Pointing to the Lepelletier painting that hung on the Convention wall, one of the deputies, Guirault, invoked his creation of Lepelletier as a republican martyr and called out, 'David…where are you? … There is one more work for you to do.' 'I shall do it,' he replied. How could he not?

The painting *A Marat* was, then, intended to be a pendant for the Lepelletier. But there was one serious difference from that earlier commission: the season. Lepelletier had been embalmed and laid out in the depths of winter. This was the hottest July anyone could remember, and Marat's body was in any case not in prime condition. The raw red skin was beginning to turn an alarming shade of green even before David's top embalmer and five assistants could get to him. Some cosmetic work was immediately necessary. The tongue ligature of the Friend of the People had to be cut to prevent it from lolling out of his mouth, and the face itself had to be heavily whitened. But it proved impossible to close Marat's eyes completely,

A MARAT, 1793, oil on canvas (Musées Royaux des Beaux-Arts de Belgique, Brussels).

giving him precisely that hooded, toady look of Girondin demonology. For three days the body was laid out in the deconsecrated church of the Cordeliers, where it was raised up high on a Roman bed similar to the one used for Lepelletier, with a great candlestick stationed on each corner. Although David could hardly have Marat sitting up as he had last seen him, he wanted the arm that had continued to write for the People to be visible. But rigor mortis had made that so difficult that an arm from another corpse had to be found and attached – not altogether successfully, since one morning, distressingly, the arm was found on the floor, separated from the body but still holding the pen. After a torchlit procession through the streets, and republican sermons that naturally compared Marat to Jesus, his body, minus his heart, was interred in the gardens of the Cordeliers. The heart was set in a porphyry urn that was then suspended from a silken cord above the venerating public, swinging to and fro, *a perpetuum mobile* of the Revolution.

David, then, was all too aware of how provisional were these rites of preservation. In their eulogies many of the Jacobins had declared that the truest revenge against the assassin's crime – which had been to obliterate Marat – would be to make him forever present, not only in memory but in sight too. David's painting was supposed to do just that – to make Marat-Martyre (the play on words wasn't missed, of course) permanent as the holy icon of the Republic.

It was David's greatest challenge, not least because the image had to work in two potentially contradictory ways. It had to console and comfort, but it also had to excite and inspire. His first obligation was to make Marat – of all people – into a neo-classical quasi-biblical hero; someone whose face and body were transfigured into the highest ideal of humanity by the sheer force of inner virtue. So, of course, David cleaned him up even more completely than he had done for the funeral. Instead of a lurid, flaking mess, Marat's flesh seems to be made of imperishable marble: a republican Pietà, its redeeming pallor in sharp contrast to the deep blood-red of the bathwater (one of the few representations of painted blood to get that colour alarmingly right). David evidently thought hard about the angle at which he would pose the head so that Marat's features could be shown to best advantage. The raw and the real are discreetly understated. Marat's terrible psoriasis is indicated by a faintly rosy rash appearing on his arm, and the deep tearing gash inflicted by Corday becomes a delicate incision of the kind used for the wound in the side of Jesus, his alter ego. Like the earlier redeemer, Marat-Martyre was also famous for his self-imposed poverty ('He died while giving his last crust of bread to the poor,' David would say in the Convention), his scourging of the rich and powerful, and his invincible determination to speak his mind.

But at the same time that the painting had to be monumental, it had also to be documentary. In his mind's eye David saw, as he would say in his speech to the Convention when he presented the painting, 'mother, orphan, widow, soldier...all you whom he defended at the cost of his life...gather round'. It was crucial that these pilgrims should be able to follow the story of Marat and his heinous murder through the painting, to 'see his pen, the terror of traitor, fall from his hand'. By combining the depiction of an idea and the chronicling of an event, David was recycling *The Tennis Court Oath*. This was David trying to reconcile two anciently opposed ideas of what art should *do*: report the real and inspire through the ideal. The best revolutionary art, the best revolutionary *politics*, ought to do this, he supposed – to minister to the reality of the people, while guiding them towards the sublime ideals of republican virtue: liberty, equality and fraternity.

Unlike *The Tennis Court Oath*, David had his own personal memory to draw on for his memorialization – the bath, the desk, the quill pen – and the cast of characters was helpfully reduced. But not to just one. David conceived of his picture (as he had done with the *Brutus*) as a drama of opposites, of good and evil. All his skill as a still-life painter was used to pair off the good pen and the evil knife. David changed the handle of Corday's actual knife from ebony to ivory, the better to highlight the brilliance of the drops of blood.

And then – for David seems to have been incapable of doing history paintings except as family romances – there are the good and evil women. Charlotte Corday is present in the form of the deceitful letter, stained with Marat's blood (page 181), which had said, 'It is enough that I am truly *miserable* for me to have a right to your benevolence'. This was not in fact the letter she had used to gain entry, rather the lure of informing on traitors to which Marat had instantly risen. But it suited the sanctity of David's picture that Marat should seem to be the victim of his own generosity rather than the rabid traitor-hunter he actually was. Opposed to the unnatural she-monster, a disgrace to her sex, was Natural Woman: the widow and mother, patriotic, sacrificing and fruitful. (Before she had gone to the guillotine, Charlotte was subjected to court-ordered vaginal examination in an effort to prove she was a whore as well as an assassin, but the physician was obliged to record that in fact she would die intact.) So on Marat's improvised desk – suggesting both coffin and tombstone – lies another letter from the widow of a French soldier fallen in battle, and mother of five good republican children. To whom, of course, the sainted Friend of the People has already given *assignats* – the paper currency of the Revolution – as a pension.

Ultimately, though, after the good and the wicked had been pointed out, after the lesson in revolutionary virtue had been given through pictured story-telling,

David wanted his *Marat* to transcend the details, for the vision of it to linger indelibly. Somehow, without robbing the history of its particulars, he had to make it seem a moment of eternity, pregnant with destiny not just for France but for all mankind. Where he can, he needs to clear the clutter. No map of France, then, no crossed pistols, and definitely no huge painted slogan of DEATH on the wall! Instead, David uses his brushiest technique (for, like Rembrandt, he could do delicate and feathery as well as hard and crisp) to describe the back wall, the paint laid on so loosely that the substance of the wall seems to dissolve within it, not containing the space but opening it to posterity, the forever, to which Marat-Martyr now belonged. And that simple desk both invites identification – the writing place of the new Jesus, the Man of the People – and, because of the physical barrier it sets before the fallen hero, obstructs it. Like that first Saviour, David wants to say, he is both of you and not of you; a common citizen, but also an imperishable divinity of revolution. The loving care David has bestowed on the grain of the wood is both his testament to the fallen hero's apostolic simplicity and his act of valedictory comradeship. The inscription of the artist's name beside Marat, with the revolutionary date, is a visible gesture of their fraternity, like the arm of Horatius locked about the waist of his brother.

X

IT'S HARD TO IMAGINE, after more than two centuries, what the painting did to people in Year II of the Republic, not least because, although the cult of Marat was sensational, it didn't last very long. Now the painting is hidden away in an underlit space in the modern extension of the Royal Fine Art Museum in Brussels. The unnerving beauty of the green baize that covers the bath, of Marat's holy pallor and of the incomparable realism of the bloody water are leached away in the unforgiving gloom. It's as though backhand compliments were still being paid to its sorcery and to its power to hold the viewer in thrall. But when cool television lights flooded the painting, the magnificent monster roared out of its cavern of dimness to be revealed in all its mesmerizing power. The hypnotic effect is not a figure of speech. The painting emits some sort of unearthly hum that seems to vibrate from the brushy marks at the back of its box, and if you stare at them long enough, the apparition of the butchered saint begins to bob and float and drift, untethered from its containing frame. Crazy? Absolutely. Why not hop on the Eurostar and see for yourself?

Trapped in the interplanetary aura of the damned thing, it takes a real act of will to bale out, shake off the ju-ju witchcraft, pinch oneself and say over and again,

'It's a lie…it's a lie…it's a lie.' Which it certainly is. It's the transfiguration of a paranoid whose happiest hours were spent hunting down and bringing to their death not just obvious traitors, but the pathetic remnants of the régime he thought had persecuted him and oppressed France – ancient courtiers with shaking chops; haggard ex-courtesans of Louis XV; painters who had made the mistake of serving the court or the nobility and who, unlike David, had failed to see the error of their ways in time; lawyers, guards officers, abbots, nuns, sailors, actors and countless small fry who somehow had got themselves incriminated by toasting the King in a tavern; tramps, whores, flower girls, carpenters, sextons, ostlers, grooms – everyone and anyone whose only crime had been birth, neutrality, indifference, self-preservation, a treasonable failure to understand that all life is political.

The painting took David just three months to complete – an astonishingly short period given its phenomenal quality and the fact that at the same time David was also designing and executing the immense, bombastic revolutionary festivals that were intended to replace Catholic ritual. On 14 October he put it on public exhib-ition in the courtyard of the Louvre, where (as in the days when he painted for the King) he had his studio. Two days later Marie-Antoinette was taken along the rue de Rivoli on her way to the guillotine. As her tumbril passed, women spat on her head from their balconies. She didn't move. Watching the scene, David made a *croquis*, a lightning sketch, of the woman who had – more than her husband – been made to personify all the evils of monarchy: extravagance, folly, ambition, lust. Revolutionary propaganda had caricatured Marie-Antoinette as an insatiably vicious Messalina, half whore, half harpy; someone who, it was alleged by the prosecutor at her trial, had taught her own little son the practice of self-abuse so as to weaken his constitution and alienate him from his republican re-education. But David – who was capable of caricatures and even made a cartoon satirizing George III and the British – did not, on this morning, make a caricature. It's both better and worse than that, and the polar opposite of the sanctification of Marat: an impassive, brutally indifferent outline of the haggard wreck the former beauty had become. But although you could read the sketch as a gloat, it also seems to give Marie-Antoinette her proper due of dignity and defiance.

Presenting his *Marat* to the Convention a month later, David made, notwith-standing his impediment, a speech: 'Citizens, the people…yearn to see once more the features of their faithful friend. David, they cry, seize your brushes, avenge our friend. Avenge Marat…I heard the voice of the people. I obeyed.' The speech was greeted with applause and the painting, hung opposite Lepelletier, with rapture. Arrangements were made for 1000 printed reproductions to be made so that it

Top: MARIE-ANTOINETTE ON HER WAY TO HER EXECUTION, 1793, pen and ink on paper
(Bibliotheque Nationale, Paris).
Above: STUDY FOR LOUIS XVI TEACHING HIS SON THE DAUPHIN THE CONSTITUTION, 1792, pencil
on paper (Musée du Louvre, Paris).

225

could be circulated through all the departments of France, and, on David's proposal, for Marat's remains to join those of Voltaire in the Pantheon.

By this time the Revolution had turned into a war dictatorship. The assassination of Marat, together with the fact that the war had been taken to rebel provinces in the south and west, had, Robespierre argued, made a 'revolutionary' rather than a constitutional government imperative. The safeguarding of liberty, then, required the imposition of a military-police state. The republican constitution enacted by the Convention was declared suspended until 'the peace'. France was governed by an executive Committee of Public Safety that took for itself draconian powers of requisition, mobilization and punishment more formidable than anything the old regime had ever attempted. A Law of Suspects did away with even elementary rights of defence for those brought before the revolutionary tribunals. And a Committee of General Security was made responsible for political policing and the judgment of those suspects. Among its members was Citizen Jacques-Louis David.

Many of those whom David had known in former lives – the Lavoisiers, the painter Hubert Robert, Barnave and others – came before the Committee and were sentenced. Robert (who would be one of David's accusers after his fall, and who had specialized in ruins, including the Bastille as it was being torn down) found himself in a revolutionary prison and did some forlornly beautiful sketches of life within its walls. But David, now close to Robespierre himself and installed as the cultural commissar of French Regeneration, had more important business to see to than mere paintings (although he did paint another martyr for public edification – the 13-year-old Joseph Bara, who had been shot and killed by royalists in the civil war in the Vendée. Ordered to surrender his horses, what Bara had actually shouted out was, 'Up yours, you fucking crooks,' translated by Robespierre and David, of course, as '*Vive la République*'. David completed the editing job by turning Bara into a beauteously androgynous nude, located, like Marat, somewhere between a wall and eternity.

Now his work was to fashion cradle-to-grave republicans. So he designed, *inter alia*, costumes for republican magistrates and legislators; a colossal Herculean statue of the People; an opera curtain featuring another colossus with sundry martyrs (including Marat) processing behind it; and four public festivals. For the Festival of Unity he created four stations: one at the Bastille, featuring a Fountain of Regeneration in the form of an Egyptian figure from whose ample breasts the pure milk of liberty gushed. The most bombastic was the Festival of the Supreme Being, during which Robespierre set fire to a pasteboard figure of Atheism, which burnt away to reveal Wisdom. On the Champs de Mars, where the Eiffel Tower now stands,

200,000 watched Robespierre ascend David's Mountain to the sound of choirs of massed virgins. Meanwhile, copies of his *A Marat* were circulated throughout the conquered provinces of France. Zealous parents renamed their children Marat; and even towns changed their names to immortalize the fallen sainted Friend of the People.

In the end, David fell victim to his own success. For it was precisely the unreality of evermore pretentious, if not megalomaniac, ceremonies that began to alienate the more pragmatic members of the Committee of Public Safety, who had a European war on their hands. Robespierre and his group of associates, who certainly included David, were increasingly seen as abusing emergency powers to eliminate anyone they had decided was lukewarm or at all equivocal in loyalty towards the messianic dictatorship.

Inevitably, then, came the day of a pre-emptive strike, on which Robespierre listened incredulously in the Convention as the fatal accusing words '*hors de la loi*' – outside the law – were cast on him as he had cast them on so many others. Thunder-struck, David got to his feet, stammering words taken directly from one of his own paintings, the one that had been done for the now guillotined Monsieur Trudaine, *The Death of Socrates*. 'Robespierre,' he shouted, 'if you take the hemlock, I will drink it with you!'

But of course he didn't. On the following day – when Robespierre was over-whelmed in the Convention with denunciations and, along with his closest allies, bundled off to prison, where he attempted to kill himself, but managed only to shoot himself through the jaw – David was conspicuously missing, indisposed. So he was spared the guillotine, and the sound of Robespierre's shrieks as the executioner pulled the bloody tourniquet from his jaw so that the blade could have a clean run.

His enemies were closing in. Five days after Robespierre's execution David was himself denounced in the Convention as a 'tyrant of the arts' and a traitor. He attempted to stammer out a defence, but the few words that came to his lips were unintelligible. Witnesses, though, noticed the sweat that soaked through his shirt and dripped to the floor. All his ghosts came back to haunt him. Initially he was imprisoned in the building that had housed the Tax Farmers, where Lavoisier had had his office. Then he was moved to the Luxembourg (not so long before a palace where Artois, among others, had held court). And there the traumatized 'Pageant-Master of the Revolution' suddenly had another conversion, this time out of, rather than into, politics. When interrogated, he claimed (of course) that he confessed to nothing more than naivety; to having been led astray by wicked, much cleverer men whose despotism he had never seen. 'My heart was pure,' he said. 'Only my head

was wrong.' If he had served as a member of the Committee of General Security, it had been as a patriotic duty – and during that time he had gone out of his way to intervene to preserve the innocent from the guillotine, including some of the artists who now stood as his accusers. But of course he still wasn't much good at talking. So instead he submitted his not-guilty plea in the form of another self-portrait: the honest soul in anguish.

Everything about it seems both calculated and instinctive. He's looking, distraught, into the mirror. You cannot possibly interrogate me, the image says, more unsparingly than I scrutinize myself. His *houppelande* – the great floppy-collared shawl-like coat favoured by Jacobins, including Marat – is opened wide to expose David's transparent heart, pulsing with good intentions. The honest self-examination extends, for the first time, to a portrayal of the fleshy bulge on his cheek and slightly twisted mouth, although not so honestly that it could give the impression of being literally two-faced. But the most startling thing David has done is to turn back the clock. Compare the 1791 and the 1794 self-portraits, and the latter looks so confusingly like that of a younger man that it has sometimes prompted art historians to wonder about its dating. Yet the dates are correct. What David has done in his mirror is to wish himself into the man he was before the Terror: younger, more innocent, untouched by politics.

David, who had made a career insisting that art's highest purpose was public and moral, now tried to start another one by reasserting its autonomy. So from his window he did the most politics-free image imaginable: a little autumnal landscape, a prison pastoral, *View of Luxembourg Gardens in Paris*, 1794. And since he has reverted to being, he believes, first and foremost, *just* a painter, for the first and only time he paints himself with palette and brushes. These had been secured for him by his long-suffering wife Charlotte. In the spring of that year, at the zenith of David's power, there had evidently been a domestic argument over the artist's vote for the death of the King, and over the question of whether art ought to function as propaganda. The scene could have been drawn straight from one of David's Roman histories: the misguided, sentimental, soft-hearted woman appealing in vain to the stern, inflexibly righteous republican. At least David didn't condemn his wife to death; merely to divorce, under the new dispensations offered by the Revolution. Naturally – as per the *Horatii* and the *Brutus* – the children were divided by gender, David taking his sons and leaving the girls to his wife. But now he suddenly rediscovered the joys of family life. Charlotte, with the help of friends, procured paints and canvas for him in prison, and attempted to communicate outside the barred window. The chastened Brutus melted, as well he ought.

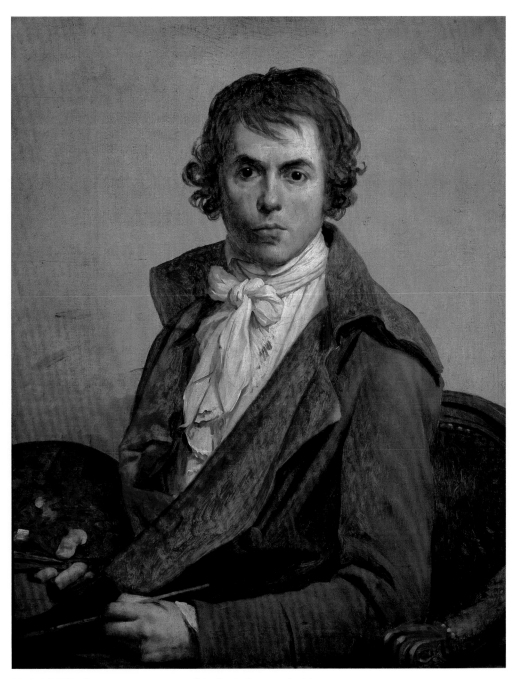

SELF-PORTRAIT, 1794, oil on canvas (Musée du Louvre, Paris).

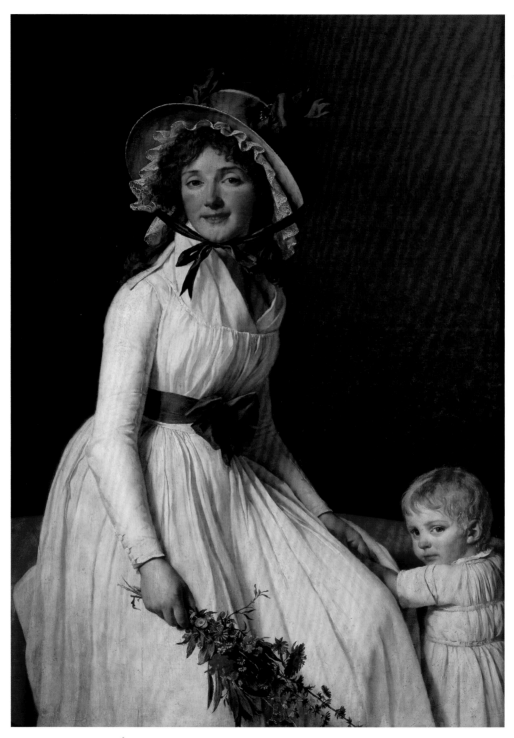

MADAME EMILIE DE SÉRIZIAT AND HER SON, 1795, oil on panel (Musée du Louvre, Paris).

David

The Art Defence worked! Twice imprisoned and twice released, David did in the end escape the punishment he had meted out to others. And the paintings he executed around 1795 all testify in their different ways to this abruptly refound sense of the priority of humanity over politics, painting over ideology, family over duty. A pair of portraits of his sister and brother-in-law, Madame and Monsieur de Sériziat, with whom he recuperated in the countryside from his ordeal, are both studies in domestic good nature. Monsieur de Sériziat wears his riding clothes, the tricolor banner of the Republic shrunk to nothing more than a fashion accessory, a cockade, itself only half visible, on his elegant hat. His wife, Emilie de Sériziat, is all wild flowers and rosy cheeks, her bonny little one at her side.

What was sundered by the *Horatii* and the *Brutus* – men from women, parents from children – has remorsefully been put back together. Now family affection commands public duty not the other way around. When David does another immense history painting (this time for the public, taking a fee for admission), *Intervention of the Sabine Women* (page 232) carries the opposite message to the earlier Roman tragedies. In this picture, mothers are the heroines and come between camps of warring men – the Sabines and the Romans. Raped or not, the Sabine-Roman women hold up their naked babies in the face of massed weaponry. Cherubic faces, chubby bottoms and fecund breasts come between the ferocity of male heroes, and this time they prevail. The two sisters who modelled the principal figures horrified David by stripping, unbidden, to show him they had what it took to stop war in its tracks. They were right. For the first time, beauty vanquishes the beasts. And David went on, for some time, doing beauties.

This is not to say that he was now immunized from having art serve the bidding of power. Another four years of precisely the relentless political and armed strife symbolized in his *Sabine Women* may well have persuaded him, like so many Frenchmen, that a firm hand was needed. But David, of course, showed himself more than ready to paint that hand firmly gripping the reins of power, as Napoleon, the new Charlemagne and Hannibal rolled into one, crosses the Alps (*Napoleon Crossing the Alps at the St Bernard Pass, 20th May 1800*). Some of the enormous Napoleonic paintings are weary retreads of old masterpieces that inadvertently betray the bankruptcy of the form. *The Distribution of the Eagles* is a servile threnody to the glories of the military Empire, in which Napoleon's marshals rehearse the gesture of the *Horatii* and *The Tennis Court Oath*, but this time with nothing more than *la gloire* and their own gaudy finery on their minds, slavishly glamorized by the court painter of Bonapartism.

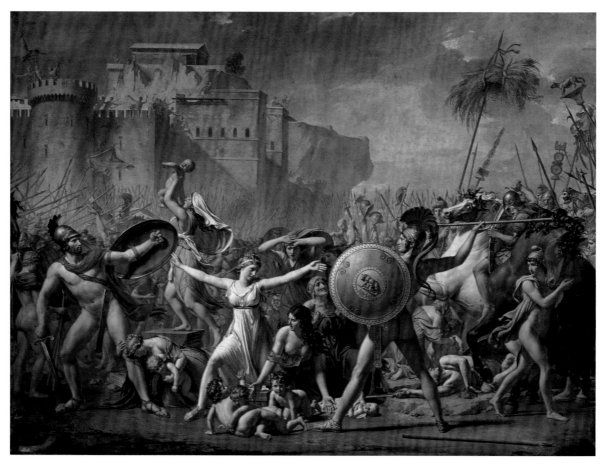

INTERVENTION OF THE SABINE WOMEN, 1794–9, oil on canvas (Musée du Louvre, Paris).

XI

DAVID'S CAREER AS PROPAGANDIST, then, ends in debased self-parody. The painter who invented a story to refute the charge that he'd dallied with a portrait commission for Louis XVI was happy to do Napoleon over and over and over. And he paid a price for his obliging servility. In 1814, after the defeated Emperor was packed off to Elba, the restored King Louis XVIII and his government decided to amnesty even those like David who had voted for the death of Louis XVI. But the brief intoxication of the Hundred Days after Napoleon's escape, in which it seemed that he could recover his power, changed that. Two of David's sons served in the imperial army, and he himself was visited by Napoleon and awarded the Legion of Honour. After Waterloo there was no more forgiving and forgetting. In 1816 David and those who had made the same mistake were banished for good.

He spent the next ten years in Brussels, a big fish in a small pond, painting portraits – some fine, some not – and histories of such glossy weirdness that they exert their own slightly deranged spell even now. There was a circle of pupils and the occasional admirer from Paris; but mostly David was a back number. When he died on 29 December 1825, he was embalmed (more successfully than Marat). A plaster cast was made of his painting hand and set in his coffin, along with his palette and brushes, and his heart was placed in an agate urn. Behind the hearse, drawn by six black horses, processed a file of pupils carrying placards bearing the titles of his most famous paintings – although not, for sure, the notorious twosome of *Lepelletier* and *Marat*, both still in the possession of the artist at his death.

Requests to the Restoration authorities for his remains to be repatriated to France were denied. There would be no plot of France for David, whose entire life had been about the fate of his country, to lie in. Permission was granted, however, for the pictures in the family's possession to be brought to Paris for sale. An exhibition was arranged for them all – except one, the *Marat*, still deemed too incendiary for display. The painting was kept concealed in the lodgings of David's son; visits could be made only by special arrangement and with a police permit. But no one wanted the thing anyway. It was a pariah.

Someone did want its mate, the *Lepelletier*, and that someone had been an eight-year-old girl when she had first seen it brought to the Convention by the artist: Suzanne Lepelletier, his daughter. In fact, she wanted it so badly that she was prepared to pay the staggering sum of 100,000 francs for it – when most of David's works were going for 5000 or 7000 or even a few hundred. But Suzanne Lepelletier's motives were not entirely filial or aesthetic, for she had become a fervent royalist, determined to annihilate the embarrassment of her father's

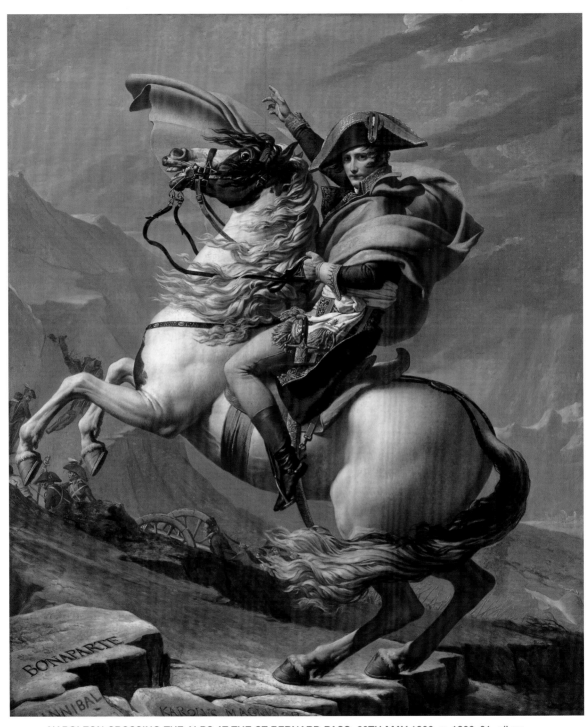

NAPOLEON CROSSING THE ALPS AT THE ST BERNARD PASS, 20TH MAY 1800, *c*. 1800–01, oil on canvas (Musée National du Château de Malmaison, Rueil-Malmaison).

revolutionary past. She was, in her way, an admirer of David, and had actually sat for a portrait by him. She paid the wizardry of her father's image the most back-handed of compliments by concealing it for as long as she lived and then burning it before she died. Even the engraving plates were mutilated beyond recognition, which is why our only idea of how it looked derives from drawings and prints made before its destruction.

But Marat had no children, either to redeem his icon or to destroy it. So it was both exiled and orphaned from the *enfants de la patrie*. But it did of course engender great and terrible icons down the generations: all those mummified Marxists – the Lenins, Maos and Ches – whose recumbent figures and sanctified features still have the power to convert utopian brutality into political piety. The comparison, however, does David a disservice, for unlike the waxworks of the dialectic, the *Marat* retains the power to startle, move and disturb. Despite everything it stands for, despite its place in the history of great lies, it remains shockingly, lethally beautiful.

Turner

PAINTING UP A STORM

I

OFF HIS TROLLEY, APPARENTLY; we have it on no less an authority than King George V. 'Turner was mad,' the King recalled. 'My grandmother always said so.' In May 1840, therefore, when Queen Victoria opened the 72nd exhibition of the Royal Academy (housed in the brand-new National Gallery), it was unlikely that she would have made a bee-line for the four Turners. With 900 pictures on display, she would have been more likely to have looked at herself, painted by the dependable Sir David Wilkie, or at other established favourites, such as Clarkson Stanfield, by common consent *the* great marine painter of his generation, famous for his clouds scudding over the briny.

But given the Queen's weakness for dogs, there's no doubt which painting in the 1840 show would have brought a smile to a face that in those days smiled a lot. *Trial by Jury, or Laying Down the Law* was the latest gem by Edwin Landseer. It featured, in the guise of the Lord Chancellor, a poodle, which gave the critics the predictable opportunity of declaring how the painting's charms gave them all paws. Waggishness aside, the chorus of praise for Landseer was fervent. When one critic called the picture 'a masterpiece of canine expression', he wasn't joking. 'What dashing facility combined with the most exquisite finish, what truth of imitation!' trilled *The Examiner*. 'Mr Landseer makes the brute race infinitely more interesting than our own!' It was simply 'perfect': 'perfect in execution, perfect in conception, perfect in colour, taste and refinement'. In short order Landseer became the Queen's favourite painter, the epitome of modern British art.

There was another prominently hung painting about which the critics were also agreed, but this time in scorn: Turner's *Slave Ship (Slavers Throwing Overboard the Dead and Dying, Typhoon Coming On)*. The very title provoked titters from *Punch*, which parodied its title as '*A Typhoon Bursting a Simoon over a Whirlpool Maelstrom, NORWAY, a Ship on Fire, an Eclipse with the Effect of a Lunar Rainbow*'. But the laborious jokes at Turner's expense, many of them featuring accidents in the kitchen with pots of mustard and tomato sauce, shared column inches with expressions of contempt for the outrage that they believed Turner had perpetrated with this latest monstrosity. Reaching for the sublime but sinking ignominiously into the ridiculous was the general view. 'Who will not grieve at the talent wasted upon this gross outrage of nature?' For the critics, the abomination managed to be somehow

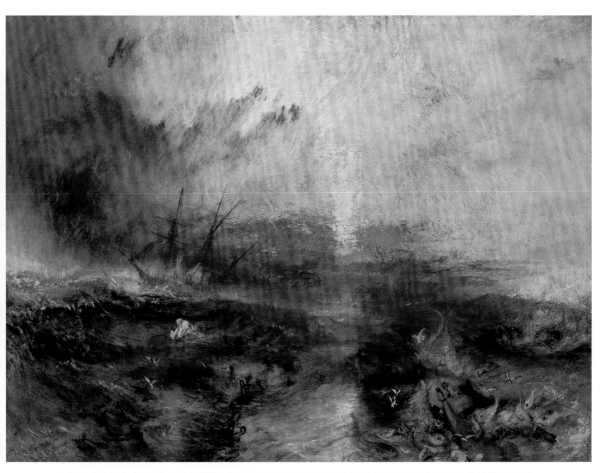

SLAVE SHIP (SLAVERS THROWING OVERBOARD THE DEAD AND DYING, TYPHOON COMING ON),
1840, oil on canvas (Museum of Fine Arts, Boston).

both senile and puerile, since Turner was apparently determined to return painting to 'the infant school of art'. (The obsession with fraud, madness and infantilism anticipated exactly the choice of abuse heaped on abstraction a century later.) When the influential *Art Union* – the mouthpiece for new British painting – described him as 'a madman who says wonderful things between the fits that place him on a level with creatures upon whom reason never had been bestowed', the insult may have cut deeper than the writer knew. Turner's mother, Mary, had died in Bethlehem Hospital for the Insane – Bedlam – after being left there by her son and husband.

It was, in any case, no time for tact. The Reverend John Eagles, who wrote as 'Sketcher' for *Blackwood's Magazine,* and had, he boasted, taken out 'letters of marque…to burn, sink and destroy' Turner's 'extravagant vagaries', believed that the old boy had become a menace to the future of British painting. 'He is now doing more mischief to art than his more sound genius ever did good,' Eagles warned. Impressionable youth would be led astray and believe that slovenly daubing was poetic painting! The critic of *The Times* agreed. Turner had 'produced such detestable absurdities under the technicality of effect that it is surprising the [hanging] committee have suffered their walls to be disgraced with the dotage of his experiments'. The consensus was that it would be 'a great kindness' – to the Academy, to the public, to national taste and above all to himself – 'to induce him to withdraw his strange performances'.

The fact that Turner's ostensible subject in 1840 was the atrocity of slaving made the lurid histrionics of his painting, if anything, even more unpardonable. For the mutton-chopped Good and Great who strolled through the Academy show were the same Good and Great who were congratulating themselves on having the institution of slavery eliminated from the British Empire two years earlier, although the original legislation had been passed in 1833 (page 286). While Turner's painting was hanging in the Academy, two abolitionist conventions were meeting in London. One of them, Thomas Fowell Buxton's 'Society for the Extinction of the Slave Trade', had secured no less than Prince Albert as its honorary chairman. His first independent appearance in public after marrying the Queen was to speak for the Society. So it was especially offensive to some that Turner would seek to perpetrate one of his unfortunate ravings on so solemn a matter.

Happily, though, there was another painting in the exhibition devoted to the iniquities of slaving: it was by a French artist, François-Auguste Biard, and this one, the critics all agreed, did proper justice to its frightful subject. Instead of a vermilion spray, there was a wharf on which Africans were being herded in head-yokes. 'Sulky

Top: TRIAL BY JURY, OR LAYING DOWN THE LAW by Edwin Landseer, 1840, oil on canvas (Chatsworth House, Derbyshire).
Above: THE SLAVE TRADE by François-Auguste Biard, 1835, oil on canvas (Wilberforce House, Hull).

negroes' were already receiving the lash; others were being yanked about in chains, while an indolent buyer in a straw hat sprawled at his leisure. And just in case the self-righteousness palled, the scene was spiced up by the figure of a half-naked black beauty awaiting her own fate with a look of voluptuously crestfallen resignation. 'Michelangelo Titmarsh', aka the writer William Makepeace Thackeray, who had denounced the Turner as an absurdity, thought the Biard just the ticket. 'It stirs the heart more than a hundred thousand tracts, reports or sermons…let it hang in the National Gallery along with the Hogarths.' 'We have seen representations of the horrors of plague, pestilence and famine,' wrote another critic, 'but we never saw a piece of more real and deep pathos [than the Biard painting].' He ventured to hope that the picture would be engraved and cheaply printed for mass distribution, and that it would be shown in America where the shame it engendered was most pressingly needed. When the Society for the Extinction of the Slave Trade decided to make a gift of a picture to its patriarch-founder, Buxton, it was, of course, the Biard they chose. Now it hangs in Wilberforce House, while Turner's *Slave Ship* hangs in Boston.

II

DID TURNER MIND? How could he not mind? 'No one felt more keenly,' his friend the Reverend H. S. Trimmer wrote, 'the illiberal strictures of the newspapers. I have seen him almost in tears, I have seen him ready to hang himself though rating their opinions at their worth.' The barbs must have caught this time. Into the *Slave Ship* Turner had poured all his poetic skills: a detonation of bloody light; the deep carving of space; the symphonic rhythm of bounding forms. And the storm of derision that greeted the painting must have been all the harder to take because it came just a year after Turner's most famous success. *The Fighting Temeraire Tugged to Its Last Berth to Be Broken Up* had been received with almost universal enthusiasm. It was then, as it still is (by popular vote, no less), *the* Great British favourite. So why was the one painting such a critical and popular success and the other such a failure?

The two pictures, after all, had more in common than met the eye. Both were British marine history paintings. Both turned on a drama of life and death. Both enacted their scenes beneath a flaming sunset. But there the similarities ended. *The Fighting Temeraire* was designed to reassure; *Slave Ship* was calculated to unsettle. Even Turner himself felt the difference, calling *Fighting Temeraire* 'my old darling'. But there were no endearments for *Slave Ship*. *The Fighting Temeraire* is British history as bitter-sweet valediction; the honoured veteran of Trafalgar, painted wanly

THE FIGHTING TEMERAIRE TUGGED TO ITS LAST BERTH TO BE BROKEN UP, 1839, oil on canvas (National Gallery, London).

in the colour of old parchment, an apparition from the heroic past, got up for its last voyage in a manner that could never have been, masts erect, sails furled, grandly looming over the Thames. The upstream progress of the old warrior makes no more than the gentlest of ripples on the surface of the river. The small boat, on the other hand, is painted opaquely, sharply, the iron and steam future chugging sootily upstream. For some Victorians – Thomas Carlyle above all – steam engines hissed at the mouth of hell. If Britain went that way, it would sink into philistine, utilitarian, money-grubbing amorality. But Turner didn't feel the same way at all. Technology was a fact of life; the British future. So his *Fighting Temeraire* is a placebo for the anxieties of a transitional age. And it's faithful to a commonplace about the genius of English history being (for Edmund Burke, for example) a mystical marriage of past, present and future. To be British, in that view, was to honour the past without being enslaved to it. To be British was to invent the future without being coarsely intoxicated by it. It was to feel the tension between what has been and what must come, but not to be torn in two by the tug.

Nothing, on the other hand, could have been less conciliatory or less comforting than *Slave Ship*, a voyage into a sweaty nightmare; incoherent in its several parts; implausible in its rendering of the sea; fantastic in its action; frantic in its apocalyptic striving. *The Fighting Temeraire* was a lullaby, *Slave Ship* is a cry from an opium dream. And yet it's much the greater painting; the failure a more profound work than the success. For it was Turner's most ambitious attempt to create a modern British history painting that wasn't mechanically anecdotal. Its force would be poetic, its attack on the moral imagination as fierce as anything penned by Milton or Shakespeare, or painted by Rembrandt.

It is, I suppose, Extreme Turner. The artist took the risk of daring to make a moral epic, and was unprepared for the very worst that sound British opinion could inflict: facetious embarrassment. Better by far the 'perfect' poodle than tragic over-reach. Which is why, in the end, *Slave Ship* (like Rembrandt's *Claudius Civilis* and David's *A Marat*) is yet another orphan of art history, a lost child in exile, this time in Massachusetts.

Stranger still, almost *all* of Turner's greatest histories remain largely inaccessible to the British public. To see the two stupendous pictures of the burning of the Houses of Parliament in 1834 you have to go to Cleveland, Ohio (where you could also take in the Rock and Roll Hall of Fame) and to Philadelphia. The unfinished but thrilling *Disaster at Sea* (in fact *The Wreck of the 'Amphitrite'*, begun in 1835) and the spectacularly cinematic *Battle of Trafalgar* remain bafflingly shut away in storage at the Tate's warehouse in Southwark. Only *The Field of Waterloo* can be seen in Tate

Britain, but you have to know where to look for it – in a generic gallery dedicated to Romantic taste, rather than with the bulk of the Turners in the Clore Galleries. It's as though the historical Turner, the maestro of gore and pathos, is *still* a bit of clunker to critics and curators alike. Never mind the bodies, bring on the Grand Canal.

III

THIS IS A PITY, since Turner saw himself first and foremost as a British patriot-painter who shared a birthday, St George's Day, 23 April, with Shakespeare. Now he is remembered for *The Fighting Temeraire* and *Rain, Steam and Speed*, 1844, and for Venetian deliquescence. But nothing truly stirred him more than the twin epics of British geography and history. When he could put them together – as in *Dolbadern Castle* (page 246), painted as his admission piece for an Associate Fellowship of the Royal Academy in 1800 – his touch for visual drama was perfect. In reality, Dolbadern was just another mossily eroded ruin on a modest knoll overlooking a lake in Snowdonia. Behind it, serious mountains rose steeply, further diluting the topographical drama of Dolbadern itself. But for Turner, the granite outcrop was pure bardic opera. He drank in the Gothic legend of the Welsh prince Owen Goch, imprisoned in the fortress, and then took scenic liberties for liberty. The invidious peaks were disposed of, the little hill was pumped up into a mountain, the angle of ascent made precipitous. Then Turner heightened the emotion by backlighting the crag and piercing it with a forlornly glimmering window. Dolbadern itself stands lonely and rugged, a petrified personification of Owen Goch. Just in case the point should be lost on anyone, Turner supplied a few verses of his own straining lament for incarcerated freedom to be included in the catalogue – a practice he would make habitual for almost all the works about which he felt most deeply.

The theatrical had never been very far away. Turner was, after all, the cockney 'sparrer' from London's Maiden Lane; his dad, William Turner, a wigmaker and barber to all sorts from quacks to quality. Although Turner claimed never to be much of a theatre-goer, he could hardly avoid the perpetual carnival that was Covent Garden Piazza: its parade of hucksters and whores, chancers and dancers, freaks and charlatans, beggars and marks, Society on the look-out for pleasure, and plenty of players ready to give them a nice old dose of it. Right opposite the Turners' house in Maiden Lane Richard Porson delivered his famous Shakespearean recitals in the Cider Cellar. And the shows of Covent Garden, indoor and out, gave Turner a feeling for the charivari of life which, every so often, he would transfer to canvas.

DOLBADERN CASTLE, 1800, oil on canvas (Royal Academy of Arts, London).

The famous *Dort Packet Boat* of 1818 may be a study in voluptuously lit calm, but the ship itself is a tub of tight-packed humanity. It's Falstaff's army afloat, done the Dutch way, with knobbly noses, potato heads, bursting bodices and meaty rumps. Birds skim the harbour water, but there too bobs a fatly bloated cabbage. Unlike Hogarth or Rowlandson, Turner didn't make the choreography of the crowd his principal passion. But there was never a time when he wasn't aware of the public gawp, of living within it and perhaps playing to it. To tell the truth, he was a bit of a gawper himself.

It began – as all stories that start in Covent Garden must – in the theatre. His first drawing teacher was Thomas Malton, who was a scenery painter at the Opera House, but also an architectural draughtsman. This combination was perfect for Turner. He learnt Malton's hard-ruled lines and arithmetically precise proportions at the same time that he got a whiff of the smoke and mirrors of stage spectacle. His real – if indirect – tutor in the sensations of epic calamity was Philippe de Loutherbourg, an Alsatian-born artist who somehow managed to be both respected academician and Regency shlockmeister, designing painted sets and backdrops, and mechanical contraptions that took dumbstruck audiences deep into the sulphurous bowels of the earth or off to the seductive atolls of Otahiti. Disasters – avalanches and volcanic eruptions, plagues and infernos, drownings and slaughters – were Loutherbourg's bread and butter.

Young Turner followed where Loutherbourg, the impresario of catastrophe, led: to the Pantheon in Oxford Street – a theatre-cum-opera house, which in the autumn of 1791 hired the 16-year-old to paint drops and sets. Unfortunately, five months later the Pantheon staged its own disaster in the form of a fire that gutted the building. Turner, of course, hurried over to sketch the smoking ruin. He was out of a job but at least he'd have a marketable watercolour – for the London public couldn't get enough of fire and wreck.

But he and his Old Dad (his earliest guide) knew that the same public that oohed and aahed through Pantheon pasteboard apocalypses also craved more placid spectacles, especially visions of Albion fair. The years after the defeat in America (Turner was born a week after the 'shots heard round the world' from Lexington and Concord in April 1775) were the time when Britain became needy for consolatory images of its rustic delights. Better, for the moment, natural history than the other kind. So the market for landscapes, and for the monuments that said Old England for ever – castles and churches, palaces and country houses – was ready and waiting for enterprising printmakers. And it was very soon obvious that Turner, the quick and handy adolescent sketcher, could turn these out in his sleep.

Top: RADLEY HALL FROM THE NORTH-WEST, 1789, pen and ink and watercolour on paper (Tate Gallery, London).
Above: GROTTO IN THE CAMPAGNA by John Robert Cozens, *c.* 1780, watercolour on paper (Birmingham Museums and Art Gallery).

The life suited him. He had been getting out of the plaguey town and traipsing the towpaths and hedgerows for a while. It was probably anxiety about infection, especially since Turner's little sister had died at five, that persuaded his parents to send him off to a butcher uncle at Brentford. By the Thames, Turner began his lifelong addiction to the river, where he cast his line and hooked idylls of deep England. For a time, too, he stayed in Bristol, with friends of his father's, the Narraways, gluemakers and leather-dressers, developing another happy habit: his summer country tramps. Turner really was one of those wayside walkers with a stick hoisted over his shoulder to which was tied a bundle of necessaries: watercolours, brushes, a clean shirt, a loaf. He walked in the new Romantic fashion, lay in the grass staring at the racing clouds, then sat up and sketched them. Those skies would be the first place Turner could exercise his feeling for natural drama; and when he came to do his great history paintings, it was always the space in which the most exquisite or violent play of sensation would be written.

His sketches – already filling books – were good enough to give his father serious hopes. He hung the drawings in the window and on the walls of his barber's shop for the quality to see while they were being shaved, shorn and powdered. More important, the work was good enough to get Turner admitted as a student to the Royal Academy. There he would show watercolour landscapes throughout the mid- and late 1790s.

But even though he had broken into the world of the Academy astonishingly early, it would still have been assumed that, if Turner were to prosper, he would have to oblige propertied patrons, much as the young Gainsborough had done. What those patrons wanted were agreeable mirrors of their own good taste, especially where it concerned house and park. For the privileged classes, art both shaped and reflected the way they lived. Their properties had been landscaped by the likes of Humphry Repton and Capability Brown to resemble landscapes by the 17th-century French artist Claude. From their saloons they could look out over the terrace to admire their flocks of pedigree sheep and herds of deer grazing the meadow. But, alas, their own houses, freshly remodelled by an Adam, a Wyatt or a Gibbs in the style of Palladio, did not appear in a Claude, so artists such as Turner must needs be hired to complete the scene. And Turner's exercises in this vein, like *Radley Hall,* do exactly what they are supposed to do: show off (on each façade) the predictably handsome limestone pile, with its pilasters and sash windows framed by embowering oaks. It was visiting card art.

And he might have made a perfectly decent living servicing the *amour propre* of the landed while making his way up the ranks of the Academy. But when he was 19

or so, around 1794, Turner was sent to a sketching 'academy' in Bedford Square run by a physician-cum-amateur artist, Dr Thomas Monro, and everything changed. Monro was known to the Turners because he was treating Mary Turner, the artist's mother, whose terrible mental illness was making her difficult to keep in the family home. He ran a private mental asylum in Hackney and was chief visiting physician at the Bethlehem Hospital for the Insane, the institution to which, in 1799, Mary Turner would be committed by her husband and son. But when the young Turner arrived, Monro had another patient on his hands: the artist John Robert Cozens. This made Monro, by default, the custodian of some of the most startling and original images ever made by an English hand. No one had manipulated the sensations of the 'sublime' – the aesthetics of ecstasy, horror and terror – quite like Cozens. His ravines plunged, his peaks soared – the usual stuff. But he also did eerie things with his washes. Delicate colours floated on to the absorbent paper so that solid surfaces seemed to dissolve into the numinous radiance. And Cozens' draughtsmanship was original to the point of perversity: specialized in optical disorientation, pulling the eye into caverns and ravines where top was bottom and bottom top. The walls of Cozens' ancient buildings in Italy took on a pitted, geological aspect, rearing like cliff faces from which the viewer half expected taloned birds to soar and swoop.

Monro evidently knew that the Cozens watercolours were remarkable for he set his two most able protégés, John Girtin (himself a brilliant watercolourist) and Turner, to copying them. Their reward was oyster suppers and close contact with peculiar genius. Girtin did the pencil drawing and Turner the washes, at which he was already something of an inventive master. So Turner couldn't have failed to note how watercolour – usually the most demure medium – had been dramatized beyond recognition in Cozens' hand. The looseness of the medium had liberated him to do things that were impossible (so far, at any rate) with oils: his experimental washes and stains allowed the spontaneous blooms of colour to shape the atmospherics. The result was works that were never meant to be hidden away in an album: watercolour epics, physically large, conceptually brave. Suddenly it was the grandiose academic oils that seemed clotted, stale and sedate – so very dim, so very brown.

Cozens' ghostly presence in the Monro 'Academy' didn't make Turner an idiosyncratic loner, not yet; perhaps never. A large part of his personality was devoted to what he thought of as the Rules, and his temper was never consciously rebellious. Invited to study Sir Joshua Reynolds' spectacular collection, Turner gratefully seized the opportunity. Throughout a long career that would represent the overthrow of almost everything Reynolds stood for, Turner would never cease to imagine himself his devoted student and respectful admirer (unlike William Blake,

Top: LAKE BUTTERMERE WITH PART OF CROMACKWATER, CUMBERLAND, A SHOWER, 1798, oil on canvas (Tate Gallery, London).
Above: SELF-PORTRAIT (detail), *c.*1798, oil on canvas (Tate Gallery, London).

who annotated his copy of Reynolds' *Discourses* (1820) with the comment that 'this man was born to kill art').

Where he most dramatically differed from Reynolds was in his embrace of poetic intensity. So when Turner tramped, sketched and painted in Wales and the north of England, this deep Romantic impulse snapped the training bands of academic drawing. He made for Poetic Places: lichen-mottled groves, or the bat-swept vaults of abandoned abbeys, such as Llanthony and Tintern. Tragic histories – the moaning anthems of the defeated – played on his imagination. His eye feasted on fitful moonlight, jagged peaks and rushing torrents, and his pen and brush translated them all. And although he would always generously insist that if Girtin had not died prematurely, he, Turner, would have starved, Turner in fact had an unparalleled gift – especially in watercolour – for making these British epiphanies into portable marvels. In his hands a rainbow over Buttermere stopped being fancy scenery and turned into an eyeful of sublimity.

The crags were thick with Romantic sketchers, but only Turner managed to deliver the instantaneous rush of rapture by ignoring cumulative details and going directly to the impression of drenching light. In fact, Turner followed Cozens' experimental freedom with blots and stains and 'stopping-out' and stippling. He would deliver pigment on to wet, scraped and rubbed paper, let it bleed and then later dunk the thing back into water, or take a wet sponge or rag and dab at it to see what happened. What he finally delivered bore no sign of those endless experiments – just a flood of illumination that made the hairs stand up on the back of the neck. He'd already trapped what he later described, when speaking devotedly of Rembrandt, as 'the mystic shell of colour'.

It was around this time that Turner painted his only adult self-portrait – innocently vain, the straight-on angle disguising his toucan beak, the slightly exopthalmic eyes and the weak chin. Instead of the nosy little cockney (five foot five), we have a dapper Regency sport, dark grey eyes deep-set and shadowed by creative thoughtfulness, the high cravat and the dove-grey waistcoat a flouncy show of sartorial theatre. The artist likes what he sees, and why not? With money rolling in and prospects bright, the new Associate of the Royal Academy moved from Maiden Lane to the more fashionable West End, taking a lease on 64 Harley Street. In 1804, three days after his mother had died in Bedlam, he opened a private gallery there to show his work (an act that some thought presumptuous for a painter still in his twenties) and moved his father in to watch over it. In short order Old Dad became general factotum, priming canvases, preparing grounds, sometimes mixing paints and zealously watching over the family interests.

But although Turner was devoted to his father and vice versa, he let it be known that he didn't think domesticity and art went together. His oils, he said more than once, were his children. In fact, he had two illegitimate daughters, Evelina and Georgiana, by his mistress Sarah Danby, a singer-actress and the widow of a musician who'd been a friend. Turbaned Sarah was kept a secret from almost everyone, even though she was installed just around the corner in Marylebone. But his erotic drawings – hundreds of them, some of them the doodles of gentle post-coital recall, others anatomically fixated on pudenda – make it clear that Turner relished sex quite as much as a rainbow over Buttermere.

IV

ABOVE ANYTHING ELSE he was a dramatist of light, the most stupendous Britain has ever produced. But his light and colour plays were never done for purely aesthetic effect. Inside him was the urge to create Grand Histories in oils – modern counter-parts to Poussin's pictures of tragic terror and grandeur that he had seen in the Louvre in 1802 when he crossed the Channel during the brief peace in the Napoleonic Wars. The times, he believed, demanded that grandeur, since Britain around 1805 was at the eye of the storm. The endless hostilities against France had taken a dangerous turn. A formidable army of invasion, 130,000 strong, was camped at Boulogne. Without crude editorializing, Turner filled big, dark canvases with images of calamity and doom, classical architecture before which acts of divine punishment would inexorably unfold: *The Plagues of Egypt* in 1800, *The Destruction of Sodom*. Thunderbolts hit their mark, columns collapse, figures flail around or flee in terror. And, given that Turner spent nearly seven years in the life class of the Royal Academy and could, when he chose, do perfectly rendered figures, those that populate his histories are aggressively stylized. Their bodies are invertebrate, faces summarily sketched with simple, almost cartoonish dots. Great pains are taken not to ennoble the figures or to make any of them stand out in the composition. Every-thing his own Academy had taught about classical modelling was discarded: no more heroic nudes, just rag dolls tossed around by the grinning jokers of historical destiny. But Turner left it to the spectators to decide whether this would be the fate visited on the French and their puffed-up imperial pharaoh, or whether Carthaginian disasters were around the corner for complacent Britain!

He was always and ever of two minds and moods: light and dark, apocalyptic and serene. Some who knew Turner well described him as a laughing merrymaker, enjoying romps with children; others saw him as a gruff and guarded man wrapped in an almost impenetrable blanket of saturnine pessimism. Maybe he was both.

To sustain his occasionally faltering good cheer Turner – like many of his beleaguered countrymen – would every so often turn inwards to the apparently untroubled heart of England. In 1805, while renting a riverside villa at Isleworth, he kept a boat, took it on the Thames and sketched, sitting between the oars, in both watercolours and oils (the latter painted sometimes on little canvases, sometimes on mahogany veneers) the hazy glow of a Home Counties summer. They are some of the most exquisite things he would ever do, mirages of almost narcotic serenity. Willows droop, gnats buzz; you can smell the cow parsley. Instead of hailstorms blitzing down blasts of divine retribution, there's nothing more punishing here than a soft shower, the clouds already moving off to drizzle on Berkshire. A sailing barge moves slowly downstream, its wake barely breaking the mirroring water. Across the river, fields stand gold with ripening wheat and a brighter light hangs on the far blue horizon. Overhead, it need hardly be said, a great rainbow bridges the two banks. Turner evidently had a thing about rainbows, the celestial light show that scripturally carried a promise of redemption, but that prismatically (for there was always a strong streak of the optical scientist in him) revealed bands of colour in their purest, most intensely radiant form. The colour experiments he would make that would lead later generations to co-opt him as the first modernist all began with rainbows.

Even when the Battle of Trafalgar called Turner back to epic statements, he decided on an unorthodox way of celebrating both the victory and HMS *Victory*. No more immune than anyone else from Nelson-mania, he went to the river Medway to see the body of the admiral, pickled in its brandy cask, en route to lie, eventually, in state at Greenwich. All manner of painters, some of them his friends, were lining up to do Trafalgar both out of patriotism and as an opportunity for popularity and profit. Turner, who was obsessed by the importance of witness, did all the homework, treading the planks of the wrecked flagship, sketching the quarterdeck and talking to seamen in the fleet, both officers and ranks. But when he came to do his own Trafalgar painting (page 256), he threw all this mere information away. Instead of painting the ships in a laboriously documentary manner that would allow spectators to 'read' the battle – here the *Victory*, there the *Temeraire*, over there the French flagship – Turner went instead for instantaneous atmospherics: chaos, confusion and the smoke-shrouded 'indistinctness' for which he would be repeatedly attacked.

He was back in the theatre. Immediacy was everything. Instead of taking one moment from the battle and freezing it, Turner went for all-action simultaneity. Everything is happening at once: the crunching collision of timbers, the fall of sail-cloth, the crack of marine musket volleys. Amidst this ear-drum-bleeding din, the eye has to search for the delicate figure of Nelson himself, already shot and dying,

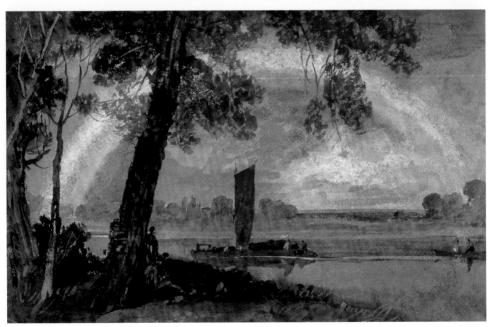

Top: THE DESTRUCTION OF SODOM, *c.* 1805, oil on canvas (Tate Gallery, London).
Above: RIVER SCENE, WITH RAINBOW, NEAR ISLEWORTH, 1805, watercolour on paper (Tate Gallery, London).

THE BATTLE OF TRAFALGAR, AS SEEN FROM THE MIZZEN STARBOARD SHROUDS OF THE
VICTORY, 1806–8 (Tate Gallery, London).

gently folded on to the deck, his slightness augmenting the heroic pathos. Despite the captured tricolor – a surrogate shroud for the fallen admiral – a less conventionally heroic image could hardly be imagined. And although the title of the painting tells us that the point of view is high in the mizzen-mast shrouds of the *Victory*, those who looked at Turner's *Trafalgar* painting must have realized, with a shudder, that the view might also have been that of the sharpshooter who had taken deadly aim at the admiral. It's this visual entanglement of victims and victors, a havoc of forms, that makes the painting, for all its bravura, so head-spinning.

<div align="center">

V

</div>

NOT EVERYONE SUBSCRIBED to the notion that, just because battles were a bloody mêlée of obscurity and confusion, *paintings* of battles should also be done that way. If anything, the opposite was true. Art's obligation, for the keepers of the academic flame, was narrative clarity. On that score Turner's *Trafalgar* was a dismal failure. He may have felt the sting of criticism since he reworked the painting over the next two years, but it still failed to find favour, much less a buyer.

There was, however, one collector who, in 1808, when *Trafalgar* was re-exhibited in Turner's private gallery, thought the painter's flame and smoke just capital. Walter Fawkes was not your run-of-the-mill, 15,000-acre landed gent. How many other Yorkshire landowners, for example, had zebra grazing their park? But then, how many other pillars of the Otley Agricultural Society kept dangerously radical company? At Westminster School Fawkes had become thick with Francis Burdett, later an MP and one of the most militant champions of radical parliamentary reform. After Fawkes bought a *Victory in Three Positions* from Turner in 1808, he and the artist rapidly became bosom friends. Fawkes had already nailed his own political colours to the mast. He had twice run for Parliament as a reforming Whig against a dyed-in-the-wool ultra-Tory, Henry Lascelles, winning on the second attempt in 1806. ('I have always been a BIG Whig,' he proclaimed.) His tenure was brief, but he sat in the Commons long enough during the ministry of the radicals' hero, Charles James Fox, to vote on the great measure that ended the slave trade in the British Empire. (And he would already have been initiated into this mass campaign by William Wilberforce, who stood in the same county election that produced, confusingly, two MPs from three candidates.)

In 1812, Fawkes took a further step towards notoriety. When his old friend Burdett (now Sir Francis) was imprisoned in the Tower for allegedly fomenting two weeks of rioting in London, Fawkes spoke vehemently in his defence at the Crown and Anchor tavern, denouncing the 'grossest abuses' perpetrated by 'Old Corruption'

and calling for a system of true representation. But then like Burdett (and probably Turner too), Fawkes saw no contradiction between his staunch patriotism (he raised a company of volunteer horse militia) and his reforming zeal. Indeed, the one was the necessary complement to the other. To be a public-spirited patriot meant denouncing 'Old Corruption': sinecures, 'rotten' boroughs (constituencies where there were no actual constituents) and 'pocket' boroughs (in the gift of the mighty). To mouth such sentiments, he thought along with other radicals, was not to court a British Jacobin revolution such as the French had recently experienced, but to pre-empt one.

None of this means that Turner was himself a militant radical, and that every time ordinary figures or crowds appear in his landscapes or history paintings we should read them as an army of the suffering disenfranchised. Unlike David, or the Picasso of 1937, Turner was laconic about politics, as about much else. Over the years his patrons would extend across the political spectrum, from the more conservative Earl of Egremont to the outlandishly pro-slaving Jack Fuller. Equally, though, aside from his father and his two mistresses, Sarah Danby and, much later, Sophia Booth, it's hard to think of anyone in Turner's life with whom he was so easily intimate as Fawkes. And no one came close to owning as many Turners – 200 by the time he died. Turner obliged Fawkes by making pretty watercolours of Farnley Hall, his house outside Leeds, but during his many visits to Farnley he was much more than the tame artist to be shown off to county society. Turner and Fawkes became, to some degree, soul mates, the painter revelling in his assigned role as the lovable, eccentric, pseudo-uncle to his friend's 11 children. He was the life and soul of the party; the one whom they could gigglingly call 'over-Turner' when he capsized a two-horse trap driving, as usual, at reckless speed; the one who would always go riding and shooting with bluff Walter.

It's inconceivable, then, that Fawkes and Turner would not at some point have chewed over the great matters then roiling the nation. And on one telling (but usually overlooked) little project, with huge political and historical resonance, the two collaborated. Fawkes was a founder member of the Hampden Club, named after Charles I's antagonist in the great 17th-century conflict between Crown and Parliament. To sign up for that club of radicals was not a sign of wary neutrality. As it happened, Fawkes had inherited a collection of memorabilia, including weapons that he called 'Fairfaxiana' after the great Yorkshire Parliamentarian and Civil War general, and wished to publish a book on them. Turner accepted the job of providing the illustrations for the publication.

The Fairfaxiana doesn't convert Turner into some sort of republican. Every so often he would make a gesture that betrayed his hunger for royal recognition. In a

Top: ENGLAND: RICHMOND HILL, ON THE PRINCE REGENT'S BIRTHDAY, 1819, oil on canvas
(Tate Gallery, London).
Above: A FIRST RATE TAKING IN STORES, c.1818, watercolour (Cecil Higgins Art Gallery, Bedford).

painting of turnip diggers at Slough, Windsor Castle looms paternally in the background, as though George III, good old Farmer George, were giving his blessing to Tubers for Victory. Ten years later Turner would paint his own house by the Thames while a tableau of England unfolds on Richmond Hill (cricket, the Union flag, a picnic) on the Prince of Wales's birthday, also his own (page 259). 'I *am* England!' the painting shouts. '*Knight me!*' No takers. When George IV made a state visit to Edinburgh, Turner hung around doing gouaches and finally got a commission for a second *Battle of Trafalgar* to hang in St James's Palace. It was greeted coolly. The King's brother, the nautical Duke of Clarence, who would become William IV, complained that the artist obviously knew nothing about real Men-of-War.

Spurned as he was by the royals, there was nothing to stop Turner from reverting to his more authentic sentiment, which was, like Fawkes's, that of a reform-minded Whig patriot. After Fawkes died in 1825, history after history that came from Turner's brush and pencil would engage with issues of the day, from a depiction of an election in which one of the Whig leaders of parliamentary reform, Althorp, was the victor to the climactic drama of the *Slave Ship*.

And it was at Farnley that Turner did something he never did anywhere else (except at Petworth): he brought the family into the making of his art. At Farnley Hall Turner is twice on record as co-opting 'Hawkey', Fawkes's second son (who would inherit after his older brother's suicide by drowning), into his work. One morning at breakfast, Fawkes asked Turner to make a drawing that would give some sense of the scale of the men-of-war that were the titans of the Royal Navy. 'Come along, Hawkey,' said Turner to the boy, then around 15, 'and we will see what we can do for Papa.' Throughout the morning Hawkey sat by Turner's side, looking on while the artist reinvented, once more, a genre: marine watercolours. Rising to Fawkes's specific challenge to represent scale, he had the inspired idea of looking up at the sheer timber wall of the First Rater, pierced by rows of shining cannon, from the waterline, where little tenders bounce around in the brilliant swell (page 259). But it was the *way* in which Turner accomplished this that stunned the boy. 'He began by pouring wet paint on to the paper until it was saturated, he tore, he scratched, he scrabbled at it in a kind of frenzy and the whole thing was chaos – but gradually and as if by magic the lovely ship with all its exquisite minutiae came into being and by luncheon time the drawing was taken down in triumph.'

Eight years earlier, in 1810, it had been Hawkey again whom Turner took into his confidence at the start of the creative process that resulted in the most ambitious and most successful history painting he'd yet tackled. *Snow Storm: Hannibal and*

His Army Crossing the Alps (pages 262–3) began with dirty weather in Yorkshire, rather than a reverent memory of Poussin or Claude, and was all the better for it. There was one other source that might have prompted Turner, a John Robert Cozens' *Hannibal* surviving only in a rudimentary drawing). But as he saw a storm gathering over Wharfedale, Turner took the boy out of doors with him to watch the funnel of dark cloud moving in while he sketched away. When he finished he said, 'There, Hawkey, you will see this again in two years and it will be called Hannibal crossing the Alps.' It's this unforced Farnley Hall union of poetic memory and direct natural observation that made for a breakthrough in Turner's history paintings. The pseudo-Poussin plagues and deluges had been darkly encumbered by reverence for the classics, with their measured arrangements of forms and light. But now Turner let the tumult of the elements *make* the history, rather than exist merely as atmospherics. So a Wharfedale squall becomes a cosmic reckoning, and the cast of thousands are sucked into the great funnel of blackness howling around their broken ranks.

Carthaginian soldiers making a painful passage over the Alps are picked off by savage mountain men. Soldiers lift their arms to the heavens – whether in acclamation of their general, Hannibal, or in imploring is left for us to decide. But the drama is elemental, the vortex hanging over the scene like some gigantic, malevolent bird of prey. And through the mayhem of the storm a dull ochre sun stands in the heavens, painted so thickly by Turner that it stands out, like a modern poster-paint disc, a quarter of an inch from the surface of the canvas. It's the sun of the south, but bloated and carbuncular: a mockery of Hannibal's Latin ambitions. Turner's poem 'The Fallacies of Hope', which he added to the catalogue, makes it clear that he thought about word and image working together in seamless performance. You come to the low picture on the wall, take in the manic gesticulation of the soldiers, the rapine and slaughter, peer at that pallid disc of orange and read his lines:

> *...still the chief advanced, looked on the sun with hope, low broad and wan*
> *While the fierce ardour of the downward year*
> *Stains Italy's blanch'd barrier with storm*

Not great (especially 'blanch'd barrier', with its hint of laundry rather than blizzard), but not terrible either; enough, in any event, to pull you into the fantastic theatre where the senses scramble for footing.

Hannibal was, in every way, a sensation. Crowds gathered around it so densely that the Quality had a hard time getting through the throng. For most of those who

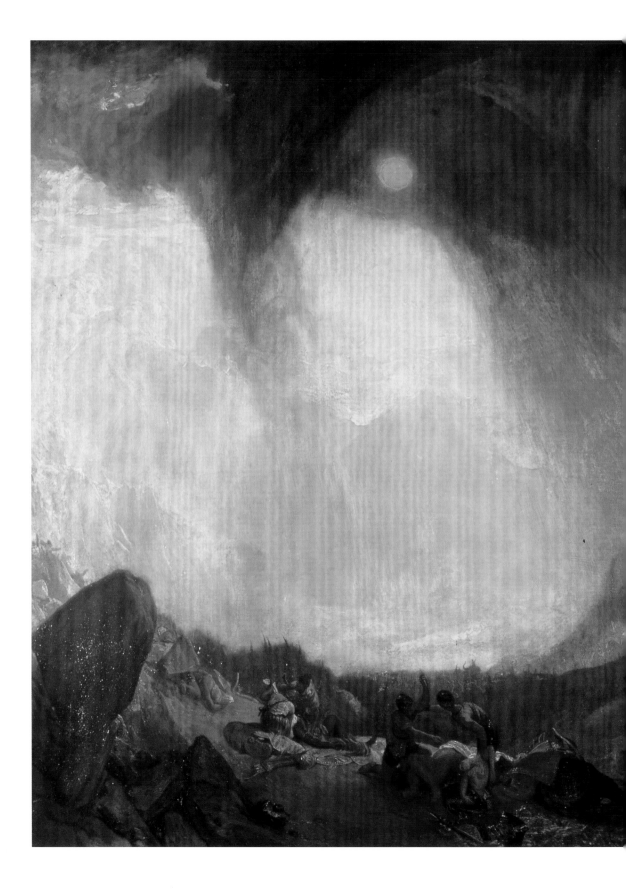

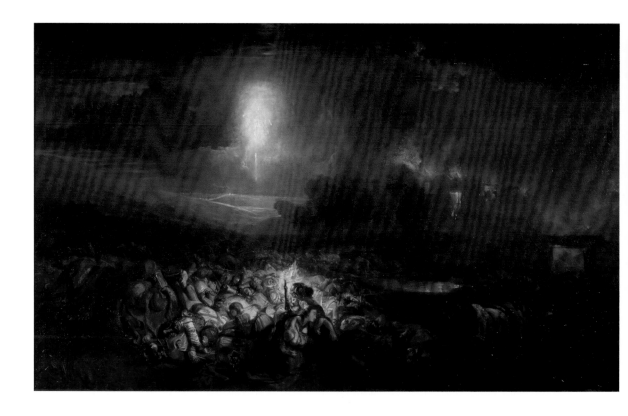

Top: THE FIELD OF WATERLOO, 1818, oil on canvas (Tate Gallery, London).
Above: Detail from the work.
Previous pages: SNOW STORM: HANNIBAL AND HIS ARMY CROSSING THE ALPS, 1812, oil on canvas (Tate Gallery, London).

saw it, the picture was modern rather than ancient history. It was, after all, 1812, and Napoleon's Grande Armée was about to make its own date with disaster in Russia. It seems that Turner may also have wanted it to be read as a warning of what might happen to British power should it overreach itself. But any cautionary subtext was lost on the adoring crowds, who saw the image entirely in terms of Napoleon's come-uppance. After all, Hannibal himself was shrunk to an almost comically diminutive figure on the horizon atop an elephant that looked more like a dung beetle – a wonderful riposte to David's equestrian portraits of the Emperor as the new transalpine conqueror.

But Turner was an equal-opportunity pessimist. After the new bridge over the Thames had been named after the famous victory at Waterloo, and Nelson-mania had been replaced in Britain by Wellington-mania, in 1817 Turner paid a visit to the battlefield. As usual, he did the historical swot-work, filling sketchbooks with details – so many thousands killed on this spot, so many on that. But then, even more shockingly than with *Trafalgar*, he threw away all the conventions. Instead of a legible moment from the battle (usually the climactic one – gallant scarlet squares holding their own against charging French Chasseurs, amid cottony puffballs of fire, the kind of thing pictured by his friend George Jones, the winner of a Waterloo competition), Turner painted a carpet of corpses. In a genre where the first rule was to be able to distinguish the sides, Turner made them indistinguishable. There are no flags, no regimental uniforms, no indomitable Iron Duke with his commanders and subalterns; just forlorn women and children searching desperately, beneath the baleful flare of a distant rocket, for the remains of loved ones. One of the women has discovered her dead sweetheart, and, in one of the most moving (and neglected) passages Turner ever painted, throws her body and arms around his upturned body. The painting was, said *The Examiner*'s critic, probably William Hazlitt, a vision of 'Ambition's charnel house', a bituminous apparition of smoking hell. Even Goya had never thought to show his unsparing *Disasters of War*, 1810–14, in his lifetime. But this was Turner's confrontational showpiece, to be displayed beside the numinous homage to Aelbert Cuyp, *The Dort Packet Boat*, 1818. It was a pictorial anticipation of *War and Peace*.

Both pictures had been the product of his travels through the Netherlands after the long war, and both are shot through with poignancy. *The Dort Packet Boat* is as saturated with nostalgia for the lost golden age of Europe (and its painting) as it is with Cuypian late afternoon sunlight. The way things were with the human comedy. But next to it would be the human tragedy: *The Field of Waterloo*. The way things are now.

To show that painting in 1818 was itself a provocation. The propertied Establishment in Britain was still living off the glories of victory and the allure of the Duke of Wellington, fending off demands for reform and for measures to cope with poverty and hunger. A year later, troopers would ride down a peacefully protesting crowd on the field of 'Peterloo' in Manchester. Fawkes, of course, was among those vocal in indignant protest at the atrocity. He had bought *The Dort Packet Boat*, but not *The Field of Waterloo*; the sunshine, not the blackness. But Turner had nonetheless dared to reinvent English history painting as a canvas of victims.

VI

IN HIS FORTIES, THEN, Turner was an odd mix of the opportunist and the provocateur. He made no secret of enjoying his good fortune (although he was beginning to get a reputation as a tight-wad). He was now the owner of several properties. An uncle had left him two buildings in Wapping, which he knocked together into a single tavern. A house on the corner of Harley Street and Queen Anne Street was acquired and turned into an improved private gallery lit by ceiling panes. And there was a villa he had designed down by the Thames at Twickenham, Sandycombe Lodge, in which his father was installed. For a time Turner insisted that the old man make the 11-mile journey to open the gallery every day, an odyssey made easier when Old Dad found a vegetable carter, who, for a tot of gin, would let him ride to town atop the carrots and onions. Eventually he was succeeded as caretaker by Sarah Danby's niece Hannah, an intimidating harridan with a skin disease that kept her wrapped in flannel, so that the Turner gallery, even before it fell into physical ruin, was never an especially inviting place to see his paintings. For some reason – increasingly hurt feelings? – this was the way Turner liked it.

The gallery filled up with the great 'poetic inventions', which, even when they were widely praised as, for instance, *Dido Building Carthage* and the refulgent Claudean pastoral transported to the English shires, *Crossing the Brook*, both painted in 1815, never found buyers. Alongside them were many of the big epic spectacles – *Trafalgar*, *Waterloo*, *Hannibal* – that Turner either wished to keep for himself or that again simply found no favour. There must have been times when he might have been forgiven for feeling that he couldn't win. On the one hand, he was upbraided for what was called the 'vicious' freedom of his looser brushwork. But those same critics, above all Sir George Beaumont, who made it their special mission to discourage anyone from buying Turners, also attacked him for making feeble pastiches of their revered old masters, especially the incomparable Claude. Beaumont wrote that Turner seemed to paint weakly, 'like an old man'.

There was one field, however, in which everyone still ceded the palm: water-colours. In 1819 there was a little apotheosis. Walter Fawkes opened his town house in Grosvenor Place to show off his collection of watercolours. A number of artists were represented, but the heart of the show consisted of 60 of Turner's masterpieces on paper. Turner, who had designed the cover for Fawkes's catalogue, made no bones about his pleasure in the triumph. He visited the show every day, an unmistakably stumpy little figure in his top hat and greasy frock-coat, the tails brushing the floor. 'While he leaned on the centre of the table in the Great Room or slowly worked his rough way through the mass he attracted the eye like a Roman general, the principal from one of his own paintings.'

The Fawkes watercolours were often spectacular, many done during Turner's travels abroad following the Napoleonic Wars: Rhineland cliffs, Alpine glaciers, French harbours. Many of them could be profitably turned into prints and, thanks to the introduction of steel engraving, in much larger editions than previously. Money rolled in. But something had started to happen in Turner's watercolours that would take him beyond the norms of Romantic scenery. The 'colour beginnings', which did indeed begin at exactly this time, were, of course, not for any kind of display, much less at Grosvenor Place. Although modern abstract art co-opted the loose transparent scrims of colour as the inaugurators of non-figurative painting, Turner never thought about them in that way. They were free experiments with stains, washes and bleeds from which he would work up a more finished figurative composition.

But it's also possible to undersell the creative leap made by the *Colour Wash Underpainting* (page 268). It can't have been an accident that these drawings began in 1819, the year in which Turner first went to Venice, the place where the distinction between solid form and fugitive reflection is least clear-cut. It was already a commonplace to notice that everything solid – power, morality, stone, money – seemed to crumble and dissolve in the iridescent dankness of Venice. And just around this time Turner seems to have begun a momentous shift towards an art that would be a representation of vision, not a reproduction of the physical world. The forms of art, then, like those suggestively vaporous marks that appeared when he let pigment bleed, streak and bloom on wet paper, existed not as a mechanical copy of life but in a more mysterious parallel universe. It was as though with his water, paper and brushes Turner could unlock the door sealing off that poetic visionary, floating world from the material world that was its shallow reflection. Colour itself seemed to perform this way, to lean towards the suggestively amorphous. In one of his 1811 lectures (ostensibly on perspective) Turner wrote beautifully of Rembrandt that some-times it would be 'sacrilege to pierce the mystic shell of colour in search of form'.

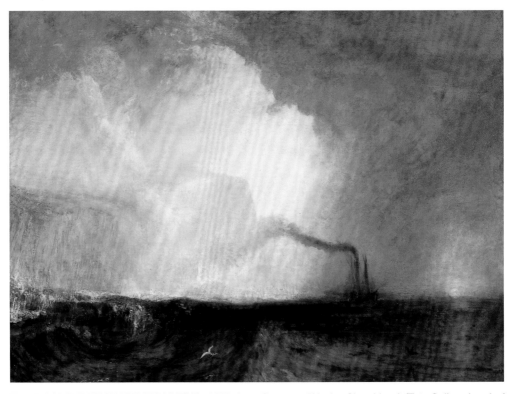

Top: A COLOUR WASH UNDERPAINTING, 1819, from *Como and Venice Sketchbook* (Tate Gallery, London).
Above: STAFFA, FINGAL'S CAVE, 1832, oil on canvas (Yale Centre for British Art, Paul Mellon Collection).

He might just as well have been speaking of his own practice. But this independent vitality of light and colour, he believed, existed in scientific as well as in poetic vision.

Traditional optical theory since Newton had held that the colours of the prism were discrete bands; but, along with the German polymath Goethe, Turner believed that when seen through air or water (the only way we receive them), those colours bled and blurred along their edges to form intermediate zones, like visual grace notes. But the further he went with this instinct (and by the end of his life he would go very far), the further he removed himself from Victorian taste that prized, above all else, the dependable factuality of life. That was a world of measures and proportions, of bolts and rivets, a world governed by engineering. It would have no truck with sentimental mistiness. In that practical mind-set, steam was not the veil of poetry, it drove the pistons of profit. No wonder, then, that the patron who (15 years after it was painted) bought Turner's staggering *Staffa, Fingal's Cave* complained about the indistinctness of the image. For Turner has dissolved the steam funnel into the storm and the snake of dark vapour becomes consumed within the piling rain clouds. Cliffs and cave, submerged into the streaming, are rendered by raw vertical scrapings of pigment. Everything but the single white seabird skittering over the heaving surface of the black water – the crashing rain, the howling gale, the spray slamming against the rearing rocks – is seen as if half-drowned in the tempest. No storm had ever been painted this way. In the circumstances, Turner was mild in his retort to the complaining buyer: 'Indistinctness,' he harrumphed, 'is my forte.'

VII

THROUGHOUT THE 1820S Turner made visits to Europe, managing to get into coaching accidents with impressive regularity. After the most spectacular over-turning, when his coach capsized into a snow bank on Mont Cenis in 1829, he sketched *Messieurs les Passagers* keeping warm by a fire, while he himself, top-hatted, draws the scene. But each time Turner came back to Britain it was with the craving to make epics. He had visited Virgil's tomb at Posillipo near Naples, had read the *Aeneid*, had brooded on Homer, Shakespeare and Byron. He was impatient now with the small scale of scenic picturing, although he recognized that work of that kind paid for his houses. When he did do harbours and rivers they were wrapped in a mantle of golden light, as if they belonged to the fairy tales of Grimm or Novalis rather than to Westphalia or the Rhône Valley. And he struggled with the way he might arrive at a poetic vision that would be more than a mere illustrated 'moment from the classics'. How to translate into oils the sensuous freedom he gave himself in watercolours? How to make light itself the protagonist of these epics?

Or, perhaps, the loss of it? Blindness drew him; blindness of different kinds. In *Ulysses Deriding Polyphemus*, 1829, the Cyclops Polyphemus rises like an immense rock from the landmass of his island, holding agonized hands to his single extinguished eye while Ulysses' ship rides the phosphorescent waters, sailors and warriors jeering at their gullible prey. But it's the victors, not the victim, that seem somehow diminished, swarming the masts and decks like ants glued to a sugar stick, adhesive, formicating, verminous.

In Rome Turner painted something even more perverse: *Regulus*, the Roman general sent back to Rome with terms by his Carthaginian captors. The terms rejected, he returns to Carthage and is punished for his failed diplomacy by having his eyelids cut off and being forced to stare into the sun until he goes blind. This is sunlight as destroyer, something that the man who worshipped it would return to, and Turner describes the path of that kinetic agony as an avenue of torturing brilliance. When he came to rework the painting in public years later, he appalled the bystanders by attacking it with a palette knife loaded with lead white. He did so over and over again until the blare of brilliance was physically painful, the white-out of life that happens to us when we've been staring at the sun too long. Turner was starting to paint from the inside of the eye. Everyone noticed that Carthage looked a lot like standard scenery from Claude. What they didn't say was that the scalding glare was Claude blinded, Claude cancelled. In Rome they didn't get it. German satirists published caricatures of Turner with the caption 'Shitting is not painting'.

The unsparing passage of light, the odyssey of life, was starting to preoccupy him more every day. Familiars were disappearing. When Walter Fawkes died in 1825, he had dug himself into a hole of debt so deep that Turner actually had to lend his old patron money to help him out. 'Farewell auld lang sine,' Turner wrote sadly, and never went to Farnley Hall again. Four years later Old Dad passed on, in his eighties, and was buried a stone's throw from Maiden Lane at St Paul's church in Covent Garden. A week after the funeral Turner made his own will, with provision for Sarah Danby and the two girls. Mortality was pressing in on him. Having enjoyed rude health for most of his life, he now started to lose weight, wheeze with asthma and feel arthritic aches. To keep the pain at bay Turner resorted to taking stramonium (tincture of thorn apple), the narcotic sending his always hyperactive imagination into planetary orbit. Out of those restless nights came nightmares – sometimes literally – as in *Death on a Pale Horse* (page 272), the animal from the Book of Revelation rearing up in space. But even this Gothic fantasy is not in fact apocalyptic. For the skeleton slung across its back is itself limp. Death is dead, then. Billy Turner lives on to paint.

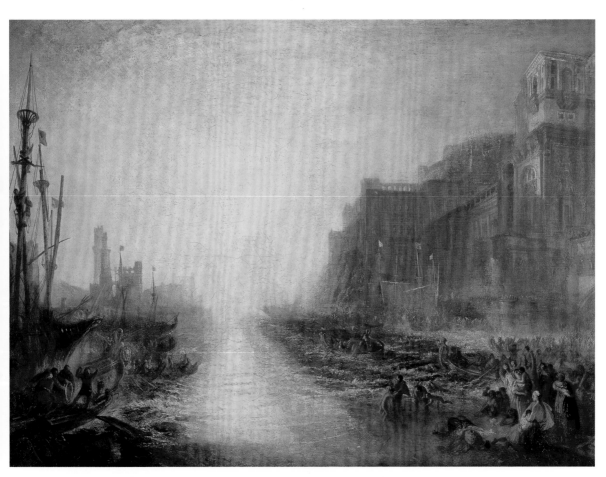

REGULUS, 1828–37, oil on canvas (Tate Gallery, London).

DEATH ON A PALE HORSE, 1825–30, oil on canvas (Tate Gallery, London).

But it was *because* Turner felt, as he wrote, 'a thousand times nearer eternity' that he found, at last, the theme that would give him the epics of his greatest years as a painter. It was the wheeling cycle of life, death and rebirth; and featuring not just classical heroes, but the vitality and mortality of states and nations. Even when he settled down to paint for the patron who largely replaced Fawkes as his provider of home-from-home, the colossally rich 3rd Earl of Egremont at Petworth in Sussex, he couldn't help allowing poetic melancholy to colour his work. On the face of it the Earl, in his seventies, was just Turner's kind of fellow: free and easy, happy to let painters come and go as they chose, and to give them the upstairs Old Library as a studio. Despite the riches and grandeur, Egremont had invested in the commercial-technological future (the new iron bridge at Brighton), while remaining properly devoted to his own ancestral past (all those Van Dycks). His house was like a palace, his art collection a museum, his park landscaped by Capability Brown. So what the Earl wanted was the kind of thing from which Turner had made his first bread and butter: estate views that would fit nicely into the panorama-shaped panels in the Carved Room where his company dined.

All he had to do was to oblige, which he did – up to a point. When Turner showed Egremont sketches for the panels, it was evident that at least one of them wasn't quite what had been expected. It was supposed to have been a picture of the Earl and his dogs in the park. What could be more straightforward, especially since 17 years earlier Turner had done a perfectly idyllic view of the Palladian house on a 'Dewy Morning'. But Turner wasn't feeling dewy any more, nor especially straightforward. For a start, he wanted to paint from behind the eyeball; to paint a vision, not a scene. The elongated format of the Grinling Gibbons carved panels allowed him to do just that and he mischievously used it to turn the format of the appreciating, lordly window into the elliptical retinal perception of the eye. To the casual observer everything seems oddly stretched, distantly distributed. And into this mysteriously elasticated space Turner put – not very much at all. There's an empty chair on the terrace; behind it a curtain blows wispily into the picture space. The 3rd Earl himself, the grandest man in Sussex, turns into a fragile, lonely figure, wistfully backlit. Intimations of mortality sigh through the whole beautiful but desolate picture. Surely Turner knew it would be rejected? There was a limit to the aristocrat's cheery bonhomie – there always is. So Turner obediently repainted the picture to anodyne prescription and it was duly set in its allotted panel. But he smuggled some visual romance into another panel in the shape of himself, seated in a little fishing boat in his battered hat and coat as a great black sailing barge makes its way down a glimmering highway of light that happens, in this case, to be

pretending to be Chichester Canal. It's a picture of Egremont's transport all right, but not the one the Earl thinks he's getting.

Turner did other things at Petworth that registered exquisitely – and against the grain of solid aristocratic endurance – the fugitive nature of sensuous experience. A series of gouaches made with the most dashing economy imaginable, sometimes just dabs and wisps of pigment, ostensibly record with delicious casualness everyday moments about the great house. Many of them are pure visual Thackeray (aka 'Michelangelo Titmarsh', Turner's frequent critic and occasional admirer) or Trollope. There are billiards in a white marble chamber; backgammon by the fire. A long-shanked vicar, hands behind his back, warms his posterior at the White Library hearth, leaning in slightly towards the company. Musicians saw away in a little room adjoining the Carved Room so that the diners may be regaled without having the bother of looking at them. It becomes apparent from the gouaches that there's nothing that Turner stalking through Petworth doesn't see or penetrate, sometimes to unnerving effect. Notwithstanding the fact that the Earl's long-time, live-in mistress, Elizabeth Ilive, was a painter herself, many of the scenes feature artists in distinctly ambiguous relationship with the hosts, allowing themselves and their work to be admired, ogled and condescended to. Sometimes the artists seem to be drinking in the admiration; sometimes not. And in one telling image Turner perhaps represents himself, in the surrogate form of a large painting propped up on a sofa beside which the admirer seems caught in tongue-tied awkwardness.

And sometimes – while supplying as many images of stately rooms as Egremont could possibly have wanted – Turner takes breathtaking liberties. The dreamy indolence of Petworth evidently excites him. No one staying there could possibly have been unaware of the Earl's reputation for acquiring and keeping mistresses with as much avidity as art. So the gouaches glow with a gentle but unmistakable erotic charge. Even the 'Petworth State Bed' is painted with the rose silk curtains knotted as if in embrace as a sunbeam slants down on to the sheets. While a man in black sprawls languidly on a chaise longue, a woman in pink turns her head the better to hear conversation. But even granted the design of Empire-line dresses, her breasts are more completely exposed than would have been possible. The bedroom scenes have their share of innocuous activity, but plenty that isn't: half-naked figures, in or out of bed; dressing and undressing; and at least one empty bed with rumpled sheets surrounded by scarlet drapes that is the purest Matisse erotica a century too soon.

But then, at some point, Turner does something even more outrageous with the niceties of protocol at Petworth. (Despite the Earl's famous affable informality, he

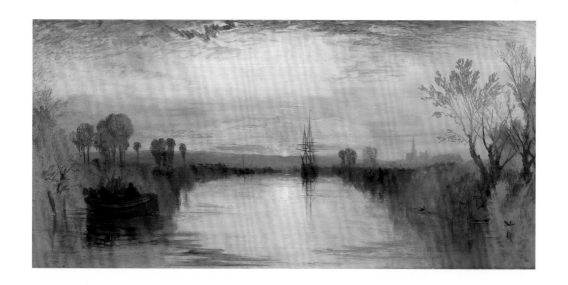

Top: CHICHESTER CANAL, *c.* 1828, oil study on canvas (Tate Gallery, London).
Above: STUDY FOR THE SACK OF A GREAT HOUSE (PETWORTH), *c.* 1830, oil on canvas (Tate Gallery, London).

was perfectly capable of summarily evicting guests who made the mistake of treating Petworth 'like a hotel'.) It's 1830 or thereabouts, and there are violent riots and deaths in town and country resulting from the working-class Chartist movement's demands for an end to social and political injustice. The Whig opposition is warning that if parliamentary reform isn't effected, the kind of revolution that's already removed the Bourbon monarchy in France will break out in England also. Over his dead body, the King seems to say, but there are those among his advisers who counsel him not to rule that out either. The old Protestant-Tory ascendancy is finally tottering to its tomb. Catholic emancipation – enabling Catholics to hold parliamentary and other civil offices – has already been enacted, despite the bitter objections of the monarch and the Duke of Wellington who was Prime Minister at the time.

Turner feels the end-game. It's his subject now. So he revisits Petworth one last time, to smash it up. *Study for the Sack of a Great House (Petworth)* is an astonishing, unfinished painting that may or may not date from after the Earl's death in 1837, and shows, through the maelstrom of red and gold paint, his coffin set out in the Marble Gallery (page 275). Turner paints Petworth as though it had been sacked by an army of marauders. There is debris everywhere: rubbish strewn around the floor, nothing remaining of the collection except a statuary niche that identifies the place as the Marble Gallery. And just what or who has committed this explosion of vandalism? The answer is given by what has become the late-storming Turner's signature gesture: an exterminating angel of intense white light exploding through a (fictitious) archway at the back and which, cyclone-like, seems to suck up everything in its destructive path so that the papers of the grand house whirl about in its eddies. Fawkes and the Fairfaxiana live on after all.

VIII

NOTHING QUITE EXCITED THE WHEEZING, pain-racked Turner in the 1830s more than the spectacle of cleansing destruction. He had begun his career, after all, standing before the smoky ruins of the Oxford Street Pantheon and in 1834 he and the rest of London had the opportunity of witnessing the biggest conflagration anyone would ever see. On the evening of 16 October a fire started in the cellar of the House of Commons. In a few hours almost the entire Palace of Westminster had been consumed by the flames. Turner lost no time in joining the immense crowd milling on the Surrey embankment. But this wasn't close enough for him, so he hired a boat and – hemmed in by the flotilla of spectators near Westminster Bridge – made furious pencil notes while bobbing on the river, its water playing with the reflected

THE BURNING OF THE HOUSE OF LORDS AND COMMONS, 16TH OCTOBER 1834, oil on canvas, 1835 (Philadelphia Museum of Art).

blaze. The fire burnt on through the night, and the next morning he was able to penetrate the smouldering yard of St Stephen's Chapel, talking to the firemen and the crowds just as he'd done with the veterans of Trafalgar and Waterloo.

But of course Turner wasn't interested in turning out a piece of mere visual journalism – he let *The London Illustrated News* do that. His instinct for the apocalyptic, never far away, could hardly resist imagining the burning of Parliament as something from modern scripture. The past few years had seen the destruction of an old political order. The Parliamentary Reform Act had been passed by a Whig government; then legislation for the abolition of slavery. But there was still intense discontent in the country, not least with the draconian Poor Law that had established workhouses that were as forbidding as possible so as to deter the 'idle' from seeking relief. More than one radical Chartist and newspaper proclaimed the burning of Parliament to be God's sentence on the iniquity of the ruling order.

Whether or not Turner thought the burning of Parliament an act of providential judgement, his paintings turned the event into an oracle of the times. In no hurry to complete the painting, he took the winter of 1834–5 to gather his notes, sketches and thoughts. And even when he was ready to paint, he did so with calculated staginess. The performance – for such it was – unfolded on Varnishing Day at the British Institution in February 1835. The Institution was the bastion of high aristocratic taste, expressly established against the Royal Academy, which was governed by the artists themselves. The Gentlemen would show the Professionals what was wanted – which was, above all, reverence for old masters and traditional history painting.

So Turner would take his own burning right into the citadel of the gentlemen. Just the fact of showing his destruction of Parliament already made an uncomfortable point, for no one was likely to have forgotten the story, reported in newspapers and journals such as *The Gentleman's Magazine,* that when the House of Lords disintegrated in flames its collapse was greeted with applause among the watching crowd. And for the first time those crowds are there in a history painting, in hundreds and thousands, on embankments and bridges, boats and rafts, packed together – men, women and children whose doll-like faces are lit by the incandescence. Turner is no Karl Marx, but for the first time a Royal Academician has painted the look of the modern crowd, a single organism of raptness. He has done something that gentleman painters were never supposed to do: he has painted the masses.

And he has done it, they must have felt, with disgusting licence: all that scrabbling with fingers, the spitting and rubbing, the frontal attacks with the palette knife that made the genteel critics feel ill. If anyone was queasy about how he made paintings, it would have been a mistake to come to Varnishing Day, since what

J.M.W. TURNER AT THE ROYAL ACADEMY, VARNISHING DAY by William Parrott, 1846, oil on canvas (Reading University, Berkshire).

Turner did there with the first of the Parliament paintings was, even by his standards, outlandish. Varnishing days – two or three – were set aside for artists to apply finishing touches to works sent for exhibition, and Turner used them shamelessly to put competitors in the shade. A touch of brilliant red lake applied to his painting, which hung beside Constable's *Waterloo Bridge,* 1832, was enough to drain his rival's work of any vividness at all. 'I see Turner has been here,' was Constable's droll concession when he saw the result.

But with *The Burning of the House of Lords and Commons, 16th October 1834* (page 277), Turner took Varnishing Day to an entirely new level of performance art. As submitted to the British Institution in January 1835, the canvas was barely discernible as a painting at all, 'a mere dab of several colours and without form and void like chaos before the creation'. Enter, early one morning in February, the dumpy little wizard in top hat and unbrushed frock-coat, with a small box of paints and thinner and some watercolour cakes – for one of his sins was to use watercolours to touch up oils! The genre painter, E.V. Rippingille, who was there, wrote that 'Such a magician performing his incantations in public was an object of interest and attraction'. He then proceeded to work, an audience gathering round him. So now the crowd in the painting was mirrored by the crowd in the gallery, who would have witnessed Turner working up the details – painting *them* in! Occasionally he would say something to William Etty, the painter working (poor fellow) next to him; otherwise Turner went at it non-stop for three hours. But 'it' seldom seemed to be what most people thought was painting. At one point he was observed to be rolling and spreading over his picture a transparent lump of stuff, the size of a finger in length.

'What is that he is plastering his picture with?' Rippingille wondered out loud to another artist, Sir Augustus Wall Callcott.

'I should be sorry to be the man who asked him,' Callcott replied.

It would be good if the last detail Turner applied was the single capitalized word that appears on a placard held up by one of the spectators on Westminster Bridge, which reads simply, 'NO'. Just to what – the Poor Law? – Turner characteristically left everyone guessing. Nor was he going to offer any verbal comment to help. When he was done, Turner picked up his materials and exited without so much as turning round and acknowledging the crowd.

What he created – both at the Institution and later in a second picture for the Royal Academy – was a pair of modern illuminations, the disaster that heralded a new age. That's why, even though they are supposed to be night scenes, the sky is a dazzling lapis lazuli blue, freckled with pale stars as if dawn was coming up fast. No wonder that the crowds summoned to witness this holy metamorphosis, the baptism

of fire of the new Britain, stretch as far as the eye can see – not just all of London, but all of Britain summoned to witness the mystery. And despite the destruction of the house of power and privilege, Turner shows two buildings – Westminster Abbey and Westminster Hall – miraculously intact in the fiery furnace. For a miracle *had* taken place: a sudden shift in the wind direction that spared the House of God and the House of Justice, greater and nobler temples than the house of politicians.

Such miracles call for magic painting. So Turner (who had been bobbing up and down beneath the arches) waves his wand over Westminster Bridge and turns it into a wall of glistening alabaster. For most of the span, at least, the Professor of Perspective makes a show of abiding by the rules he was supposed to teach at the Academy. But then he burns them, along with traditional history painting. For the bridge at its far end simply dissolves into a liquid trail of molten gold spilling into and across the river, as light, fire and water all intermingle. So what is seen by the crowds on the embankments and the bridge – and the crowds staring at him doing this on Varnishing Day – is a vision of holy phosphorescence. In the second picture, done for the Royal Academy in May, he continues to take liberties with topographical truth, greatly widening the Thames (seen now from Waterloo Bridge) so that it becomes a vast watery bowl in which the helix of flame is reflected. Needless to say, the writer for *The Athenaeum* clucked at its extravagance and let it be known that he would have preferred 'the accuracy of a district survey'.

IX

BUT THEN, AS TURNER'S OILS became more ambitious, more visionary, the dismissive humour became more aggressive. The jokes about accidents in the kitchen started. Once he had been attacked by Sir George Beaumont for initiating 'the white school'. Now he was said to be the victim of 'yellow fever' (*Mortlake Terrace* of 1827, washed in a peachy-gold light that hung over the Thames, was said to be a case in point). Told at Petworth that it would be impossible to paint a figure against a yellow background, Turner responded with his stunning *Jessica*, 1830 (from *The Merchant of Venice)*, a Romantic take on Rembrandt, as ravishingly beautiful as any head and shoulders painted in the entire 19th century. It was met with hoots of helpless laughter and predictable remarks about women leaning out of mustard pots. The poet William Wordsworth joining in the culinary fun, said, 'It looks to me as though the painter had indulged in raw liver until he was very unwell.'

As if to goad the critics further, in 1836 Turner called a jewel-like vision of Venice *Juliet and Her Nurse*; admittedly, it was difficult to make out the dramatis personae, and it prompted the critics to bay in unison 'WRONG CITY!' as if

he hadn't noticed. The Reverend John Eagles, writing in *Blackwood's Magazine*, complained that 'poor Juliet has been steeped in treacle to make her look sweet and we feel apprehensive lest the mealy architecture stick to her petticoat and flour it'. Moved to indignation that Eagles, the philistine foe, had vowed to 'sink, burn and destroy' Turner's extravagances, John Ruskin, the 17-year-old son of a Herne Hill sherry merchant, who had first seen Turner at the Academy four years before, penned a lyrical defence of his hero's 'mighty Shakespearean imagination'. Matching Turner's brushstrokes with his own prose poetry, he wrote: 'As the spires of the glorious city rise indistinctly bright into those living mists like pyramids of pale fire from some vast altar…there is as it were the voice of a multitude entering the eye…' This is the kind of teenage writing that both delights and worries fathers, and Ruskin senior advised his son that it might be best to let Mr Turner see it before sending it to the magazine. Turner was touched but embarrassed by his young champion's ardour, thanking him for his 'zeal and kindness' but assuring him that he never replied to such attacks as it only made for more mischief. And in fact a new patron, Hugh Munro in Scotland, bought *Juliet* and would prove to be one of Turner's most loyal supporters in the last years of his career. Ruskin's letter was never published; but Turner could hardly have failed to feel emboldened by his puppyish admirer's beautiful and extravagant outburst to believe that what the 'iron age' needed from artists was more visual lyrics and fewer feebly conceived and slickly executed animal paintings, landscapes and Plantagenets in tights.

So Turner dreamed on and did so, increasingly now, while staring hard at the waves. He was in any case spending more time away from the wasps' nest of London, leaving the gallery in Queen Anne Street in the charge of grim Hannah Danby to sink further into decay. Cracked glass in the ceiling panes let in the rain. Hannah's six Manx cats roamed around over canvases – some finished, some not – on the floor. Turner was now living with another widow, Sophia Booth, who kept a boarding house in Margate on the Kent coast and, after a while, him. He was entering his sixties but, on the evidence of another burst of erotic drawings, with lustily undiminished appetites.

Margate was more than an amorous bolt-hole and an asylum from the critical brickbats. Turner walked on the cliffs, gazed at the waves churning up the pebbles and communed with history. He had always been the least picturesque, the least ingratiating of the countless marine painters who filled the galleries with pseudo-Dutch seascapes of Men-of-War in stiff breezes and fishing smacks fighting their way through the teeth of a gale. Turner had had his Dutch moments too, and in homage to another of his gods, Jacob van Ruisdael, invented a 'Port Ruysdael',

which was nothing more than grey-brown slapping water torn by the wind. But he felt the connection between the two maritime empires, one past, one present, instinctively, so that when, around 1830, there was scared talk of another English revolution, it was natural for Turner to paint the landing of Dutch William III at Torbay in 1688. Liberty, he evidently felt, rode on the waves.

And his waves were like no one else's. He had always been drawn to the sea in its most ungovernable uproar, and prided himself on capturing the hydraulics of the tides, their suck and pull, or the broken lacework of surf as it pounded the shore. All this close observation, done at first hand from small boats, he had taken to the images of wrecks that more and more entered his imagination and his painting. But in Margate he was thinking of more than just the wreck of this or that ship. In his mind the sea became the storm-racked arena on which the destiny of the empire would – for good or ill – play out.

And in 1835 – the same year that he painted *The Burning of the House of Lords and Commons* – Turner began to tackle another passionate drama of life and death. *Disaster at Sea (The Wreck of the 'Amphitrite')* was a history that the powers of the British Institution and the Royal Academy would rather not have had dramatized by his brush. But Turner, horrified by the story, could hardly help himself. Two years earlier the *Amphitrite*, a convict ship bound for Australia, but carrying only women and children, had run aground off Boulogne. The ship had begun to break up and the French authorities had offered to land passengers and crew. But the captain, evidently a strict disciplinarian, had declined on the grounds that he had received no orders to land the prisoners anywhere except their final antipodean destination. The crew had survived, clinging to masts and spars. But the women and children – all 125 of them – had been swept into the sea and drowned.

It would have been one of the very greatest pictures, perhaps *the* greatest picture, he ever made – but he never got beyond an oil sketch. Even so, it's a masterpiece of tragic fury. It's possible that in 1819 Turner had seen the French painter Théodore Géricault's *Raft of the Medusa* as it toured Britain in a commercial exhibition organized by the artist. On the oceanic-sized canvas, survivors of a wreck drift among titanic waves and attempt to hail a ship seen diminutively on the horizon. But Géricault's figures – even the dead ones on the raft – are heroically modelled. Turner's are just so much human flotsam and jetsam, roped and coiled pathetically about the mast. He barely began to model their faces (although since Waterloo he had been making his rag dolls cartoonish, somehow the better to emphasize their helplessness in the face of tragic calamity). Yet, within the frantic chaos, mothers hold infants to their breast; there is screaming and crying as the sea

DISASTER AT SEA (THE WRECK
OF THE *AMPHITRITE*), 1835, oil on
canvas (Tate Gallery, London).

engulfs its victims. Every so often Turner does something extraordinary – such as a wash of upchurned water filming a broken, half-submerged spar, the observation delicately precise amidst the uproar of dense paint that describes the heart of the boiling storm. And even in all this raw visual havoc, the design of the picture is perfectly controlled and calculated to maximize the drama, the helical whorl of victims standing precariously against the enveloping darkness.

But Turner, of course, never finished *The Wreck of the 'Amphitrite'*, never showed it or sold what would have been remembered as one of the most stupendous British paintings of all time. And we shall never know whether it was political nervousness, his own aesthetic dissatisfaction, other more pressing commissions for new patrons, or completing the two Parliaments that stayed his hand. For a century and a half the work has languished unconsidered, called (until Cecilia Powell recognized its true subject) only *Disaster at Sea*. But the idea born with *Amphitrite* – murder, martyrdom at sea – did not disappear. It simmered away in Turner's moral imagination until, in 1840, it returned with a vengeance in a sky the colour of blood.

X

AMPHITRITE WOULD HAVE BEEN A SHOCKING ACCUSATION. The danger of *Slave Ship* was that it might be read as unseemly self-congratulation. In 1838 Britain had completed the abolition of slavery in its empire. The original legislation had been enacted in 1833, but it had set a 'transitional' period for both slave-owners and slaves. That had broken down in dangerous conditions of near-revolution in the Caribbean, accelerating the timetable. The two years that followed outright abolition saw a surge of worldwide campaigning against the heinous iniquity. Abolitionists everywhere – especially in the United States and the Spanish and Portuguese empires, where slavery still survived and, indeed, flourished on the back of the cotton boom – now looked to Britain as a beacon of hope. There was a renewed surge of abolitionist publishing. Thomas Clarkson's classic from 1786, *An Essay on the Commerce and Slavery of the Human Species...*, along with his *History* of abolition from 1836 were reprinted in a new edition (with the old patriarch of the campaign still alive), and Thomas Fowell Buxton's new attack was serialized in *The Times* throughout 1839.

Turner, who had been initiated into the Cause many years earlier by Walter Fawkes, and who evidently had decided to make his own contribution in paint while the two anti-slavery conventions met in London during the Academy show, would certainly have read all of this. Two especially horrifying episodes must have fused in his moral imagination to give him the subject of his great painting. The first would have been the most notorious case of inhumanity, originally described by Clarkson

and thus rehearsed again in the new edition of his book – the event that more than any other had first mobilized the campaign against the slave trade in the 1790s. In 1781 the master of the slaver *Zong*, in an attempt to guarantee insurance payments for an ailing slave cargo, had decided to jettison 132 live Africans, still shackled in their irons, into the shark-infested waters of the Caribbean off Jamaica. His reasoning was commercial. While the 'live cargo' was insured, the underwriters would not pay up for Africans dead on arrival – only for property that could be deemed to be 'losses at sea'. The master, Luke Collingwood, thus made sure his 132 Africans would constitute reimbursable losses. But in London the underwriters refused to pay; the owners sued, and a case proceeded based on infamous deliberations about whether or not the cargo could legitimately be claimed for under the terms of the insurance.

But there were also much more recent horrors that undoubtedly fed into Turner's profound allegorical sermon in paint. For the pursuit of slavers by Royal Navy cruisers of the African Squadron had had inadvertently tragic consequences that some in the abolitionist movement believed had made the inhumanity of the trade worse, not better. Hunted by the cruisers, slavers had been known to jettison their slave cargo for two reasons: to gain speed on their pursuers and, if overtaken, to rid themselves of incriminating evidence. Since cruisers successful in capturing slave ships were paid a 'head fee' proportionate to the numbers liberated, abolition-ist critics accused naval captains of waiting until the slave ships had set sail (rather than attacking them in port) so that they might profit from those fees. By this argument, the liberators bore at least some of the responsibility for the jettisoning and drowning of the Africans!

Whether or not Turner himself subscribed to this attack (voiced by Clarkson, among others), the subject he chose and the way that he painted it was – almost as much as the aborted *Amphitrite* – a sharp stick against complacency. But of course his approach wouldn't be – any more than at Waterloo or Westminster – that of a literal documentarian. He'd never seen tropical waters; didn't care whether slavers, either in 1781 or in the past year, had chosen to throw humans overboard in a storm or in perfectly calm waters. What he wanted, Prospero-like, was to summon an immense tempest, his typhoon of blood, retribution and redemption.

So the slave ship in the painting is both real and unreal. It has the low lines of the fast vessels that did indeed ply the trade in the hope of outrunning their pursuers. But this time it is trying to beat the storm, seemingly hopelessly, with just its jib flying; and as the art historian John McCoubrey has pointed out, it is sailing, in so far as it is sailing at all, into, rather than out of, the dirty weather. It is, in fact, a kind of anti-*Temeraire,* a hunted, haunted, cursed vessel, akin to the ship of the

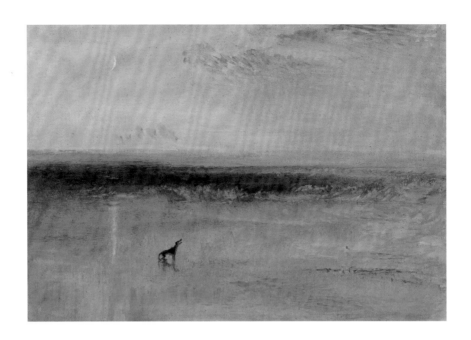

Top: DAWN AFTER THE WRECK, *c.* 1841, graphite, watercolour, bodycolour, scraping, chalk (red) on paper (The Samuel Courtauld Trust, Courtauld Institute of Art Gallery, London).
Above: SEASCAPE WITH BUOY, *c.* 1840, oil on canvas (Tate Gallery, London).
Previous pages: SLAVE SHIP (SLAVERS THROWING OVERBOARD THE DEAD AND DYING, TYPHOON COMING ON), detail, 1840, oil on canvas (Museum of Fine Arts, Boston).

290

Ancient Mariner, sailing through an ocean of black and blood-red mythic doom. Likewise, the fishy monster bearing down on all the obscene carnivorous nibbling and gobbling that is frantically going on in the right foreground isn't to be found off the coast of Jamaica or Africa, but rather in the prints of Pieter Bruegel the Elder. Big fish eat little fish. Little fish eat humans. It's hell in high water.

Poetic suspension of disbelief is needed to deal with all the other unlikely foreground details, such as the floating chains, which caused an epidemic of giggles among those critics who deigned to notice Turner's painting at all. But just as in *Waterloo*, *Parliament* and *Amphitrite*, Turner used a kind of dramatic shorthand to convey humans in distress, so the gesticulation of half-submerged hands and arms, indicated with crude, almost childish, marks operate much more terribly and powerfully than anything he could have dredged up from those seven years spent in the Academy life class. There was nothing in Sir Joshua's rules that would have allowed for the upside-down, half-submerged torso of a naked African woman, just one leg raised helplessly and horribly into the air as her bloated body bobs obscenely below the surface. Like Goya in *The Disasters of War* (and unlike Biard with his half-naked African torsos), Turner is not about to offer beauty as the sacrifice of obscenity, but rather to dismember it.

Altogether irrelevant, too, were the usual strictures Turner got from Old Salts (he was, after all, fairly salty himself) on the impossibility of his wave formations, the unreality of immense swells occurring in the eye of a tropical storm, and so on. Meteorological and hydrological precision isn't the point here, as the vessel labours in the blackly heaving waves, its hull almost torn in two by the boiling spray, its direction rudderless in the spin of fate it can't control. The point was entirely scriptural. Nothing in the painting, and especially not the great pinwheel of fire and blood at its core, would operate on our vision without the deep cleft that Turner has cut in the ocean, no more naturalistic than the dry road opened by Jehovah to allow the Hebrews their escape through the Red Sea. Here the chasm is exactly as though the hand of God had passed over the scene, lifting and tearing the waters before hurling them down again on the cursed vessel. For down that gulch shines the unmistakable light of punishing providence. It's the same avenue of destruction that appears brutally in *Regulus* (to which Turner had just returned to give yet more violent emphasis with his white-loaded palette knife), or the intruding flare that breaks into Petworth as the coffin of the Earl lies in his Marble Gallery and the remains of his lordly treasures whirl around in the sunlit dust.

But this is the light of redemption as well as retribution. A patch of sky (as in all of Turner's immense epics) clears at the top right-hand corner, and the gesture

of the sinking martyr, hands thrown to the sky, is that of salvation rather than perdition. The gesture was taken from a famous medal struck to celebrate and commemorate the abolition of slavery, one that was seen everywhere in the kind of liberal circles in which Turner still moved. That he desperately wanted *Slave Ship* to be seen as closing the great circle of moral epics that had begun 28 years earlier with *Hannibal* is clear from the fact that he included with the painting lines from the same poem he had attached to that earlier picture, 'The Fallacies of Hope'. The vessel, trapped in its sea and sky of blood, was – unlike its victims – truly hopeless.

Hope, hope, fallacious hope,
Where is thy market now?

XI

TWO YEARS LATER, IN 1842, a young Scottish artist and admirer of Turner's, William Leighton Leitch, paid a visit to the gallery in Queen Anne Street. No doubt he had the jitters of the awestruck pilgrim. This was the place where the greatest works of the master he revered were still on display. He had heard that the Turner gallery was in disrepair, but nothing had prepared him for the squalor. It was hard enough to gain entry. The door was opened, barely, by Hannah Danby, herself a broken-down ruin swathed in dirty flannel, who slammed it shut against Leitch before finally allowing him, on a second attempt, to cross the threshold. Inside the gallery it was soaking wet, as rain poured through the broken ceiling panes, heavy enough for Leitch to have to open an umbrella as he stood in the evil-smelling gloom. Some canvases were on the revolving easel Turner had made so that he could work on several simultaneously; others lay around on the floor. Everything was filthy. Hannah Danby's six cats scratched and defecated among the works. '*The Building of Carthage* was cracking…in long lines like ice when it begins to break up; other parts of the picture were peeling off,' wrote Leitch. Somewhere in the Gothic desolation was – for the moment – the unsold, unwanted *Slave Ship*. But Leitch had no time to discover that painting or others he was looking for because he suddenly felt something furry on the back of his neck: a Manx cat. That was enough. He fled, full of dismay and confusion about whether his idol had in fact fallen.

He had not. After the fiasco of the Academy show, Turner had gone to Venice to lick his wounds and do whatever he wanted with watercolours, filling book after book with sketches; these, untroubled by exhibitions or critics, he later worked up into some of the freest poetic inventions ever set down. When he got back to Britain, far from being constrained by the unhappy reception, Turner launched himself on an ocean of pure painting. In the studio of John Mayall he had discovered

photography and sat for his daguerreotype portrait. Turner, who had always been fascinated by technology, may paradoxically have had his belief that painting had its own independent work to do – to capture vision rather than surface likeness – reinforced by the photographic entrapment of appearances. Formlessness, what may or not materialize within a void, began to fascinate him. Mirages appear rinsed in vapour, and some of his most ecstatic pictures return to primordial moments of creation that Turner would paint in a circular format, as if those visions – monsters and angels – appear on (or behind) the iris.

Dramas of appearance and disappearance, making and unmaking – as the subjects of his art, but also as a living record of its practices – acted out in the wild strokes of his brush and knife and fingers, obsessed him. Often, the agency of unmaking was the ocean: the undoer of ambition or fortune, seen at telling, ironic distance. On a remote strand the homeless but imperially hatted and booted Napoleon stands in absurd proximity to the diminutive rock limpet that would never be unfastened from its house. On a beach a forlorn and exhausted dog, the sole survivor of a wreck, its wobbly hind legs collapsed beneath its body, howls dismally at the rolling, empty sea (*Dawn After the Wreck*, page 290). Whale factory ships that have rendered the biggest animals alive into so much industrial inventory are made helplessly inert by closing floe ice (*Whalers [Boiling Blubber] Entangled in Flaw Ice…*). Many of the late seascapes feature ships in peril; possibilities of rescue, salvation and redemption – safety rockets fired from the shore, a wreck buoy or just a rainbow – are always at hand, but never quite secured. That, evidently, was how Turner felt about everything that mattered.

But wait, young John Ruskin is at the helm of the lifeboat! In 1840 he finally got to meet his demi-god face to face. 'Everybody had described him to me as coarse, boorish, unintellectual, vulgar. This I knew to be impossible. I found in him a somewhat eccentric, keen-minded gentleman, good natured evidently, bad-tempered evidently, hating humbug of all sorts, the powers of mind not laid out with any intention of display…but flashing out occasionally in a word or a look…' It hurt Ruskin, then, that Turner, the mighty thinker and poet, should be so bruisingly misunderstood, but equally he and his father wanted to avoid being patronizingly over-protective. All the same, he could not help overhearing Turner muttering over and again the cutting words used of another of his free-form masterpieces, *Snow Storm – Steam-Boat off a Harbour's Mouth*: 'Soapsuds and whitewash, soapsuds and whitewash.' Much of Turner's late work Ruskin himself thought represented some sort of deterioration of conception and skill, but certainly not *Slave Ship*. In 1843 he tried, with his father, to arrange its sale, along with the other paintings from the 1840

Top: WHALERS (BOILING BLUBBER) ENTANGLED IN FLAW ICE, ENDEAVOURING TO EXTRICATE THEMSELVES, 1846, oil on canvas (Tate Gallery, London).
Above: SNOW STORM – STEAM-BOAT OFF A HARBOUR'S MOUTH, 1842, oil on canvas (Tate Gallery, London).

show, including *Rockets and Blue Lights*, which Turner may indeed have meant as a pendant. But the sale failed. Instead, Ruskin senior bought *Slave Ship* himself and presented it to his son as a gift on New Year's Day, 1844.

Slave Ship changed Ruskin's life and made him more than ever Turner's impassioned champion. In his bravery, originality, energy and poetic imagination, his capacity for grasping a truth deeper than shallow verisimilitude, Turner became for Ruskin a titanic visionary, a beacon of light in a depressingly philistine age. He appointed himself Turner's gospel-bringer to the unenlightened, his St Paul. And in his own struggle to find a form of words that would somehow translate the storm of Turner's colour into prose so forceful that it would sweep away the reader's resistance, Ruskin tore from himself one of the most astounding passages in all 19th-century writing:

> *Purple and blue the lurid shadows of the hollow breakers are cast in the mists of night which gather cold and low, advancing like shadows of death upon the guilty ship as it labours amidst the lightning of the sea, its thin masts written upon the sky in lines of blood…that fearful hue which signs the sky in horror…*

But, of course, when people actually got to see the painting – especially in Boston, after he had sold it in the centennial year of 1876 – they looked in vain for the purple, since Ruskin and his father seem to have washed it out in a misguided attempt at cleaning. All they had was the purple prose. Faced with a quite small, distinctly odd, extremely scarlet painting, a mishmash of allegory, fantasy and seascape, most viewers responded with disappointment and resentment at Ruskin for having so outrageously oversold Turner and this picture in particular.

But if *Slave Ship* once needed rescuing by Ruskin, it now perhaps needs rescuing from him. You don't need to be murmuring 'the multitudinous seas incarnadine' when you look at it. Altogether better, in fact, that you don't. Nor do you want to look at it only on the printed page (like this one), for the paper version can still oddly bemuse and make the painting seem a peculiar in-betweener, lacking the easy grace of *The Fighting Temeraire* or the proto-modernist dreaminess of the very late watercolours. What you should do is take a trip to Boston, climb the circular staircase in the Lowell Wing of the Museum of Fine Arts, walk into the 19th-century room – and instantly the thing will waylay you, attack the optic nerves, explode off the wall as you stare at the churning chasm in the pitchy ocean, the screaming bloody sky, the seething waters, the flailing limbs, the pathetically torn patch of clearing blue. It's quite simply the greatest union of moral power and poetic vision that British art ever accomplished.

Van Gogh

PAINTING FROM INSIDE THE HEAD

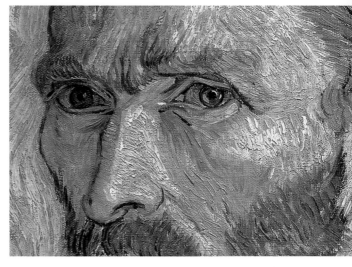

I

IN MAY 1890, the last springtime of his life, everything seemed to be going right for Vincent van Gogh. He was no longer neglected. Painters he admired reciprocated the appreciation and had offered to swap canvases. In Brussels his paintings had been shown alongside works by Cézanne, Renoir and Toulouse-Lautrec. One of them, *The Red Vineyard*, 1888, had even been sold for 400 francs. In Paris ten of his paintings had been shown in the Salon des Indépendants. In the *Mercure de France* an influential young critic, Albert Aurier, had praised him to the skies, describing van Gogh's paintings as built from 'walls of [glowing] crystal', which was a bit much even for Vincent.

In Auvers, 20 miles northwest of Paris, he was working like a demon, polishing off a painting a day, sometimes two. He had never been so productive, so original, so brave. Together the 70-odd paintings done at Auvers – tumultuous translations in line and colour of how the emotions register natural experience – revolutionized what painting could do. Van Gogh felt this power surge himself. The psychic storms that as recently as April had threatened to engulf him had been miraculously converted into creative energy, and the doctors at the asylum-hospital in Provence where he had been receiving treatment had declared him officially cured. 'It is as if the nightmare had lifted completely,' he wrote to his brother Theo. Other friends who had witnessed first hand his descent into self-destruction were similarly cheered. After seeing one of Vincent's paintings, Gauguin (usually stingy with compliments) wrote excitedly that 'despite your illness, you have never before done such *well-balanced* work without sacrificing any of the feeling or any of the inner warmth demanded by a work of art'.

Balance was just what Vincent lacked. Bipolar and epileptic, he swung between elation and desolation, and there were times, as he wrote, when he didn't have to 'put himself out very much to express sadness and extreme loneliness'. But when he was at work, the melancholy burnt off like morning fog. To his mother and sister Wil (Wilhelmina) he wrote that he was utterly 'absorbed in that immense plain with wheat fields up as far as the hills, big as an ocean, delicate yellow, delicate soft green, the delicate purple of a tilled and weeded patch of soil…everything under a sky of delicate tones of blue, white, pink and violet. *I am in a mood of almost too much calm, just the mood needed for painting this.*'

A few weeks later van Gogh was dead from a self-inflicted gunshot wound. Predictably then, those last, most challenging paintings of 1890 – *Wheatfields under Thunderclouds*, *Tree Roots and Trunks* and *Wheatfield with Crows* – done in an unusual, three-feet-wide, double-square format, have been interpreted as suicide notes, expressions of despair at the failure of his career. But that is to read them backwards, to sentimentalize them as 'cries for help', like the anguished poetry of a high-school overdoser. The crows flap malevolently over the blazing field, the sky darkens – bang, he's dead. It's true his painting had become so intense that it was high risk. A last letter to Theo, never posted, spoke of his work jeopardizing his life. But this wasn't at all the same thing as suicidal despair over the failure of his art, which, he already knew, had transformed the two genres about which he cared most – landscape and portraiture. Whatever it was that made van Gogh pull the trigger on 27 July 1890 may have been unconnected with his painting – which, of course, makes the suicide more, not less, painful. For van Gogh may have killed himself exactly at the moment when everything he had wanted from his work was on the point of spectacular consummation.

II

SO WHAT *DID* HE WANT THAT ART TO BE? Simple: Vincent van Gogh yearned to make painting that was charged with the visionary radiance that had once been supplied by Christianity. Jesus, he wrote, was an artist whose medium had been humanity. Vincent wanted modern art to be a gospel, a bringer of light, that would comfort and redeem through ecstatic witness. Its mission would be comparable to the Saviour's in that it would connect, intuitively, with the *misérables* – the poor and illiterate, the walking wounded of industrial society. The grim and dusty toil of Everyman and his trudge through life would be turned into a communion with nature, a revelation of the infinite down here; and it would be accessible enough to become part of daily life, as stained glass and altarpieces had been for that older world of belief. Like those windows, this new art should blaze with colour – for colour marked the presence of the divine. The unadulterated colour would have the innocently brilliant intensity of children's art, and it would be laid on in excited short streaks, dashes and coils, simultaneously artful and artless, the kind of strokes we *imagine* we could make ourselves. The artist's own heightened perception would be translated for the spectator so that we might share in this universe of intense feeling and looking. Modern paintings would be acts of friendship, a visual embrace. 'Yours with a hand-shake' Vincent used to sign off his letters to his brother Theo. And, in effect, that's the way he signed his work for all of us.

III

PERHAPS VINCENT WOULD NEVER HAVE ARRIVED at the threshold of this new Church, the People's Church of Colour, had he not been immured for so long in the old one. It was not that he rejected the temples of art and of Christ out of hand. Quite the contrary: he yearned for them to recover their powers of epiphany. When one Church failed him he would turn to the other, always trembling with agitated hope.

His own father's house was a place that alternated between godly zeal and rain-soaked mournfulness. The Reverend Theodorus van Gogh, preacher to the small Calvinist flock in the village of Groot Zundert in the predominantly Catholic region of Dutch Brabant, was himself a devotee of a kind of revivalism that emphasized simplicity and natural immediacy. But from early childhood Vincent was never allowed to forget that, although he was the oldest in what became a brood of seven, he would always be Vincent Wilhelm the Second, the Replacement, conceived just three months after his brother's death in infancy. Every Sunday, the family would gather in the churchyard to pray for that first Vincent's soul.

There was also a third Vincent: Uncle Cent, and he was in art! (So were Uncles Hein and Cor.) Although Uncle Cent had sold his stake in the gallery of Goupil & Co, he had enough clout to open the doors of the firm in The Hague for his nephew. So the artist who managed to sell just one painting in his own lifetime was also the only modern master who actually started out in the trade. Perhaps this was not altogether accidental. Surprisingly, Vincent was never against art as decoration: the house interior as a sanctuary from the grind of modern labour. But he had high standards for what that decoration should be: a glimpse of paradisiacal nature, the burgeoning life force of flowers and fields. What Goupil sold – dimpled nudes frolicking in the shallows, heavy udders in the water meadows – was certainly not that.

Van Gogh's attack on what he would call the 'worm-eaten' traditions lay years ahead. For the present, the carrot-haired 20-year-old was so good at buttering up the Mijnheers and Mevrouws that he earned an early promotion to London, where Goupil & Co had a dealership in Southampton Street, Covent Garden (a stone's throw from where Turner had grown up). It was in the Victorian gaslight, then, that the real Vincent emerged from the chrysalis of the starchy young Dutchman, first as an omnivorous reader, the discoverer of Shakespeare, George Eliot and Dickens. The painter usually billed as the least intellectual of the moderns, a raver in thick pigment, was, in fact, a bit of a professor. His letters to Theo are chock full of the engaged, often learned, insights that mark van Gogh not as a creature of instinct at all, but as someone who compulsively, relentlessly thought – and talked – about poetry, literature, the State of the World.

Van Gogh

All fired up, he discovered a different kind of passion. Staring at the heavily corseted, sharp-eyed daughter of his Stockwell landlady, Vincent fell – and fell hard. Never mind that Eugenie Loyer was engaged to somebody else; he was convinced that the sheer force and sincerity of his feeling would bowl her over. It didn't. Crushed by the rejection, he fled the lodgings.

And straight into the arms of Jesus, who had never been very far away. In the lower depths of Disraeli's London, among tramps, drunks and whores, Vincent cast himself as a missionary to the destitute. He read Emile Zola, Victor Hugo, more Eliot and Dickens, and, finally, John Bunyan. Van Gogh likened himself to a pilgrim with staff and lantern out on the stony road, bringing light to those in darkness. The first sermon he preached, in Richmond, began: 'It is an old faith and it is a good faith that our life is a pilgrim's progress – that we are strangers on the earth, but though this be so we are not alone for our Father is with us. We are pilgrims and our life is a long walk from earth to heaven.'

The plush-carpeted gallery of Goupil, whether in London or Paris, where he also worked for brief spells, could no longer satisfy this craving; indeed, he despised the kind of third-rate art they served up for the aspidistra classes. So Vincent set off for captive congregations starved of the light. First were the boys at the Reverend Stokes's school in Ramsgate, where he tried teaching French, German and maths. To Theo he wrote, enclosing a drawing of the grimly Gothic school, 'I wish you could see them going down the dark stairs and through the narrow passage to where they have their dinner. The sun does shine pleasantly in there. Another peculiar place is a room with a rotten floor where there are six basins…and a dim light is all that reaches the washstand through the broken panes of the window…the youngsters have made an oil stain on your little drawing…please forgive them.'

Although he was one of life's perpetual probationers, Vincent couldn't have been a complete washout as a teacher, for when the Reverend Stokes moved his school to Isleworth, just west of London, van Gogh went with him, this time as a teacher of Bible history. Then he took to a little sermonizing, but the high-hat parishioners of the western suburbs (where Turner had lived) had no idea what to make of the gangly, unpersonable young man with his old coat and heavy Dutch accent. It didn't help that he was given to torturing the poetry of Christina Rossetti for their benefit:

And does the road go uphill all the way
Yes, to the very end
And does the journey take all day?
From morn to night my friend.

Next stop was a bookshop in Dordrecht, back in the Netherlands, but what van Gogh needed was a flock really blocked from the light each and every day. If he was looking for a modern industrial hell, the Borinage, the coal-mining region of southern Belgium, was just about perfect, with its hacking lung diseases and filthy tenements in slag-heap villages. So Vincent took his dog-eared Bible and his eager-retriever look through the grimy streets where women hauled sacks of nutty slack home for the hearth. He did his best to bring them a shred of hope, but that wasn't what the Protestant Society, which paid his pittance, wanted. At the end of his six-month probation they declined to renew his contract: too much zeal and not enough eloquence, apparently. But you didn't get rid of van Gogh the evangelist that easily. Unpaid, ill-clad and even more impoverished than the people to whom he was ministering, he hung around the village of Cuesmes, a tramping wayfarer in a landscape of sulphurous darkness. But, of course, being Vincent, he thought the scenery 'picturesque'. And he had found a way to survive: he drew emaciated miners grimly plodding to work in the snow. What choice did they have but to endure until they couldn't? He felt the same way, lived the same way: 'I earned a few crusts here and there…in exchange for a picture or drawing or two I had in my bag. But when my ten francs ran out I tried to camp in the open…once in an abandoned carriage which was completely white with frost the next morning and once…in a haystack.'

Although those early drawings are amateurish, spidery things, they had finally moved Vincent, at the age of twenty-seven, to a decision. He would be an artist. He had never so much as picked up a brush, and knew he was badly in need of instruction. He tried a little in Brussels, and had discussed art with a Protestant minister in the Borinage, but preferred to teach himself, buying a few books on perspective, making a little frame with cross hairs to help, and then going back to Brabant to live at home and make another attempt at drawing. This time he had much more success: women stooped under heavy sacks; a moody marsh beneath bunched and angry clouds; old men throwing bundles of sticks on to the fire. These were pen-and-ink poems of gloom and exhaustion.

Novice though he was, and still innocent of brushes and paints, Vincent had already arrived at the convictions that would sustain him to the end of his short, startling career. First, he believed that art should never be content with massaging the self-satisfaction of the bourgeoisie, but rather that it should be thought of as a social ministry. Artists, especially in the Netherlands, had long taken ordinary labouring people at work and play as their subject. But Vincent wanted his work to be *for* those people as well as about them. But (and this took him a while to realize) they would only be receptive to that art if it did more than simply reproduce their

wretchedness. It needed also to restore a sense of child-like wonder from which most adults had been cut off by their poverty. Art, then, would have to succeed where the conventional Churches with their forbidding messages of repentance and obedience had failed. It was precisely the remoteness of what they had to offer by way of consolation – a distant Jerusalem – that made it even more imperative for the new Church to provide visions of salvation here and now. For Vincent himself, sightings of the infinite were everywhere, even in the Borinage – on a grimy face, a calloused hand, the petals of a flower struggling to bloom amidst the slag-heaps. The artist who wanted to capture *this* could not be a dandified aesthete. He would, in his own way, have to be a common labourer too, someone whose nose was never far from the coalface, the loom or the soil.

It's ironic that van Gogh has been thought of as the ultimate loner, someone who pursued his vocation in eccentric solitude. Albert Aurier, his first eulogist in print, started off the tradition by entitling his article '*Les Isolés: Van Gogh*'. And it may actually have been true, especially later, during his time at Arles, that Vincent's best work – sometimes of figures, such as sowers and reapers, isolated in the fields – was indeed done on his own. But of all the founders of modernism, van Gogh was actually the most irrepressible and needy pluralist. He even conceived of his pictures as little (or big) families, repeating subjects like orchards, harvests, boats and sunflowers over and over again, and then sometimes making drawings *after* the paintings rather than the other way around. His ideal vision of how they should be perceived was as a wrap-around domestic environment enveloping the melancholy in a bed of sensory bliss.

But to accomplish this he needed companionship himself: an end to the anomie and alienation he thought was not just his own condition, but that of men and women who had to shift for themselves as best they could. When he preached that we were strangers walking the long path from earth to heaven, the solitude of the trudge was made more bearable by the knowledge that 'Our Father is with us' – as friend, guide, succour. When you were feeling low you'd get a nice hearty handshake from God – the kind Vincent himself liked to give everyone he was fond of. And he was fond of almost everyone. Friendship was what he wanted to give, and in turn to receive, from all those to whom he poured out his heart in his letters: Theo and artist friends such as Anton Rappard and Emile Bernard, with whom he shared dreams of a painters' fraternity, half workshop, half extended family. That's what he would gamble on later in his social-artistic experiment in Arles with Paul Gauguin. And that's what he craved from the succession of women with whom he desperately hoped to share a domestic nest.

It hadn't happened with Eugenie Loyer in Stockwell. But back in Holland, after his sojourn in the coalfields and his dabble at art college in Brussels, Vincent thought he had found his soulmate in a recently widowed cousin, Kee Vos, in Amsterdam. As usual, the timing and manner of his courtship left something to be desired. Out came the hangdog look and the emotional panting as he stalked her from town to town and unnerved her with his trespasses. Kee's response, unsurprisingly, was *'Nimmer'* – never. You'd suppose the message would have got through. But this was van Gogh. To him, *'Nimmer'* was just a test of his ardour. He comforted himself by imagining that the beloved who had fled his advances was a prisoner of stern guardians, unable to express her true feelings. Thrown out of the house, back he would come – on one occasion holding his wrist to a lit candle while declaring that all he wanted was to be able to see Kee for as long as he could keep his hand to the flame.

Extreme courtship failed. Banished from the Amsterdam house, in early 1881 Vincent moved to The Hague, where for a few weeks he was taken under the wing of yet another patient relative – the famous and very successful painter Anton Mauve. But while he was – as always – desperate for affection, he bridled whenever he thought father-figures (including his own father) were imprisoning his passions. The answer, then, was to make his own household, especially since when he wrote to Theo (who now paid the bills for his rent and materials) of his hunger for love, he didn't just mean spiritual love. There was something sweetly and profoundly Dutch about this yearning for cosiness: a hearth and a pot-bellied stove, sex and sock-darning. When, years later, he obsessed over the interior decorations for his little Yellow House with Gauguin, he was, as always, being the Dutch householder, plumping up the pillows and seeking *gezelligheid*, comfort. But to him, true *gezelligheid* was not trivial. It was redemption.

If somehow he could marry this yearning with his other passion – for healing the sores of the modern world – such a household would, though simple, be both virtuous and happy. So he escaped from the bourgeois claustrophobia of Mauve and went instead for one of the *misérables*. Vincent had been reading a lot of Emile Zola, and it had become an article of faith with him that the wretched were just as ready for love as he. In Claesina Hoornik, a frumpy whore with a sickly five-year-old daughter, another child on the way and a bad case of quinsy, he had the perfect candidate on whom to test his naive optimism. To Vincent, 'Sien' was perfect material for domesticity precisely because she was so beaten up by life, the opposite of a sturdy *huisvrouw*. And for once there was someone who needed *him*. Sien would be his experiment in mutuality. She would model for him, and in return he would be the good spouse and father. He couldn't wait for Theo to come and see the nest:

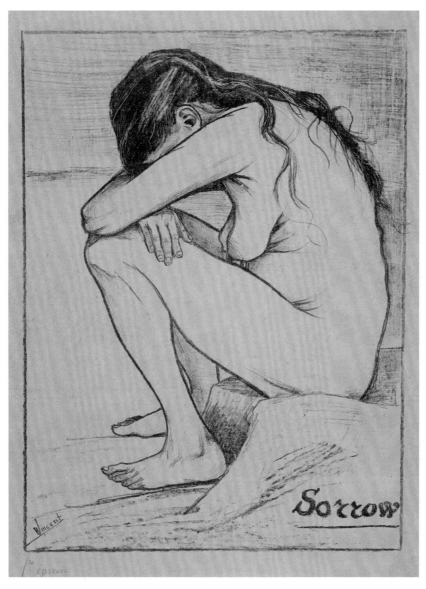

SORROW, 1882, black crayon on paper (Van Gogh Museum, Amsterdam).

'My dear Theo…I think it delightful you are coming. I am longing to know what impression Sien will make on you. There's nothing special about her. She's just an ordinary woman of the people who has something of the sublime for me. Whoever loves a plain ordinary woman, who endears himself to her, is happy despite the dark side of life…'

And, remarkably, van Gogh *does* transform Sien with his pen and brush into an image of noble emotion, not in spite of, but because of, the fact that she looks absolutely nothing like even the most unpromising life-class model. Echoing his idol Rembrandt's etchings, van Gogh stares unflinchingly at her used body – the drooping breasts hanging on a scrawny frame, the bony, angular face and lank, stringy hair – and in *Sorrow* (page 305), conjures up an image that is both spiritual and physical. Another image catches Sien with a cigar, legs drawn up to her chest in a garment that both conceals her pregnancy and draws attention to it as an anti-madonna – there is nothing immaculate about this conception. No wonder that, touchingly, van Gogh seized on a phrase from the French historian and essayist Jules Michelet: when you love a woman she can never be old.

But the attempt to create an ideal home out of the least promising materials imaginable was challenging. A baby was born, but as Sien came out of hospital, Vincent went in – to be treated for a case of raging gonorrhea, probably contracted from his love-object. Still, with the monthly allowance from Theo, who had entered the art trade after Vincent had fled it, he was actually able to graduate at last from drawing to painting. Amazingly, he was all of 30 and had never yet used a brush. At the outset, though, van Gogh wasn't doing the kind of mildly picturesque commercial watercolours that would have allowed him to repay some of his mounting debt to his brother. Instead he took to oils: dense, turbid, mucky studies of manure spreaders and peat diggers; and then, born from his passion for the old Dutch masters, a thickly done beach scene at Scheveningen with herrings and day-trippers. These are unassuming little things, but done with such a thickly loaded brush and such unfashionable attack that of course no one went near them.

But then Vincent wasn't one – ever – for understatement. Playing house with the ex-prostitute Sien, and playing daddy to the baby, didn't satisfy his domestic cravings. He told Theo that he wanted to marry Sien: 'You can give me money but you can't give me a wife and child.' Not surprisingly, none of this went down brilliantly with the vicar father back in Brabant, nor with the respectable painter-cousin Mauve. It wasn't long before Sien, addicted to cigars and gin, began, as they all did, to get restive at the suffocating intensity of Vincent's attention, and disappeared back into the wet, gaslit streets where he had found her.

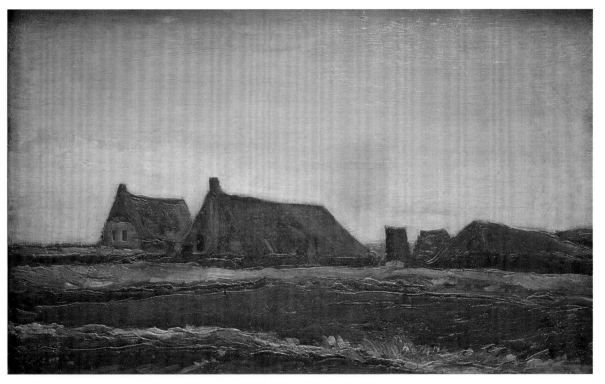

TURF HUTS, 1883, oil on canvas (Van Gogh Museum, Amsterdam).

IV

WHICH LEAVES HIM WHERE EXACTLY IN SEPTEMBER 1883? He was 30 but, as he wrote, his wrinkles and furrowed brow (he was a great smiler and scowler) put another ten years on him. He already felt short of time to accomplish something 'full of heart and love'. He had bounced around from place to place and job to job, from art dealing to teaching to preaching and back to art. And what he wanted was to master all of the above: an art that would teach and preach, but somehow without seeming teachy and preachy. And despite the serial disasters with women, he still wanted to set up house. Failing to figure how to do it, he went to the remote northeast corner of the country, Drenthe, and urged his friend Anton Rappard and Theo to join him. There he set his broody fretfulness down on canvas: desolate cottages silhouetted darkly against the low, wet sky. They are actually very powerful, tight micro-dramas packed into a small frame. But nobody bought them and nobody came north. So Vincent went back home to Nuenen, where his father had moved the family. He had hardly settled in when there were loud, distressing quarrels between Theodorus and his wayward, scruffy, elder son: 'I sense what Father and Mother think instinctively – I do not say intelligently – about me. They shrink from taking me into the house as they might shrink from taking in a large shaggy dog with wet paws… He will get in everyone's way. And his bark is so loud. In short he is a filthy beast.'

Nonetheless, perhaps partly as a result of this tension, van Gogh got to work on images of weavers at their handlooms; and on extraordinary drawings of bare trees in winter, their branches bent and jagged against the hard sky. And in 1885, at long last, it happened: the first indisputable masterpiece in a career that would last just another five years.

The Potato Eaters (pages 310–11) is a synthesis of everything van Gogh had felt and thought about art up to this point. He took his time with the work, spending a whole winter drawing studies of gnarled hands and knobbly chins. His friends noticed how he was drawn to the ugliest models, 'accentuating the boorish snub noses, jutting cheekbones and ears'. But from human material that was a classicist's nightmare he created something genuinely monumental. When he moved from drawing to painting it was with the same dark palette, thickly applied, that he'd been using for the cottage paintings; however, in *The Potato Eaters* coarseness is applied not just pictorially, but philosophically, to say something. That something is an attack on meretricious rustic charm, the sienna and burnt umber picturesques he'd seen in Goupil's stock and on the walls of Dutch drawing-rooms. Those 'earth tones' were the polite materials of art. This brown is different: the unrelieved hue of mud,

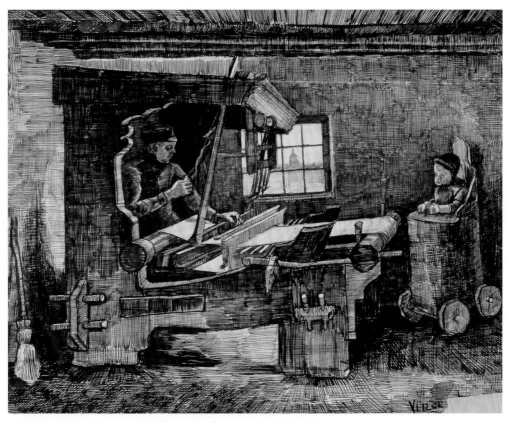

WEAVER, WITH BABY IN A HIGH CHAIR, 1884, pencil, pen in brown ink, heightened with opaque watercolour, on wove paper (Van Gogh Museum, Amsterdam).

THE POTATO EATERS, 1884–5,
oil on canvas (Van Gogh
Museum, Amsterdam).

muck and soil, the material from which these people are themselves constituted. It's also, as he explained, the grey-brown of dusty potatoes before they have been rinsed. They are what they eat.

So the painting feels trowelled and dug rather than painted, caked with the heavy, sodden clay of Brabant fields: 'I've tried to bring out the idea that these people eating potatoes by the light of their lamp have dug the earth with the selfsame hands they are putting into the dish…manual labour, a meal honestly earned.' Lost in total identification, van Gogh does his utmost to paint like a clod, the laboriously sculptural brush doing its own manual labour. Suddenly all the feeble 19th-century reworkings of 17th-century peasant scenes seem so much slumming for the bourgeoisie. It's these folk who dine in a state of grace, their potato supper a communion for the toiling classes, the coffee bowl held sacramentally along with the potatoes.

Van Gogh knew he had done something uncompromisingly dramatic, and in a lather of excitement he sent *The Potato Eaters* to Theo in Paris, prescribing exactly how it should be hung – against a background of gold or copper. But his enthusiasm failed to catch fire with his brother, who just saw yet another dark painting that would be impossible to sell in Paris where everything was so…bright. Van Gogh, committed to his labouring art, shrugged off the criticism. Debora Silverman noticed that one of his most precious possessions was a box filled with yarn, and that Vincent was so taken with the weavers of Nuenen that it occurred to him he might make paint look as if it were roughly woven with discrete threads of colour. The short marks that would be his signature manner do, in fact, resemble untrimmed threads poking through the back of a knitted fabric. This is his artisanal moment, even if he hankered after the proletarian. In Amsterdam a doctor, looking at his hands, guessed that he must be an iron worker, a surmise that made van Gogh deliriously happy. He devoted himself to the picturing of aggressively simple things: pipes, hats, tables.

But a series of domestic upheavals in 1885 pushed him around a corner – as such occurrences would always do. In March his father Theodorus died. Flooded with guilt about all their past disagreements, Vincent painted an open Bible as a memorial eulogy. But his father's successor at the church wanted no part of him in the house or the village. And his sister Anna thought his presence at home was making their mother suffer unduly. Vincent had become scandalous yet again, having an affair with a 39-year-old neighbour, Margot Begmann. For once the passion seemed to be reciprocated – which may be why Vincent, listening to the pieties of his family, broke off the relationship. Margot took poison in an attempt at suicide.

Facing an emotional cul-de-sac, Vincent painted a skull smoking a cigarette and then did what he always did – trudged off somewhere else. On this occasion it was Antwerp, where he took a cheap room and more money from Theo with which he paid for unnecessary art lessons. In the Belgian port city, though, van Gogh made two life-changing discoveries: Rubens and Japanese prints, both flooded with colour. The familiar story about Paris turning the Dutch frog into the prince of Impressionists isn't entirely wrong, but it is mostly fallacious. He had already been thinking about lightening and loosening, and Rubens's gorgeous lushness accelerated the process even though, as he told Theo, he still had trouble 'hearing colour'. More and more he thought that perhaps he did, after all, need to be in Paris to hear it properly. But what he really wanted was to live alongside Theo in a two-man art commune, the dealer and the painter, the merchant and the worker cohabiting in perfect harmony. His brother, he thought, had become dangerously remote. In Paris Vincent would rescue his brother from the 'cold respectability' that had made him indifferent to his painting, to everything that really mattered.

V

VAN GOGH ARRIVED IN PARIS just when the Impressionists were holding their last major exhibition, so the shock of their brilliance could hardly help but make an impact. He was befriended, among others, by Lucien Pissarro (the son of Camille) and the pointilliste Paul Signac. And for a while he did what he was supposed to do, down by the river at the already hallowed Impressionist site of Asnières. Trap the light and you've got the point, so everything in those paintings is freckled and dappled: Pissarro on Monday, then. But the impressionable Impressionist was also taken with pointillisme, which advertised itself as less ephemeral, the colour-coded dots set down according to strict scientific laws and then mixed in the eye. So it would be Seurat on Tuesday. But the excruciatingly calculated procedures were at odds with van Gogh's addiction to the adrenalin rush of the stabbing brush, the transcription of impulse. So it's not surprising that his artistic encounters in Paris constituted more a flirtatious infatuation than an enduring love. The Impressionists marinaded human existence in the rinse of their luminescence. But van Gogh's art would always be stronger, smellier, truer – much like his own life. Ultimately, the notion that painting was nothing more than light plays, artful arrangements of colour and form, repelled him.

So some of his paintings seem like creative corrections of Impressionist ease. When Monet did poppies in a meadow he would take a high vantage point, drenching the image with light. But in his *Wheatfield with a Lark,* van Gogh the

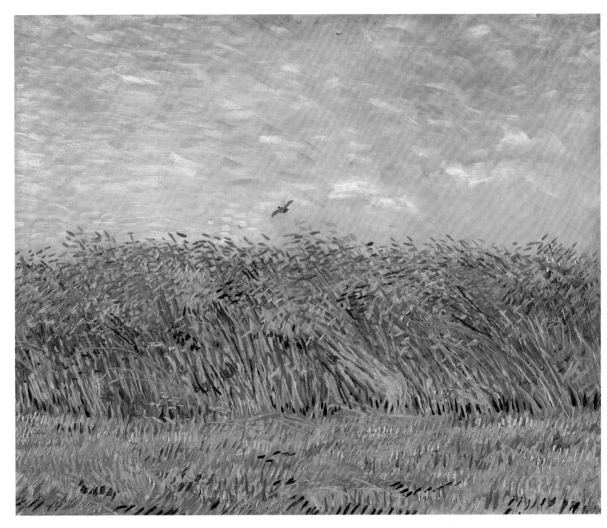

WHEATFIELD WITH A LARK, 1887, oil on canvas (Van Gogh Museum, Amsterdam).

Netherlander drops down to fieldmouse level. Tall grass screens the view, and the poppies are strangled in the greenery above the stubble, blanketing the composition with pastoral claustrophobia, as if we ourselves had just had a close shave with the reaper. Shut in by the vegetation, the soaring flight of the single lark transcends the countryside cliché to become an escape into the empyrean. Trust van Gogh to turn a greetings card into a moral drama.

He found his own way to lay down brilliant colour, straight from tubes of industrially produced pigment. It was an Impressionist rule of thumb that, whether they were painting in gossamer threads like Monet or bead curtains like Seurat, the effect should be as though the colour was somehow impersonally *found*, through a blink of the eye in sunlight, the involuntary optical tic of what Marcel Duchamp would call the 'retinal shudder'. A display of the hand of the painter doing his mucky work – slap, smear, stab – was at all costs to be avoided.

But the pretence of self-effacement was impossible for Vincent the hand-shaker. His radically original style of marks, in short bristly streaks, was unavoidably personal, aggressive and direct. Every stroke was a letter to the beholder, wanting us to feel them as if they had been laid down just seconds before. Proximity, intimacy, the sense of standing beside him as he worked, was everything. That's how he connected. So even when he's bathing us in prettiness, as he does in the Paris pictures, van Gogh's marks are self-consciously indelicate: smeary dashes, the hog bristle whacking away at the canvas to create a painting that grunts and sweats. It's loaded with autobiographical, confessional intensity, and it dares us to get out of the way.

So the portrait of *Père Tanguy* (page 317) is a comprehensive document of their many points of connection, personal, professional and even political. Tanguy was van Gogh's supplier of materials, so, as in *The Potato Eaters*, his entire persona is constituted from his work: a living paint shop. But he and van Gogh shared an enthusiasm for Japanese woodblock prints, so naturally he was posed among items from Vincent's own collection: the Buddha of the boulevards. But he was also an old-time republican socialist, a personification of the politics that Vincent himself endorsed and from which, through Tanguy's easy-terms credit, he benefited. Tanguy exhibits the rope-veined hands and rustic hat of the authentic worker.

Van Gogh needed all the financial help Tanguy could give him because his work was still not selling. Unconvinced, now that he had brightened up to conform to his brother's specification, that Theo was doing everything in his power to show and sell the work, Vincent took matters into his own hands. He organized exhibitions of his and Theo's Japanese prints in the Restaurant du Châlet and in the Café Tambourine,

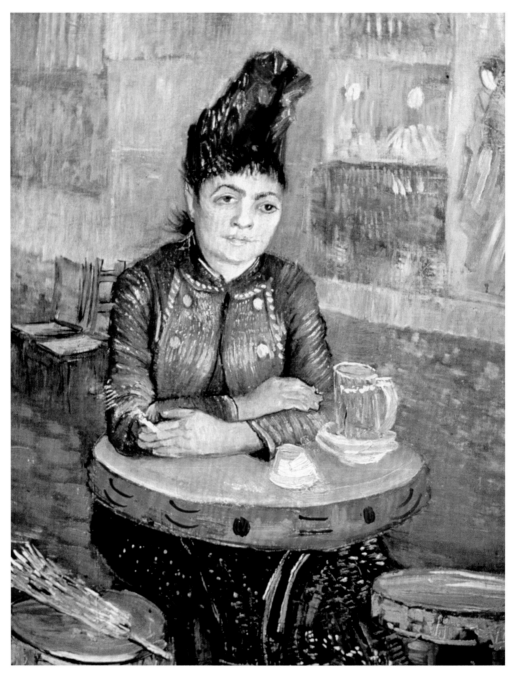

Above: WOMAN (AGOSTINA SEGATORI) IN THE CAFE TAMBOURINE, 1887, oil on canvas (Kröller-Müller Museum, Otterlo).
Opposite: PORTRAIT OF PERE TANGUY, 1887, oil on canvas (Niarchos Collection, Paris).

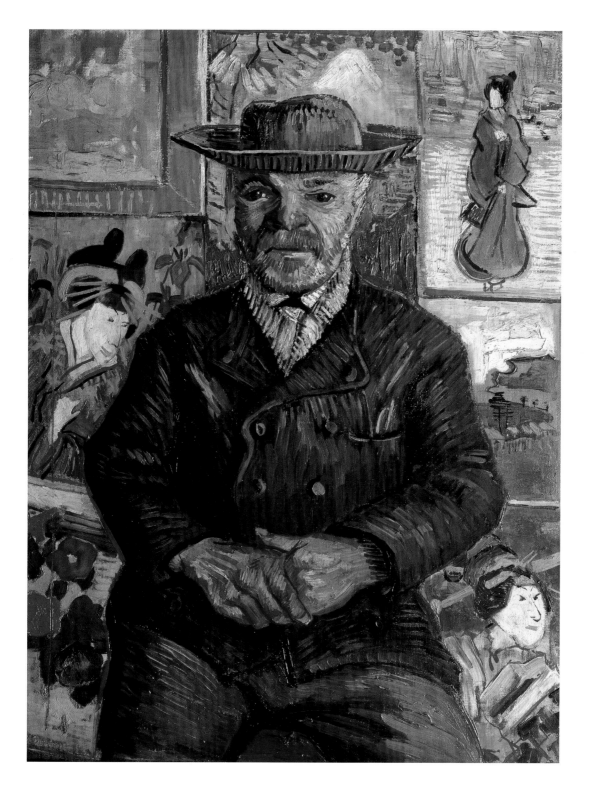

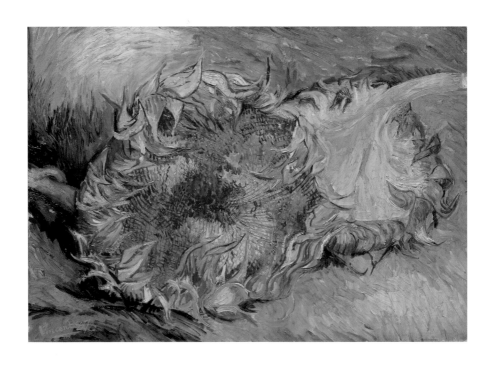

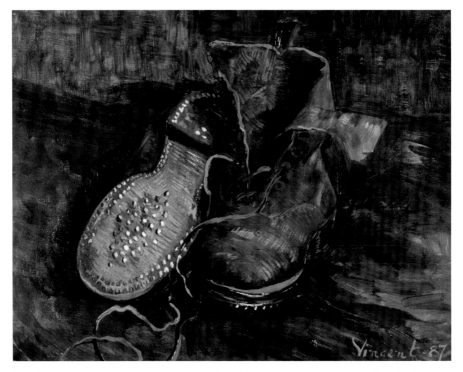

Top: SUNFLOWERS, 1887, oil on canvas (The Metropolitan Museum of Art, New York).
Above: A PAIR OF SHOES, 1887, oil on canvas (Museum of Art, Baltimore).

which belonged to his mistress, Agostina Segatori (page 316). One of the shows included alongside the woodblock prints two extraordinary paintings of ostensibly ordinary things: hobnail boots and cut sunflowers. No one who saw them, though, could possibly confuse either painting with charming little '*natures mortes*' – still-lifes. These are unstill-lifes. The boots were an emblematic self-portrait of the pilgrim still tramping that long, lonely road between earth and heaven – only now that he had abandoned formal religion, Vincent was after a heaven here on earth, where it was urgently needed. And the cut sunflowers have absolutely nothing in common with demurely decorative flower painting. They hardly seem botanical at all – more like alien organisms crash-landed from a burning star. Laid down, they seem massive, potent, mysterious, bursting with life force in their big, black seeds. Together, the boots and flowers signpost van Gogh's journey towards radiance, resolute and rapt. In France the sunflower, after all, is the *tournesol* – the turn towards the sun – which increasingly for the northerner has come to replace the Christian God as the life source, the power of raw nature. Inevitably, then, he finds himself drawn towards that scorching gold.

VI

IN THE DEPTHS OF WINTER, in February 1888, Vincent got on a train bound for Provence. Even by his nomadic standards, the move was sudden. He had been living for two years with Theo, who believed that his brother's career was about to take off. Now that other painters were expressing interest, buyers might follow. But even Theo's devotion had limits. Like everyone else who came into close proximity to Vincent, Theo may have found his brother's neurotic mood swings – the alternation between cloying gratitude and paranoid suspicion – unbearable. Besides, he was going to marry a nice, apple-cheeked Dutch girl, Johanna Bonger, and set up his own home. Inevitably, the lives of the brothers would have to be adjusted.

Always quick to feel spurned, Vincent took his brother's marriage personally. But sick, wheezing and stooped, his head often lost in a vapour of absinthe, he needed to be out of the chilly damp of Paris. He was escaping more than grim weather. Some of the Impressionists, once the rebels, were starting to be courted by fashionable galleries and to behave grandly, quarrelling amongst themselves and regarding van Gogh as an unwashed eccentric, someone for whom models refused to sit even when he had the money to afford them; someone barely this side of crazy. For his part, van Gogh had been smitten by another of the Impressionists' pet curiosities, the human irritant and sometime stockbroker and canvas salesman Paul Gauguin.

Gauguin was tolerated as an amateur, permitted to hover at the edge of the charmed circle. He was indulged as the Impressionists' tame primitive, someone who had a knack for making intricately exotic wooden boxes and cloisonné pots. The more Gauguin spat at the bourgeoisie, the more he screwed and boozed, the more puppyish Vincent became in his presence. Gauguin spoke heatedly of tropical esoterica which, for the Nippomaniacal Vincent, marked him out as a true rebel and poet. He couldn't hear enough of the sojourn in Martinique where Gauguin had contracted malaria and a lot else besides. Basking in the unaccustomed devotion, Gauguin gave van Gogh one of his paintings of black women, thus sealing, so far as Vincent was concerned, their blood-bond. In return he sent Gauguin the two paintings which added up to his visual signature: the beaten up boots and the cut sunflowers, the wayfarer and the mysteries of the organism. Side by side, larger than life, they were now re-imagined as heralding the arrival of a great art double act: Vincent and Paul.

Both of them hated the Parisian art world of the *grands boulevards*: the dealers and critics, the vanity and backbiting. They hankered after some less corrupted place where they might live in comradely affinity, sharing expenses and pooling the proceeds from sales. The trouble was that Gauguin and van Gogh had different ideas about where such a place might be. Gauguin went west to Pont-Aven in Brittany, taking with him van Gogh's close friend Emile Bernard. Drawn by the saturated colours of a Marseille painter named Adolphe Monticelli, who had died in 1886 (but not before Theo had bought some of his paintings), Vincent went south in search of what had made Monticelli shine. Always the bookworm, he had been reading John Ruskin who was committed to communities of virtuous work. And, as usual, he was inspired by Japan – this time by the example of Buddhist monks. In the south van Gogh hoped to establish a fraternity of selfless devotees. It would be Zen with olive oil.

It was a shock, then, to alight from the train and find Arles deep in snow. Disconcerted but not despondent, van Gogh took a room in a cheap hotel near the station and saw something that spoke to him of the inevitability of spring awakening: a peach tree standing in the snow, its boughs laden with blossom. He drew and painted it and dreamed of orchards, all resolutely budding in the chill. Come April and the thaw, the dreams had become reality: van Gogh filled his vision with a parade of blossoming fruit trees – almond, apricot, plum – and covered his canvases with their delicate dance of pale petals. It was his hymn of rebirth. Along with the sun came the revival of his dream of a little art commune in the south. He rented a two-up, two-down house in the Place Lamartine and painted it bright yellow.

Without any money to furnish it, he left it empty for the moment and took rooms in the Café de la Gare. But his belief in the Studio of the South, ensconced in the Yellow House, was total. He wrote first to Bernard in Brittany and got deafening silence in return; but it was Gauguin whom he really wanted to land.

Gauguin and van Gogh were a mismatch in every way that counted. The differences were not just temperamental: the worldly, cynical, self-consciously swaggering Gauguin against the hyper-emotional, feverishly sincere van Gogh. Their philosophies of art were fundamentally at odds too. For the mystical Gauguin, art's mission was to detach itself from earthly reality and, through arrangements of pure colour, float free, taking the beholder into a blissed-out state of alternative consciousness. Use your imagination, he would tell Vincent; paint from memory, not from what's in front of you. The ride art was supposed to give you would be away from the here and now (for who wanted to hang around *that*?); a trip into the tropics of the mind on Spaceship Purple. Gauguin was the first artist to throw the word 'abstract' around a lot, and that's where he thought art should be headed: a swim in pure sensation. Don't sweat it, he once said, crushingly, 'dream on it'.

But for van Gogh, there was no possibility of joy *without* sweat. The work of painting was not a stoned-in-the-hammock trip of the imagination, it was blood and blisters and staring till your eyes popped. When the scorching mistral assaulted him, Vincent embraced the onslaught like a gladiatorial foe, securing his easel with ropes attached to iron stakes, which he hammered into the hard soil as the wind howled around him. His art was earthy or it was nothing: embedded in the material of the natural world, not unhitched from it. While Gauguin's colours were flatly two-dimensional and vaporous, Vincent's were dense and textured like coarsely woven cloth or vegetable matter. You inhale Gauguin and let the vapours circulate. Nice, isn't it? But you digest van Gogh's meaty hotpot of colour and you let the juices seep.

Which is not to say that van Gogh didn't have his mystical moments. It's rather that the gravitational pull of his work was different. Gauguin wants to take off; van Gogh wants to pull heaven down so that it becomes indistinguishable from the earth. It is, he was coming to believe, the only heaven we have. But the mistake of older painters, even those whom he deeply revered, such as Jean-François Millet, the lyrical artist of peasant life, had been to tie art to the soil so completely that it became clotted with its heaviness. So while Millet's version of *The Sower*, 1850, made the booted labourer monumental, married to the earth, van Gogh's *Sower at Sunset* (page 322) seems to hover on a carpet of radiance like Jesus walking on water. He called it 'An Exercise in a Composed Picture', meaning that he reworked it many

SOWER AT SUNSET, 1888, oil on canvas (Kröller-Müller Museum, Otterlo).

times to try to achieve a finished monumentality. In one alteration he changed the sower's clothes from white to purple to make the figure dissolve more completely into the multicoloured aura. It's a scene from the terrestrial paradise. A few crows hover, with no particular evil intent. Drudgery is dissolved into a fertility miracle enacted beneath the high-wattage sun-god; as Silverman observed, it's a sacred spilling, an insemination of the world.

Van Gogh wrote of his paintings when they came off that they were a *jouissance*, French for 'orgasm'. And this is certainly how he thought of this kind of painting – as an ejaculation of emotional energy in paint. 'The enjoyment of any beautiful thing,' he wrote, 'is like coitus, a moment of infinity.' But he also meant a kindred sense of *jouissance* as a kind of 'blinding', when in a moment of utter rapture the senses collapse in on themselves and the mind is simultaneously paralysed and energized. Everything in *Sower at Sunset* streams: the seed, the rays of the sun, the paint shooting from Vincent's loaded brush.

You can almost hear Gauguin sneering, 'Well, yes, that's what I go to the brothel for.' But that's why van Gogh decided to deny himself that doubtful pleasure in Arles – or at least limit his visits to once a fortnight. When they exchanged portraits, van Gogh painted himself as a Buddhist monk, a crop-haired *bonze* set against meditative celadon green, while Gauguin did himself confrontationally, his head sharply chiselled like the wooden bust of an African or Inca warrior. On the back wall is a cartoonish profile of their mutual friend, Emile Bernard, beneath which Gauguin has written the comradely inscription '*les misérables*'.

His head ablaze with southern light, his output prolific – at least three major paintings a week – van Gogh saw none of the difficulties that lay ahead in their prospective partnership. And since Theo had bought some of Gauguin's paintings, Vincent enlisted his brother in the campaign to get Paul to come south. It was strictly a one-way romance. Gauguin was as nervous about Vincent's notorious moodiness as was everyone else. But in the summer of 1888 he began to listen to Theo's suggestions. He was sick, broke, tired of the Breton rain. Theo had promised to pay for his room and board in Arles, and perhaps for his materials and train fare too. And Gauguin thought there might be a way to convert van Gogh's crackpot utopia into a proper business enterprise run by himself. He had lost enough money to know something about it. He was in no hurry, though, to catch that train to Provence. It was not until August that he agreed to go to Arles and not until the third week of October that he finally showed up.

In the meantime, van Gogh acted like a nervous groom awaiting the arrival of his bride. Supplied with funds by Theo, he bought two beds in different woods,

a mirror and *twelve* chairs – an almost manic act of faith that the Yellow House would become home to a little community. There were two studios on the ground floor, one also serving as a kitchen. And in the 'guest bedroom' he hung big paintings of pots of sunflowers, the hot yellows slathered on wet in wet, as if the thicker the paint the more substantial the dream of the Studio of the South. 'I really do want to make it *an artist's* house, but not affected, on the contrary, *nothing* affected but everything from the chairs to the pictures full of character.' This was more than just decor. It was the furnishing of a new life, a community of two.

All this neediness to be one of a pair translated into van Gogh's technique. Ever since being lit up by colour in Antwerp, he had been fascinated by optical opposites that were also complementaries – violet and yellow, red and green – and the drama they played with the senses. For van Gogh, of course, that drama could never be merely aesthetic. He was still the pilgrim in search of heaven on earth, but he knew that along the way there could be detours into hell. On his Arles canvases a struggle took place between fruitful and barren worlds, fertility and self-destruction, comradeship and loneliness. Who else but a bipolar epileptic could encompass both those poles?

The most barren of all is *Night Café in Arles (Place Lamartine)*, a place of garish alienation 'where one can destroy oneself, go mad or commit a crime'. The colours barge into each other like drunks looking for a fight, 'soft pink with blood red… soft Louis XV green with…harsh blue greens, all this in an atmosphere of an infernal furnace in pale sulphur to express the powers of darkness in a common tavern'. It's the absolute opposite of van Gogh's dream of social solidarity and mutual succour. Here you're on your own, loser. Gas lamps emit a ghastly glare that paints the walls the colour of blood. Drunks slump on the tables. One holds his head in his hands as if already crucified by a hangover. Even the chairs, scattered this way and that, seem to speak of people going their separate ways rather than an evening of chatty conviviality. The waiter's jacket is purest jaundice, his moustache and hair green. On a billiard table a cue, its tip French-chalked like the touch of a social disease, lies beside white balls in a macabre mockery of lechery.

The opposite of the *Night Café* and its denizens was home: a warm kitchen hearth, domesticity, the French version of *gezelligheid*. Vincent's happy family were the Roulins. *Joseph Roulin* (page 326), salt of the earth, solid republican and patriot, was only a postman, but van Gogh's primary colours and arresting frontal pose signalled grandeur and honesty, and turned the public servant into a pillar of society, someone who wore his uniform as if he were an admiral from Toulon. Roulin's luxuriant whiskers were the outward sign of his patriotic virility, for the Roulins were reproducing for France. Madame Augustine Roulin (*La Berçeuse*), then, was painted

NIGHT CAFE IN ARLES (PLACE LAMARTINE), 1888, body colour on paper (Collection Hahnloser, Berne).

 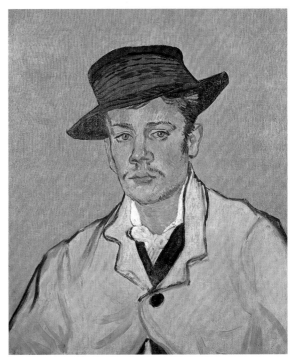

Above left: PORTRAIT OF JOSEPH ROULIN, 1889, oil on canvas (Kröller-Müller Museum, Otterlo).
Above right: PORTRAIT OF ARMAND ROULIN, 1889, oil on canvas (Van Gogh Museum, Amsterdam).
Opposite: LA BERÇEUSE (AUGUSTINE ROULIN), 1889, oil on canvas (Museum of Fine Arts, Boston).

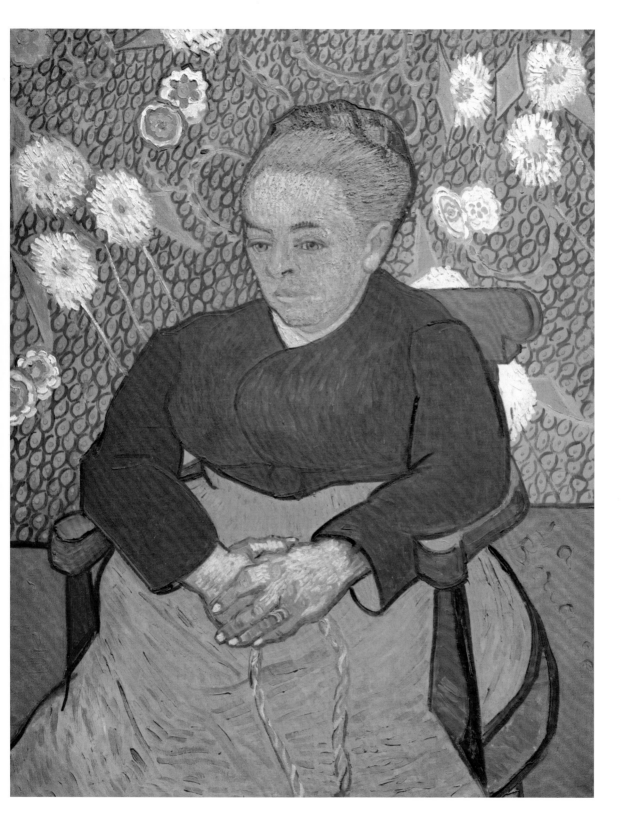

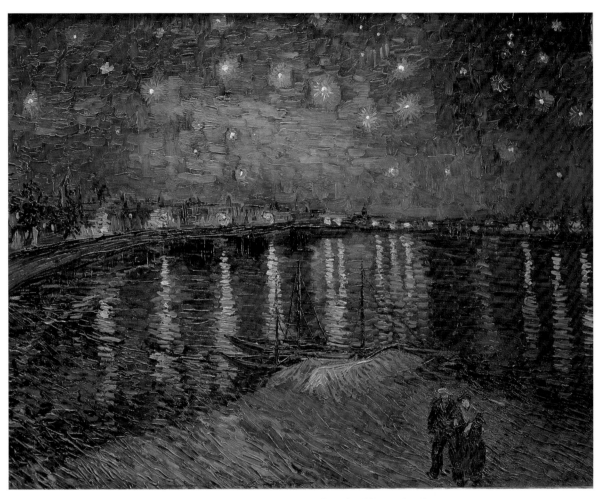

STARRY NIGHT OVER THE RHONE, 1888, oil on canvas (Musée d'Orsay, Paris).

as the personification of the citizen-mother: bosomy, one hand on the cradle. Vincent couldn't get enough of the Roulins. He painted both the toddler Camille and the handsome young buck *Armand Roulin,* 16 years old and right on the cusp between the innocence of childhood and manly bragging. The background is blue-green to suggest the adolescent's frank honesty. The check-me-out yellow jacket trimmed in complementary blue, black waistcoat, white scarf tied at the throat and cocked hat allow the teenager his Arles street attitude, but the swagger is undercut by the soft wispiness of his barely evolved moustache. It's a parents' picture done by someone who often (like Turner) described his paintings as substitute children, made with visible tenderness. The simpler the people, the more noble van Gogh found them. 'In my pictures I want to say something consoling as music does. I want to paint men and women with a touch of the eternal, whose symbol was once the halo which we try to convey by the very radiance and vibrancy of the colouring.'

It was not just through landscapes, then, that van Gogh tried to bring heaven down to earth. His sympathetic portraits of the Roulins and the *Zouave,* 1888, turned ordinary people into gods and heroes, and Arles became what its famous promenade was actually called: Alyscamps – the Elysian Fields. And van Gogh was reading Tolstoy (with whom, improbably, he shared so many traits) on the imminence of a new kind of religion, 'something completely new which will be nameless but which will have the same effect of consoling, of making life possible as the Christian religion used to'. It would be the art revolution to render political revolution beside the point.

On a warm night in September van Gogh went to the Rhône embankment and had a Moment. In *Starry Night over the Rhône,* the sky is hung with stars, and the town gas lamps burn with fairy sweetness, reflecting in the river. He translates this nocturnal epiphany into an affirmation of what he has known all along: the dissolution of the boundary between the terrestrial and celestial worlds. Arles is reduced to a slender strip barely separating the mildly lapping water from the starry sky. A couple, middle-aged, arm-in-arm, gaze raptly up to the heavens and seem, like his sower, to be water-walking, ushered into the heart of the miracle, canoodling on the threshold of infinity. With them, with that sky, van Gogh has arrived at his own startling vision: that what we should see is what they *feel.* What we see is the vision of their rapture, caught not prosaically in some stock piece of character depiction, but in all the unutterable, immeasurable intoxication of the senses. He has finally come to paint, as he often said he wished he could, the fullness of our hearts. But he also had to contend with the din in his head.

VII

JUST AS VINCENT WAS GIVING UP ON HIM, Gauguin arrived and put paid to the summer of ecstatic visions. Paul didn't much like the look of Arles – 'everything small and mean' – and in any case, he was in the habit of taking his time to settle in and check out the cafés and brothels before starting work. But van Gogh let Gauguin have exactly one day before rushing them off on their first 'campaign'. Looking at his tiny room in the cramped Yellow House – which he could only reach by walking through Vincent's bedroom – Gauguin felt the sudden grip of claustrophobia. For a while, this sense of being trapped in a big mistake was held at bay by Vincent's breathless deference, treating Paul as the master from whom he had everything to learn. (As it turned out, van Gogh's painting most obviously indebted to Gauguin, *Memory of the Garden at Etten*, 1888, is also one of his most feebly ornamental.)

The two of them set off together into the cafés and dance halls, parks and fields. At first Gauguin found the friendly competition amusing and even creatively challenging. But, as Debora Silverman argues, the results always pointed up the ultimately unbridgeable differences between them. Vincent's version of a grape harvest is a jolt of febrile energy – tiny bustling figures, much bending, lifting, reaching and picking beneath the great sun-god, the brush jiggling and wriggling. Gauguin's take on the same rural labour is called *In the Full Heat of the Day*, 1888, and features a drowsy moment with two figures, one of which is a pig. A half-naked woman seen from the back, her arms stained to the elbows with grape juice, leans conveniently forward, her heavy breasts outlined as though asking for animal contact – which Gauguin duly supplies with his brushes. Both paintings have the quality of textiles; but while Vincent's is hectically woven from his box of yarn, the threads hanging loose, Gauguin's, though painted on jute, seems the fabric of dreams, velvety and silky.

Towards the end of November van Gogh did two pictures of their respective chairs, painting them again on the homely material of jute. It was another gesture of wishful comradeship, even while Vincent observed the differences: Gauguin's chair has something nocturnal about it – gaslit, flamboyantly carved, with open books, as befitted the intellectual titan van Gogh thought he was. Vincent's chair catches the morning – sunlight warming the straw seat with its waiting pipe and wad of tobacco. Given what was happening, the statement is unavoidably poignant, and one or other of the pictures may have been done in solitude after a row. The dominant notes in *Gauguin's Chair*, 1888, are, after all, red and green: the complementaries that clash.

For as the weather had chilled, so had their relationship. Gauguin was exhausted by van Gogh's merciless earnestness and irked by his manic rate of work

(at least one picture a day), as if this were somehow a reproach to his own more studied routine. He didn't know which he hated more: van Gogh's grovelling infatuation or his fits of fearsome temper, some of them the heralds of epilepsy. And he began to feel something he never imagined would ever visit him in van Gogh's company: envy. Incredulous at the luminous power of yet another batch of sunflower paintings, Gauguin exorcised his jealousy – somewhat – by doing van Gogh as 'the painter of sunflowers', slumped in a chair, body and face distorted as if already a deranged invalid. Vincent's sunflowers in Gauguin's version, of course, wilt pathetically. 'Yes it's me,' van Gogh told Gauguin, 'but it's me gone mad.' What he was in fact suffering from were seizures of epilepsy and fits of manic depression, both diseases that ran in his family. The precipitous downswings of mood were deepened, no doubt, by desperation at the relentlessly bleak news from Theo that still his paintings could find no favour with buyers. The absinthe through which van Gogh escaped immediate pain only made it worse.

By mid-December, less than two months after he had arrived in Arles, Gauguin realized that he had to escape, if possible without sending Vincent over the edge. But van Gogh knew exactly what was going on. 'I think Gauguin is a bit disillusioned with me,' he told Theo, and became once again harrowingly self-critical. Every time he had tried to build a nest – with Sien the whore, with Theo in Paris, and now with Gauguin – it had gone wrong, so who could be blamed but himself? He was also beginning to hate the faithless friend who refused to stay long enough to give the great experiment in comradely cohabitation a chance. One evening, in the throes of sorrow and rage, he flung a glass of absinthe at Gauguin.

A week later, just before Christmas, the two of them patched up their quarrel enough to take a trip to Montpellier to visit an art collection that was open to the public for just a few days each year. They had been arguing a lot about art, 'the arguments exceedingly electric', van Gogh wrote, adding that afterwards he felt like a spent battery. But the Montpellier trip provoked a truly violent quarrel in which Delacroix acted as a sounding board for their mounting hostility. Vincent prostrated himself before the French Romantic's *Human Miseries*, while Gauguin sniffed sceptically at the stage props and the sentimentality, and told van Gogh with calculated brutality that it left him completely cold. Gauguin the fencer had brought his foils with him to Arles, and it was as though he was ready to be *en garde*.

A week later, on 23 December, van Gogh thrust into Gauguin's hand a fragment from a newspaper article about a local knife attack. The last line read: 'The murderer fled.' Gauguin didn't need the message spelling out. He was the murderer of the Studio of the South. That evening he decided not to go back to the Yellow House and

instead spent the night in a hotel. When he returned home in the morning there were police at the front of the house and blood inside it. Gauguin was arrested as a suspect. But it didn't take long for the truth to come out. Around midnight van Gogh had shown up at his favourite brothel and handed one of the girls, Rachel, a small package. Inside was a large slice of ear lobe. Rachel fainted. (A few months later, allowed to visit Arles in the company of a hospital guard, van Gogh – who had no memory of the incident – thought it would be polite to go round to the brothel and apologize for the nasty parcel. The girls – obviously troupers – told him not to worry, since there was nothing surprising about that sort of thing in their line of work.)

Bleeding copiously, he was taken to a local hospital, where he was diagnosed by the chief consultant as suffering 'acute mania with delusions'. A few days later Theo, summoned from Paris by Gauguin, made sure his brother was in good hands and then left by the evening train. Gauguin, who had not seen Vincent since the night of their last confrontation and would never see him again, left on the same train. Discharged from hospital ten days after the self-mutilation, van Gogh returned to the Yellow House and worked there for a while before further seizures triggered another spell in hospital. When he returned again, in the company of his postman friend Monsieur Roulin, he found the house sealed off and guarded by policemen. Thirty neighbours had petitioned the mayor to evict him as a mentally unstable menace to the district. Sadly, van Gogh did not altogether disagree. The Studio of the South was finished.

VIII

BUT NOT, OF COURSE, VAN GOGH'S ART, the very best of which was still to come in the year and a half that remained of his life. Which immediately raises the issue, endlessly rehearsed in the academic literature, as well as in novels and films, of whether Vincent's mania was also the condition of his most original creativity. That, of course, is the popular view of tormented genius: in van Gogh's case, that some-how by plumbing the depths he was enabled to soar into the Starry Night; that his mania opened a vision denied to the prosaically sane. This romance of the unhinged visionary was first articulated by Aurier, and Vincent responded indignantly (if a bit churlishly) to Theo, who had delightedly sent it to him, 'I need hardly tell you I don't paint like THAT.'

There were times, both in the hospital at Arles and later at the asylum of St Rémy, where he voluntarily committed himself in May 1889, when Vincent wasn't even sure he *was* mad, perhaps no more than epileptic. But manic depression ran all through his family, and before long he resigned himself to the inevitability of

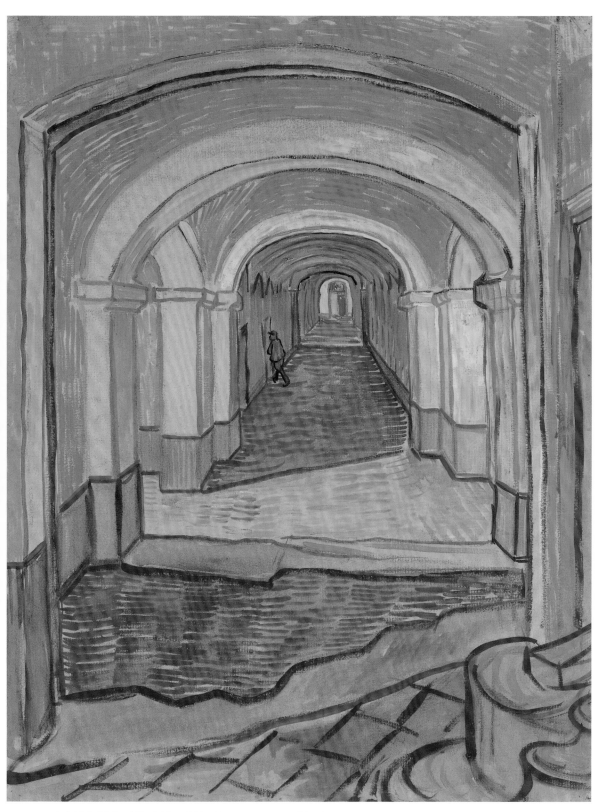

A CORRIDOR IN THE ASYLUM, 1889, watercolour (The Metropolitan Museum of Art, New York).

periodic 'attacks' that, as he told Theo, were 'no joke'. But neither his letters from the spring of 1889 nor his paintings and drawings have derangement written on them. Living with lunatics, he wrote, paradoxically took his mind off his own state and the frightening unpredictability of the fits. 'For although there are some who rave and howl a great deal, there is <u>much</u> true friendship here. They say we must tolerate each other so others may tolerate us...and we understand each other very well.' In between the attacks, then, van Gogh seemed possessed by clarity and strength. So the phenomenal sequence of paintings achieved in the Arles hospital, and especially at St Rémy, with their convulsive bucklings and writhings, the cartwheeling stars, rocks heaving in sinuous arabesques, the cyclonic rush of brushstrokes through the quaking cypresses (page 336), should not be read as documents of a descent into lunacy. They are indeed landscapes of the embattled mind. But there really is a battle going on – not a frantic retreat with brushes lashing and flailing. Vincent's art attacks, the better to defend the beleaguered lines of his composure. It works. The 'horror of life' receded, he told Theo, and with every stupendous picture he felt more, not less, sane; energized, not depleted. Which is why, when Paul Signac came to see him, he could report to Theo that he found Vincent in perfect physical and mental health.

That, perhaps, was an exaggeration, as was Vincent's description of the last of his 38 self-portraits (and surely the greatest) as a picture of calm. It invites the eye, after all, into a whirlpool of coiling paint that not only snakes about his head like the graph of some migraine on the march, but continues through his clothes, wheels through his brow and temples, and rides through the sweeping waves of his red hair. But van Gogh is not helplessly dragged down. The cast of his face is resolute – it is the hard rock around which the swirling ocean crashes. And the (unreproducible) colour, a steely blue-grey he's chosen for the action-painting, has the effect of making the onslaught less, rather than more, threatening. Contouring the jawline, the red hair of his beard – the colour of pugnacious strength – signals the watchful determination of the fighter. It's this struggle between creative anchorage and being swept into the engulfing tide that colours all the masterpieces of his last phenomenal year.

What we're looking at, when we see cypresses and wheatfields, are pieces of Provence, but only incidentally so. What we're invited to contemplate is the inside of van Gogh's head, which is no place for sun-drenched tourism. Anyone averse to the confessional outpourings of the crucified ego, who believes that art should never primarily be about the artist, will probably feel that the confrontational expression-ism that van Gogh inaugurated was the worst turn that modern painting could have taken. Countless millions, though, have taken his hot and sweaty handshake and

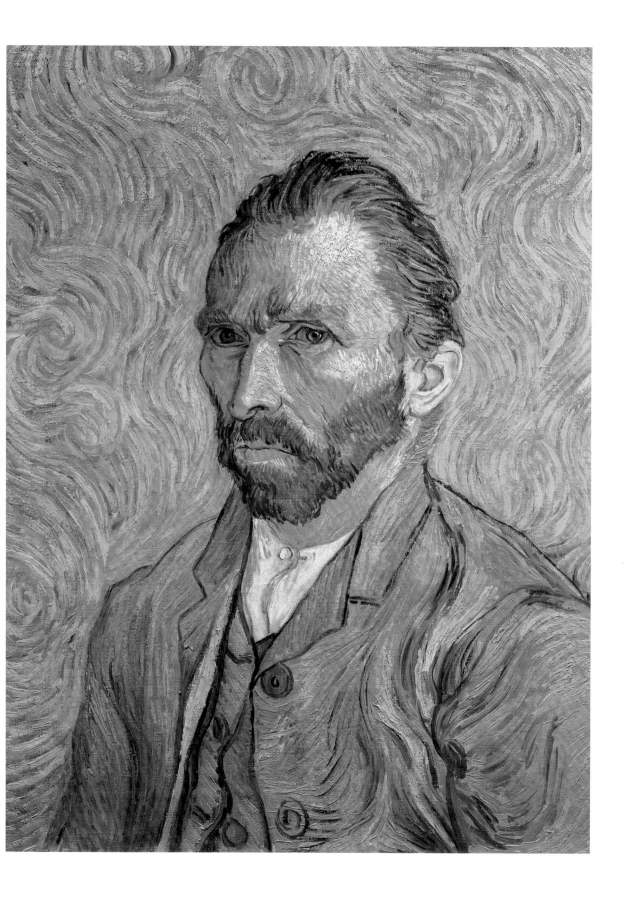

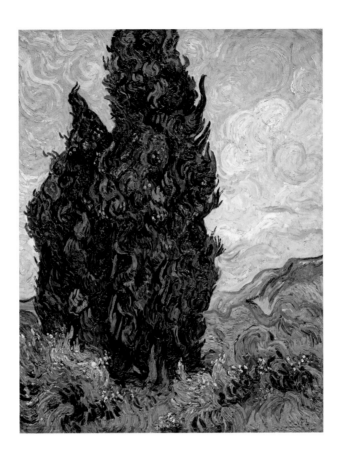

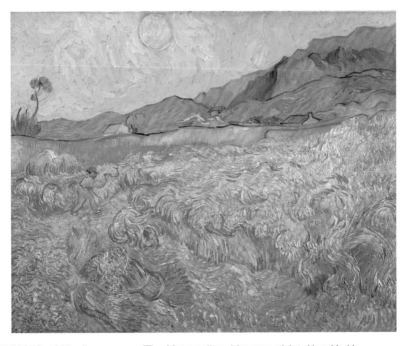

Top: CYPRESSES, 1889, oil on canvas (The Metropolitan Museum of Art, New York).
Above: WHEATFIELD WITH REAPER, 1889, oil on canvas (Van Gogh Museum, Amsterdam).
Previous page: SELF-PORTRAIT, 1889, oil on canvas (Musée d'Orsay, Paris).

embraced the emotional and psychological connection he offers. Instead of being repelled by the emotional overload, we're moved by van Gogh's humane openness, the unconditional confidence in our sympathetic engagement.

So unless you turn away, there's no choice but to be pulled into van Gogh's maelstrom of paint, each slashed-on mark a rope that tightens about our attention, making wandering impossible. During his stay in Arles Gauguin had written to a friend that what especially alienated him from van Gogh was the Dutchman's addiction to the massively loaded brush, while he, Gauguin, detested 'the mess of brushwork', preferring rather to lay down pigment in ponds of flat-smooth, untextured colour, precisely because it rose above the embarrassing opera of the emotions and towards some universal condition of disembodied karma.

It's the difference between out-of-body reverie and Vincent's sometimes agonized, sometimes deliriously happy, sense of internalizing the world *within* his body – sometimes, alas, literally. Although he knew nothing about it until he was told, he had spells of coprophagia, dirt-eating. And in the middle of a manic spell, terrified of being consumed by paint, he'd fight back by consuming it, swallowing tubes of chrome yellow, cobalt and carmine and washing them down with turpentine before the nurses got to him.

There were, however, also quiet moments in St Rémy. As always, when he was not painting, van Gogh was compulsively reading – Shakespeare above all. The Bard excited him so much that he had to go and look at something simple – a blade of grass or a flower – before he could calm down. From time to time a wistful, autumnal note crept into his work, as though he had been spending too much time with *Hamlet*, *Richard II* or – of course – *King Lear*. The needful quietus began to tantalize him. Four years earlier, he had written this about his painting of the church at Nuenen where his father preached: 'I wanted to express how very simple death and burial are, just as easy as the falling of an autumn leaf.' Now he painted a solitary figure – his own double – walking alone, like an apparition from another world, in the park near St Rémy, amongst those falling leaves, one foot on the path, one foot on the grass. His remoteness – part of our world and yet not – was hinted at by the obstructing twist of tree trunks that kept him out of reach. Van Gogh feared death less than madness. There were times when death seemed to him to be just a dissolution of the finite self into the infinite profusion of nature; an ecstatic as much as an elegiac moment. So between the madly incandescent stars, comet-like trails of light turn into astral tentacles, looping and groping for the star-gazer, hauling him into the cobalt beyond. Most movingly, the figure of the reaper in *Wheatfield with Reaper* (page 336) could scarcely be less grim, since he is swallowed alive within the

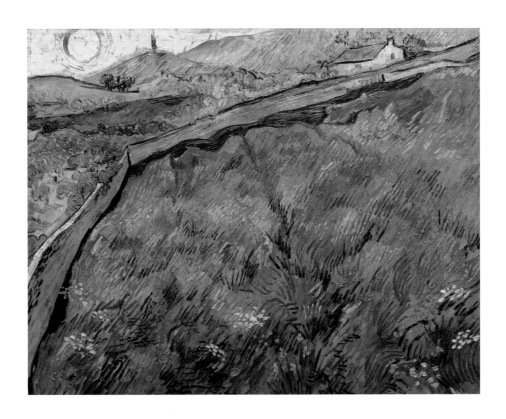

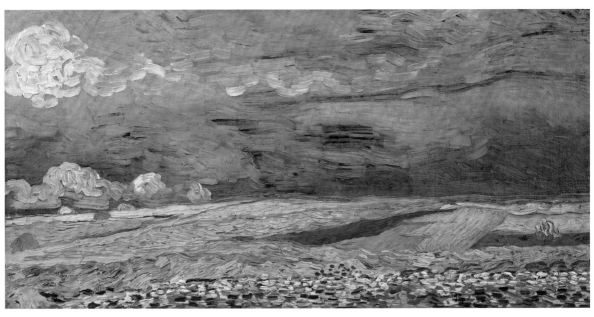

Top: FIELD OF SPRING WHEAT AT SUNRISE, 1889, oil on canvas (Kröller-Müller Museum, Otterlo).
Above: WHEATFIELDS UNDER THUNDERCLOUDS, 1890, oil on canvas (Van Gogh Museum, Amsterdam).

enveloping ocean of wheat, beneath a sky as golden as the grain – heaven and earth once again folded together.

Along with this feeling of being so immersed in nature that he could be buried alive in it came a wistful longing for a return to the north. While he was recovering in the hospital at Arles in May 1889, lost to the world, he told Theo he could see very clearly the little universe he had left not so very long ago – the squat Brabant churches standing in the rain and, further back, the grassy paths of Groot Zundert. If he was doomed never to be able to create that artists' home he had hoped for in the south, perhaps it was time to *go* home. He painted some very beautiful versions of what he called 'Memories of the North' (for once acting on Gauguin's instruction), one of them an image of women in their Brabant caps bending to dig turnips against a background of tumbledown, moss-roofed cottages. He planned new versions of *The Potato Eaters* and *The Old Tower*, works he had done at Nuenen; recommenced an affectionate correspondence with his younger sister, Wil; and painted his mother from a photograph, transforming Calvinist bleakness into maternal twinkle.

With Theo, it was always more complicated: love interrupted by suspicion. Sometimes Vincent had blamed his brother for failing to show his work, much less sell it. Perversely, now there was talk in Paris and Brussels of his art, he worried about Theo showing too *much* of it! And he fretted that the marriage to Johanna and the impending baby might dilute their brotherly intimacy and jeopardize the unfailing material support he had always counted on. Genuine pleasure in his brother's family life competed with a kind of gloomy, apprehensive envy that may actually have triggered another and exceptionally severe bout of attacks in February 1890. When he eventually came out of them, Vincent was receptive to Pissarro's idea that perhaps he would be better off in the village of Auvers-sur-Oise, where the famous Dr Paul Gachet, painter and engraver, collector, specialist in melancholy, champion of homeopathic cures, might take him under his wing. On 4 May, 'categorically rejecting' Theo's suggestion that he should have a travelling companion for the whole train journey, Vincent wrote to Theo that he would come first to Paris and stay with him and Jo, before moving to Auvers for perhaps a few weeks. He had no doubt that in the north his sickness could be contained, if not reversed: 'I need some air.'

IX

AT BEST, JOHANNA VAN GOGH must have anticipated the arrival of her brother-in-law with mixed feelings. So she was pleasantly surprised by the Vincent who showed up at their door on 17 May. 'I had expected an invalid but here was a sturdy,

broad-shouldered man with a healthy, ruddy colour and a broad smile on his face and a resolute appearance.' For two days Vincent warmed himself in the family nest, staring happily at the baby boy who (despite the artist's protests) had been named after him. Then he did the rounds, fell in love – somewhat improbably – with the paintings of the Symbolist Puvis de Chavannes, and went to see old Père Tanguy, who had stored some of his paintings. But the racket of Paris got to him, and when told that he was being mentioned in the same breath as Cézanne and Toulouse-Lautrec, he immediately worried that he might be misunderstood and over-exposed!

Auvers seemed exactly the antidote for these self-inflicted anxieties. On 21 May Vincent moved into rooms at the Café Ravoux in the centre of the village. In no time at all he was in the best of moods: bursting with creative energy, delighted by the beauty of the gently undulating wheatfields round about, enjoying Gachet's company (though not the five-course meals he had to sit through at his house), and so pleased that the doctor was in fact a sufferer from the same melancholy he was supposed to treat that he did a portrait of him deep in its grip. The brotherliness Vincent evidently felt was translated into a picture of the doctor, head on hand, with the same red hair as van Gogh, the same sorrowing and pensive stare into the distance, and everything, including the delphiniums, streaked with the blues. This van Gogh knew how to do; this van Gogh rather enjoyed!

It was not all plain sailing. Despite painting some astounding portraits, including one of Gachet's daughter Marguerite at the piano, in which her dress was built from a dense plumage of zinc white squeezed straight from the tube, flattened on the canvas, and made to swag and fall with its own weighty sonority, this turned out to be yet another of the homes that was too small to contain the ever-expanding passions of Vincent van Gogh. There were little outbursts of ill temper. Van Gogh stopped going to those five-course meals. He may even have suspected Gachet's commuting to Paris as a kind of desertion.

But the rift didn't slow him down as summer warmed up the Oise valley and the wheat began to ripen. Van Gogh started work on a series of paintings in a new format: an elongated double square 20 by 40 inches. The 'wide-screen format' might have been the perfect frame for conventional exercises in lofty views and deep perspectives, allowing nature to be processed into panoramic views, as if seen from the windows of a railway carriage. Hung close together in a continuous series, the slices of scenery could be imagined as a wrap-around decor, like Puvis's friezes over which he had so enthused. But in reality those elongated scenes were neither the thinly painted, flatly applied pseudo-Renaissance murals of Puvis's archaism, much

less the railcar panoramas the commercial market wanted. Instead, the sensation of enveloping nature was worked by van Gogh into something like total immersion: a lungful of air when he chose to elevate the point of view, a strangulation in vegetation when he didn't.

It's at this moment in the history of art that vision separates itself from mere optical operation. Something fabulously, intoxicatingly weird is going on with sight lines, something that had begun during the week at St Rémy in *Field of Spring Wheat at Sunrise* (page 338). The picture literally describes a frontier between one kind of picturing and another, between traditional and modernist. Behind the wall a sun rises (or a buttercup moon sets). There are a cream sky, blue mountains, cottages. But then a low wall cuts like a turning blade right through the image. In front of it – ostensibly a poppy-flecked meadow – space and depth collapse. The verdure rises like a wall; the visual crutch of perspective gets knocked away, our eye staggers and reels giddily around.

Six weeks or so later it gets much, much worse – or better! You can't help getting lost in *Undergrowth with Two Figures* (pages 342–3) because the tree-trunks planted in parallel rows that, at first sight, seem to function almost as a text-book exercise in perspective, on a second look make it apparent that there is no vanishing point at all. The avenues, seen through dizzying diagonals, multiply perspectival paths, all of which lead nowhere except to some darkly indicated interior glade. As with the *Field of Spring Wheat*, the usual conventions are reversed, with the maximum point of optical concentration at the front rather than the back of the picture space, marked by the foremost tree-trunk. But in the middle of this chaotic, hallucinatory, *Alice in Wonderland* vision stand two figures, male and female, perhaps emblems of Vincent's yearning for companionship. At first sight they seem to be approaching us. But they are so undelineated that they could as easily be going away, or more perversely, passing each other in the glade. Like perspective, the emotional message has got lost in the woods.

These compositions entirely decompose every known rule of landscape, but they are so cunningly conceived and dazzlingly executed that they can't possibly be the product of a mind in disintegration. Much closer to the truth is the opposite: that these last pictures are so complicated, both conceptually and technically, that they required – for all van Gogh's hell-bent speed – every ounce of concentration he had left. Their vantage points are either the rocking, aerial suspension of a high hover, or else what van Gogh called *sousbois* – the skyless view from the undergrowth, penetrating the interiority of nature with such invasiveness that, just as in the forest, the organizational power of the eye is defeated.

UNDERGROWTH WITH TWO FIGURES,1890, oil on canvas (Cincinnati Art Museum, Ohio).

TREE ROOTS AND TRUNKS, 1890, oil on canvas (Van Gogh Museum, Amsterdam).

Tree Roots and Trunks (pages 344–5) may well be another view from inside Vincent's hectic brain: all knots and strangling thickets, knobbly growths, bolting ganglia, claw-like forms, and pincers that look more skeletal than botanical (and that recall his harshly affecting drawings of winter trees at Nuenen six years before). But this amazing painting – one of the very greatest (and least noticed) masterpieces from the founding moment of modernism – is yet another experiment in the independent vitality of painted line and colour, as well as the uncontainable force of nature. Almost lost within it – as in *Undergrowth with Two Figures* – are allusions to, and repudiations of, the exhausted traditions of landscape. Miniaturized tree-forms fight for space and light amidst the monstrous Brobdingnagian root growths, so could the Japanophile Zen-Vincent have wanted bonsais in the corn? The view is therefore bipolar: simultaneously that of the rabbit and the hawk. Colours – wheat-gold, clay-brown – tease the eye with possibilities of making sense of a field or a hill, but then scramble them into chaos. The usual aesthetic markers – beauty and ugliness – have been made meaningless. In *Tree Roots* the painted forms rap against the pane of our visual window, as if trying to crash through the glass. In other paintings from these last weeks in Auvers the interior of the field – green or gold stalks – occupies the entirety of the *visual* field like a curtain. Without a beginning or an end, this infinity of growing matter closes over us. It's the ulti-mate compression of heaven and earth, a live burial within the engulfing sea of creation.

X

THE PAINTINGS BLOW OUR MINDS, so perhaps they are what Vincent meant in that last, unposted letter to Theo, when he wrote of his work putting what remained of his own reason at risk. But their compositional fierceness is not a symptom of mental implosion, a crumbling into suicidal delirium, but rather the evidence of a creativity racing to keep up with its own breathtaking reinventions. No wonder that in this last phase he had no time for drawings. Dazzling as this last group of paintings is, it's hard to contemplate them without poignancy – not because they constitute some sort of farewell song, but because of the extreme solitude they signal: the thing that Vincent had most acutely feared throughout his life. At some point while he was making these revolutions, he drew a tiny sketch of a man sitting alone in a little sailing boat, his hand on the rudder, setting out into the ocean. By any standards of what painting could possibly be and do, van Gogh had become that lone sailor (for it would be almost another decade before Cézanne worked a comparable act of destruction on the nature of painted representation). Aurier was

right. He was indeed becoming *un isolé*. And the thought terrified him. What he needed more than ever were like-minded friends, loving family, to lean on.

But they were disappearing. Having made the Studio of the South impossible, Gauguin was now talking about a Studio of the Tropics, somewhere very far away. Worst of all, frustration at his position in the Paris dealership and an urgent need to earn more money to support his family was making Theo talk about moving back to Holland, probably to Leiden, where their mother had settled with her daughters. The prospect was especially painful to van Gogh, as he'd had a happy visit from his brother, Jo and baby Vincent. His family affection uncorked, van Gogh insisted on showing his baby nephew every barnyard animal he could round up. Perhaps it was then to Vincent's dismay that Theo first hinted at what was coming. On 6 July he went to Paris, almost certainly to try to dissuade his brother from the move. The journey was in vain; the fraternal atmosphere soured bitterly and van Gogh returned to Auvers deeply distressed and fearful that his lifeline was about to be taken away. Sometimes he would play up the likelihood (real enough) of future seizures. At other times he blamed himself for being a burden on a brother who was himself often sick and whose priorities were now his immediate family. But one suggestion of Theo's in particular shocked and terrified him – that now he was becoming recognized and on the cusp of great success, it might conceivably be Vincent's turn to bear at least a share of the family responsibilities. That was why the prospect of success actually filled van Gogh with dread. And that, not any sense that his *work* was in trouble, was why, in the middle of July 1890, the skies over his landscapes began to darken again in *Wheatfield under Thunderclouds* (page 338).

XI

AT LEAST THERE *IS* A SKY from which to give some relief from the visual asphyxiation of *Tree Roots*. But just how dark that sky was in *Wheatfield with Crows* (pages 348–9) remains ambiguous. The colour is deep cobalt, within which there are nubby little black clouds; hardly a Turnerian tempest. The crows might be flying towards us, but since they are described with the most elementary marks, may equally well, like the ambiguously oriented figure in the forest glade, be read as flapping away. What is unmistakable, though, is that van Gogh's target practice on landscape conventions, inaugurated with *Field of Spring Wheat at Sunrise*, has come to an ultimate place. He has, in fact, retreated from the literal radicalism of *Tree Roots* (*radex* is, after all, a root), where, since there is no possibility of reading the image in terms of its subject, we are forced into looking at it as a construction of colour and form that somehow conveys the strength of nature without describing it. At first sight *Wheatfield with*

WHEATFIELD WITH CROWS, 1890, oil on canvas (Van Gogh Museum, Amsterdam).

Crows seems an easier take, playing less combatively with our visual expectations. There *seems* to be a path through the field, an impression of distance. But on a second look, perspective seems to have gone for another shot of absinthe at the Café Ravoux, for once again it's been reversed. Without a vanishing point, it's a path to nowhere. The flanking tracks likewise lead to nothing, but flap aimlessly like wings at the sides of the picture. And the passages of dashed green are what? Hedges? Grassy verges? All our assumptions about how to read visual signs have gone wrong. It's as if the 'up' arrow of a road sign telling us to go straight ahead has suddenly turned into an order to levitate.

Instead of an invitation into deep space, this seems more like a barrier curtain; optically we are not drawn forward, but pulled into and under the densely writhing, brilliant wall of paint. And this sensation of being swallowed alive, simultaneously in nature and in paint, was, of course, what Vincent van Gogh had been working towards ever since he had picked up a paintbrush on the beach at Scheveningen and on the dark, wet moors of Drenthe. For years he had struggled to realize a vision of total absorption within the vital surge of nature, a sensation so electrifying that it would make the loneliness of modern life disappear. This was in fact close to Tolstoy's awesome discovery of the meaning of life being nothing more, but nothing less, than the daily living of it, but the perception of that quotidian flow being heightened to the point of extreme joy. For poor Vincent, however, sometimes extreme joy was indistinguishable from extreme pain.

XII

THE REST WASN'T QUITE SILENCE. It's clear from his last letters that it was the thought of abandonment by Theo and Johanna, a terror of having to make his own way now that he was a recognized success – but still vulnerable, as indeed he would have been, to epileptic seizures and manic depressive attacks – that made him pick up the gun rather than his brushes on 27 July. It was probably difficult to shoot himself with a shotgun, and if he aimed for the heart, he didn't hit the target. Vincent staggered back to the Café Ravoux. Well, he often staggered, Madame Ravoux thought. It was only when she thought she should perhaps knock on his door after all and enquire, and heard his quiet moaning, then a sheepish confession that he'd gone and shot himself, that she understood. Not to worry, he said; nothing serious.

The fatal mistake was to send for the nearest doctor – Dr Gachet, that is, the homeopathic specialist convinced of the power of Positive Healing – rather than getting Vincent to the nearest hospital. Later that day a Dutch painter who was living at Auvers and who didn't share Gachet's breezy optimism knocked at Theo and

Johanna's door in Montmartre. When Theo got to the Café Ravoux he found his brother sitting up in bed smoking a pipe. For a while Theo too was optimistic that the wound might heal, and the two brothers chatted quietly. But then a septic fever set in, Vincent slipped into unconsciousness and he died two days later. On the 30th a little funeral party made its way in broiling July heat up the little road that wound through the fields, the place of Vincent van Gogh's consummate reinvention of painting. Père Tanguy was there, as was Lucien Pissarro – friends who understood that the painter had killed himself at the precise moment when his entire life was being vindicated.

Theo believed it too: that Vincent's time in the sun had finally arrived. But it was too late for both of them. In a few months Theo's own physical and mental health collapsed. Before he succumbed, he tried desperately to fulfil Vincent's wishes, holding an exhibition of his work in his Paris apartment and attempting to establish that fraternal syndicate of artists that had been so dear to his brother's heart. But on 12 January 1891, barely six months after Vincent's suicide, Theo died in Utrecht. In 1914 his remains were reinterred beside Vincent's in the little hilltop cemetery at Auvers, where they are covered by the same indivisible blanket of creeping ivy.

It's right that they lie there, far from any church, separated from the hilly fields only by a low stone wall. For the sense of earthiness we take from the thick dazzle-ment of van Gogh's art, that feeling of dirt under our nails, the fragrance of flowers in our nostrils, the palpable texture of hair and skin, was how he wanted his painting to touch our lives. No mystic aesthete like Gauguin, van Gogh was incapable of disembodiment. Rather the opposite, in fact: his painting was meant to make us feel our bodies more keenly, the better to sense our place in the cycle of nature.

The legacy to modernism of van Gogh's obstinate attachment to the material reality of life was, I think, profoundly benign. It saved modern art from going headlong in the direction of abstract self-patterning. Van Gogh insisted, even when he was most dramatically disregarding the literal colour and shape of things, that he was, at root, a nature-bound realist. But as much as, if not more than, Turner, he understood that there were other ways to apprehend the reality of the world than the optical machinery of perception. Such visions – the things that go off inside our heads, as opposed to mere sights – he thought happened to everyone. They just needed someone to trap that second vision, lit as it is with the emotional fullness of a life lived to the utmost; the sudden illumination that infinity is now.

Picasso

MODERN ART GOES POLITICAL

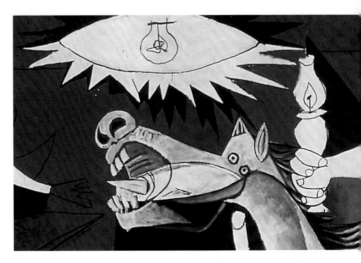

I

IN THE WINTER OF 1941, Pablo Picasso was living and working at the top of an old house in the rue des Grands Augustins in Paris. The Seine was a stone's throw away. Hard northern light swept in over the rooftops. Pigeons perched on the sills. But Picasso's Left Bank life during the Occupation was more bohemian than he would have wished. It was bitterly cold and the electricity was unreliable. Only an old-fashioned floor-to-ceiling stove, and his latest lover Dora Maar, kept him warm. His painting was becoming gloomily repetitive: jagged-headed women weeping tears like steel beads or thin spills of blood; flayed heads of sheep. And, unfortunately, he fancied himself as a Surrealist playwright.

There was a conspicuous absentee from the display kept around the studio: *Guernica*, the painting that had made him the most famous – or notorious – artist in the modern world (pages 384–5). The Germans didn't like it very much, the scream of pain at the barbarities inflicted by the Luftwaffe on the helpless civilians of a Basque town in the spring of 1937. But they couldn't get to it. In the nick of time, in 1939, *Guernica* had been shipped off to New York on the SS *Normandie*, like a refugee, along with the violinists and psychiatrists from Vienna and Berlin. Installed in the Museum of Modern Art, it had become more than just a picture of horror. *Guernica* was a billboard of moral indignation; a site where people gathered to be reminded of what separated them from fascist cruelty. It was the good incendiary.

Thwarted from seizing the offending object, the Nazis in Paris gave Picasso the hardest time they could, short of actually arresting him. Collaborators attacked him in the Vichy press for corrupting the noble art of painting. Hints were dropped that he might be Jewish himself or that he was hiding Jewish artists. 'Where is Lipchitz?' the French militia thugs yelled at him as they trashed the studio. But Picasso was not easily intimidated, and brazened out the attacks. He kept postcard reproductions of *Guernica* in his studio and enjoyed giving them to the intruding Gestapo and French police: 'Go on, take one,' he would say impishly. 'Souvenir!'

One day, so the story goes, a German officer, both bully and secret admirer, paid Picasso a visit. Picking up one of the *Guernica* postcards, he turned on the painter and asked him accusingly, 'Did you do this?' 'Oh, no,' said the artist, 'you did!' It's a smart come-back, quick as a whip. But who really got the better of the legendary

exchange? Picasso's disingenuous deference to the difference between power and painting was actually a gesture of self-congratulation. He knew that as long as his picture was around, the world would remember the bombing of Gernika as an unspeakable atrocity. In this sense, at least, even though the painting had done nothing to defeat General Franco's fascists in Spain, nor stopped a single act of massacre in any of the wars that followed, art had, at least, become testimony for the prosecution. But is that also a delusion, a salve for tender consciences while the brutality grinds on? Maybe it would be more honest for art, especially modern art, to drop the self-righteousness and just get on with what it does best: the delivery of pleasure?

For a decade in the late 1930s and 1940s, Picasso didn't think so. And this was itself extraordinary because of his past stubborn indifference to emotive judgements made in art. The goal of art, he had said apropos Cubism, was 'to paint and nothing more'. 'Neither the good nor the true, neither the useful nor the useless' were any business of art's. Even five years before he painted *Guernica*, Picasso had shrugged off any suggestion that painting might be polemical. 'I'll continue to be aesthetic,' he said. 'I'll continue to make art without preoccupying myself with the question of whether it humanizes life.'

But *Guernica* said, or rather shouted, the opposite: that there could be no higher obligation for modern art than the reinstatement of a sense of humanity amidst the cinders. It was a commonplace that art, both traditional and modern, should give us fresh eyes and enable us to see the ordinary as extraordinary. In the 1930s and 1940s mass murder became ordinary. Or so it could seem from the welter of newsprint and the fugitive flicker of film. The work of art, Picasso came to believe, was to resist the presumption that this was the way the world was, and would ever be. And this turning of Pablo Picasso, from amoral aesthete to moralist, is perhaps the most unlikely conversion story in the entire history of art.

II

PICASSO'S FRIEND AND DEALER, Daniel-Henry Kahnweiler, once called him 'the least political person I know'. But in July 1937, while working on *Guernica*, Picasso issued a public statement that his 'whole life as an artist had been nothing more than a continuous struggle against reaction and the death of art'. The truth was somewhat different. For most of his career the precondition for modern art's creative freedom, he had thought, was its uncoupling from politics, not the reverse.

Picasso, born in 1881, had arrived in Paris at the turn of the 20th century from Barcelona, by Spanish standards a hothouse of experiment. He was a small, pugnacious and frighteningly gifted Andalusian, and must have felt, along with most of his

talented contemporaries, that it was art, not politics, that made the pulse race. In Paris every assumption about what art meant was in the process of being overthrown. Poetry was no longer a rhythmic compression of observation and sentiment, much less a narrative. Now, for Picasso's friend Guillaume Apollinaire, it was a breathless run of sound, symbol and allusion, performance mattering more than meaning. In the hands of Ravel and Satie, music had ceased to be cathedrals of symphonic sound and had become a flowing, directionless river of associations flooding the senses. Likewise, painting had junked many of the old rules and regulations: high-minded storytelling, edifying figures set in picturesque landscapes, single-point perspective, descriptive colour.

For the young Picasso, in his Left Bank garret, with his oil-slick hair and big rabbit's nose twitching for excitement, wanting, as he later said, 'to live like a poor man with a lot of money', this was a rich feast of endless possibilities. He may not have known right away what he wanted from art, but he certainly knew what he didn't want: the hoary old pantomimes of the mighty. It was a truism of the times that what made modern art modern was its repudiation of historical narratives, the vanities painted for aristocrats and plutocrats, kings and bankers, that lined the walls of the museums – especially Spanish museums, with their battles and prancing steeds, necessary lies told about power and war. When, in the 17th century, Diego Velázquez painted a king on horseback, it was as the picture of omnipotence, absolute control embodied in the nonchalant handling of his mount, just one hand on the reins. If the prince could handle the Great Horse, the message ran, he could manage the affairs of state with unshakeable aplomb. It was the most ancient and enduring image of pure power.

Picasso dismounted the platitude. Instead of a prince in the saddle, he painted a naked boy leading a barebacked horse – without even a bridle – through an eerily featureless primordial landscape, entirely bereft of the picturesque (page 358). In the elegantly elongated features of the youth there are echoes of Cycladic and early Greek *kouroi* statues. Prehistory, stripped down and elemental, replaces the exhausted clutter of history. The hue of the image is of grey dust and baked clay: primitive materials out of which life, as well as art, remains to be fashioned. So Picasso's painting brought us to an artless moment: without heroes, stories, subjects, expressions. With a gesture of economic poetry, he made an end-run around centuries of ceremonious picturing, the modern coming straight out of the archaic, as if there never had been anything much worth noticing in between.

History down and out for the count, then. Next up: beauty, the most anciently defining ideal of art itself; perfection made visible in the proportions of the female

Above: SELF-PORTRAIT, 1906, oil on canvas (Philadelphia Museum of Art, Pennsylvania).
Overleaf: BOY LEADING A HORSE, 1905–6, oil on canvas (MoMA, New York).

nude. All the centuries since the Renaissance of gazing at classical nudes and muttering preciously about harmonious form end up in the brothel line-up of *Les Demoiselles d'Avignon* (page 360). The title wasn't his, he later complained: his was *The Avignon Brothel*, named after the street in Barcelona, the Calle Avignon, where the house of ill-repute was located. The girls strip and stretch (possibly, it's been suggested, for medical examination) and throw the unexamined gallery pastime of male inspection back in the suddenly self-conscious eye of the beholder. The staginess of the scene – two of the figures pulling curtains – only adds to its confrontational charge. The two central figures, sheets falling over their thighs, play the sex-tease for us in a parody of old-master drapery games. The two figures further right, their heads sharply chiselled, influenced by African tribal carvings that Picasso had seen at an ethnographical museum in March 1907, have entirely abandoned faux coyness. They are bitch-warriors, the figure at the back with a black cyclopean eye, dog-faced and snouty. The *demoiselle* below squats, thighs splayed, but her body is simultaneously seen from the rear, front and profile, the face with its little moue of derision suddenly turned to the spectator. Everything associated with the traditional European nude – grace, obliging sensuality, fertility, tender compassion – has been sheared away. Instead there is the blazingly returned glare, the possessing stare dispossessed. You want to buy something? Fine, buy *this*! No one did. The American Leo Stein, until then a loyal patron, thought Picasso had gone mad.

His dealer Kahnweiler kept on saying the painting was unfinished. Matisse thought it was a hoax, and said it made him feel as though he had swallowed gasoline. Picasso turned it to the wall in his studio and waited 17 years for a buyer.

By 1909 Picasso was ready for the final assault. It would be made on the most sacred cow of all, the characteristic that for most people visiting museums and galleries summed up the whole point of art: likeness. Artists, Picasso said, 'should invent, not just copy nature like an ape'. If a two-dimensional duplicate of the world is wanted, the modernist argument ran, then photography is always going to supply that much more efficiently than painting. Since the 1860s, self-consciously modern art had defined itself as post-photographic, always seeking a different reason to be looked at, something other than a surface impression of the world. Before Cubism, modern painting had flirted with this break-up of coherence. Van Gogh, for instance, chose the colour of things and people according to emotive perception rather than optically observed hue. But around 1910 Picasso and his friend Georges Braque, stirred by Paul Cézanne's late destructions of solid form into crystallographically faceted structures that were somehow both broken and coherent at the same time, went for the kill. Bye-bye resemblance.

LES DEMOISELLES D'AVIGNON, 1907, oil on canvas (MoMA, New York).

The departure from resemblance pointed in two directions: decoration or sculpture. The decorative way – chosen, for example, by Matisse – was the road to abstraction: shimmering arrangements of flat, brilliant colour designed to set our senses dancing and put a smile on our face. But Picasso, the least sentimental and the most sculptural of all modern artists, went the other way, wanting somehow to register the tactile in paint. Although he spoke of his Cubist experiments as beginning in pure compositional painting, he also insisted that they were paintings of something other than themselves. Deep within the slinky-toy Cubist unfurlings of form, seen as if juddering through time, was something substantial and concrete. The simultaneous multi-dimensional rendering of different aspects of a figure *was*, somehow, a representation of what that figure truly was. So no colours other than those of engineering and architecture – rusty browns, dusty ochres and steel greys – were to distract the viewer from the exposed scaffolding on which he hung that idea of fundamental form.

The provocation was entered into in the utmost good faith. By blowing up the apparent look of things – and people – the Cubists were saying that they were offering an alternative reality, the reality of memory or shifting perception. 'Any form that conveys to us the sense of reality,' Picasso said many years later, 'is the one *furthest* removed from the reality of the retina; the eyes of the artist are open to a superior reality; his works are evocations.' His evocation of his friend *Daniel-Henry Kahnweiler, 1910* (page 362), began as a cascade of chipped facets and overlapping planes, but later – partly in response to Kahnweiler's plea that Picasso give the viewer some visual bearings – he added details of clasped hands, a shock of wavy hair, a piece of earlobe. With its invitation to the viewer to assemble a sense of the sitter through our own fragmented associations and memories, the crazy-paved physiognomy was a concession to contact. But it was still not remotely recognizable as plain anatomy, and it hardly compared for eye-pleasure with the bathful of bliss Matisse was offering.

But then Picasso wasn't interested in pleasuring the public. He positively revelled in the cult of difficulty. 'Too *hard*?' you can hear him sneering. 'Tough.' He had – for the moment – decisively turned his back on everything the majority of the public wanted in painting: beauty, emotion, stories, colour, grace, resemblance. And yet this was also the artist who would have, 30 years later and with one painting at least, the greatest of all successes in popular communication.

<div align="center">

III

</div>

FROM 1914 TO 1918 Paris had a strange, unreal war: the boom of distant guns punctuated by sudden panics that there might be a German breakthrough. Picasso had friends, such as Braque and Apollinaire, who went off to fight and came back terribly

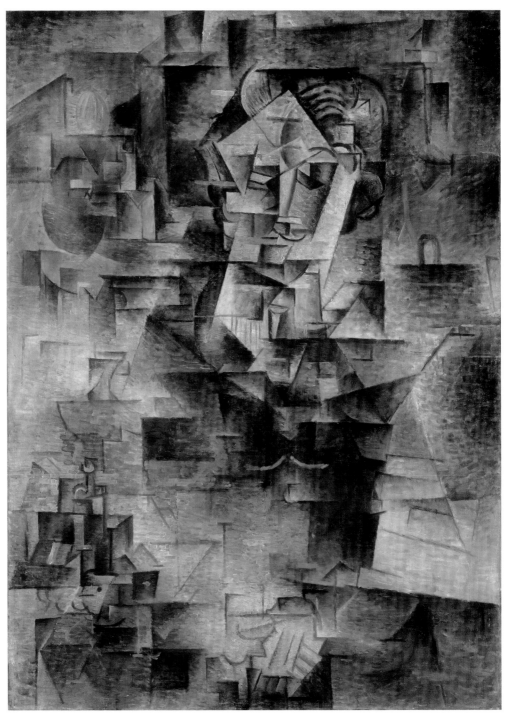

PORTRAIT OF DANIEL-HENRY KAHNWEILER, 1910, oil on canvas (Art Institute of Chicago, Illinois. Gift of Mrs Gilbert W. Chapman in memory of Charles B. Goodspeed, 1948.561).

wounded. Other friendships changed. As a German national, Kahnweiler left in a hurry without paying Picasso the 20,000 francs he owed. He was never forgiven.

The broken world that emerged from the carnage seemed to have made prophets of the Cubists. What good did the old histories do in a trench full of freezing mud? A farewell to art, then? No, but a farewell to the pieties of museum art. 'In the museums...there are only pictures that have failed,' Picasso wrote. Out of slaughter, defeat and revolution came a new urgency that art ought, perhaps, to connect with the People, act as the herald of the age of the masses. Instead of the landscape, then (which, after all, had been reduced to Golgotha), the poster and the billboard: strong, simple images that would move the powerless to passionate action. But this kind of art happened mostly elsewhere, fed by the chagrin of defeat. In Germany violent colour and grotesque faces shouted fury and disgust from the canvas at the old order, both social and aesthetic. In revolutionary Russia, hard-edged geometric abstraction spoke to the scientific certainties of Marxist dialectical materialism at the same time as iconic heroes of the proletariat summoned the workers to obedient patriotic sacrifice.

The postwar Picasso, however, had never seemed more remote from politics. It was how to make a collage that exercised him, not how to make a revolution. So glued-on or painted fragments of newspapers contain no news to read. They are torn notes and signs, no more 'readable' than the f-holes of violins or the patterned caning of a chair seat. But, unlike *Les Demoiselles* and the hard-core Cubist paintings, they were loved by the buyers. Picasso grew rich and famous from the appreciation, got married to a Russian ballerina, Olga, and began to live the bourgeois rather than the bohemian life in a swish Right Bank apartment in the rue de la Boétie. When he chose, prompted by Matisse, he pushed Cubism towards a more decorative, high-coloured flatness. But often he did not so choose. Sometimes, to the consternation of his avant-garde friends, he 'relapsed' into figurative drawing, doing portraits that were the closest that 20th-century art got to neo-classicism. Then, when the mood took him, he would experiment with extreme distortion (making even the aggressions of *Les Demoiselles* seem tame) in explorations of the subject that he found inexhaustibly fascinating: sex.

It became self-obsessed. The capricious murders and mayhem of the political world interested Picasso not at all in the 1920s, but brooding artfully on his calling did. So he produced lots of images of Artist in the Studio: heroic, antique, bearded, with mirrors and models, especially models who were, like Marie-Thérèse Walter, putty in his hands, and whom he fancied for her combination of Nordic features and Greek-bust profile. In 1927, when she was just 16, Picasso had noticed the tall blonde

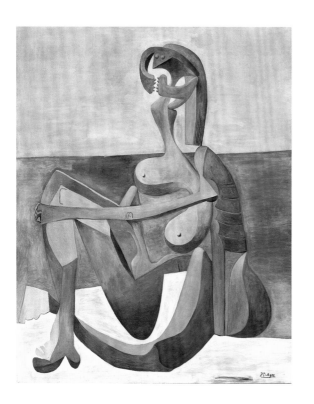

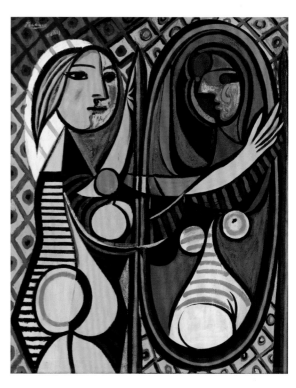

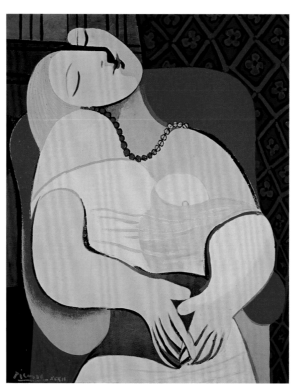

Top left: SEATED BATHER, 1930, oil on canvas (MoMA, New York).
Top right: GIRL BEFORE A MIRROR, 1932, oil on canvas (MoMA, New York).
Above: THE DREAM, 1932, oil on canvas (Ganz Collection, New York).

with the athletic body and classical profile outside the department store Galeries Lafayette. He lost no time in approaching Marie-Thérèse, telling her she had 'an interesting face' that he would like to paint. 'I am Picasso,' he added, closing the deal.

Olga and Marie-Thérèse became polar opposites in his experimental representations of sexual experience. Depending on whether misery or ecstasy was uppermost on his mind, Picasso's women could be pulled this way or that, like so much human plasticine, body parts artfully rearranged. *Figure* painted in 1927 in Cannes (where he and his wife had some painful confrontations) featured a brutally angular easel from which emerged an acid yellow, head-like form with black eyes situated at its extreme ends. Between the eyes is a smile-bright toothy vagina. In *Bust of a Woman with Self-Portrait*, 1929, another of these spike-tongued, devouring harpies creeps up on the silent silhouette of the painter trapped in his frame, her saw-jaws monstrously opened and about to snap shut on the victim. A year later, in *Seated Bather*, Olga mutated into a wooden praying mantis with multi-purpose toothed orifice. Evidently, Picasso's marriage was no longer much fun.

After the rack, though, came the bed, with the welcoming Marie-Thérèse in it. For her there was no angularity of line, but voluptuous arabesques and glowing colour, especially Matissean purple. In one piece of gentle erotic wit, *The Dream*, Picasso posed Marie-Thérèse in a deep red chair, eyes closed, a breast exposed, smile playing on her lipsticked mouth, lost in a languid masturbatory reverie. She has sex, literally, on her brain. It's the kind of painting that does what it says, stroking us into a kind of dopey pleasure. It's all very clever and seductive, and it could not possibly have been further from the imminent fate of Spain.

IV

Picasso had grown up in a country that, even a half century before the Civil War, was divided. One Spain – Catalan Barcelona where his father, a drawing teacher, had moved the family from Málaga in 1895 – had embraced modernity. The city was commercial, secular and hospitable to all kinds of cultural experiment. And there were other regions, such as the northern Basque country around the port of Bilbao, where industry pointed the country towards the future. But in the rugged centre an eternal Spain of nuns and donkeys, cathedals and immense landed estates, fierce devotion and harsh subsistence showed no sign of conceding its grip. The question for the 20th century was whether those two Spains could possibly live together.

The answer, given by the ballot box in 1931 – the first election in 60 years – was a resounding no. Because the new Spain was concentrated in the populous cities, it was able to put together the majority that voted to end the monarchy. King

Alfonso XIII went into exile. A new golden age of social justice and political liberty was supposed to dawn. But the eight years of the Spanish Republic proved a prolonged and tortured ordeal for its defenders and enemies alike.

The trouble was that both of the mutually incompatible Spains claimed to be the authentic nation and each had the same number of dependable votes – around 4.5 million. When the verdict of the ballot box went against them, neither was prepared to accept the results and resign themselves to a state of political opposition. When the left wing won, the Church and army treated the moment as if Spain itself had gone down to defeat. When a coalition on the right won, the unions organized a general strike. Had each side been capable of conceiving of themselves as rival parties, some form of coexistence might have been possible, but this was never the case. Traditionalists saw the socialists who dominated the Republican governments as anti-Christ, bent on destroying the institutions that, for them, made Spain: Church, Army, Land. Worse, Republican democracy was a Trojan horse for the anarchism and communism of the trade unions, which would bring godless revolution to this most Christian nation. For their part, the social democrats saw the conservatives as a fortress of wealth, superstition and privilege. There were too many monks, too many army officers, too many landless peasants who could barely put bread on the table. All that needed to change if Spain was ever to enter the modern world. For both sides, the salvation of the country required the annihilation of the other. From the outset, then, the history of the Republic was an unforgiving culture war. It was only a matter of time before the culture warriors reached for their guns.

While the antagonists were stockpiling their resentments and their ammunition, Pablo Picasso, a three-decade exile, was suddenly hankering for home. In some ways he had never left. Many of his closest friends, such as Jaime Sabartés, were uprooted Spaniards. He felt close to modern poets and playwrights like Lorca, and a flamenco guitar and the memory of bullfights never failed to stir him. Around 1930 something bleaker and harder began to burrow its way into his sensual narcissism. That something was tragic homesickness, naggingly insistent inside him. The urbane expatriate, the ultimate Parisian started to have Spanish dreams, or rather to fall prey to Spanish nightmares. And they were quite different from the diluted Cubism and half-hearted Surrealism he could turn on at the drop of a three-cornered hat.

Evidently, Picasso had been looking again at the Spanish master who seemed to personify Lorca's dictum that 'Spain is the only country where death is the national spectacle'. Lorca had meant bullfights, but he had also meant history. And the bullring became for Picasso, as it had been for Goya, a way of reconnecting with Spanish memory. The theatre of cruelty that he'd played with in his gaudy oils

of toothed succubi now had less self-indulgent work to act out. The same shrieking palette now coloured a series of bullfight paintings – all of them taking their cue from Goya's terrible *Death of a Toreador* – and featured horribly gored horses, a bull in its death throes and the suddenly limp body of a resplendently dressed, dying matador thrown across the bull's back (page 369). The paintings just were a long way from the self-contained calculations of his paintings of the studio and the model.

In 1934 Picasso crossed the Pyrenees, went to a *corrida* and wallowed in his fame. But he was not yet a partisan for anything or anyone. Spain's community of artists was, in any case, itself politically divided, even when it was most anxious about the future. Salvador Dalí's *Soft Construction with Boiled Beans (Premonition of Civil War)*, 1936, was a bravely horrifying prophecy of agonized Iberia. But the Surrealist who was radical in his art was deeply conservative in his politics. When the time came to choose sides, he threw in his lot with Franco's Nationalists. Some right-wing intellectuals saw no reason not to hope that Picasso might do the same, and even made overtures to him that the artist neither encouraged nor discouraged.

Back in Paris in 1935, Picasso moved further and further away from the purity of modern art. In the same city the Dutchman Piet Mondrian, making his uncompromisingly two-dimensional grids with their panes of primary colour nailed to the surface, exemplified modernism's search for an art liberated from time and place, history and subject matter; an art that was purely itself and therefore universal. Picasso's idea of appealing to the universal was quite different. Instead of banishing myth and memory, the series of etchings he did in 1935, called the *Vollard Suite* excavated its most ancient layers. The dramatis personae of ritual sacrifice – bulls and horses – are everywhere, but Picasso is also in the world of the Cretan labyrinth, drawn by the thread of archaic recollection to the lair of the Minotaur and the fateful collision of bestiality and innocence. In this series of prints his obsessions with erotic carnage became projected on to a screen where mythology and history played out. Sometimes Picasso is himself the testosterone-driven Minotaur, half-man, half-bull; sometimes merely a shaggy party animal; more often an onrushing rapist. But through all these wanderings in the labyrinth of his imagination, one thing is abundantly clear: that the supreme modernist was now committed to reawakening ancient fetishes. Just as *Boy Leading a Horse*, painted almost 30 years earlier, had instinctively connected the archaic and the modern, so ancient ritual, magic and allegory spoke again to contemporary terrors. The beasts are out, Picasso seems to say. I know; I'm one of them.

Later in 1935, with Spain on the brink of self-destruction, all these jumbled images of bulls, Minotaurs, horses and toreadors resolved themselves into an etching

that has the weight, solemnity and potency of a monument, an altarpiece or classical frieze. Following Goya's bullring *Tauromaquia* prints, Picasso calls this one the *Minotauromachy* (page 370). Some sort of sacrificial performance is under way, enacted on a shallow stage, seemingly carved on a rocky height above the sea like the temples of Aegean antiquity. However, the spectators are not in an amphitheatre, but in a Mediterranean house, observing the happening from a window with doves perched on the sill, just as they do in the rue des Grands Augustins. The scene has the feeling of a dream or memory, both sexual and scriptural, weirdly frozen but also arousingly vivid. A horse, its mouth agape in death agony, spills its viscera. Over its back is draped the half-naked body of a woman toreador, perhaps asleep and dreaming *this* dream, or perhaps dead. A Minotaur, frighteningly muscled, advances but is stopped in its tracks by light: a single candle held by a small girl, the image of virginal innocence in her school uniform and sensible shoes, and who, in her other hand, holds a posy of flowers. So the beast can be stopped by the power of light. But the issue is unresolved within the shallow, crowded space. Like all nightmares, the image is claustrophobically oppressive, pushing the fearful imagination towards the edge and perhaps over it.

All the symbolic actors who will feature in *Guernica* – the bull, the impaled horse, the house that does and does not offer sanctuary – have made their entrance even before Picasso has turned explicitly political. So when the time came for him to make a monumental statement about light, violence and martyrdom, he didn't need to reach for some party political statement. The imagery came from deep within his own psyche, from his identification with both aggressors and victims. That's why the connection that *Guernica* makes is indeed universal: a hotline to all our fears.

V

IN THE SPRING OF 1936 Picasso toured Spain again, drinking in the fame from the back of his Hispano-Suiza limousine. But this time he was not impervious to the gathering disaster. With the threat of a military *coup d'état*, carried out in the name of ultra-Catholic nationalism, many of his fellow countrymen to whom Picasso felt closest – Lorca, the Catalan Surrealist Joan Miró and the architect Josep Luis Sert – had committed themselves unequivocally to the Republic. They knew that a victory by the Falange, as the Spanish fascists called themselves, would mean the end of artistic freedom. Their courage and clarity carried all the way to Paris, where for the first time Picasso was beginning to abandon his modernist indifference to politics and history. But how could he find a way to create what, up until this moment, had seemed to be a contradiction in terms: a modernist history painting?

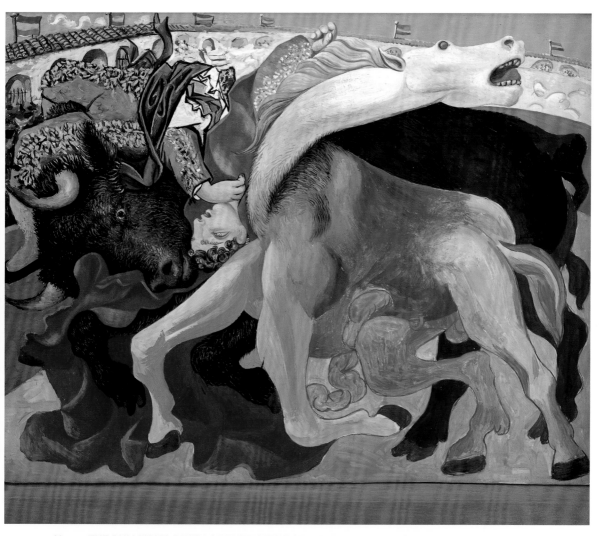

Above: THE BULLFIGHT: DEATH OF THE TOREADOR, 1933, oil on panel (Picasso Museum, Paris).
Overleaf, top: LA TAUROMAQUIA by Francisco de Goya y Lucientes, etching, plate 21, *Dreadful Events in the Front Rows of the Ring at Madrid and the Death of the Mayor of Torrejon in 1801*, published 1816 (Private Collection).
Overleaf, below: MINOTAUROMACHY, 1935, etching and grattoir (Ulmer Museum, Ulmer).

The occasion came soon enough. In mid-July 1936 General Francisco Franco, a small man with an imperious bearing, who had said that to save Spain from socialism and atheism he would, if necessary, shoot half the country, opened hostilities by ferrying an army from Spanish Morocco over the Mediterranean to Spain. Air transport was obligingly supplied by the Luftwaffe of the Third Reich, and the army that Franco would use to conquer Spain included 40,000 Italian troops on loan from Mussolini. It was the indecent eagerness of the fascists and Nazis to use the Spanish Civil War as a dry run for their coming battle with the degenerate democracies and Soviet communism that made this conflict both inevitable and ferocious, especially since Stalin felt much the same way from the other side. '*Viva la muerte*' (Long live death), the rallying cry of Franco's rebels, said it all. The bet that, faced with this naked intervention, the appeasers in Britain and France would do no more than make bleating noises proved dismayingly accurate. In the League of Nations, set up after World War I to promote international peace, impotence hid behind a mask of neutrality. Arms shipments to both sides were embargoed. The immediate result was to clear obstacles for Franco's army, which duly swept through large parts of Spain. Seville, Cadiz and Córdoba all fell; surprisingly, Madrid did not, Republican defences halting Franco's advance just south of the city.

Inside the capital, with shells and bombs raining down, the Republican community of writers and artists did what they could to mobilize resistance. Communiqués shouting defiance were issued, poems written, recruiting posters designed and printed. And although wars are never won with poems and posters, loyalist propaganda had a galvanizing effect on the Spanish expatriate community in Paris. When a shell hit the Prado Museum, Picasso felt personally assaulted. The modernist supremo was suddenly protective of his ancestry: El Greco, Zurbarán, Velázquez and, of course, Goya, the witness to *Disasters of War*. So when Picasso was asked if he would accept the honorific position of Director of the Prado, he didn't hesitate. It was a signal to the world that, finally, Picasso stood with the Republic. When a decision was made to evacuate some of the museum's masterpieces to the Mediterranean coast, Picasso was consulted on the selection. A convoy carrying Velázquez's *Las Meninas*, 1656–7, and *Las Lanzas (The Surrender of Breda)*, 1634–5, and Goya's *Majas on a Balcony*, 1808–12, both naked and clothed, went south through the narrow corridor of Republican-held territory to the safety of Valencia. Picasso waited nervously for news of the patintings' arrival, his own fate now locked into that of his country.

By the end of 1936, Franco's forces had occupied nearly two-thirds of Spain. And the fate of the Republic had become personal for Picasso in ways he had never

anticipated. His Andalusian birthplace, Málaga, had fallen after a traumatic siege that had reduced most of the city to rubble. His mother was trapped in staunchly Republican Barcelona, which awaited the inevitable attack. The painter turned unhappily restive. He was going through an acrimonious separation from his wife Olga, while Marie-Thérèse was carrying their baby. Creatively, he seemed paralysed. 'It was,' he later said, 'the worst time in my life.'

And then Spain came knocking on his studio door in the shape of a small delegation among whom was Sert, the architect who had designed the Republic's pavilion for the International Exhibition to be held in Paris that summer. Other Spanish artists, Miró among them, had already agreed to make works for the pavilion that would amount to a declaration of loyalty for the beleaguered Republic. Picasso was asked if he would consider painting something, perhaps as imposing and ambitious as a mural, that would occupy an entire inside wall of the building, making the most forthright statement possible?

Picasso accepted the commission, although he had no idea what he might produce. But while he was brooding on the challenge, he took a single day off to do his bit for the cause. Between breakfast and supper he drew *Dreams and Lies of Franco*, a sheet of linked prints that could be sold together or separately to raise money for the Republic's Refugee Relief Fund. Picasso, who was going through all kinds of conversions, abandoned the anti-populist stance he'd taken since the invention of Cubism and became crudely, lavatorially dirty. *Dreams and Lies* was a comic-strip attack on Franco's pretensions to be Spain's Knight Crusader. Instead of depicting a modern El Cid mounted on a gallant steed, Picasso drew him astride a comical phallus. He also appears as a polyp, bristling, squishy and – according to Picasso – turd-like, something nasty surfacing from the gurgling sewage. It's all a bit juvenile, especially when Picasso threw in a dash of Surrealism in case anyone had missed the point: 'a scouring brush of hair cut from the priest's tonsure, standing stark naked in the middle of the frying pan, his mouth crammed with the bug jelly of his own words'. And a lot more in this vein, his mission to be the Hero-Artist of the Republic not much advanced, before he returned to the studio and immersed himself again in painted meditations on mirrors, models and the Nature of Images. Perhaps, he thought, one of those pictures might do for the pavilion? But then life overtook art.

VI

GUERNICA – OR IN BASQUE, GERNIKA – 15 miles from Bilbao, was a town of just 7000 inhabitants, but its importance to that nation's culture and history went well beyond its size. At its centre, at the summit of a small hill, was the ancestral oak beneath

DREAMS AND LIES OF FRANCO (1st Series), 1937, etching and aquatint (Picasso Museum, Paris).

which, so the Basque account of their own liberties went, the people had for centuries assembled to elect their legislators and air their grievances. The town was the cradle of the sense of separate identity – linguistic, historical and even ethnic – tenaciously held by the Basques. Franco and the Falange stood for the old centralizing absolutism, intolerant of any such regional autonomies, so when the war began, there was no doubt which side the Basques would be on, especially after the Republican government specifically offered them autonomy. Their first modern prime minister, José Aguirre, had taken the oath of office in Gernika, vowing to defend his homeland to the death.

By early 1937 it was clear that he would soon be put to the test. General Emilio Mola's Falange army was advancing from the north, closing in on Bilbao, the port from which not just the Basques, but all the Republican forces in the region, were being supplied. But the Basques were dug in, ferocious, fighting for Euskadi, as they called their homeland, so Franco knew that some punitive act of military terror would be needed to make them reconsider their resistance.

It was about four in the afternoon on a spring Monday, 26 April: a market day. The people of Gernika were emerging from their siesta. Shops and banks were opening; old men in long Basque moustaches were sitting outside cafés, toying with brandies, drinking the April warmth. The sky was limpid. Out of the blue a speck appeared, a solitary plane. It made a few low passes over the market and the assembly house with the oak at its back, and then, hanging over the densest part of town, disgorged six bombs. The town was immediately engulfed in smoke and flames, while the plane rose again into the unstained sky.

Minutes later three more planes dropped 50-kilogram bombs, and then successive waves of Heinkels and Junkers flying in formation inflicted a storm of havoc that continued for over an hour. Rather than risk incineration in their houses, the people of Gernika ran into churches, where they thought they might be safe, or down the hilly streets into the fields and woods surrounding the town. Which is exactly what the German fliers had been anticipating, so they emptied round after round of machine-gun fire on the frantic, helpless civilians. Bodies started to pile up in the streets.

The *coup de grâce* remained. In a third wave, the Heinkels delivered a payload of 3000 aluminium-cased tubular incendiary bombs, designed to maximize conflagration on the ground and turn the town into a bowl of fire. It took three hours to reduce Gernika to that ashy cauldron. One thousand, six hundred and forty-five of its people – nearly a quarter of the population – perished right away; thousands more were terribly wounded. Somehow, though, the oak tree stood amidst the flames, charred, cauterized but not destroyed.

For the pilot of the first, exploratory bomber, also the commander of the Condor Legion, Lieutenant Colonel Wolfram von Richthofen, the action had been tremendously gratifying. Looking at the flames from a nearby hillside to which he had been driven for a good view, he pronounced the operation a total success: surgically precise, and in its calculated effect of terrorizing civilians, just what had been hoped for. He had read all the right books, especially the primer by M.K.L. Dertzen, who had confidently predicted, just two years earlier, 'If cities are destroyed by flames, if women and children are victims of suffocating gases…if the population in cities far from the front perish due to bombs…it will be impossible for the enemy to continue the war'. Gernika was the Luftwaffe's first opportunity to rehearse what would become standard operational procedure over Warsaw, Rotterdam, London and elsewhere. The Basque town, of course, had no strategic significance whatsoever, the real target being Bilbao. But, Richthofen thought, the flare of the fireball would have been visible from the port. Bilbao would get the message. Elated, he reported: 'Gernika literally levelled to the ground; bomb craters in the streets…simply terrific, perfect conditions for a great victory.'

Someone else was indeed seeing the night sky turn orange, hearing the explosions and wondering what was happening. George Lowther Steer, correspondent for *The Times,* covering the Basque war from Bilbao, got himself to Gernika as fast as he could. At the entrance to the town he was stopped by a 'carpet of live coals' like a moving river of lava from a volcanic eruption. Once he penetrated the town, he saw the scale of destruction: 'blocks of wreckage slithered and crashed from the houses and from their sides which were still erect, the polished heat struck at our cheeks and eyes'. Steer picked up the housing of an incendiary bomb and noticed right away the German mark and date of manufacture. Then he took a photo of it.

This was inconvenient for his editor back in London, Geoffrey Dawson, an appeaser who was much more inclined to credit Franco's assertion that there were no foreign planes flying missions in Spain. It had been Basque socialists, that version went, who had been responsible for blowing up their own town in an effort to discredit the Falange. But Dawson ran Steer's story anyway; it was the first newspaper report of the calculated massacre of civilians from the air. Two days later, on 30 April 1937, Picasso read the French translation of Steer's *Times'* article, published in *Ce Soir.*

At 2 a.m. today when I visited the town the whole of it was a horrible sight, flaming from end to end. The reflection of the flames could be seen in the clouds

of smoke above the mountains, from 10 miles away. Throughout the night, houses were falling until the streets became long heaps of red, impenetrable debris. Many of the survivors took the long trek from Gernika to Bilbao in antique solid-wheeled Basque farm carts drawn by oxen. Carts piled high with such possess-ions as could be saved from the conflagration clogged the roads all night.

Looking at the front-page photo that accompanied Steer's report, the nocturnal inferno burnt itself into Picasso's imagination. As he found his subject for the Spanish pavilion, he saw it as a night slaughter, even though it had actually been death in the afternoon. From the start, then, his painting and the news were in dialogue – or in contention – with each other as to which could deliver the more compelling report; the deeper reality. Already, the right-wing press in France was busy proclaiming that the commies had blown up the town to pin the blame on Franco. So Picasso called on all his powers for the most serious thing he had ever attempted: telling the truth. He would characterize art as 'a lie that makes you find the truth', but just this once, fibbing was out of the question.

Of course, in this act of truth-telling Picasso couldn't compete with Steer's eye-witness report from Gernika. But if he succeeded with his painting, it could transcend mere chronicle. It would be Cubism with a conscience – the very moral eloquence its inventor had repudiated as having nothing to do with art. The classical Cubist compositions of 1910–12 had offered a representation of objects lying beneath surface appearances. Breaking the coherence of visible form had been the precondition of apprehending these deeper values. But what Picasso had to translate into art in the spring of 1937 was an act of destruction beside which the most radical Cubist experiments seemed just so much cerebral entertainment. Now he had to take the beholder into the molten core of a place where the fragments were pieces not of violin but of people.

The conversion of Picasso's calling from pure modernist to propagandist also changed his work habits, from locked-doors recluse to showy exhibitor. It was as though he was already performing on a world stage. And he now had a creative partner, public relations manager and nimble muse in one dazzling package. Dora Maar, born Isadora Marcovitch, was a Croatian Surrealist photographer and, for once among his women, Picasso's intellectual equal rather than a submissive ornament. Picasso had spotted her in a Left Bank café. He could hardly have missed the elegant, dark-haired, strong-jawed woman stabbing the table. Dora had taken a knife from her handbag and spread the fingers of one hand open while she jabbed the wood between them at high speed. She missed a lot; then she put her gloves back

on and bled into them. This was what Croatian Surrealists did. Wide-eyed, Picasso was introduced to Dora and made an offer for the bloody glove.

Their affair, it need hardly be said, did not mean that Picasso was going to give up Marie-Thérèse, who had by now given birth to their daughter, Maya. But he parked her in a country house outside Paris and went to see mother and child at weekends, while Dora moved him into the top two floors of 7 rue des Grands Augustins, where she ruled the roost. Acutely aware that what the painter was about to tackle would mark his place in the history of art, she made herself the photographer of record, and Picasso, who until this point had never let anyone take shots of him at work, consented. The photographs are a unique record of the evolution of *Guernica*.

The momentousness of the commission made the task of rising to the challenge all the more daunting. There was, for one thing, the problem of its form. Whatever modernist liberties Picasso took with the event, *Guernica* would still, somehow, have to be a picture of an explosion. People, houses, a place would have to fly apart. But if the composition disintegrated into incomprehensible chaos, it would risk incoherence – and incoherence is the prelude to boredom.

Then there was the question of place. How could a work called *Guernica* not say: 'This happened at this place on this day'? But Picasso was never going to be ploddingly documentary. There would be no planes or bombs marked with German crosses. The painting would have to speak equally to other barbarities, past and future – to work through a symbolic language that could be universal. Picasso would have to return to the repertoire of cruelty he had rehearsed in the bullring nightmares and the *Minotauromachy*. But while the painting needed to be timeless, it also had to have the feeling of a modern crime; to imply the inkiness of the news although without its ephemerality; to possess the immediacy of newsreel, but a reel that was on a perpetual feedback loop.

So conscious was Picasso that the moment was a trial of strength between art and brute force, between truth and lies, good and evil, that for once the modernist called not just on his own ensemble of archetypes, but on the entire history of image-making. Old masters, such as Rubens and Goya, Christian apocalypse manuscripts and ancient sculpture were all called upon to help him in the superhuman effort.

VII

ON 1 MAY 1937, two days after Picasso had read Steer's story, he began work. Beyond the rue des Grands Augustins he could hear the low drone of a May Day march going through the streets. He still had no clear idea of what he was doing, but was certain that he had to begin. He started with a pure adrenaline rush – graphite

scribbles on blue paper, thoughts racing ahead of his hand. But even on that first day, the ambitious grandeur of the concept was apparent. The format was dictated by the rectangular dimensions of the pavilion wall, but also by the inspirational spectacles of 19th-century histories: David's paintings for the French Revolution (pages 180–235), Goya's *Execution of the Defenders of Madrid, 3rd May, 1808*, 1814 (page 386), Géricault's *Raft of the Medusa*, 1818–19. The cast of characters imprinted on his mind over the previous three years – a wounded horse, a massive bull and a candle-light bearer – make an immediate appearance. Later that afternoon, as if trying to kick free from the oppressive solemnity of the work, Picasso impersonated a small child's drawing of a horse, something utterly innocent of the weight of history. But the playfulness didn't last. The next day the horses were rendered in states of excruciating torment: necks violently twisted (as they had been in some of the bullfight paintings); the tongues conical, as if a spear had pierced the animal through the throat; bottle-cork teeth agape in a whinny of death.

Then, after two days of creative fury, he stopped. Just like that. Evidently, the hero of Spanish art was not locked in the remorseless grip of his vision. The deadline for the opening of the Paris Exhibition was fast approaching, but for a week Picasso did no work at all on the composition. Instead, he went into the country to see Marie-Thérèse and the baby. Encouraged, Marie-Thérèse ventured to the rue des Grands Augustins, triggering a tremendous catfight, which Picasso rather enjoyed umpiring (the bastard), while baby Maya paddled her little hands in the paint.

It got worse – or better. At some point Picasso had the inspired, if typically ruthless, idea of transferring the theatrical agony of his personal life into his new-found political art. Heads of women, tracked with arteries of pain and punctured with bloody tears, began to appear in the *Guernica* drawings. As he played with the baby at weekends (and he did love that), visions of domestic tragedy processed through his mind. Instead of embracing the pleasures of play, he plunged into easily imagined misery. For the first time, a mother carrying a dead baby crawled on to the scene, mouth wide open in distracted, screaming grief. A series of sketches drawn over the next few days repeated this thrown-back head of the grieving mother, breasts painfully distended, unable to nurse the dead infant, seen folded in two-dimensional limpness over her arm. In the finished painting Picasso understated this image, replacing swollen breasts with slack ones and summarizing the face of the baby in a rudimentary mask. The move was, I think, a mistake, since it takes some-thing away from the palpable, anatomical immediacy of the tragedy and makes it more schematic, as if already part of a memory. Other images of domestic calamity quickly follow, some called up from the copious archive of images that Picasso held

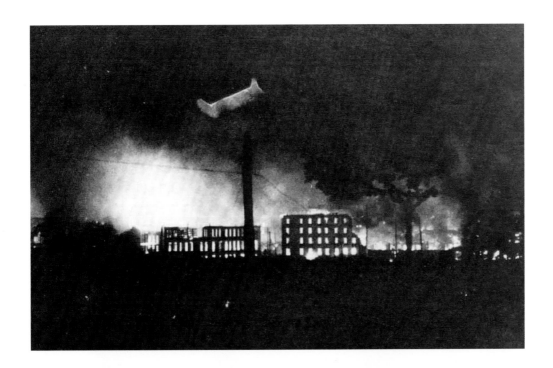

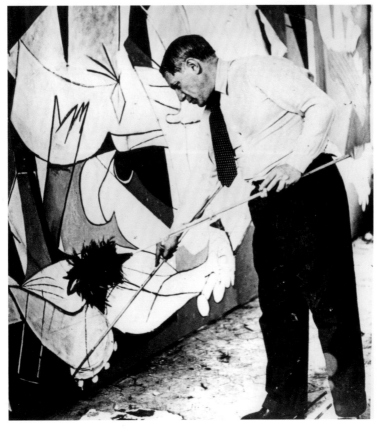

Top: GUERNICA BURNING AT NIGHT, 26–7 April 1937, photograph.
Above: PICASSO PAINTING *GUERNICA*, 1937, photograph by Dora Maar (Archives Charmet, Paris).

in his brain (though carefully disguised in his avant-garde years as dismissive amnesia). The fleeing woman with upraised hands, for example, is a direct quote from Rubens's great *Horrors of War*, 1637–8, in the Pitti Palace in Florence. Picasso would undoubtedly have known that the picture had been painted by an artist who thought of himself – and was officially appointed by the court of Spain – as an ambassador for peace.

On 11 May he began to attack the huge canvas. At 20 feet long and 12 feet high (almost the same dimensions as Caravaggio's *Beheading of St John the Baptist*) it was too tall to fit perpendicularly between floor and roof rafters, so Dora and Picasso propped it against the wall at an angle. The painter climbed a ladder to work on the upper sections, and tied brushes to sticks to reach the topmost area. When working on the foreground, he squatted or sat on the floor. None of the discomfort bothered him. Picasso chain-smoked his way through it all in a storm of impetuous creativity.

The feverishness translated itself into the frantic, bolting energy that surges through *Guernica*: a manic this-way-and-that, a futile flight from burning buildings, a pyre of falling and fallen bodies. It's impossible to look at *Guernica* and not feel the panicky sense of No Way Out, intensified by its black and white night vision, at once brutally sharp and obscurely disorientating. To achieve this spatial havoc, Picasso went back to the period of his greatest invention, setting the catastrophe in claustrophobic Cubist space. But this kind of Cubist theatre is less cerebral and more intensely emotive. Instead of a multi-dimensional sculpture housed within an optical conundrum, *Guernica* uses the scrambling of planes narratively, to generate visual panic. So walls and windows fail to do the things they are meant to do. Turned inside-out, they trap, obstruct and expose rather than contain and protect. It's exactly the kind of mimicry that would have appalled the grandly conceptual Picasso of 1910. But with his own mother feeling the heat of the siege of Barcelona, he had become a moral dramatist. And in *Guernica* solid forms fold in on themselves, as they would have done when the incendiary bombs flared and blew.

Deeper into the painting, changes became dramatic. 'When you begin a picture you often make some pretty discoveries,' he had said two years before. 'You must be on guard against these. Destroy the thing, do it over several times.' The alterations were almost all pessimistic. The gestures towards hope and redemption that had appeared early on – a clenched socialist fist rising from the pile of bodies; a head of wheat; a massive bull standing against the mayhem – now collapsed into the more unrelenting tragedy. The bull shrank, to stand impassively above the dreadful figures of the mother and baby, and beside the shrieking horse, itself dying from a huge, lozenge-shaped wound. In some of the earlier versions, Picasso had played with an

optimistic gesture. From the hole a tiny winged horse – Pegasus, the mythical symbol of the birth of art and poetry – emerged. In classical mythology the horse had been born from the Gorgon Medusa after she had been killed by the hero Perseus. Pegasus was his mount who flew high, landing on Mount Helicon. From the touch of his hoof a pool sprang bright and clear, blood turned to crystal purity, and the pool became the font of the Muses, the source of the arts. Something good – art itself – Picasso evidently wanted to say, may yet come from slaughter. A sweet idea, which is why, as the tragedy sank its claws into the painting, he killed it. Dora Maar was brushing in a grey wash, as if mantling the picture in smoke, and Picasso turned a vagina back into a frightening, deep, black gash at the optical dead centre of the painting.

Originally, too, the fallen warrior with the broken sword had been grander, stronger, his head helmeted like a classical hero, a Hector. Then Picasso remembered an image from a late medieval Spanish apocalypse manuscript and turned the warrior on his back, mouth open, slack-jawed and gaping. But from the squared-off base of the neck and the severed arm, it also seems that Picasso has made the figure a shattered, hollow statue, its bust and torso broken. Beside its right hand he has set another unconvincing emblem of hope: a single daisy, a smidgen of life amidst the carnage, all the more poignant for being drawn in the manner of a child, that gesture of art-less innocence that the cleverest painter in the world (once a child prodigy) has taught himself to impersonate. More startlingly, on the opened palm of the left hand (more like flesh and less like plaster) he has drawn an unmistakable puncture wound, the stigmata of the risen Christ.

So the cool modernist was now quoting the Gospel. It was General Franco who was supposed to be the Christian Soldier. And that, of course was the point, turning the tables on the sanctimoniousness of the Falange leader, the Caudillo. For Picasso's head contained one more image of the agony of his nation. It was one that every Spaniard knew and for which he, as Director of the Prado, had personal responsibility: Goya's *3rd May, 1808* (page 386).

That masterpiece too had been the response of an artist to cruelty and massacre, in Goya's case to the execution in Madrid of rebels who had risen against Napoleon's invasion. And, like Picasso, Goya's standing as a tribune of outrage was complicated by the fact that his politics had been ambiguous, as were his attitudes to the two Spains, old and new. Intellectually he was a reformer – which might have put him on the side of the pro-French party against the obscurantist reactionaries of the court. But Goya was also in his way a traditional Spanish patriot, and on this occasion he unequivocally took the side of the victims. In the pudding of gore to which the face of a shot prisoner, fallen on the ground, has been reduced, and in the

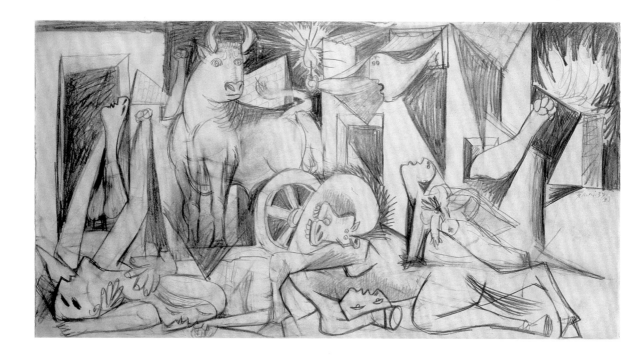

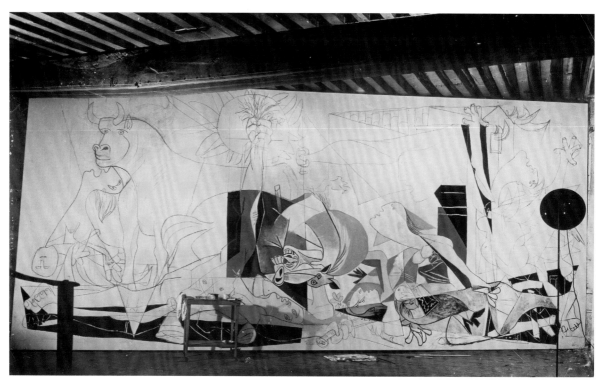

Top: STUDY FOR GUERNICA, 1937, pencil on paper (Museo Nacional Centro de Arte Reina Sofia, Madrid).
Above: GUERNICA (2nd State), 11 May 1937, oil on canvas, Zervos IX, 58, photograph by Dora Maar (Picasso Museum, Paris).

faceless machine of the firing squad, the muzzles of their guns a perspective line of death, Goya created the first painting of modern state brutality; the polar opposite of Jacques-Louis David's cosmetic classicism. But the Spaniard's painting is also saturated with redemptive symbolism and coloured (literally, for the martyr at the post is dressed in the Papal-Catholic colours of yellow and white) by the hope of salvation. He is dying the Saviour's death, arms flung wide, Christ's puncture wound appearing on his opened palm – the same wound that appears on the left hand of the *Guernica* sword-bearer.

Picasso has – more obliquely – taken something else from Goya's execution, which, like *Guernica*, is a nocturnal massacre. It's a detail that stands the conventions of art themselves on their head: the alteration of light from a source of good, the primary condition of the creation of art, to the accomplice of evil. In everything written about painting, everything done, radiance is the bringer of beauty. Describing masterpieces as 'luminous' had long become commonplace, as had the habit of alluding to works by Caravaggio and Rembrandt as somehow *emitting* light. But there's something about Goya's terrible fancy that modern light might also be malign – the enabler of torture and murder – that wormed itself into Picasso's imagination. He thought of *3rd May, 1808*, a scene in which dirty business is being done in the dead of night, and saw that the lantern is, literally, the light in which we regard evil. Now look at *Guernica*. The swell of writhing bodies, the pyramidal form prescribed by the academic rules of composition that Picasso would have learnt as a child, heaves up towards an eye-shaped lamp, its brilliance denoted by a jagged flare like the flash of a sunspot. Initially, the apex of the entire composition was upbeat and heroic: an upright arm, its fist clenched around a flower stalk, backlit by the sun. Did Picasso know that this might have been too much of a communist salute for a Republican government struggling against not just the Falange, but an almost equally brutal take-over by Stalin's Moscow? Instead of that stock image of comradely resistance, Picasso set a blank eye: the organ of beholding. Around the time that he altered this detail he made a strangely eloquent drawing of the bull's head under attack by a plague of alien eyes, little monsters swarming and swimming, seeing sperm with bad intentions and stinging irises and pupils – that flagellate, right on target, into the bull's eye. But then, at the last minute – when Picasso had so many of his best ideas – he changed the centre of the heartless, artless eye in *Guernica* into a single light bulb, an implacable incandescence beneath which the horse writhes in its death throes and shrieking mayhem proceeds. When he was later asked about the symbolism of *Guernica*, Picasso turned laconic again, resisting over-reading. The bull was just a bull and the lamp just a lamp. But it's hard not to be put in mind of Goya's lamp of darkness, or

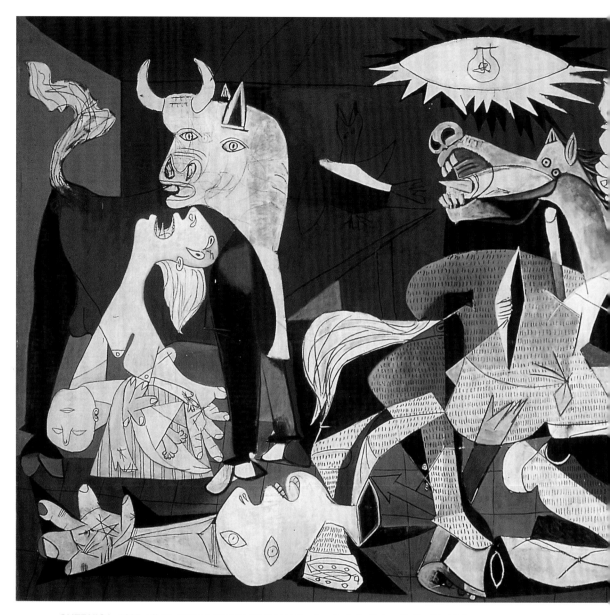

GUERNICA, 1937, oil on canvas (Museo Nacional Centro de Arte Reina Sofia, Madrid).

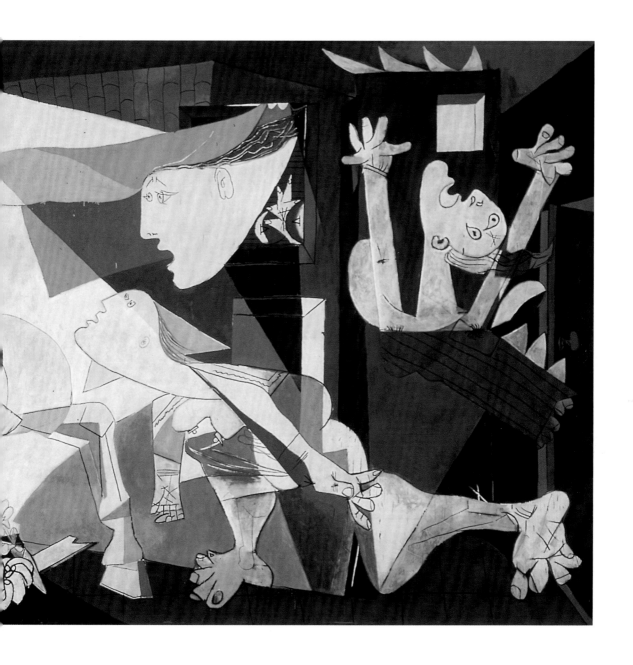

EXECUTION OF THE DEFENDERS OF MADRID, 3RD MAY (detail), 1808, by Francisco de Goya y
Lucientes, 1814, oil on canvas (Prado Museum, Madrid).

the searchlight of the targeting bomber and so many other brightly illuminated modern miseries. Franco the bristling turd, the slimy sea-squirt, has been replaced by something much more malignant in its impersonal banality. Against its flare is, after all, the candle-light, held straight out by a classically beautiful arm. It's a tournament of lights, then, good and wicked; art versus electricity.

It was almost done. But there was one more necessary touch. Piled up around the studio were stacks of newspapers. Newsprint had played a central part in Picasso's career, scissored for collage, for super-subtle allusions – in-jokes about his friends or his love-life or just for their signalling effect; all very art-smart. But when he was painting *Guernica,* Picasso used stacked papers as palettes, so their newsprint was covered in black and white paint like a palimpsest of superimposed marks. But if there was paint on the news (enduring art asserting its effacing superiority over ephemeral journalism), Picasso also wanted, in some devious way, to have news on the paint. So he and Dora, working together (the one and only time someone else made marks on a 'Picasso'), covered the body of the dying horse with a field of sharp little downward hatchings that make its torso dissolve into a sea of illegible pseudo-print, or perhaps into the whirr of the projector: the visual equivalent of static. But Picasso's figures rise – for ever – above the drone of the news.

By the beginning of June the chestnut trees were in full leaf, and Picasso thought he had finished. Friends were invited round to 7 rue des Grands Augustins: the sculptor Henry Moore, the poet Paul Eluard. But then, at the last moment, on the point of delivering *Guernica* to the Spanish embassy, he had a bizarre idea, drawn from his collages of 20 years earlier. Perhaps the strobe-hatched mono-chrome was too unrelenting? Perhaps he should make the picture bleed a little? So Picasso proceeded to glue scraps of coloured paper, especially red, here and there on the figure of the running woman, the mother and the burning house. He then asked his friends what they thought of the idea. 'Wordlessly,' recalled the poet José Bergamin,

we said no. The pure white, grey and black of Guernica answered for us. Little by little the experiment was reduced to one tiny scrap of paper, a red tear of blood. Picasso moved it about against the figures' eyes. Obstinately and with a hint of childish mischief he refused to relinquish it entirely. Finally the tear disappeared. And Guernica – white, grey and black – remains for all time an undying testimony of art. Here the painter professed his purest, most brutally naked, most poetic truth.

Picasso didn't need Bergamin to tell him this. He knew he'd achieved the near-impossible: a defiantly modern painting that somehow manages to pull us into the tragedy of the ages; a Cubist commotion, but also a classical monument, with wailing women flanking the towering pyramid of death. It's just paint and canvas, just *black and white* paint, but it somehow has authority and endurance: unbombable, indestructible. And it achieves another miracle for, despite the glut of images of 20th-century massacre, this one somehow manages, still, to get under the skin. This is what all great art should do: crash into our lazy routines. *Guernica* fights the truly deadly habit, a sickness of our own time as well as of his, of taking violent evil in our stride, of yawning at the video-massacre: seen it before; go away; don't spoil the fun of art. *Guernica* wasn't made for fun. It was made to rip away the scar tissue, rob us of our sleep. It did. So in every way that mattered Picasso had won, art had won, humanity had won.

VIII

BUT IT DIDN'T SEEM LIKE THAT IN 1937. There was no doubt that, with the odds against the Republic's survival lengthening, *Guernica* was desperately needed. But whether it would make conversions was uncertain. When modern art in the 1930s had a strong message to communicate, it usually did so in beefy naturalism, stylized a little, but without risking incomprehension. Picasso was probably expecting either acclaim or outrage. Either way he would know his masterwork had done its job.

What he got, though, was bemusement. When Picasso handed the painting over to the Spanish authorities and received his handsome fee, there was the unmistakably deadly sound of polite appreciation. When *Guernica* was hung on the ground floor of Sert's sleek, modernist box, the installation screamed 'mixed feelings'. As planned, it covered an entire wall, but the stepped ramp on the exterior of the building took visitors straight up to the next storey, so that they would either have missed the painting entirely, or have first seen it from the one angle it had never occurred to the painter to consider as important – from top down, from the point of view of the bomber's light!

Perhaps *Guernica* wasn't exactly what its patrons had hoped for. The outside walls of the pavilion were covered with more orthodox homilies. Here were posters, blown-up photos in the standard manner of the 1930s – Heroes of the People, depicting soldiers, peasants and children; and advertisements for Good Works: numbers of schools and hospitals built by the social democratic governments of the Republic. Picasso had not given the Republic muscular proletarians, nor even jackbooted villains. But in the event, alas, his choice of both style and symbol didn't

matter anyway. For over Sert's glass box towered the neo-classical monstrosity that Albert Speer had designed for the Third Reich. From the viewing platform of the Eiffel Tower, looking over the Champ de Mars, the Spanish pavilion was completely hidden. And, disappointingly for its sponsors, there was nothing in Picasso's painting that clearly and unequivocally identified the fascist aggressors. The Germans were amused and wrote it off as the work of someone who had become deranged. In Britain Anthony Blunt, already on the payroll of the Soviet Secret Service, wrote it off in the *Spectator* as a 'private brainstorm', an exercise in self-indulgent bourgeois obscurantism. (Twenty-five years later he would write a short book praising it as a peerless modern masterpiece, with no mention of his original dismissal.) As for Picasso's French friends and peers, from them there was either tepid praise or deathly silence. The French pavilion, after all, was bright and gay: Dérain, Dufy, Matisse, exactly in keeping with the head-in-the-sand, party-on cheerfulness before the abyss.

Picasso himself showed no sign of going broody over the mixed reception. He went to the Côte d'Azur with Dora, and gathered all his old friends together in the sun. Every so often news came over the Pyrenees of the slow strangulation of the remaining Republican strongholds in Spain. The noose was tightening about Barcelona, and, as *Guernica* was being taken down from the wall of the pavilion at the close of the Exhibition, Picasso learnt of the fall of Bilbao and the rolling-up of Basque resistance. He was not unaffected by these melancholy reports, organizing soup kitchens to feed orphans and refugees as the trail of homeless grew longer.

And their number now included *Guernica* itself. It was the property of the Spanish government, but with the military outlook so bleak, there was no question of sending it to Spain. Franco was still standing by the lie that it had been the Basques themselves who had destroyed their ancient town. It was thought that he was eager to lay hands on the painting in order to destroy it. So a 40-year exile began, abetted by Picasso, who did not want his painting to lie dormant in a particular museum, but rather to turn into a nomad for democracy. Even after the final defeat of the Republic, he wanted *Guernica* to tour the world so that the atrocity would never be forgotten.

It was not what everyone wished to see. On the same day, 29 September 1938, that Neville Chamberlain signed the Munich agreement with Hitler, Picasso's picture arrived in London. Some of the leading lights of the anti-appeasement intelligentsia – Leonard and Virginia Woolf, Henry Moore, E.M. Forster – had organized its exhibition at the New Burlington Gallery. But the crowds were thin and

the critics carping. Anthony Blunt was at it again, calling the painting a 'fraud' in his article 'Picasso Unfrocked'.

A second show, at the Whitechapel Gallery, was a different story. It was, unapologetically, a demonstration for the Labour left, opened by the party's leader Clement Attlee and shown alongside films documenting the war in Spain. Beneath *Guernica* rose a second pyramid, this time of boots donated for Republican soldiers. Fifteen thousand people came to see the painting. But the boots couldn't save Republican Spain. In April 1939 Barcelona fell. At some time during the slow strangling of Catalonia, Picasso's mother had herself died.

The artist had once described the process of painting as a great emptying: an emotional and psychological evacuation. Now he was indeed empty and there was nothing much, except his domestic comforts with Dora, Marie-Thérèse and Maya, to occupy him. He painted, of course, but in a desultory way, devoid of the self-imposed challenges that had characterized his most inventive work. There were two exceptions to this vacant hobbyism. One was a series of 'Weeping Women', the first of which had been painted at the time he was completing *Guernica*. It's Dora's head, in livid colour and held together by an armature of black lines, like the leading of a stained-glass window, as if Dora Maar of all people was a sobbing Madonna. The jagged lines, broken eyes beneath the absurdly flamboyant hat, describe a neural map of distress. Then, as if Picasso couldn't quite get heads out of his own, there was a series of sheep skulls, the brain cavity open and emptied, that looked back to Rembrandt in their identification of martyrdom and butchery. This was where the ritual combat of the beasts had ended: in a mess of smeared bone and sinew.

Meanwhile, *Guernica* sailed west on the liner *Normandie* – which would be fitted out two years later as a troop carrier. In New York it was the centrepiece, along with *Les Demoiselles d'Avignon*, of a Picasso retrospective at the Museum of Modern Art (MoMA). There, as in London, the press was mixed: hoots of derision from some critics, some accusations of communism from others, lukewarm approval from modernists. But a younger generation of painters, some from Europe, some not, who were themselves struggling with direction – Jackson Pollock and Willem de Kooning among them – came to *Guernica* for a shot of supercharged energy and got high on its fire and fury. Then the picture went on tour all the way to California, where it raised a little money for refugees and won more polite praise. When the European war started in earnest, Picasso readily agreed that *Guernica* should stay at MoMA, not just for the duration of hostilities but until democratic institutions were restored in Spain. Optimistically, Franco attempted to have it seized for

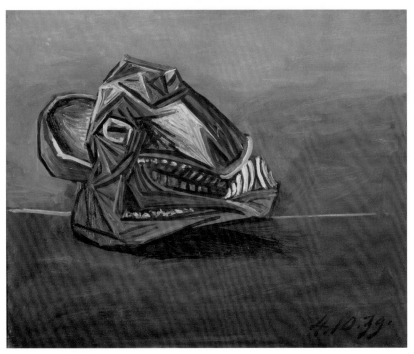

Top: WOMAN WEEPING, 1937, oil on canvas (Tate Gallery, London).
Above: SHEEP'S HEAD, 1939, oil on canvas (Picasso Museum, Paris).

non-payment of Spanish taxes, but there on West 53rd Street it stayed, gathering iconic power with every atrocity committed by the Axis war machine.

Picasso, on the other hand, was largely spent. The war meant survival, and then, at the Liberation in 1944, a horde of worshipful pilgrims converging on the rue des Grands Augustins, eager to hear all about the making of *Guernica*. For the most part, Picasso was happy to oblige, reliving those hectic days in 1937 as if he were a field marshal recollecting his finest campaign – which, in all the ways that mattered, this indeed was. He was also increasingly given to making lofty pronouncements about the political obligations of the artist, which substituted for actual work that might make the point. One ambitious painting, *The Charnel House*, his response to the revelations of the death camps, is, aptly enough, a kind of collapsed *Guernica*, the black and white thinned to phantom washed-out grey, with disjointed, ectoplasmic figures sunk into a bleached bone-pile. But the painter who once fought shy of any political posturing lest it cramp his creativity now did little else. In October 1944 he proudly announced his membership of the Communist Party in the offices of their newspaper, *L'Humanité*, and declaimed that 'art and liberty, like the fire of Prometheus, are things one must steal, to be used against the established order'. And it was at this moment that he also described art as 'an offensive and defensive weapon against the enemy'.

As he became more and more politically obedient, so his art marched in lockstep with the dictates of Soviet propaganda, becoming ever more banal and airless, the visual equivalent of a party conference oration. Doves and sententious murals of war and peace make their standard appearance, and, at the very nadir, a hideously ingratiating portrait of the Great Soviet Hero, Marshal Stalin. Picasso had become the poster boy for tyranny.

From which role he exited, only to turn into the darling of the fashion glossies. Transformed in the late 1950s from party hack to party animal, Picasso was endlessly photographed in his sailor T-shirt and Riviera swimtrunks, the eyes still bright, the tan ever deepening, the wives getting younger as he got older, his mischief undimmed but somehow uninteresting. Measured by sheer output, Picasso's last years might be thought a triumph of energy over age; measured by quality, they represented a slide into bathos. As his art collapsed, the cult of Picasso became ever more slavish and ubiquitous. The French film-maker Henri-Georges Clouzot spent hours with a camera behind a glass panel on which Picasso daubed and glared, and called the result *The Mystery of Picasso*, 1956. But he did it precisely at the moment when there wasn't much left.

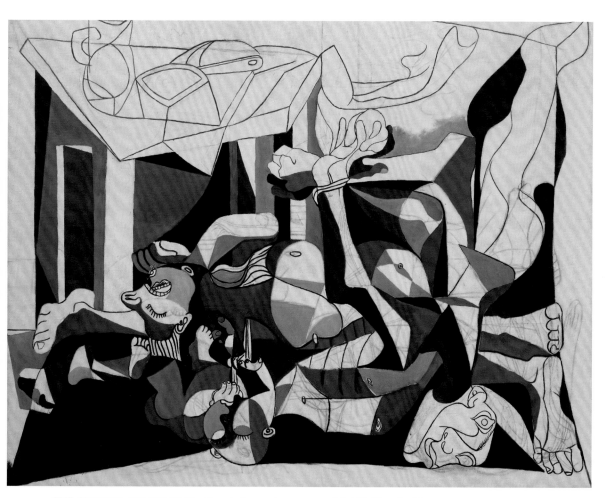

THE CHARNEL HOUSE, 1945, oil and charcoal on canvas (MoMA, New York).

IX

ON THE OTHER HAND, *Guernica*, in exile on West 53rd Street, burned over the decades with moral heat as its creator's candle guttered. The postwar world could be depended on to inflict horror on helpless civilians with enough regularity to make the immense painting timelessly shaming. Through the Cold War and the Vietnam War it became a banner for the possibility of humane indignation in modern art, just when the high priests of art criticism, such as Clement Greenberg, were laying down the law that abstract colour painting was the purest form of art, being so strictly and exclusively an arrangement of colour and line on a flat surface. Predictably, then, *Guernica* – which was most certainly not that – was written off as an embarrassing lapse.

But it survived these priestly strictures, and so did modern painting. Paradoxically, the one work of Picasso's that was created to be more than merely an art act ended up giving modern art on both sides of the Atlantic a desperately needed new lease of life. Subject matter? Allowed! Emotive expression? You bet! History? Wow, let's try! In Germany it was the moral authority and painterly power of *Guernica* that allowed painters to be eloquent about the obscenity of their recent history while writers struggled and the news was (for a while) heavily dosed into pragmatic amnesia. In America, *Guernica* saved modern art from death by navel-gazing, rescuing it from the curse of its own cleverness and the obligations of novelty.

Guernica has always been bigger than Art, uncontainable by the museum, one of those rare works that gets into the bloodstream of the common culture. But just because it chose to take on power, it has always had to deal with its vagaries. Picasso relished this, giving a contemptuous thumbs-down to the ageing dictator Franco, who, oddly enough, wanted it back in Spain. Picasso knew that *Guernica* might have lost the battle, but also that it had won the war – that the decrepit old fascist would die, and with him would perish his horrible regime. The painting, on the other hand, would endure and, when freedom was reborn in Spain, would find its way home.

Of course, where that home *is* remains open to debate. The Basques insist it belongs in Bilbao, the heart of Euskadi, where the wound was opened. But in 1981 it went to Madrid, nervously guarded by armoured glass and police until, in 1995, both were removed and *Guernica* was allowed to face the public with only the un-dimmed courage of its convictions for protection.

And just when you think it's a magnificent relic, stupendous in its time but not what's needed in our 24/7 digitally enhanced, globally interconnected world, something comes along to remind us that it is precisely the video saturation, the routinization of carnage, that makes the painting a reminder of what art can do that the news can't. And since the popularity of slaughtering innocent civilians in the

name of a righteous cause is growing apace, we can always depend on murderous moments that will awaken from the old black and white creatures the tempestuous force of their original creation.

Just a few hundred yards from where *Guernica* hangs in the Reina Sofia Museum is the Atocha railway station. On 11 March 2004 three bombs planted by Muslim terrorists exploded at the height of the Madrid rush hour, killing 192 and wounding 2050. The station became a shrine to the defenceless fallen. But when the candles had gone out and the public rites of mourning passed, countless thousands made their way over the road to *Guernica* and stood before its pall of smoke and mutilated humanity. They needed no acousti-guides to tell them why it mattered. A year later, during the anniversary commemorations of the Atocha bombing, I saw Madrileños come back from the station once again to the painting. At the site of the explosions there was now a little video installation, surrounded with memorial candles. The slides did their thing as best they could. Horror. Click. Horror. Click. But it wasn't enough. The slide show numbed rather than spoke. But *Guernica* still speaks. And when it does, it screams bloody murder.

This puncturing of routine can be a terrible nuisance. In February 2003 the US Secretary of State, Colin Powell, had put his pessimistic case on the likelihood of armed intervention in Iraq to the United Nations Security Council. A press conference was to be held in the corridor by the Council Room. But then, at the last moment, someone – whether among the American staff or the media – noticed something inconvenient about the location, to whit a tapestry reproduction of *Guernica* hanging on the wall. Oh, dear. Screaming women, burning houses, dead babies. Bummer. A sky-blue standard-issue United Nations drape was found to cover up the offending item and the press conference went ahead.

Of course, had the panicky newsmen and handlers thought for a moment, they might have co-opted *Guernica* rather than shrouding it. This is what tyrants do, they might have said: death, suffering, horror. But they didn't. However you massaged it, there was something about the way the damned picture would look on the six o'clock news that would upset people, take everyone right off message. Much better to cover it up.

It was, I suppose, the ultimate backhanded compliment to the power of art. You're the mightiest country in the world; the most powerful news organization around; you can throw armies at dictators; get rid of them; and you can cover the whole thing live. But don't tangle with a masterpiece. Not this one, anyway.

Rothko

THE MUSIC OF BEYOND
IN THE CITY OF GLITTER

I

JUST HOW POWERFUL IS ART? Can it put you off your food the way love or grief or fear does? Can it slam the brakes on the relentless business of life, fade out the buzz and cut straight through to our most basic emotions: anguish, desire, ecstasy, terror?

For most of art's history, it was assumed that if you pitched the stakes that high you would need stories, or at least figures, to deliver the poetic rush of feeling: weeping madonnas; voluptuously vulnerable nudes; soulful self-portraits; embattled heroes laid low. Even figureless landscapes drenched in light worked through the presumption of sentimental memory, briefly passing felicities.

But Mark Rothko believed that tradition was all used up; that figurative art no longer had what it took to connect us, viscerally, to the human tragedy. In the century of mass incinerations, who cared about a few darts in the side of St Sebastian? The problem of modern life, especially in consumer society, he thought, was that unspeakable things had been done and contemporary culture's answer was to dull the pain with distraction, with the daily satisfaction of the appetites. The problem of modern art was how – with such elementary materials as paint and canvas – it could throttle the relentless chirpiness of contemporary life and re-connect us with the strenuous drama of the human condition. The triumph of the photographic image only compounded the problem, since the equation of the optically fixed image with reality had made us more impervious to the deeper truths of experience. Only a completely new visual language of strong feeling, Rothko thought, could wake us from moral stupor. So he set himself – and New York – a test.

In 1958 Rothko took on a commission through which, he thought, he could bring his monumental dramas right into the belly of the beast. The Canadian distilling company Seagram's wanted the best modern art to complement the elegant, modernist space of the Four Seasons, the restaurant located on the ground floor of their corporate headquarters in mid-town Manhattan. Rothko's work would join paintings by Picasso and Jackson Pollock. So he accepted the commission, but rather in the manner of a duellist picking up a flung glove. He understood well enough what he was up against: gossip, fashion, glitter. But that was the point. He was at the top of his game, and if it was *haute cuisine* against high art – *his* high art,

Above: RED ON MAROON (SEAGRAM Mural Section 2), 1959, oil on canvas (Tate Gallery, London).
Page 397: MARK ROTHKO IN HIS STUDIO (detail), 1952, gelatin silver print by Kay Bell Reynal
(Archives of American Art, Smithsonian Institution, Washington).

at any rate – the truffled soles didn't stand a chance. Whether or not they knew what they were in for when the linen napkins dropped on their laps, the diners would be transformed by the paintings surrounding them. Between the consommé and the coffee they would be pulled deep into the Human Tragedy.

II

IT DIDN'T WORK OUT QUITE THAT WAY. On 25 February 1970, nine of the Seagram 'murals' arrived not in New York but at the Tate Gallery (now Tate Britain) on London's Millbank. A few hours before, on the same day, Mark Rothko's body had been discovered on the floor of his Manhattan studio. He had committed suicide by cutting his wrists. The painter who had spent a lot of time in his own mind walking the realms of the dead now had, in London, something like his own mausoleum.

Which is why, in the spring of that year, I didn't feel in much of a hurry to see the Seagram paintings. Their installation in a single gallery in the Tate smacked a bit too much of reverence: a dutiful monument to one of the great fallen of the heroic age of abstraction. And I wasn't into reverence that much, not in 1970; didn't want to know about the eternal verities. I was into playtime, the kind of art that bottled contemporary fizz and made it rock: in Britain (in their different ways) Richard Hamilton, Peter Blake, David Hockney, Bridget Riley, Patrick Caulfield; in America, Andy Warhol, Jasper Johns, James Rosenquist, Roy Lichtenstein. SHAZZAM! We all knew that the great patriarchs of abstraction had seen their painting as a bulwark against the tide of trash they saw in pop culture, and we hated them for their puritanism. *Our* painters were those who, instead of panicking at mass culture, made love to it, and made art from it. The idea that we should turn ourselves in for a remedial course in transcendence was a turn-off, like being made to go to church. The fact that Rothko had now joined the pantheon of high-minded, suicidal abstractionists only made the prospect more funereal.

On the other hand, that morning I had a yen to see Francis Bacon; so into the Tate I went, down the grand processional space of the Duveen Gallery, took a wrong turn and there they were. It was definitely not love at first sight. Sight was in any case a problem, Rothko having insisted that the lighting be kept almost pretentiously low. But that, of course, was a clever prescription. One's eyes took their leave from the white glare of the gallery wall, and, as they adjusted to the velvety obscurity, entered an altogether different optical realm. It was rather like going into a cinema where the main feature had had the sound turned down: expectation in the dimness. Some-thing crimson and purple in there was doing a steady throb, like the valve of a body part. Rothko had said of his paintings that they were 'an adventure into an unknown

world which can only be explored by those willing to take risks'. The longer I stared, the more powerful was the magnetic pull through the black columnar forms towards the interior of Rothko's world. I still wasn't sure it was somewhere I wanted to be; only that by some sorcery of vision I had no choice but to go on. And that the destination might not prove to be a picnic

III

ROTHKO PROTESTED – over and again – that he was no abstract painter, which seems perverse. What are his big paintings if *not* arrangements of coloured forms? But what he meant was that, for him at any rate, it was not enough to lay down those forms and leave it at that. That way lay arid self-containment, aesthetic narcissism. Subjects mattered, he said, and his own subject (even if the beholder was, at first, hard pressed to see it amidst the stacked colour panels) was the universal tragedy of the human condition.

Although Mark Rothko had fought in no wars, he believed that he carried that history in his blood. He claimed that in Dvinsk, in tsarist Russia, where he had been born Marcus Rothkowitz in 1903, he could remember Cossacks roughing up Jews in the streets. A relative, so a family story went, had even been beheaded. Little Marcus was only ten when he left Dvinsk, and although half the population were Jews, there had been no pogroms. But he was certainly old enough to know what a pogrom was, and to be terrified by what was happening in the Pale of Settlement where Jews were concentrated. When he was seven his father Jacob, a bookish pharmacist (the usual story: dreamer, hopeless with money), left for the United States with Marcus's two older brothers to scout for a new home. By the time the family was reunited in Portland, Oregon, in August 1913, Rothkowitz senior was already seriously ill with colon cancer. Seven months later he died. So Marcus's mother Anna (known in America as Kate) had been twice deserted. When, eventually, he came to paint an intimate family group as if he were Chagall, it's the mother who is holding the little clan together.

Much later, when he was successful enough to be short with journalists whom he thought would never understand what he was really up to, Rothko retreated into aggressive taciturnity. 'Silence is so accurate,' he said rather grandly and, by definition, irrefutably. But for most of his life – and especially his youth – he was no Jewish Trappist, but a much more recognizable type (at least to me): loquacious, exuberant, hot-tempered, deeply immersed in literature and history. The Orthodox Judaism in which he'd been brought up would seem to have no part in the art he would make, except that once you've done *cheder* – Hebrew school – it never really

goes away, however much you try to banish it. Nor did it for Marcus. He was what everyone would call, with smiles both admiring and pitying, a *chochom* – a know-it-all. And what could *chochoms* do if they weren't going to be rabbis?

Yakk, that's what. At Lincoln High School Marcus was the star debater, and went to hear the firecracker orator 'Red' Emma Goldman lay into capitalism and sing the praises of the Russian Revolution. But he also took 'dramatic arts' and thought for a while about a different career. In the event, he himself put on the greasepaint just briefly – but his pictures would sustain the drama.

Rothko was, of course, scholarship material, and won a place at Yale before the Ivy League decided they were about to be inundated by clever Jews and imposed admission quotas. But Rothko felt the sting of the Wasps all the same. If they couldn't actually evict the talky-smart kikes, 'those people', they could at least make it hard for them to stick around. At the end of a year spent studying mostly history of philosophy and psychology, Rothkowitz's scholarship was rescinded. He lived off-campus with relatives in New Haven, and accepted the role that had evidently been assigned to him by launching a lefty underground newspaper called the *Saturday Evening Pest*. At the end of his second year he dropped out altogether.

The antidote to all that ra-ra was jazz-age Manhattan, and Rothko lost no time getting there. Later he said he just wanted to 'wander around, bum about and starve a bit', but it wasn't the bootleg and boogie-woogie that drew him in the autumn of 1923; more like Marx and Mozart. Just when he got the art bug isn't clear. He had stayed away from it at Yale, but as soon as he got to New York, he enrolled in a life drawing class at the Art Students' League. But – significantly – he was torn between the studio and the stage. In 1924 the artist who would be remembered (inaccurately) for his lofty silences went back to Portland to train as an actor in a local company. It was Josephine Dillon's company, he said, that first exposed him to music, colour and design. Put all those things together with his instinctive feel for tragedy and you have – already – the makings of Mark Rothko.

But between the makings and the made there were 30 years of struggle, sometimes excruciating. In 1925 he took still-life classes with a painter and teacher called Max Weber. Cézanne was all the rage, the bridge to modernism, and Rothkowitz started with still-lifes, nudes and landscapes, some of which (the apple-breasted women with scenery between their thighs) were, in effect, all the same subject. To make a living, he worked as a book-keeper for relatives in (what else?) the garment industry, and did maps and illustrations for *The Graphic Bible*, the project of a young rabbi, Lewis Browne, whom he had met on the way from New Haven to New York. When the work was published Marcus believed he had been

short-changed, for both credit and cash, and – at the age of 24 – sued Rabbi Browne and Macmillan publishers. The case went all the way to the New York Court of Appeals, where the tigerish young litigator lost.

But he was now very definitely part of the Manhattan art world, taken up by Milton Avery and his wife Sally. Every week Marcus went to their apartment on Riverside Drive for a life class, and produced more doughy, distorted, pallid nudes that ooze repressed voluptuary appetite – a slightly strangled form of Manhattan Expressionism lost somewhere between Soutine, Beckmann and the Brooklyn Bridge. But in 1928, at the well-named Opportunity Gallery, Rothkowitz showed work along with Milton Avery.

Much later Rothko would look back on the struggling years of the late 1920s and 1930s with a degree of romantic fondness: 'No galleries, no money, no *critics*. But a vision to gain and nothing to lose.' And it was true that the time was both difficult and splendid for a young painter in the process of finding his place. There were patrimonies to hit against. The Museum of Modern Art didn't yet exist; the Metropolitan Museum tended to look down its patrician nose at modernism; and the Whitney favoured exactly the kind of American painting young Rothkowitz most despised: scenic, provincial, anecdotal, trite.

Rothko already had the mixed feelings about America and American painting that he would keep for the whole of his life. On the one hand he knew he was part of the classic immigrant story, and when he did begin painting, it was Jews, sidewalk peddlers, family portraits, string quartets – pictures that could as easily have been done in Dvinsk or Berlin as in the Lower East Side of Manhattan. Urban America was his America, and he vibrated to its thrum. But what was on the mid-town gallery walls was, for the most part, another America altogether: Big Skies, fruited plain, purple mountain majesty, the light of providence shining on the prairie. About that America Rothko knew little and cared less. Early on, he had the sense that America ought to offer an art to the world that was as new and vital as its history; but he also wanted that art to play for high stakes, to be hooked up somehow to the universal ideas he was chain-smoking his way through. Just what such an art might look like, however, he had as yet not the slightest idea.

Rothko had taken a job teaching art at a Jewish school in Brooklyn. Many years later, when some of his ex-pupils discovered that their teacher had become famous as a modern master and tortured soul, many of them said they recalled him quite differently, as 'Rothkie': expansive, warm-hearted and voluble! Perhaps this was because in the instincts of the children Rothko saw a natural affinity for the brilliant colours and spontaneously formed shapes that he, for one, was not going to drill out

Top: SELF-PORTRAIT, 1936, oil on canvas (Christopher Rothko Collection).
Above: UNTITLED (STRING QUARTET), 1935, oil on hardboard (National Gallery of Art, Washington).

of them with laborious drawing exercises. 'Painting,' he said, 'is just as natural a language as singing.'

But when Rothko began painting himself in the 1930s it came out, all too often, as a croak: dark, impacted little things, mounted on boards, visual jottings from late-night discussions with friends on Whither Modern Art? It's all very talky, and as if Rothko is burdened by an overload of competing influences, doing the Grand Tour of modernist motifs: the darkly leaded armature of some of the lines from Georges Rouault; the loaded slather from Soutine; the angst from Munch. There were some successes – a string quartet (1935), whose wasted features set against Rothko's favoured background of clotted mud embodies a kind of gloomy dissonance. But most of the paintings were dutifully derivative, Rothko trying on German Expressionism for size, finding it didn't quite fit, but doing it anyway. And the paintings of the early 1930s are the polar opposite of his schoolchildren's happy daubs, the brightness and freedom that Rothko said he loved.

IV

SO WHEN THE WALL STREET CRASH came in 1929, followed by the Great Depression, Marcus Rothkowitz had not very much to show for his decade in New York. He was exhibited, but not much sold, and when it did, it wasn't a living. He was married to Edith Sachar, bright and Jewish, whom he had met at a progressive summer camp at Lake George in the Adirondacks: downing dialectical materialism, Freud and Cubism along with the weak coffee. Marcus was never much one for the Greenwich Village boho scene, so the couple lived in a cold-water, walk-up apartment in mid-town Manhattan, where Edith kept the wolf from the door by turning out silver jewellery that seems to have combined commercial sparkle with modernist flair. This, of course, did not do much to soothe Marcus's anxiety that he had yet to find his way.

Although he was prolific and getting show space, a turbid joylessness (not entirely the product of urban angst) hangs over the pictures. Perhaps he was still one of those artists who found it easier to draft manifestos than to create? The voice of Emma Goldman had not gone away. In 1934 Rothkowitz was one of the original 200 founding members of the Art Union. A year later he became a member of the group who called themselves 'The Ten' (the minimum number of Jews who can pray together) and who agitated for 'experimentation' and against conservatism in museums, schools and galleries. Naturally, there were nine of them. They showed their work, but their zeal for experiment wasn't that novel. Mostly, they were concerned to *look* experimental, depending on whatever was coming in over the European cultural radar.

Rothko

Amidst the usual talmudic bickering of leftist factions, the denunciations and walk-outs, Rothkowitz and his comrades were all burning to make an art that would say something about the alienation, as they saw it, of modern American life. When Roosevelt's New Deal came along, he was taken on by the Works Progress Administration (WPA), hired for the wonderfully named 'easel division'. But, in the spirit of the time, what he really wanted to do were public projects – murals – that would escape gallery fodder and make a social place in which Everyman and Everywoman could dwell. But his two attempts to compete for commissions – one for the New Rochelle Post Office – failed. To make life more challenging, Edith's own work was taken up by the WPA.

In 1936 Rothkowitz went to the Surrealist and Dada show at the new Museum of Modern Art, entered the dreamworld of Giorgio de Chirico and Yves Tanguy, and finally felt his way towards a motif that he could make his own. His subway paintings are the first that catch the beholder off guard with their compelling oddness. They took their cue from the spooked-out night plazas of the Surrealists, but their cleverness is precisely in the fact that they are rooted not in the Illustrated Freud, but in the gritty beat of city experience. It's the commute as hallucination (we all know about this, don't we?): the sense of being suddenly aware of the passing strangeness of being trapped in a carriage, whooshing along to nowhereville. So Rothko's subways catch something about that urban routine that is both socially experienced and bleakly haunted: the mean hum of the lines, the sour-sweet odour of disinfectant, the moving threshold between now and whenever.

Rothko made his connection. There's clammy doom gathering on the platform, and Orpheus searching for Eurydice on the uptown D train. Commuters from the Bronx appear as if wandering souls, gathered in purgatory. Rothko thrived on the claustrophobia, even intensified it. The architecture of the subway with its mournful rows of cabbage-green columns, stairways that ascend and descend to and from nowhere in particular, the syncopated openings and closings of the carriages, become an animated grid, a gift to Rothko's instinct for psychologically fraught design. As he got deeper into the series, the pictures became less and less like urban genre paintings. Rothko was never going to be the subway's Edward Hopper. Anecdotal and local detail were lost (along with the commuters), the faces of the passengers reduced to an unreadable blur. These are just the stragglers in the swarm, their attenuated bodies pressed to the columns like so many stick insects.

The real action is going on where the colours themselves seem to have a life of their own, unplugged from what they're supposed to represent. Rothko called his colours 'performers', and in the platform edge, done as a brilliant crimson smear,

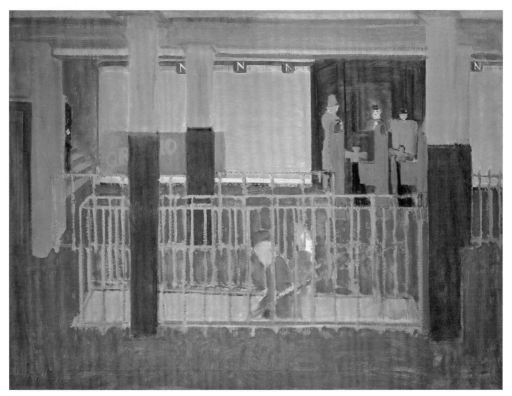

Top: UNTITLED (SUBWAY), *c.* 1937, oil on canvas (National Gallery of Art, Washington).
Above: ENTRANCE TO SUBWAY, 1938, oil on canvas (Kate Rothko Prizel Collection).

set down with a dry dragging brush, you can see what he means. The sharp energy of the mark carries the tension of the line, but it also vibrates with its own purely pictorial electricity. Turn the image around 45 degrees and you can see in prospect some of the features that will make Rothko Rothko: fields of intense colour contained, but not severely, by framing lines. The jig had started.

But unlike the subway cars, it didn't go anywhere. War tugged at Rothko's creative conscience, and subway riffs suddenly seemed parochial, not weighty enough to answer the call. It seemed to him a moment of universal moral crisis. He had become an American citizen only recently, in 1938, and Roosevelt's confrontation with fascism was exactly what he wanted from America: an escape from narrow-minded isolation, a reconnection with the destinies of modern history. Now Rothko and his painter friends – so many of them originally European Jews – wanted American art to go the same way. With European civilization annihilated by fascism, it was up to the United States to take the torch and save human culture from a new Dark Ages. It was not just a matter of offering safe haven to the likes of Piet Mondrian or *Guernica*, but rather the authentic American way – doing something bold and fresh, taking the fight to the enemy which had classified modernism as 'degenerate' and had done its best to destroy its partisans.

This was easier said than done. Barnett Newman, one of Rothko's closest friends, issued yet another manifesto, saying how he and the group felt that 'in the moral crisis of a world in shambles' it was impossible any longer to paint the old subjects – 'flowers, reclining nudes, people playing the cello'. But the conclusion Newman drew was to abandon art altogether for the four years during which America was involved in World War II. Rothko waded through his own tide of moral uneasiness, and his disqualification from the military by virtue of his acute shortsightedness (an embarrassment for a painter) didn't help. In all kinds of ways he was floundering. His marriage to Edith was falling apart. In his forties he was eaten by anxiety that he might never find that elusive form of painting that somehow was simultaneously American and universal, radically new and unarguably timeless. Every successive show he visited at the Museum of Modern Art – Dada in 1936, Picasso in 1939 (he couldn't understand why *Guernica* was black and white) – made him feel worse.

So he did what dismayed intellectuals generally do when they're blocked – went back to the big books, the works that spoke to him most eloquently of the perennial human taste for carnage: Greek tragedy, Shakespeare's tragedies, Nietzsche's *Birth of Tragedy*. Then he attempted to pin down this sense of brutality on canvas, as if he were an archaeologist uncovering the remains of ancient sacrifices. So myths and

UNTITLED, 1941–2, oil and graphite on linen (National Gallery of Art, Washington).

Top: BIRTH OF CEPHALOPODS, 1944, oil and charcoal (National Gallery of Art, Washington).
Above: SLOW SWIRL AT THE EDGE OF THE SEA, 1944, oil on canvas (MoMA, New York).

monsters, entrails and auguries appear in his work: Syrian bulls, Egyptian hawks, Indian serpents; half-men, half-beasts; feathers and scales, beaks and talons; peck, slither and hiss. The images were laid down in frieze-like arrangements of segmented colour zones, as if the excavator were digging his way through the bone pile. And although the obedient modernist made sure to disconnect the heads from the hindquarters, they still feel like a professor self-consciously discovering his feral side.

Every so often Rothkie, the instinctive Brooklyn teacher, broke free of all this portentousness and did what his kids did, except that it was now called 'automatic drawing': letting the line come as instinct prompted. And lo and behold biomorphic forms appeared that were not so much archaeological as palaeolithic: invertebrate squirmers and swimmers from the pre-Cambrian primordial soup. The critters were loosening up, and so was Rothko, getting more watery, his paint losing its blocky opaqueness. Arabesque forms rendered in thin patches of translucent colour drift and shimmy across the picture space like stingless jellyfish. The moves are almost seductive and often musical. *Slow Swirl at the Edge of the Sea*, 1944, with its male and female humanoids gently gyrating against some sort of marine verge, is playful (a gentle poke in the ribs from Miró) and, in a teasing way, sexy. Peggy Guggenheim – who was definitely both, as well as being the most voracious patroness of American avant-garde art – scented something different about Rothko (no more exercises in archaeological symbology) and she snapped up *Slow Swirl*.

There were reasons both personal and historical for the unexpected sensuousness. Rothko had fallen in love with Mary Alice Beistle, a dark, vivacious illustrator, eighteen years younger than him, and whom everyone called Mell. She evidently helped Rothko put a spring in his step and a lightness in his brush. The paintings are, after all, about the beginnings of life.

V

WHICH, AS EUROPE PICKED OVER ITS DEAD, was pretty much how American artists felt in the late 1940s. The moment was one of those rare convergences that don't come along very often: when power meets inventiveness and the two produce pictures. It had happened in Holland three centuries earlier, when, after the end of a long war against Spain, there had been a brief, muscular intoxication, a sense of being cut loose from the chains of an older world, an earned right to see the world afresh. And, as in the Dutch Republic, this giddy feeling of starting over came from a fusion of immigrant and native energies. The Nazis had art (as well as everything else) entirely the wrong way round. The modernism they demonized as 'degenerate' was in fact the seed of new growth, and what they glorified as 'regenerate' was the

stale leavings of neo-classicism. Their mistake was America's – and particularly New York's – good fortune. Painters such as Hans Hoffman and Willem de Kooning (who had arrived before the war) uncorked their energies in the city, their canvases soaking up the attack of brilliant, savage, racing marks. It was still idea-driven drawing, but it read as nimble, fancy footwork turned handy, the brush and pencil tripping the light fantastic all over the surface. Even anal old Mondrian (a famously accomplished ballroom dancer) stirred to the beat, took the nails out of the grid, and let it slide and jiggle wherever the hell the rhythm of the city took it.

For far too long American artists had gone to Europe – either actually or conceptually – as receptive students, deferentially self-conscious of what they supposed to be their cultural naivety. That was the way Rothko had listened to his teacher Max Weber in the 1920s, and he had tried his best to tune into Berlin and Paris. But now there was nothing out there transmitting. Picasso, Léger and Miró all lived in the south of France, their inventiveness snoozing on the beach. It was time to cut loose. So in the late 1940s, provoked and encouraged by women patrons and gallery owners such as Peggy Guggenheim and Betty Parsons, American painters such as Pollock, Franz Kline and Clyfford Still, who had laboured through Surrealism, producing symbolically congested meditations, suddenly threw away their Jung and came out of the sticks swinging punches, grease-lube cowboys with their cans and house painters' hog bristles, all of them revelling in the raw physical heft of their marks, the sweaty stains, the copious spillings. Astoundingly, they found both power and grace – so many Joe di Maggios in the studio.

But what they were up to went way beyond sport. The artists whom the critic Harold Rosenberg had dubbed 'action painters' were taking aim at the tepid blandness of postwar American life – a life that they thought was lived virtually, not physically. What did they see when they looked at the world? The Cold War and the Korean War, the two superpowers locked in deadly embrace; at home, paranoia and terror, Reds under the beds, the mushroom cloud merely a button-push away. Coping meant denial built into a lifestyle: the suburban dream in gingham and bobby socks; Buicks in the driveway, wife in the kitchen baking pies and pieties; young Billy on the gridiron, freckled Susie in pineapple pickers cheering him on; Pop off to work in his crisply pressed Brooks Brothers suit, back home for the martini and the slippers; the whole family like Rex the happy labrador, panting and jumping for joy, and always, always in the background the cathode-tube flicker and canned chuckles of the TV. Hey, what was a megapower to do? It was either bromide or suicide.

This was the American life the action painters wanted to smash – or at least bruise beyond recognition. There was nothing more truly American, they thought,

than to use painting to reattach people to physical reality. Although their art looked like nothing that had gone before, not even the most radically disintegrated Cubism, its aims were restorationist. In their hands art would be once more what it had been in the past; what Rothko's friend the poet Stanley Kunitz called 'the defence of the world'. It wouldn't do it illustratively, though, but with the fundamental materials of art itself: colour and line. For the first time those qualities no longer battled for domination of what painting was: in Pollock's travelling cyclone of paint the elements became indistinguishable.

None of them took this vocation of rehumanizing the world by attacking the sedative quality of contemporary life more seriously than Rothko. His life was getting back on track. In 1945, just a few months after he had divorced Edith, he married Mell. He was painting furiously. Since 1940 he was no longer Rothkowitz.

And what he was painting was, for the first time, stunningly dramatic. What Rothko wanted, he said, was to 'stretch his arms out', take a deep breath, a plunge into the liquid looseness he had allowed himself after his spell with automatic drawing. But he'd gone a step further. Now it was not so much a fantasy of the primordial deep as a look down the microscope at pulsing cell forms, which, as magnified shape-shifters, he called 'multiforms'. For the first time as well, rather than translate ideas on to the canvas, Rothko seemed to let the painting come to him.

He got help from Matisse. In 1949 *The Red Studio* (page 414) entered the Museum of Modern Art's collection, and Rothko went to see it over and over again, a thunderstruck pilgrim. Matisse's painting had simply abolished volume and reinvented pictorial space. Venetian red covered the entire field, with no help given to the eye as to where the floor ended and the wall began. Objects themselves – a window, a decorative plate, paintings – float without discernible volume upon the red field. The third dimension, for centuries the whole illusionist point of painting, had simply been waved away. And yet, far from emptying the painting of drama, the transformation (once you got used to the idea that, in this schema, objects no longer have colour, but the *painting* does) actually intensified it.

Rothko took the point. *How* he took it! Now, if he needed to convey the sense of a mythological or primal evolutionary moment, he no longer needed to labour it with drawn figures, but could let his own freely drifting patches of colour work their suggestive magic on our perception. That connection he was after – direct, intimate, but also monumental – was beginning to happen.

The paintings of 1947–8 seem to move mysteriously, organically, staining and seeping, swelling and dissolving. Sometimes they seem to hover over the surface of the canvas as if we were looking down from a height at layers of coloured cloud

Top: THE RED STUDIO by Henri Matisse, 1911, oil on canvas (MoMA, New York).
Above: UNTITLED, 1947, oil on canvas (Kate Rothko Prizel Collection).

blooming and fading. At other times the colours seem more embattled. It's all very seductive: a cocktail for the eye. Rothko now began to sell. And for that very reason he suspected it wasn't enough.

He was up against a compositional problem that all the Abstract Expressionists faced: how to stay loose and free without becoming entirely random, tediously incoherent. The dialogue between freedom and limits was, of course, definitively American, even though Rothko once claimed it was his tight swaddling in Russia as a baby that made it his particular compulsion! In its most banal form, the argument was translated into advice manuals published for bewildered parents confronting their own incomprehensibly anarchic Jimmy Deans. Pollock and Kline were the Deans of ab-ex, revving the throttle between their thighs. But Mark Rothko wore sports jackets and ties and lived in mid-town. Well, to have the drama you needed Pop as well as kiddo; you needed limits; you needed an edge to get one. (Pollock disagreed.) For Rothko, the tension between the framing edge of the canvas and the pulsing forms that pressed against it was not just an aesthetic flourish. He needed ambiguous boundaries the better to give his colour shapes a sense of movement tearing and fraying those edges, pressing down on them. Animation made his colours potent.

He was acutely aware of the Technicolorization of American life: scarlet lipstick, hot-dog mustard, avocado fridges, the duck-egg blue Chevy Impala. From this synthetic brightness, as painful as a starlet's grin, Rothko wanted to rescue the true force of colour – let it transport the eye somewhere it had never before gone. And in 1949 he finally found where that place was.

VI

ROTHKO ONCE SAID that paintings had to be miraculous. Arguably, in 1949 the world had never been more in need of miracles in paint. Suddenly, the middle-aged, balding chain-smoker who, on the strength of everything he had done up to that point, would have been remembered at best as a mildly interesting, derivative talent, produced eye-popping miracle after miracle.

Everything resolved itself. The ectoplasmic shifty-shapes of the year slide against each other in big, vertical canvases of shimmering, contrasting colour panels, some dense and opaque, some translucent, some again quite transparent. In *No. 1*, *1949* (page 416) the busy cellular activity becomes confined to a central panel, like a screen on which ochre shapes bustle about against a blue ground, that field itself enclosed in black, as if not long for this world. As the weeks and months of intense painting unfold, Rothko's forms themselves enlarge as if engorged on the light.

Above: NO. 1, 1949, oil on canvas (Collection of Kate Rothko Prizel and
Christopher Rothko).
Opposite: NO. 11/NO. 20 (UNTITLED), 1949, oil on canvas (Christopher Rothko
Collection).

The cast in his drama thins out: the vertical bars that existed in dialogue with the horizontals become gradually edged out of the picture field, as if consumed by the horizontals or pressed beneath them into a sub-field of immanent light.

And then it happens. The colour panels stack up on top of each other, layering and hanging with exquisite subtlety and complexity. Where Pollock darted back and forth across the flat surface of the canvas with whizz-bang force, Rothko switches axis to a notional space both in front of and within the picture, teasing the eye into a lit core of indeterminate depth. Rothko is painting with intuition controlled by countless fastidious calibrations of space and chromatic intensity. The canvases were sized, then the layers were progressively set down – or, as he liked to say, seemingly 'breathed' on to the surface, the colours thinned or thickened to make them engage with each other and with us. The ambiguity with which we read those shapes that seem to push out at us or fade away behind the picture plane; the way forms unveil themselves or cover themselves up; and the interior glimmer all make looking at them an inexhaustible process. Are, for example, the magenta 'bars' beneath the primrose veil in *Untitled*, 1949, ghostly progeny of the fat bar of colour apparently projecting below it, or – as the faint stripe of colour at the top implies – part of a deep nether-field? Do we read the black panel, floating on its bed of hot cream, at the top of *No. 3/No. 13*, 1949, as 'interior' space, dead flat, or an extruded panel? These permutations can go on for ever, manipulating the sensations. (At a 2004 show at the PaceWildenstein gallery of paintings from this miracle year of 1949, hard-boiled New Yorkers were seen sitting on the floor, leaning against the walls, like so many people who had just had blindfolds taken from their eyes. I was one of them.)

He was nudging 50, but he had got there. For ten years he would paint nothing else – but, then, why should he? He had become the maker of paintings as powerful, complicated and breathtaking as anything by Rembrandt or Turner, his two gods. The 'classic' Rothkos of the early and mid-1950s do seem to me fully the equal of those old masterpieces: as if they emitted an uncanny force field so magnetic that, when one turns one's back on them (and Rothko wanted one to turn around only to see another of his pictures), it's still impossible to escape their pulsing emission of light. It burns on the neck.

At the time, some of Rothko's fellow abstract painters who had also been experimenting with pure blocks of colour, such as Clyfford Still, and even his old pal Barnett Newman, accused him of stealing their ideas and techniques. There were ugly rows in the Manhattan coffee shops. But the truth (never clearer than 60 years after the fact) is that Rothko's colour-stacks are utterly original. To describe them

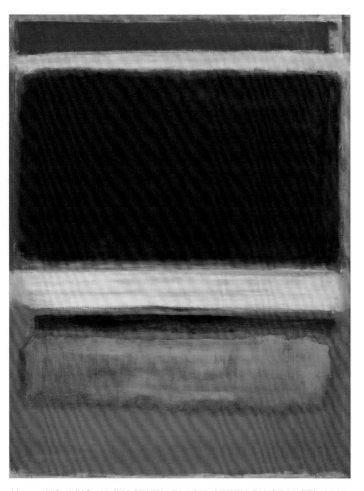

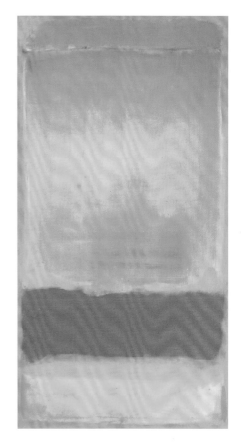

Above: NO. 3/NO. 13 (MAGENTA, BLACK, GREEN ON ORANGE), 1949,
oil on canvas (MoMA, New York).
Right: UNTITLED, 1949, oil on canvas (Kate Rothko Prizel Collection).

merely in terms of pleasing colour combinations, as if they were a sweetly sewn, companionably fluffed quilt, is not really to describe them at all, for it's not what the colours are so much as what the painter has them do. In his mind, and thus in our eye, they are animated organisms: they respire. So while at first sight the paintings seem composed and still, a minute or two in their company reveals a world of movement, sometimes racing energy, much like Turner's clouds streaking across the sky. His horizontal divisions often put people in mind of the elementary organization of landscapes, and although Rothko didn't want any sort of pastoral associations landing on his paintings he did recognize the mysterious affinity with Turner – both of them masters of dramatized atmospherics, both of them dematerializing the scenery. When he got to see a Turner show in New York in 1966, his droll verdict was that 'that guy Turner must have learned a lot from me'. Rothko's colours have that same quality of airy, oxygenated vitality; they tremble with it. And his pictures are not passively framed objects hanging on the gallery wall for inspection. They seem to move off the wall and into our space, coming to get us. Which is only right and proper since, as we know, Rothko always thought of his colour-forms as actors. So there they are, downstage, at the lip of the proscenium reaching into the darkness for our sympathetic connection.

All this was calculated, worked for. No other painter in the history of modern art – perhaps in the entire history of painting – was so obsessed with the relationship between the artist and his audience. Painting, he said, was an exercise in continuous clarification: the painter clarifying his idea, but then making sure that that clarity was passed on to the beholder. So although Rothko is sometimes thought of as the most authoritarian of modern painters, he was actually the least. He flatters us by needing us – indeed, we are indispensable – for the picture to work. Without that elusive communion, the picture, he thought, would be incomplete. It would, in fact, fail.

Hence, for Rothko, the painting was never finished with the last brushstroke. That was merely the end of the beginning. The picture continued to form, grow – 'expand and quicken' was his lovely phrase, bringing to mind the mystery of foetal development – in the eye of the beholder. So the conditions in which the connection between Rothko's hand and our eye are made were not just incidental, but formative to the experience of the art. That's why what seemed to dealers like Sidney Janis as the unbearable fuss Rothko made over installation (sneaking into the gallery when no one was around to dim the lights a little more), was as important to him as the painting itself. And that's also why Rothko was so fearful about letting his paintings go 'out into the world' – an experience he described as 'unfeeling', as if he were saying a tearful farewell to a child embarking on his first year in college. Rothko did,

in fact, sometimes cry when faced with this graduation. A Swiss dealer in the 1960s was so shocked at the artist's response to separation – Rothko stammering between sobs that he couldn't possibly bear to let the works go – that the man felt he had to comfort the big bear of a painter with soothing words and strong liquor. No wonder that in 1959, faced with a restaurant full of fashionably attired gobblers, Rothko choked on their heedlessness.

Given this obsessive relationship with his pictures, it was natural that Rothko would try to give them the optimal conditions for their impact on the viewer. One reason why he favoured the vertical format in the early 1950s was as a crowd-control device. Since he calculated that only a limited number of people could gather before one of the pictures, the sensuous communication could be more selectively targeted. Ideally what Rothko wanted was the undivided, intense attention of a single beholder, and when his paintings went on display in Manhattan galleries, he did everything he could to hold the viewer hostage to their power. If he didn't get his way, he would throw a tantrum or pull the paintings from a show. So the lighting had to be low. No spots could be tolerated as they threw artificially 'romantic' (his term, and an apt one) illumination on pictures that he believed already had their own interior drama and that had been painted to emit rather than absorb light. Position on the wall was also critical – as low as possible, with the foot of the unframed painting almost touching the floor. This was, after all, the position in which he had painted them. For Rothko passionately wanted to circumvent the gallery space, to go directly from his studio into the beholder's gaze. His ideal was to try to make the gallery space an approximation of the studio so that we could share with him the illusion of the painting perpetually *becoming*. The sense of that image forever evolving, even during the time of our looking, was at the heart of its vitality. A done picture was a dead picture. And Rothko forever worried about depletion setting in as soon as a painting escaped from his presence, about its being doomed to hang on some apartment wall above the sofa.

If he couldn't control the circumstances of eventual display (short of never selling anything), he would at least conquer the homogenizing whiteness of the gallery. So he insisted on the biggest paintings (preferably installed in the smallest room) hitting the incoming visitor first. Size mattered to Rothko. As far back as 1943, long before he had begun to find his vision, in reply to a hostile critic of his Surrealist mythologies, he and Adolph Gottlieb had said they were for the 'large shape' because they favoured 'the simple expression of complex thought'. And the notion that big could be friendlier, more communicative than compact, ran through everything he did. He was only too aware, he wrote, that, historically, big pictures

were reserved for bombast and ceremony. But he looked at the matter of scale differently. Small paintings, he said, were actually cold things because the painter was necessarily outside the image as he made it. With big ones, at least *his* big ones, the painter was necessarily within its making, and his challenge was to bring the beholder within that interior. If they succeeded, such paintings could do what no other Western paintings had yet done: be simultaneously intimate and monumental.

No chance, then, for gentle introductions; instead maximum collision, total immersion. This meant of course, if at all possible, no paintings by anyone except him, which on the face of it seems outrageously arrogant. In fact, though, he was right. Put a Rothko next to a Pollock or a Kline or a de Kooning and they shout him down. Enter a room full of nothing but Rothkos – the custom-designed room of the Phillips Collection in Washington DC – and you are instantly addicted. Even within those rooms, though, he thought there should be no chance for the art to sit against bare wall space lest it be read in any way as decoration. So little or no room, then, *between* the pictures. The paintings, Rothko said, should not just occupy the wall, but defeat it. He was asked how close one ought to stand. Oh, about 18 inches, he replied, not altogether in jest.

If Rothko was a control freak, it was because each and every painting was the product of so many fine calculations. Invitees (and there weren't many) to his studio would have seen him surrounded by pots, brushes, rabbit-skin glue he used to glaze intermediate layers of paint, and crates of eggs (heavily present in his pigments). More likely, though, he would have been found just staring, cigarette in hand for hours on end, refining over and again the gathering visual impact of his composition and exploring how it might be further fine-tuned for greater effect.

And just because Rothko was often spoken of as some sort of transcendental philosopher, he was at pains to deny any trace of mysticism. What he wanted to deliver, he said, was not some sort of ethereal lightness at all, but a sense of *material* experience, the sensuousness of the sampled world in all its gorgeous richness. Paradoxically, though, he wanted to do that through paint that felt, as he put it, breathed on to the canvas. This meant that he thinned and thinned with turpentine, diluting so much that sometimes specks of pigment came away from the paint film itself, speckling the surface of the canvas like the glinting particles lodged in lapis lazuli. When he wanted richer, more solid areas, Rothko simply layered another of these delicate scrims over the last. The richness thus builds slowly in the eye, becoming optically inexhaustible: precisely the opposite effect from either the solid colour blocks of Josef Albers or the discrete stains of colour-field painters, such as Morris Louis, the bald economy of whose pouring was supposed to be its own

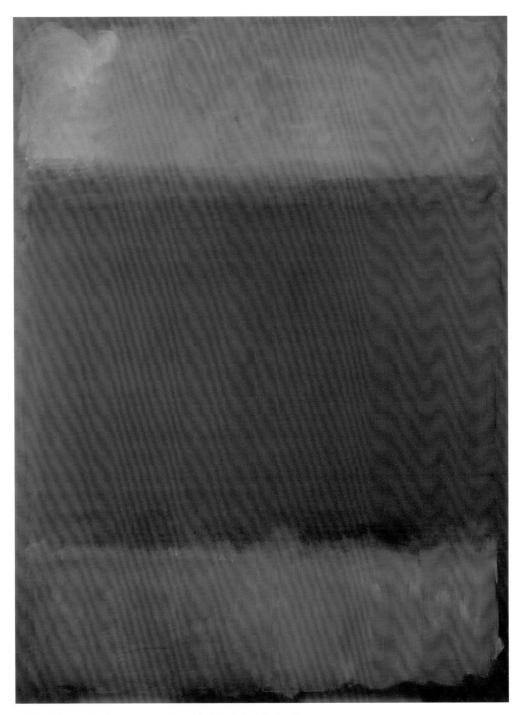

UNTITLED, 1955, oil on canvas (Kate Rothko Prizel Collection).

virtue. Rothko was, I suppose, more of an orientalist. Instead of dense blocks of thick colour, his are diaphanous gauzes that drift together, closing and separating, hovering above or gliding beneath each other, building their numen, tremulously sexy.

None of this teasing of the eye could have worked had not Rothko also been the most soft-edged of all modern painters (another reason for the awkward place he fills in a canon in which hard-edged minimalism is equated with high-minded forthrightness). Ragged, indeterminate borders are crucial to Rothko's emotive picturing both at the perimeter of the painting and in the frayed seams he tears between the large colour zones so that they don't read as boundaries at all, but as a visible glimpse of some glowing bed of light over which everything else is unstably superimposed. When the overall image is darker, as in *Untitled*, 1955 (page 423) the intensity of the border 'burn' is made even stronger. That inner light, mysteriously potent, Rothko believed had originated with Rembrandt, which is why when he taught a course on 'Contemporary Artists' at Brooklyn College it was with Rembrandt that he began. Painting, he said at one point before the darkening of his palette had set in at the end of his life, should be ecstatic or nothing. And he shared with Rembrandt and Turner the power to switch on in our eye the tap of bodily delight.

VII

SO FOR THE MOMENT NO MORE STRUGGLING, either with himself or for public recognition. When they were shown in Manhattan in the early 1950s, the big Rothkos were recognized right away by both critics and collectors as a body of work that made the case for American painting in an entirely new way: emotionally stirring and sensuously addictive. Those hours spent absorbing Matisse's *Red Studio* had paid off. To the old world of European art, where the veterans of modernism, Léger, Picasso and Dali, were pottering around to ever less effect, Rothko's paintings refuted the trite accusation of American shallowness. Whatever else they were, they were unmistakably deep.

In three years, between 1954 and 1957, prices for Rothko's paintings trebled. The big museums – MoMA just down the street from his studio, and the Whitney that he'd attacked as a young turk in the 1930s – all wanted Rothkos. And buyers who prided themselves on building a collection of modern American artists now had to have a Rothko along with their de Koonings, Pollocks and Klines. Not that this burst of fame and fortune relaxed the painter very much. Most of the painters grouped as 'The Irascibles' by *Life* magazine – de Kooning and Barnett Newman among them – don't look *that* irascible. Pollock gives good value, though, his face a mask of indifferent contempt. Rothko manages a superlative glower, as though he

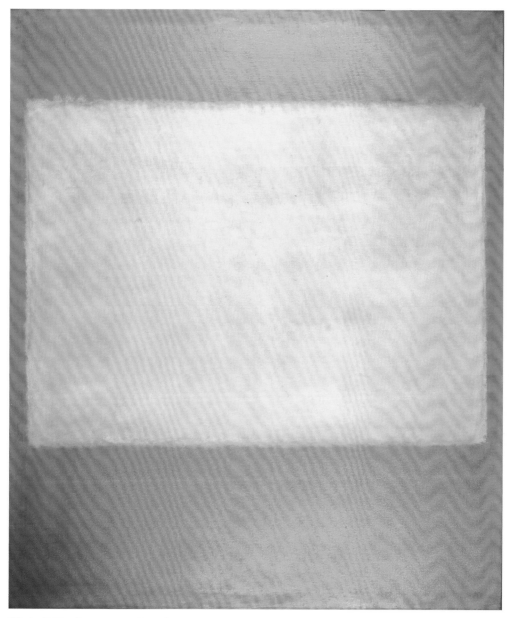

NO. 1, 1957, oil on canvas (Kate Rothko Prizel Collection).

were desperate to leave, which he almost certainly was. Hungry for compliments, he was capable of biting the head off those who offered them. And no sooner had he begun to make money than he began to complain about being misunderstood, always bookended with Pollock, the solemn philsopher to his fellow artist's tearaway Dionysian. He especially disliked being told that his paintings gave those who saw them a feeling of repose. His pictures, he protested, weren't supposed to calm you down, but to get you aroused. They were the tragic performances he'd been training for ever since his time at Josephine Dillon's rep company in Portland. They were as violent and sacrificial as anything he had done in his Aeschylus-Nimrud archaeo-logical vein, but with the fate-laden gestures dissolved into the paint layers. They ought still, he thought, to provoke the most extreme sensations of doom and ecstasy. 'A sense of the tragic is always with me when I paint,' he said in the last lecture he ever gave in 1958. The radiance of his work was, he commented, like the afterglow from some explosion. Look at *No. 1*, 1957 (page 425) and you see right away what he means.

Likewise, when some innocent ventured praise for his abstractions, Rothko would retort that they were not abstract at all but had a subject: human experience, the elemental emotions. 'The fact that some people break down and cry when they encounter my pictures,' he said, 'means that I communicate those basic emotions.' What he hated most was to be told how very beautiful his paintings were – though they are just that. The B-word rang alarm bells for Rothko: he always feared that his work might be treated as no more than interior decoration for the rich. Nothing set his teeth on edge more than imagining his pictures as what he called 'overmantels', flanked by flower arrangements and invitations to cocktail parties.

It was exactly when he *was* selling his work to the rich, when his income trebled from $20,000 in 1958 to $60,000 in 1959, that Rothko deliberately turned away from the brilliant colours that had turned him, he suspected, into millionaire-friendly wallpaper. In place of the hot yellows, blues and greens came subdued tones that spoke poetically of the ruin of time: the deep greens of invading moss and lichens; the verdigris of decayed copper; the crimson of staining wine lees; the terracotta and blacks of archaic pots and funerary urns. Black had often been part of Rothko's colour schemes – especially when, again like Rembrandt, he wanted to show that it could, against all the conventions of optics, seem to project from the canvas. He usually set it off with scalding vermilion or brilliant yellows in one of those colour fights he spoke of. But now the light-sucking absorption of black shadowed the whole composition. Windows that had opened now were draped, the beguiling transparency masked.

LIGHT RED OVER BLACK, 1957, oil on canvas (Tate Gallery, London).

So if he was already combative about the possibility of being used as wallpaper, what was Rothko doing signing up for what must have seemed the ultimate job in decoration? He was about to supply a suite of paintings for the Four Seasons restaurant, the place, he told John Fischer, the editor of *Harper's* magazine, whom he met aboard the SS *Independence*, 'where the richest bastards in New York come to feed and show off'? The impression he gave to his fellow passengers and new friend was that he had accepted the commission gladiatorially. It would be art versus greed, mystery versus materialism, Mark versus Manhattan. Trapped by his murals with their in-built memories of ancient sacrifices, the 'rich sons of bitches' would lose their appetite. Once that had happened, and their glossy parade of wealth had been sloughed off like a snakeskin, diners would be ready for moral transformation. 'If the restaurant would refuse to put up my murals,' he added, 'that would be the ultimate compliment.'

It sounded brave. But at the outset it wasn't quite that simple. Many aspects of the commission (quite aside from the fee of $35,000 – $2 million in today's prices) were flattering and creatively challenging. Rothko had long been interested in the way painting and architecture played off each other. The fact that there were now all those glamorous Manhattan apartments with his paintings in their dining and sitting rooms only sharpened his need to create out of a public space what he called 'a place' – his kind of place.

And the Four Seasons wasn't just another guzzling palace. It occupied the ground floor of a sleek skyscraper designed by the high priest of the modernist International Style, Mies van de Rohe. For whatever else could be said about the corporate headquarters of the Seagram Corporation, it certainly wasn't glitzy. Slender and razor-sharp, it was ribbed in the same matt metallic hues with which Rothko was himself experimenting in his new manner of painting. The building brooded over Manhattan, as if taking it to task for its addiction to gaudy consumerism.

The Four Seasons itself, with its half-sunken floor and modernist furniture designed by Mies and Philip Johnson, aspired to understated neo-classicism with a shot of Zen lite: fig trees and reflecting pools. All the same, however you cut it, the Four Seasons was a restaurant. But Rothko trusted Johnson, not least because, as head of MoMA's architecture department, he had been responsible for buying the first Rothko for the museum's collection. Among Johnson's many talents, he was a famously irresistible persuader, and he must have switched on the impish charm to maximum wattage to persuade Rothko that, notwithstanding the huge windows along one side of the room in which his pictures were to hang, and the metallic,

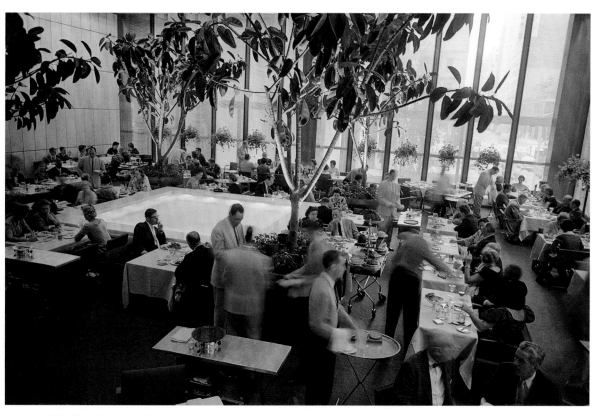

The Four Seasons Restaurant, Seagrams, Park Avenue, New York, 1959 (Bettmann Archives).

electrically controlled waterfall curtains, he could somehow control the installation as completely as he had in the galleries of Betty Parsons or Sidney Janis.

If Rothko was in denial about the problems that might get in the way of his realizing his greatest ambition – to have his paintings interact with architecture in the same way as they did in a Renaissance chapel – it was because the opportunity to bring the grand project off seemed so tantalizingly close. In 1950, visiting the monastery of San Marco in Florence with Mell, Rothko had seen Fra Angelico's frescoes and had been powerfully affected by the way each of them imparted a mysterious glow to the simple spaces, which cumulatively became overwhelming. He was convinced he could work the same kind of magic in New York.

Nine of his pictures would cover the three walls of the smaller of the two rooms that made up the restaurant (the fourth being the curtain window). So their crowding effect, like a frieze, would indeed wrap around the diners. The half-sunken floor would then have the effect of elevating the pictures somewhat, as if on a stage – the natural platform for his dramas to exert their spell. Although one of the walls was pierced by door openings so that the paintings had to hang above them – seven and a half feet up – he consoled himself with the thought that when the doors were open, the restaurant staff would have a view of the paintings facing them. The walls would, in fact, be not just defeated, but entirely replaced by his burnt orange and crimson glow. That's why he insisted on calling the pictures 'murals', even though they were to be hung, not painted, on the walls. Bus-boys, waiters, maître d' and fancy diners would all be brought together in a solemn conversion experience. Mastication would slow down and silverware would lie idle as the swallowers were swallowed by the pure power of art.

The more Rothko thought about it, the more he came to feel this was indeed the consummation of his life's work. Needing a big space to think big thoughts, he rented an old YMCA gym on the Bowery. Inside the studio he erected scaffolding to the same dimensions as the Four Seasons space so that he could work three-dimensionally, seeing at each stage how the paintings would react with and against each other. Every day he went downtown, changed from the habitual sports jacket or suit, and got to work on the huge canvases. Twenty-seven of them were painted in less than two years, from which he would work up the nine that would cover his allotted three walls.

But he was unhappy with the first attempts, painted in the summer of 1958. They were too much Rothko in his old vein, the vertical format hardly meeting the needs of the room if he were indeed to replace those walls with his murals. So, prompted by the demands of the space and also by some inner adjustment of mood

and tone, he did something simple: he turned his usual format through 90 degrees so that instead of uprights, some became expansive horizontals. Architecture now not only became the occasion for the change, but echoed through it. What had been shutter-like bars of light turned into load-bearing columns. And the load they were bearing was the tragic weight of human history. On that earlier trip to Florence in 1950 Rothko had also seen Michelangelo's Laurentian Library, with its blind stone windows. Now he felt his own dark rectangles, that took instead of gave light, would sober up the intoxicated glamorists who lived just for the moment, for that exquisitely pricey meal. After paying the bill, there would be no summoning the limo, no swanning off into Park Avenue.

The next series of full-size sketches, in flaring burnt orange, the radiance of a dying sun, attract and repel, beckon and bemuse; the ominous gestures of an ancient magus toying with our cravings to take that 'journey into the unknown' he had said was only for the brave.

In June 1959, almost finished but exhausted by the work, he took Mell on a trip to Italy, where, in the Villa of Mysteries at Pompeii, Rothko was stunned to discover in the Roman murals 'a deep relationship' with his work for the restaurant; an attempt to put hedonism in touch with the sublime. And he returned to the Laurentian library in Florence, where he looked with satisfaction at what he thought of as the Michelangelesque genius of entrapment.

But it was Rothko who suddenly felt the teeth of the trap. When he got back to New York, he and Mell went to dine at the glamorous and recently opened Four Seasons. Rothko had said that it was immoral to spend more than five bucks on a meal, and was often happiest eating takeaway Chinese. But as he sat there with Mell, his confidence that he could indeed 'make a place' that would stop the diners in mid-soufflé sank. In their apartment, in a high dudgeon, he called a friend and barked, 'Anyone who will eat that kind of food for that kind of money will never look at a painting of mine'. But was the remark descriptive or prescriptive, a sad admission or a threat?

The next morning Rothko went to 222 Bowery roiling with rage and anguish. He looked at the paintings he had made: the maroons and crimsons and blacks, the fiery oranges and umbrous browns – some of the most moving pictures that any modern artist had made. And all he could see was ruin.

Back went the down payment of $7000. Manhattan had beaten Mark. Or had it? By withdrawing from the commission, perhaps he had struck a blow for the integrity of his work, for its resistance to ingratiation? It's true that by now he was earning more than enough to survive and, keeping the paintings he had completed,

Above: BLACK ON MAROON (SEAGRAM MURAL SKETCH), 1958, oil on canvas (Tate Gallery, London).
Opposite: BLACK ON MAROON (SEAGRAM MURAL SKETCH), 1959, oil on canvas (Tate Gallery, London).

he might have reasoned to himself that he would hardly be out of pocket. However, he was certainly not going to sell them off piecemeal, but wait for another tabernacle to come along. And besides, how many contemporary artists do you know who would turn down flat a cool $2 million?

VIII

THE SEAGRAM ENTERPRISE WAS OVER, but Rothko's struggle to 'make a place' of meditation was not. After selling the initial batch of paintings, he was careful never to put any of the rest, the ones that counted, on the market. He was sustained by a belief that perhaps some day, somewhere, he would be able to resurrect his idea of a modernist chapel. Not in a museum, for he called those 'mausoleums', but in a custom-designed space from which the fatuous white noise of life could be blocked out.

One day, while he was still brooding unhappily on the wreckage of the Seagram project, a German art historian, Werner Haftmann, came to invite him to the Kassel art fair, Documenta. Rothko made his visitor a counter-offer. Build a chapel of expiation for the Holocaust, he said. It doesn't have to be big or grand. A tent will do, and if you do this, I will paint you some work to hang there and I will do it for nothing. How very interesting, said the curator. And didn't get back to the artist.

Rothko spent much of the next ten years – his last decade – looking for that perfect wayside chapel in which he could realize the vision that had been thwarted in the Four Seasons. If he couldn't prevail in a restaurant, perhaps a university, a place devoted to the Higher Values, would be more accommodating. When Harvard came along, the Jewish modernist spoke mystifyingly to its Dean about the Crucifixion and paintings of the Madonna and Child he had seen in the basilica on the island of Torcello in the Venetian lagoon. Predictably, his paintings were installed in a committee room, in a modernist building designed by Sert, the architect of the pavilion in which *Guernica* had languished in 1937. Instead of being ignored by diners, the Harvard Rothkos faded away to the drone of arguments about tenure. Coming into too-close contact from all that academic chair shuffling, they also suffered some physical damage.

Rothko was himself now an American institution, representing the United States at the Venice Biennale, where he did succeed in installing a pure 'Rothko-room'. He was invited to the inauguration of JFK, and treated like the grandest surviving patriarch of the 'New York School'. But none of this seemed to give him much joy. With fame and wealth, he got more argumentative about money. His tippling, which began at ten o'clock in the morning, developed into alcoholism. And his lifelong

chain-smoking began to give him heart and lung problems. All this poor health, and the bad temper that often went with it, put an intolerable strain on his marriage. Shadowed by melancholy, his work got darker just as the avant-garde was going POP! Flags! Marilyn! Comics! For Rothko, modern painting had always been an alternative to pop culture, not an accomplice of its domination. But this seemed to be the kind of thing the galleries now wanted. Stuck in the manner of painting he had been doing for 15 years, he was defensive, bewildered and angry, accusing the 'youngsters' of trying to kill him, when the truth, of course, was that he was killing himself.

So when, finally, he did break out of his old style, it was to go raven-black; as black as Texas oil. In 1964, when Dominique and John de Menil, enthusiastic collectors of modern art from a family that had become hugely wealthy through selling drilling equipment, offered Rothko exactly what he wanted – a chapel, custom-built to his specifications – he jumped at the opportunity. But what he had built, and the pictures he made for it, sucked away the warm light of the Seagram pictures and seemed to replace them with a sepulchre of the spirit. At first sight, the stark octagonal room feels like a chamber of live burial, a black full stop to Rothko's journey through radiance. The rippling flares of light at the edges of the colour panels, his sunspots, have been wiped out. Instead there are hard-edged panels covered with opaque layers of black paint. But this isn't the end of the story visually. Between the two crow-wing panels of one of the triptychs is a brushy purple panel, with more forgiving stainings and soakings. Although the modulation seems slight, the relief from the hard black seems like an invitation to a different universe. And as one's eyes adjust, it's this velvety tone that expands and diffuses, like air entering a sealed chamber. An American actress friend of mine (from a long line of butchers), about to film a famously difficult part on location in Texas some years ago, decided to get into the role by spending the night in the Rothko chapel – an experience that would not, I suspect, have most of us on our toes in the morning, bright, breezy and ready for action. But no, she said, it was wonderful: 'Coming out, I felt so light.' Rothko would have loved that.

He, however, got heavier. In 1968 he suffered an aortic aneurysm that nearly killed him. Then he turned to drink in a serious way. His marriage to Mell fell apart. But he resisted the clichés. Instead of a complete extinction of light, the very opposite happened. Brilliance was reborn. It was not the luminous explosion of the early 1950s – in the late 1960s the radiance is almost always challenged by areas of inky darkness. But that only gives it startlingly augmented force, as if the painter were himself on the threshold between two worlds. In the lower section of painting

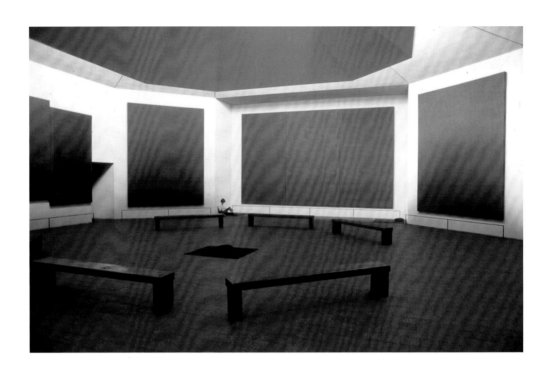

Top: ROTHKO CHAPEL, dedicated 1971 (Houston, Texas).
Above: UNTITLED (BLACK ON GREY), 1969, acrylic on canvas (Kate Rothko Prizel Collection).

after painting made in 1969 he laid down a zone of milky grey, like the rim of the moon – a way station to the universe, still soaked with light and somehow tethered to the known world, but on the very lip of infinity. It's as if Rothko had himself already gone into deep space and was looking back, presiding god-like over a moment of creation, dividing the light from the darkness.

That he was not at all running out of creative juice is suggested by the party Rothko gave for friends in December 1969 so that they could voice their reaction to these new paintings. He was also suffering from emphysema. After the aneurysm doctors had advised that (apart from giving up smoking and drinking) he should paint nothing taller than two feet. He responded, in the few months before he cut his wrists and arms open, with gestures of heroic defiance against any enclosing of the night. Both chromatically and conceptually the acrylics on paper are some of the most brilliant things he ever did, poetically compressed and lyrically intense. A celestial cobalt breaks into the black and pushes into the advancing darkness, blue flame licking at the edges. The very last canvas is a blaze of vermilion light, a warrior cremation.

IX

So how wrong did I get it that morning in 1970, just before I collided with Mark Rothko? About as wrong as I could. If there was one word I might have ignorantly used to sum up his late paintings, it would have been 'forbidding'. But in fact they are embracing. No artist in the modern canon, at any rate, went to such lengths to include us, the spectators, in the enactment of the work. If ever we think of Caravaggio, Bernini, Rembrandt, David, Turner, van Gogh and even Picasso at his *Guernica* moment as virtuoso solo turns, off doing their own thing, heedless of anyone else, we couldn't be more mistaken. All of them assumed our participating presence. But perhaps none, not even the master of unfinish, Rembrandt, not even the sweetly hand-shaking Vincent van Gogh, took such pains to make us partners, not just in the beholding, but in the creation of his art. Without our becoming enfolded within his mantle of light, Rothko thought, there was no art. His greatest paintings, and especially the Seagram murals, are, then, performance pieces, the work of someone who never stopped talking about their drama. For some critics, then and now, this theatricality smacks of visual posturing. Not for me, though. The artist's reach through the canvas seems, as it does for Caravaggio and Turner, a gesture of humane inclusiveness. We, as much as the artist, are players. We enter stage left. We stick around. We are moved by what happens. And when we exit stage right, the rest of our lives are marked by that performance.

UNTITLED, 1969, acrylic on paper, mounted on canvas (Christopher Rothko Collection).

Rothko

The greatest compliment that Rothko (who wasn't free with them) handed out was to describe someone as a 'human being'. How moving, then, to discover that he needed us ordinary human beings to make his art just as much as we certainly need the extraordinary one who was Mark Rothko. I believe that one reason we need the 'place' that did eventually get made in Tate Modern is that it goes so much against the grain of the contemporary fetish of Now. It's ironic, given how much fissile creative energy has been generated by contemporary British art, that when Rothko was looking for somewhere he might place the last series of nine Seagram murals, he settled on Britain as perhaps the place farthest from the commercial hustle and critical blood sports that animated its counterpart in New York. (And this was 1969!) But then Rothko had last visited England ten years before, and then his pilgrimage had been to the cosy art enclave of St Ives in Cornwall.

But the fierce buzz of Tate Modern, of course, only makes the effect of its fade-out in the Rothko room, where the Seagram paintings have been reinstalled, the more complete. Whatever that room is about, it's certainly not Now. More like forever. This is a place where we come to sit – on the kind of bench Rothko specified, naturally – in the low light, and sense the aeons rolling by; where we can feel beckoned towards those hanging veils with their mysterious interior glimmer; or through the portals that seem to suggest both a vision of infinity and its unattainability. One of the words Rothko used most often about his art – but it could be extended to all art – is 'poignant', for the best of it is suffused both with a sense of the inevitable passing of things, including us, and with art's determination to trap, consolingly, those fugitive visions. It's impossible, then, to come to this room and not be touched by that poignancy: of our comings and goings, entrances and exits, womb, tomb and everything in between.

Which only makes the discrepancy between writing and looking the more pitiful. One of the words that Mark Rothko used with greatest disdain was the dismissive word about words: 'verbiage'. If there is any commandment hanging in the place that he (with help from the Tate, but also from all of us) eventually made, it is, finally, to please shut up. So just for once I will.

Acknowledgements

Power of Art began as an idea for a television series for BBC2, but became much more than the scripts between hard covers. Inevitably, and happily, the book offered space for reflection on works that couldn't be accommodated within the television hour, Caravaggio's *Medusa* and Van Gogh's *Undergrowth with Two Figures* being two important examples. But the project has been indivisibly a labour of two loves: for the craft of television documentary and that of popular narrative about art.

The series started as conversations with Jane Root, then Controller of BBC2, and Glenwyn Benson, Controller Factual TV at the BBC (but actually supremissima) about how programmes on art might be visualized as dramas of 'creative commotion'. I am so grateful to Glenwyn, and to Roly Keating, current Controller of BBC2, for keeping faith with what must have seemed a difficult and daunting challenge, and for their unwavering support throughout the long process of writing, filming and editing. Without my colleagues in the Arts Department at BBC Television – above all, its head, Mark Harrison, who has been an extraordinary source of ideas, constructively critical comments and generous advice on both scripts and cuts – the whole endeavour would have been unthinkable. Basil Comely, our Executive Producer, has given us another clearly focused vision of what the programmes might be. But it is Clare Beavan, Series Producer and my extraordinary, impassioned creative partner in the series, to whom I'm most indebted for sustaining and realizing the vision we had of arts programmes that would move, enlighten and entertain audiences from start to finish. The other directors of the films – David Belton, Steve Condie, Carl Hindmarch and James Runcie – have all been inspired and inspiring collaborators, always challenging the presenter to write better, tighter scripts, and whose powers of visual and dramatic invention have astonished me with their energy and subtlety. Alan Yentob and Melvyn Bragg, who know a lot more about making arts documentaries than the present greenhorn, have been exceptionally generous with their encouragement. In the Arts Department, Annabel Yonge and Emma Fowler have kept the project in good order and the presenter in good cheer, but I am also deeply grateful to my assistants on the shoots – Mona Hamed, Kim Lomax, Lulu Valentine and Samantha Earl – for helping me survive the rigours of filming. Thanks also to Matt Utber for a title design that so brilliantly captures the spirit of the series and the book.

At WNET, New York, our co-producer, I'm grateful for the enthusiasm and constructive responses offered by Margie Smilow, Kristin Lovejoy and Barry Sherman, and to all at PBS who helped to bring the project to an American audience. Alice Sherwood was generous enough to read the scripts as they developed, and offer helpful comments as the drafts progressed. Caroline Michel and Jill Slotover very kindly did the same with the chapters, and Chloe Schama and Ginny Papaoiannou took precious time out of our vacation to apply their eagle eyes to the first pass of page proofs.

I am immensely grateful to Geraldine Johnson and Debora Silverman (whose account of Van Gogh deeply informed my narrative) for reading chapters; also to Gary Schwartz for his helpful comments on the Rembrandt chapter; and to the students in my Turner seminar at Columbia University during the spring of 2006 for their exuberantly intelligent enthusiasm for a difficult subject. I am also grateful to Sarah McPhee for her work on Bernini's bell-towers, and for not being put out on discovering that my own long-standing fascination with Costanza Bonarelli coincided with her much more original archival research. Gijs van Hensbergen was generously encouraging about *Guernica*; and Kate Rothko Prizel and Christopher Rothko have been immensely considerate and helpful with the chapter and film on their father's work. In a more general sense, I am grateful to all my colleagues and students in Columbia's Department of Art History and Archaeology, for creating a challenging and inspiring community within which to think about the history of image-making. I also owe a debt to the Provost of Columbia, Alan Brinkley, for extending leave to me during the major period of filming.

At BBC Books I am most grateful to my editor Martin Redfern for his patient belief that the book would get done, his helpful comments on the manuscript and his acutely intelligent advice once the book was in production. Belinda Wilkinson and Linda Blakemore have, as usual, been superhuman, somehow combining speed and exacting devotion. Grateful thanks also to Claire Scott, Stephanie Fox, Lynda Marshall, Esther Jagger, David Brimble, Trish Burgess, Cath Harries and Margaret Cornell; and to Gail Rebuck and Fiona MacIntyre at Random House, who have inherited the publishing project.

At Ecco Press in New York my editor Dan Halpern has been unfazed by finding he has taken on a book that in scope – and illustrated density – was not quite what he had bargained for, and, as usual, putting all his engaged enthusiasm into making it a success. Millicent Bennett and the designer of the US cover, Mary Schuck, have been exceptionally resourceful with the wayward author.

As ever, my agents – Rosemary Scoular on the TV side and Michael Sissons and Michael Carlisle on the book side – have been stupendous in their loyalty and affection, beyond anything the author deserved, and have always been towers of strength against which the periodically wobbly Schama could dependably lean. At PFD I must also thank James Gill, Sophie Laurimore, Rachel Hamilton and Carol Macarthur for their unstinting help at many stages.

It's customary to describe the family victims of a television-literary work as 'long suffering', which doesn't begin to do justice for the disruptions, long absences and fits of uneven temper that my wife Ginny and children Chloe and Gabriel

Acknowledgements

have had to endure. I thank them for their forbearance with all my heart. If the end result on television and in these pages manages to communicate my passion for art, they should

know that it has always been kindled and sustained by those many hours spent together with them in galleries and museums in a state of wonder – and not just at the pictures.

Credits

BBC Books would like to thank the following for providing photographs and for permission to reproduce copyright material. While every effort has been made to trace and acknowledge copyright holders, we would like to apologize should there have been any errors or omissions.

©ADAGP, Paris and DACS, London, 2006: 379B, 382B. **Archives of American Art, Smithsonian Institution**: 397 (detail), Courtesy of the Photographs of Artists, Kay Bell Reynal Collection, 1952. **Akg-images**: 40, Thyssen-Bornemisza Collection; 134L, Rembrandtshuis; 170T, Gemäldegalerie, Neue Meister, Dresden; 307, Van Gogh Museum, Amsterdam; 325, Hahnloser Collection, Berne; 338T, Kröller-Müller Museum, Otterlo; 370B, Ulmer Museum, Ulmer/©Succession Picasso/DACS 2006. **The Art Institute of Chicago**: 362, Gift of Mrs Gilbert W. Chapman in Memory of Charles B. Goodspeed, 1948.561. Photography ©Art Institute of Chicago/©Succession Picasso/DACS 2006. **Artothek**: 174B, Staatliche Graphische Sammlung, Munich. **Art Resource, New York/©Kate Rothko Prizel & Christopher Rothko/ARS, NY and DACS, London** 2006: 404T, 407B, 414B, 416, 417, 419L, 423, 425, 436B, 438; 436T, Nicolas Sapieha. ©**BBC**: 77, 87T, 91BL/BR, 98, 104, 116. **BPK**: 53, 137, Gemäldegalerie, Staatlichen Museen zu Berlin/ Photo: Jörg P Anders; 149L, Kupferstichkabinett, Staatliche Museen zu Berlin/ Photo: Jörg P Anders; 174T, Hamburger Kunsthalle, Hamburg/ Photo: Cjristoph Irrgang. **Bridgeman Art Library, London**: 104T, Museo Nazionale del Bargello, Florence; 118, Santa Maria della Vittoria, Rome/Joseph Martin; 127 (detail), 176–7 ©Nationalmuseum, Stockholm; 134–135, © Museum of Fine Arts, Boston, Zoe Oliver Sherman Collection; 149BR, British Museum, London; 151, Gemaeldegalerie Alte Meister, Dresden ©Staatlic Kunstsammlungen Dresden; 152, Gemaeldegalerie Alte Meister, Kassel ©Staatliche Museen Kassel; 185, Wallraf Richartz Museum, Cologne; 189, Musée de la Ville de Paris, Musée du Petit-Palais; 191, Musée des Beaux-Arts, Lille, Lauros/Giraudon; 192, Ecole Nationale Superieure des Beaux-Arts, Paris; 208, 209, Chateau de Versailles; 225T, Private Collection; 229, 230, 232, Louvre, Paris; 234, Musée Nationale du Chateau de Malmaison, Rueil-Malmaison, Lauros/Giraudon; 241B, Wilberforce House, Hull City Museums and Art Galleries; 248B, ©Birmingham Museums and Art Gallery; 259B, ©Cecil Higgins Art Gallery, Bedford; 268B, ©Yale Center for British Art, Paul Mellon Collection; 279, Reading University, Berkshire; 290T, ©Samuel Courtauld Trust, Courtauld Institute of Art Gallery, London; 315, Kröller-Müller Museum, Otterlo; 326R, Folkwang Museum, Essen; 327, Museum of Fine Arts, Boston. Bequest of John T Spaulding ©2006 Museum of Fine Arts, Boston; 348–9, Van Gogh Museum, Amsterdam; 360, MoMA, New York/Lauros/Giraudon/©Succession Picasso/DACS 2006; 369, Musée Picasso, Paris/© Succession Picasso/DACS 2006; 370T, Private Collection; 379B, Archives Charmet/©ADAGP, Paris and DACS, London, 2006; 382T, Museo Nacional Centro de Arte Reina Sofia, Madrid. **Cincinatti Art Museum**: 342–3. Bequest of Mary E Johnston. **Corbis**: 79, 429, ©Bettmann Archive; 93, ©Araldo de Luca; 115, ©Massimo Listri; 122, ©Francesco Venturi; 124, ©World Films Enterprises/photo. Vladimir Lefteroff; 163, ©The National Gallery, London, 318B, ©Francis G Mayer. ©**The Devonshire Collection, Chatsworth**: 241. Reproduced by permission of the Chatsworth Settlement Trustees. ©The Devonshire Collection ©**The Frick Collection, New York**: 144, 168. Copyright ©2006 by **Kimbell Art Museum, Fort Worth, Texas**: 32. **Collection Kröller-Müller Museum, Otterlo, The Netherlands**: 322, 326L. **The Metropolitan Museum of Art, New York**: 34, Rogers Fund, 1952 (52.81), Photograph ©1983 The Metropolitan Museum of Art; 83, Purchase, The Annenberg Fund, Inc., Gift, Fletcher, Rogers, and Louis V Bell Funds, and Gift of J Pierpont Morgan, by exchange, 1976 (1976.92), Photograph ©1996 The Metropolitan Museum of Art; 161B, Robert Leham Collection, 1975 (1975.1.799), Photograph ©1984 The Metropolitan Museum of Art; 165,

Purchase, special contributions and funds given or bequeathed by friends of the Museum, 1961 (61.198), Photograph ©1993 The Metropolitan Museum of Art; 198, Catharine Lorillard Wolfe Collection, Wolfe Fund, 1931 (31.45), Photograph ©1995 The Metropolitan Museum of Art; 199, Purchase, Mr and Mrs Charles Wrightsman Gift, in honor of Everett Fahy, 1977 (1977.10) Photograph ©1986 The Metropolitan Museum of Art; 318T, Rogers Fund, 1949 (49.41), Photograph ©1983 The Metropolitan Museum of Art; 333, Bequest of Abby Aldrich Rockefeller, 1948 (48.190.2) Photograph ©1998 The Metropolitan Museum of Art; 336T, Rogers Fund, 1949 (49.30) Photograph ©1984 The Metropolitan Museum of Art. Photograph ©2006 Museum of Fine Arts, Boston, Henry Lillie Pierce Fund 239, 288–9 (detail). ©**The National Gallery, London**: 26, 129, 145, 243. Images ©2006 Board of Trustees, National Gallery of Art, Washington, Gift of Mark Rothko Foundation, Inc/©Kate Rothko Prizel & Christopher Rothko/ARS, NY and DACS, London 2006: 404B, 407T, 409, 410T. **Rembrandtshuis, Amsterdam**: 170B. **Rijksprentenkabinet, Amsterdam**: 149TR. **Rijksmusem, Amsterdam**: 153, 156–7. ©**RMN, Paris**: 204–5, Louvre, ©Gerard Blot/Christian Jean; 215, Musée des Beaux Arts, Dijon; 225B, Louvre/©Thiery Le Mage; 373, Musée Picasso, Paris/©Beatrice Hatala/©Succession Picasso/DACS 2006; 382B, Musée Picasso, Paris/©Franck Raux/©ADAGP, Paris and DACS, London, 2006; 391B, Musée des Beaux-Arts, Lyon/©Gerard Blot/© Succession Picasso/DACS 2006. **Royal Academy of Arts, London**: 246 © **Scala, Florence**: 15 (detail), 55, Stiftung Schlossert und Garten, Sans Souci, Potsdam; 17, 29, 73, 84, 91T, 95, 96, 97, 101; Borghese Gallery, Rome; 19, Biblioteca Marucelliana, Florence; 43, 44–5, 50, 51, Church of San Luigi dei Francesi, Rome; 57, Sant' Agostino, Rome; 59, Louvre, Paris; 64, Museo di Capodimonte, Naples; 66–7, San Giovanni, Valletta; 108, Vatican, Rome; 119, Santa Maria della Vittoria, Rome; 123, Sant' Andrea al Quirinale, Rome; 141, Hermitage Museum, St. Petersburg; 181 (detail), 220, Musées Royaux des Beaux-Arts, Brussels; 87B, Contini Bonacossi Collectiion; 37, 183, Uffizi, Florence; 161T, 194–5, Louvre, Paris; 277, Philadelphia Museum of Art; The John Howard McFadden Collection, 1928 ©2004 The Philadelphia Museum of Art/ Art Resource; 297 (detail), 328, 335, Musée d'Orsay, Paris; 316, Niarchos Collection, Paris; 353 (detail), 384–5, Museo Nacional Centro de Arte Reina Sofia, Madrid ©2003/Photo Art Resource/©Succession Picasso/DACS 2006; 357, Philadelphia Museum of Art, A. E. Gallatin Collection, 1950 ©2004, Photo The Philadelphia Museum of Art/Art Resource/©Succession Picasso/DACS 2006; 358, MoMA, New York, The William S Paley Collection/©Succession Picasso/DACS 2006; 364T, MoMA, New York, Gift of Mrs Simon Guggenheim ©Succession Picasso/DACS 2006; 393, MoMA, New York, Mrs Sam A. Lewisohn Bequest (by exchange) and Mrs Marya Bernard Fund in memory of her husband Dr Bernard Bernard and anonymous/©Succession Picasso/DACS 2006; 364B, Ganz Collection, New York/©Succession Picasso/DACS 2006; 410B, MoMA, New York/©Kate Rothko Prizel & Christopher Rothko/ARS, NY and DACS, London 2006; 414T, MoMA, New York/©Succession H. Matisse/DACS 2006; 419R, MoMA, New York/©Kate Rothko Prizel & Christopher Rothko/ARS, NY and DACS, London 2006; 297 (detail), 328, 335, Musée d'Orsay, Paris; 316, Niarchos Collection, Paris; 353, 358, 360, 364T, 393 ©Succession Picasso/DACS 2006; 364B, Ganz Collection, New York/©Succession Picasso/DACS 2006; 386, Prado, Madrid; 410B, ©Kate Rothko Prizel & Christopher Rothko/ARS, NY and DACS, London 2006; 419R, MoMA, New York/©Kate Rothko Prizel & Christopher Rothko/ARS, NY and DACS, London 2006 ©**Tate, London, 2006**: 236 (detail), 248T, 251, 255, 256, 259T, 262–3, 264, 268T, 271, 272, 275, 284–5, 290B, 294; 391T/© Succession Picasso/DACS 2006; 399, 427, 432, 433/©Kate Rothko Prizel & Christopher Rothko/ARS, NY and DACS, London 2006. **Van Gogh Museum, Amsterdam**: 305, 309, 310–11, 314, 336B, 338B, 344–5, 348–9. **Copyright © Times Newspapers Ltd, 1937**/George Steer: 376.

Further Reading

This is a brief, selective, subjective and opinionated guide to further reading. I have mostly confined myself to relatively recent books in English, and with the general reader in mind.

ART AND SPECTATOR
Berger, J., *Ways of Seeing* (Penguin, 1972).
Freedberg, D., *The Power of Images: Studies in the History and Theory of Response* (University of Chicago Press, 1989).

ARTISTS AND THE MELANCHOLY MOOD
Kris, E. and Kurz, O., *Legend, Myth and Magic in the Image of the Artist: An Historical Experiment* (Yale University Press, 1957).
Sturgis, A., Chistiansen, R., Oliver, R, and Wilson, M, *Rebels and Martyrs: The Artist in the Nineteenth Century* (National Gallery, London, 2006).
Wittkower, R. and M., *Born under Saturn: The Character and Conduct of Artists from Antiquity to the French Revolution* (W.W. Norton & Co, 1969).

CARAVAGGIO
Bal, M., *Quoting Caravaggio: Contemporary Art, Preposterous History* (University of Chicago Press, 1999).
Hibbard, H., *Caravaggio* (Icon Editions, 1983).
Langdon, H., *Caravaggio: A Life* (Chatto & Windus, 1998).
Puglisi, C., *Caravaggio* (Phaidon Press, 1998).
Robb, P., *M: Caravaggio* (Bloomsbury, 2000).
Spike, J. T., *Caravaggio* (Abbeville Press, 2001).

BERNINI
Avery, C. and Finn, D., *Bernini: Genius of the Baroque* (Bullfinch Press, 1997).
Baldinucci, F., *The Life of Bernini (1682)*, tr. Engass, C. (Penn State University Press, 1966).
Blunt, A., *Borromini* (Harvard University Press, 1979).
Connors, J., *Borromini and the Roman Oratory: Style and Society* (MIT Press, 1981).
Hibbard, H., *Bernini* (Penguin Books, 1990).
Lavin, I., *Bernini and the Unity of the Visual Arts*, vols 1 and 2 (Oxford University Press, 1980).
Lavin, I., *Gian Lorenzo Bernini. New Aspects of His Life and Thought* (Penn State University Press, 1985).
Magnuson, T., *Rome in the Age of Bernini*, vols 1 and 2 (Almqvist & Wiksell, 1982, 1986).
Marder, T. A., *Bernini and the Art of Architecture* (Abbeville Press, 1998).
McPhee, S., *Bernini and the Bell Towers: Architecture and Politics at the Vatican* (Yale University Press, 2002).
Morrissey, J., *The Genius in the Design: Bernini, Borromini and the Rivalry That Transformed Rome* (Duckworth & Co, 2005).
Wittkower, R., *Gian Lorenzo Bernini: The Sculptor of the Roman Baroque* (Phaidon Press, 1966).

REMBRANDT
Alpers, S., *Rembrandt's Enterprise: The Studio and the Market* (University of Chicago Press, 1988).
Chapman, H. Perry, *Rembrandt's Self-portraits* (Princeton University Press, 1992).
Chong, A., and Zell, M. (eds), *Rethinking Rembrandt* (Isabella Stewart Gardner Museum, Boston, 2002).
Haverkamp-Begemann, E., *Rembrandt: The Night Watch* (Princeton University Press, 1982).
Nadler, S., *Rembrandt's Jews* (University of Chicago Press, 2003).
Nordenfalk, C. A., *The Batavians' Oath of Allegiance: Rembrandt's Only Monumental Painting* (Nationalmuseum, Stockholm, 1952).
Schama, S., *Rembrandt's Eyes* (Alfred A. Knopf, 1999).
Schwartz, G., *The Rembrandt Book* (Harry N. Abrams, 2006).
Strauss, W., and van der Meulen, M., with van Heel, S.A.C. Dudok and de Baar, P.J.M., *The Rembrandt Documents* (Abaris Books, 1979).
Van de Wetering, E., *Rembrandt: The Painter at Work* (Amsterdam University Press, 1997).
Westermann, M., *Rembrandt* (Phaidon Press, 2000).
White, C., *Rembrandt and His World* (Thames & Hudson, 1964).
Zell, M., *Reframing Rembrandt: Jews and the Christian Image in Seventeenth-century Amsterdam* (University of California Press, 2002).

DAVID
Brookner, A., *Jacques-Louis David* (Icon Editions, 1981).
Crow, T. E., *Emulation: Making Artists for Revolutionary France* (Yale University Press, 1995).
Crow, T. E., *Painters and Public Life in Eighteenth-century Paris* (Yale University Press, 1985).
Herbert, R., *David, Voltaire, 'Brutus' and the French Revolution: An Essay in Art and Politics* (Allen Lane, 1972).
Honour, H., *Neo-Classicism* (Penguin USA, 1968).
Johnson, D., *Jacques-Louis David: New Perspectives* (University of Delaware Press, 2006).
Lajer-Burcharth, E., *Necklines: The Art of Jacques-Louis David after the Terror* (Yale University Press, 1999).
Lloyd Dowd, D., *Pageant Master of the Republic: Jacques-Louis David and the French Revolution* (Books for Libraries, 1977).
Roberts, W., *Jacques-Louis David, Revolutionary Artist: Art, Politics and the French Revolution* (University of North Carolina Press, 1989).
Rosenblum, R., *Transformations in Late Eighteenth Century Art* (Princeton University Press, 1967).
Schama, S., *Citizens: A Chronicle of the French Revolution* (Alfred A. Knopf, 1989).
Schnapper, A., *David* (Alpine Fine Arts Collection, 1983).
Vaughan, W., and Weston, H. (eds), *Jacques-Louis David's 'Marat'* (Cambridge University Press, 1999).

Further Reading

TURNER

Bailey, A., *Standing in the Sun: A Life of J.M.W. Turner* (HarperCollins, 1998).

Brown, D. Blayney, Rowell, C., and Warrell, I. (eds), *Turner at Petworth* (Tate Publishing, 2002).

Egerton, J., *Turner: The Fighting Temeraire* (Yale University Press, 1995).

Finberg, A.J., *The Life of J.M.W. Turner* (Clarendon Press, 1961).

Gage, J. (ed.), *Collected Correspondence of J.M.W. Turner* (Oxford University Press, 1980).

Gage, J., *Colour in Turner* (Studio Vista, 1969).

Gage, J., *J.M.W. Turner: A Wonderful Range of Mind* (Yale University Press, 1987).

Hamilton, J., *Turner: A Life* (Hodder & Stoughton, 1997).

Hamilton, J., *Turner: The Late Seascapes* (Yale University Press, 2003).

Joll, E., *et al*, *The Oxford Companion to J.M.W. Turner* (Oxford University Press, 2001).

Lindsay, J., *J.M.W. Turner: His Life and Work* (Harper & Row, 1992).

Rodner, W. S., *J.M.W. Turner: Romantic Painter of the Industrial Revolution* (University of California Press, 1998).

Ruskin, J., *Modern Painters* (Alfred A. Knopf, 1988).

Shanes, E., *Turner's Human Landscape* (Heinemann, 1989).

Townsend, J., *Turner's Painting Techniques* (Tate Publishing, 1996).

Venning, B., *Turner* (Phaidon Press, 2003).

Wilton, A., *Painting and Poetry: Turner's Verse Book and His Work of 1804–12* (Tate Publishing, 1991).

Wilton, A., *Turner and the Sublime* (British Museum Publications, 1980).

VAN GOGH

Cabanne, P., *Van Gogh* (Editions Pierre Terrail, 2002).

Dorn, R., Herzogenrath, W., and Hansen, D. (eds), *Van Gogh: Fields* (Hatje Cantz, 2002).

Druick, D., *et al*, *Van Gogh and Gauguin: The Studio of the South* (Thames & Hudson, 2001).

Gayford, M., *The Yellow House: Van Gogh, Gauguin, and Nine Turbulent Weeks in Arles* (Viking, 2006).

de Leeuw, R. (ed.), *The Letters of Vincent van Gogh*, tr. Pomerans, A. (Allen Lane, 1996). For an unabridged version, consult *The Complete Letters of Vincent van Gogh* (Thames & Hudson, 1979).

Pickvance, R., *Van Gogh in Arles*; *Van Gogh in Saint Rémy and Auvers* (Harry N. Abrams, 1985, 1986).

Pollock, G., and Orton, F., *Vincent van Gogh: Artist of His Time* (Phaidon Press, 1978).

Schapiro, M., *Van Gogh* (Thames & Hudson, 1968).

Silverman, D., *Van Gogh and Gauguin: The Search for Sacred Art* (Farrar, Straus & Giroux, 2001).

Van der Wolk, J., *The Seven Sketchbooks of Vincent van Gogh*, tr. C. Swan (Thames & Hudson, 1987).

Van Heugten, S., *Van Gogh: Draughtsman* (HNA Books, 2005).

Zemel, C., *Van Gogh's Progress: Utopia, Modernity and Late Nineteenth Century Art* (University of California Press, 1997).

PICASSO

Arnheim, R., *The Genesis of a Painting: Picasso's 'Guernica'* (Faber, 1964).

Ashton, D. (ed.), *Picasso on Art: A Selection of Views* (Thames & Hudson, 1972).

Berger, J., *The Success and Failure of Picasso* (Penguin Books, 1965).

Blunt, A., *Picasso's 'Guernica'* (Oxford University Press, 1969).

Chipp, H. B., *Picasso's 'Guernica': History, Transformations, Meanings* (University of California Press, 1992).

Cowling, E., *Picasso: Style and Meaning* (Phaidon Press, 2002).

Karmel, P., *Picasso and the Invention of Cubism* (Yale University Press, 2003).

Krauss, R. E., *The Picasso Papers* (Farrar, Straus & Giroux, 1998).

Martin, R., *Picasso's War: The Destruction of Guernica and the Masterpiece That Changed the War* (Plume Books, 2003).

Rankin, N., *Telegram from Guernica: The Extraordinary Life of George Steer, War Correspondent* (Faber & Faber, 2003).

Richardson, J., *A Life of Picasso* (Random House, 1991, 1996).

Schapiro, M., *The Unity of Picasso's Art* (George Brazilier, 2001).

Van Hensbergen, G., *Guernica: The Biography of a Twentieth Century Icon* (Bloomsbury, 2004).

Warncke, C.P., and Walther, I.F., *Picasso* (Taschen, 2003).

ROTHKO

Anfam, D., *Mark Rothko: The Works on Canvas* (Yale University Press, 1998).

Ashton, D., *About Rothko* (Oxford University Press Inc, 1983).

Barnes, S.J., *The Rothko Chapel: An Act of Faith* (Menil Foundation, 1989).

Breslin, J.E.B., *Mark Rothko: A Biography* (University of Chicago Press, 1993).

Chave, A.C., *Mark Rothko: Subjects in Abstraction* (Yale University Press, 1989).

Kellein, T., *et al*, *Mark Rothko: Kaaba in New York*, exhibition catalogue (Kunsthalle Basel, 1989).

Mark Rothko (Washington National Gallery, 1998).

Mark Rothko, A Painter's Progress: The Year 1949 (PaceWildenstein, 2004).

Mark Rothko: The Seagram Mural Project (Tate Gallery, Liverpool, 1988).

Perl, J., *New Art City* (Albert A. Knopf, 2005).

Phillips, G., and Crow, T. (eds), *Seeing Rothko* (Getty Publishing, 2005).

Polcari, S., *Abstract Expressionism and the Modern Experience* (Cambridge University Press, 1991).

Rothko, C. (ed), *Mark Rothko, The Artist's Reality: Philosophies of Art* (Yale University Press, 2004).

Sandler, I., *Abstract Expressionism: The Triumph of American Painting* (Pall Mall Press, 1970).

Index

Index

Index